BORN TO HEAL

Born to Heal
The Life Story of Holistic Pioneer
Gladys Taylor McGarey, M.D.

by

Analea McGarey

Inkwell Productions

ISBN: 0-9728118-9-3

Library of Congress Control Number: 2003111587

Published by
Inkwell Productions
3370 N. Hayden Rd., #123-276
Scottsdale, AZ 85251
Phone (480) 315-9636
Fax (480) 315-9641
Toll Free 888-324-2665
Email: info@inkwellproductions.com
Website: www.inkwellproductions.com

Table of Contents

For my mother, of course

Acknowledgements

I wish to offer heartfelt thanks to the following people, without whom this book would have never been written:

First and foremost, to all the people around the world whose lives have been touched, directly or indirectly, by my mother. It is your love that has sustained her through her darkest times, and helped her to grow into the woman she is today.

To Doris Solbrig, so generous with her time and expertise, who courageously waded through the piles of my handwritten pages, and committed them to the modern magic of the computer disc. If I ever do this again, I promise I will learn to type. There is no way I could have ever done this without you. Thank you. Thank you. Thank you.

To Dorothy Baker-Mill, who really, really pushed me into keeping on with it.

To Dale Zarzana for her words of wisdom, editorial comments, and unflinching belief in my ability.

To Barbara Jacobsen, who convinced me that truly, I could do this.

And to everyone in my family, for their overwhelming support and love.

Introduction

Several years ago, my mother and I were on our way to Paris. She had been invited to address an International Congress on Holistic Medicine. She invited me to accompany her for support because she knew I had always wanted to go to Paris.

I had dreamed of Paris since I was old enough to dream. I had fantasies of finding my true love in a sidewalk café in the City of Lights, of strolling the banks of the Seine with the soft Paris rain falling all around. I dreamed of the Left Bank, the Louvre and Notre Dame, chestnut trees in blossom; April in Paris. Besides all that, my mother, even at seventy-five years old, was a real kick to be with. When she invited me to go along with her, I grabbed the opportunity with both hands.

So, flushed, excited, and talking a mile a minute, we boarded the plane. We gave our passes to the flight attendant, took the stubs, and made our way to our seats. After arranging ourselves and our baggage, I began to put the boarding passes in my wallet, just in case they forgot to log my frequent flier miles.

"Hey, Mom, look at this!" I laughed. "Look at your name on the boarding pass." The airline computer had shortened first names to the first four letters, so her pass read, "McGarey, Glad." We had quite a chuckle over that, enjoying the play on words. But then I flipped my pass over, and to my horror and my mother's eternal delight, the diabolical computer had printed "McGarey, Anal." We stared, open mouthed with shock, then burst into hysterical laughter. We laughed for hours, all the way across the Atlantic. We woke up in the middle of the night in our hotel and roared. We laughed about it on the banks of the Seine and in sidewalk cafés. We decided

to write a travel book called *Glad and Anal Go to Paris.* Somehow, it just seemed so appropriate. We still chuckle about it when we get together.

In this book I intend to capture that laughter and excitement, and to tell of her travels through a life of joy, sorrow, and fulfillment. I want to tell the tale of her journey, of courage in the face of overwhelming odds, of great losses and even greater rewards, and finally, of the deep faith and joie de vivre that underscores each step of the way.

So I invite you to come along on this journey with me, and to share the experiences of one extraordinary woman's extraordinary life.

Most of the following is a true story. I hope you enjoy reading it as much as she enjoyed living it.

Foreword

It was 5:30 in the evening on a hot Arizona summer day when I realized that my patient who was in labor would not deliver in time for me to get home and fix dinner for my family. My immediate solution was to call home and talk to Annie who was nine years old. I asked her to put together a tuna casserole and a green salad. The family could eat fruit for dessert. She knew what I was talking about and said, "Don't worry, I'll take care of it." I immediately stopped being concerned and went right back to the business at hand of caring for my patient. I realized that this nine-year-old child of mine would handle the situation at home with single-minded creativity and dispatch. When I did get home, the household was quiet and peaceful, which didn't happen very often. I stood at the door for a moment to say a prayer of thanks.

I found Annie curled up in the big easy chair with a book. The boys were doing their homework or some other boy thing around the dining room table. Bethie was putting a puzzle together. Bill was in his study, having put baby David to sleep, with Annie's help, and things seemed to be well in hand. Of course I went into the kitchen and it was a total disaster. She had taken care of what needed to be taken care of, and then had gone on with her life. She understood priorities. The family had been fed and it was no big job for me to clean up the kitchen.

It was with the same sense of purpose and clarity that three years ago Analea (a k a Annie) took on the job of writing my biography. Thus the pattern repeated itself with me being involved in a multitude of activities and she supporting me and bringing to my life the excitement and joy of taking the ordinary and creating

something exceptional. She had made the ordinary tuna casserole something special by adding her own genius as a gourmet cook. Now she took the stories she had heard throughout her life and the ones she had experienced herself growing up as my eldest daughter and wrote them so they became interesting, even for me. Her ability to take what I considered ordinary situations in my life and make them colorful and extraordinary has been a joy to experience.

For me to relive my life through the eyes of my daughter has been a rare privilege. I thank God for the high mountains that have been climbed and the deep valleys that have been gone through.

I am deeply grateful for my family of origin, my extraordinary parents, and magnificent siblings. My children, each in their own special way, have played on the strings of my heart with high notes and low notes, creating a song of life that has been wondrous. And my grandchildren are ongoing rays of light.

My patients and my friends, my prayer partners and those who have supported me in difficult times, have woven themselves into the tapestry of my soul.

I've often said that I thought that when I got to be 80 my life would slow down. It now appears that there are new vistas opening up which are beckoning and there are paths which I will need to travel before my last chapter is written.

It is with a sense of humility, and yet, deep gratitude that I recommend this book written by my loving daughter who brings the message, my life, to you, the reader, in a way that no one else could.

– Gladys T. McGarey

Part 1

India

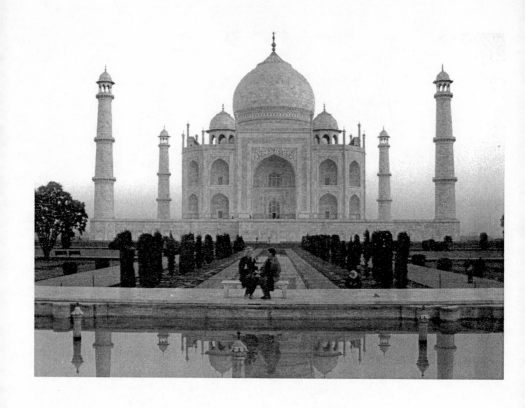

Chapter 1

1920

Northern India

\mathcal{S}he was born into a world that teemed with life, yet reeked of death. It was a world fragrant with incense and the heavy scent of jasmine and roses, underscored and overlaid with the stench of garbage, and rotting things of all kinds.

India, with her burden of millions, did not notice one more small soul born into her overcrowded bosom. She was unaffected by the event, no matter how significant it may have seemed to those intimately associated with the occurrence.

But India, the essence of her, the deep rivers of suffering and the incredible beauty of the Himalayas at sunrise, the juxtaposition of life and death, purity and squalor, laughter and tears – all of this had an ineradicable influence upon my mother and her life. The person she was to become and the effect she has had upon the lives of countless people, was formed from the clay of the Indian soil. The power and the misery, the tigers burning bright in the jungle, and the lepers with their wide-eyed children, these were the raw materials upon which a life of extraordinary consequence was built.

Her birth was remarkable only insofar as its timing. Her mother went into labor at her first sight of the Taj Mahal. Was it the heart-stopping beauty of that fabled monument to love that triggered her

1

labor pains? Or was it simply the bone-jolting ruts in the roads over which she'd been traveling? No one knows for sure. I, personally, tend to believe it was due more to the circumstances than the landscape.

It was 1920 and my grandparents had been in India, working as medical missionaries, for six years. This would be their fourth child, and my grandmother, Beth, had decided to have this baby in the Presbyterian Hospital in Fatehgarh, where her good friend, Dr. Adelaide Woodard, could preside over the birth. A full week before the baby was due, they left their beloved Rourkee bungalow in a swirl of dust. They had decided to take a short side trip to see the Taj Mahal, as it was on the way to Fatehgarh.

Beth was showing no signs of labor as she climbed into the old Model T Ford. My Grandfather, John, and the *ayah* (nurse) grabbed the two boys, who were running in circles around the car, shrieking in excitement, and bodily threw them into the back seat. Two-year-old Margaret, good as gold as usual, was already in the car. She was snuggled up against Dar, who was their cook, as well as the *ayah's* husband. Finally, with the boys firmly planted in the back seat, John and Ayah climbed into the coughing, spluttering old car, and they were off over the rutted roads on another adventure.

It was November and the monsoons had come and gone, but it was still sweltering in the plains. Dust clouds rose behind the jolting car while John expertly passed the slow bullock carts and moved through the hordes of people walking slowly down the road. Rather like Moses parting the Red Sea, Beth thought, with a small smile on her face.

Little John and Carl were hanging out of the windows, calling to the people they passed, acting like a couple of jungle monkeys. At four and six years old, they were inexhaustible bundles of energy, not stopping from the moment they bounded out of their cots in the morning until their inevitable collapse at night. They never minded the heat and dust and flies, in truth they seemed entranced and invigorated by the

wonders of this magical land. Monkeys and bejeweled elephants, peacocks and cobras and crocodiles; they lived in the midst of a fairy tale, every child's dream.

Margaret was behaving perfectly. She sat quietly beside Dar, playing with the bit of brightly colored string that was her favorite toy. She seemed to exist in a tiny bubble of serenity, enjoying the noise and bustle around her, but seldom participating.

As Ayah frantically grabbed at the flailing foot of one of the boys who had launched himself through the window to get to the monkeys screaming by the side of the road, Beth leaned back with a heavy sigh. Being pregnant was hard enough under the best of circumstances. In this heat it was well-nigh unbearable. But, she reminded herself, she was of good strong German stock and they were doing God's work. It wasn't her place to question the Almighty. But just for a moment she closed her eyes and was back on the front porch of her mother's house in Cincinnati, rocking on the porch swing, in the moonlight. In December. Pristine whiteness all around. Her breath hanging in a sparkling cloud, and quiet; quiet as far as her ears could hear. Silence broken only by the whisper of the wings of the snow owl and the crack of the tree branches frozen in the night.

Peace. Quiet. Cold. Clear.

Pain.

Pain? What was happening? Deep, grinding, stabbing pain, flickering and then gone. She'd been through enough pregnancies to know it was a labor pain, but, "False labor," she whispered to herself through parched lips. "It surely must be false labor." Every rut in the road seemed to increase her discomfort, but the deep grinding pain did not return. Yes, she thought to herself, it was false labor. The Lord would see to it that she was safe in the mission hospital, in the capable hands of her friend, before she was given the trial of another birth. Ayah was watching her knowingly, but Beth shook her head and said, "It's all

3

right. Nothing but a twinge...get Carl!" The four-year-old had climbed out onto the running board and was playing tag with some of the children racing along side. Beth shook her head in amazement. In her elephantine state she could not even imagine running, laughing and playing in the blazing sun.

She turned to her husband, drawing strength from his rugged profile. He was a tall, strong, Scotch Presbyterian, firm in his faith. His stern Scottish heritage was reflected in the set of his lips, but Beth had become quite adept at coaxing a smile, and when he laughed his brown eyes sparkled and his whole long, lanky body joined in. Today his face was alive with excitement – there was nothing he loved better than an adventure. To see wondrous new places, face a man-eating tiger in the jungle, preach the word of God and spread His gospel – these were the things that fueled his love for life and endeared him to all, especially his devoted wife. His love was the best thing that had ever happened to her, and she fondly called him "Dad" in all but their most intimate of moments.

She completed her study of his face, and resettled herself in the seat, trying in vain to find a comfortable position.

"How much farther, Dad?" she asked.

"Not long now, Mother," he replied, his voice full of concern and anticipation. He pulled the Model T around a particularly slow bullock cart and they entered the city.

The car came to a stop. Everyone alighted and moved with the crowd to the grand gate. Dar was sent to the bazaar outside to purchase food for the hungry boys. The rest of the group stepped through the arch and gazed in wonder at the sight before them. Like a jewel amongst rubbish, surrounded by the squalid, overcrowded city, there lay the Taj Mahal, glimmering, luminescent in the sunlight. The reflecting pool gave the illusion of two palatial tombs, both sculpted by a master's hand; perfect in symmetry, a monument to love everlasting.

4

Beth's eyes filled with the beauty of the sight, and she reached out to touch John's hand. Public displays of affection were rare for them, but this seemed necessary, somehow, in the reflected glory of that solidified commitment to love.

As his huge hand enveloped her small one, a monstrous pain tore through her and suddenly she was standing in a puddle of water. Her eyes clung to his face, and she realized that her time was upon her. A baby does not wait for convenience or comfort.

"John," she said slowly, gritting her teeth against the pain, "get back into the car. We must get to the hospital. The baby is coming <u>now</u>."

And to the intense disappointment of the boys and the quiet consternation of Margaret, they turned the old Ford around, leaving Dar behind, and went flying back down the road. They jolted and bounced over the rutted roads while Beth's labor quickly became an interminable nightmare of pain. Every jolt of the car ripped through her but she knew she mustn't cry out, mustn't frighten the children. Ayah did what she could with small sips of water and cool cloths. After what seemed like a million years, they traversed the twenty-four miles and arrived in Fatehgarh, screeching into the hospital compound. They were in luck. Dr. Woodard was there to meet them at the hospital, and Beth gave herself over to the loving support of her friend.

Within the hour, little Gladys was born, making her presence known loudly and insistently. As Beth held her in her arms for the first time, she marveled once again at the wonders the Lord creates. Stroking the baby's cheek to quiet her, she murmured, "My, my, little one. I think you have a lot to say. And you certainly are not shy about saying it!" As if in agreement, Gladys stopped crying and looked her mother directly in the eye. Then, with a tiny smile curving her baby lips, she burped a miniscule burp, closed her eyes, and fell asleep.

Beth & baby Gladys
1920

Completely exhausted, Beth held her newborn daughter in her arms and gazed out of the window into the hospital compound. She'd been moved to a small bungalow for her recuperation, and Ayah had already made it feel like home. Dar, after having been left behind at the Agra bazaar, had walked and hitchhiked the twenty-five miles to Fatehgarh. Now he was busy in the small kitchen, making *chai* and humming to himself. An enormous sun was rising with fierce intent upon this new day, and the sounds of an Indian morning were just beginning. The creak of the water wheel in the courtyard mingled with the subdued murmurs of the women carrying water and gossiping in *Urdu,* the local Indian dialect. She and John had become quite fluent in it, and of course, for the children, it was their first tongue. Ayah spoke to them, scolded them, and sang them to sleep at night with the soft musical syllables, and they were more familiar with it than with English.

Ayah came into the room, took the sleeping baby, and fussed over Beth as if she were one of the children. The new mother reveled in her unusual state of justifiable laziness, yawned hugely, and stretched out in the clean sheets, letting her mind wander in that delicious state between waking and sleeping.

She traveled back in time to her first experience with childbirth: little John had been born at the end of a long labor in a small hospital in Cincinnati. So different from this one. But then, she had never been known to do the expected thing, or to walk the paths that other girls her age followed.

Born Elizabeth Siehl, in 1881, to a family of German extraction in Cincinnati, Ohio, she grew up happy with her life, but somehow always longing for something more. Something more interesting, more fulfilling, more useful than being a teacher or a nurse, a seamstress or a wife. After her father died, she worked as a seamstress to help support the family, all the while attending night school towards a college degree. Although she saw herself as a short, plain, sturdy girl, her ready smile and laughing eyes, snapping behind her wire rimmed glasses, attracted several suitors. But none of them fired her imagination or won her heart, and she determined to stay uninvolved until she found her heart's desire.

She didn't get many chances for soul searching between her school work, her job, and her duties at home helping her mother with her six siblings. But she could set a seam of perfect, invisible stitches without thinking about it, so, while the other girls at the dressmaker's factory were giggling and gossiping, she spent many hours searching her mind and heart, looking for the path that would give purpose and fulfillment to her journey.

One fine spring day in 1907, Beth was sitting on the front porch, watching the younger children play. It was Sunday afternoon, and the street was shaded by the new green of the stately trees. Neighbors and friends strolled up and down, stopping to chat, showing off new Sunday hats. Cincinnati was still a small town at heart.

Mrs. Gimble from three houses down came striding by, stopped, and fixed Beth with an expectant look.

"Good afternoon, Beth," she said excitedly. "Notice anything different about me?"

Beth watched her parade back and forth, trying to identify the change. Was it her hat, her hair, her dress? No, they were just the same as always. But wait – it came to her as Mrs. Gimble executed a small dance step and whirled around in place.

"You aren't limping anymore, Mrs. Gimble! You're walking like a young girl! Did the doctor finally do something about your lumbago?"

As long as the Gimbles had lived on their street, Mrs. Gimble had walked with a severe limp, due, as she constantly told everyone, to intractable back pain. She called it "her lumbago" and cursed the doctors for not being able to give her relief.

"Well, my dear, let me tell you." She danced nimbly up the front steps and sank down on the porch swing. "It was my brother-in-law, Harold's brother, you know, the one we thought was never going to amount to anything. He was in a little town in Missouri – Lord knows what he was doing there – and he heard about a man named Andrew Still, who founded a college in that town for the study of osteopathic medicine. Now, I know you've never heard of that, dear, well, neither had I, but I must tell you, it's a miracle! Harold's brother says he learned just as much about medicine as regular doctors (not that any of those quacks have ever been able to help me!), and he also learned to move your bones around to cure all sorts of things that have been incurable until now. Well, dear, just look at me! He put me on the dining room table and twisted me around like a pretzel. I must say, I was slightly mortified at first, but then I remembered he's a doctor, too, just like all those other quacks who poked and prodded me in areas ladies don't talk about." She stopped for a breath and a lady-like blush. Beth was too excited to even think about being embarrassed. She felt like the earth had stopped and the entire universe was holding its breath; she knew with all her heart that this was the answer she had been praying for.

Mrs. Gimble, unaware that the earth was standing still, rambled on. "So – I got off the table and, as God is my witness, I stood straight for the first time in twenty years and I haven't had a twinge of pain since! Harold's brother says that Dr. Still is a pioneer – why, he even

accepts women into his school! Imagine that!"

Beth felt the earth begin to turn again and she knew her life had just changed in the most profound way imaginable. She had known she wanted to help people, people who were sick and in pain. But she knew she was too strong minded and independent to become a nurse. Following doctors' orders, never being able to think or act for herself just was not a part of her character. In her heart of hearts she knew she wanted to be a doctor. She also knew that, as a woman in 1907, that was next to impossible.

But here was an angel, in the form of her old neighbor, telling her it was possible after all. She walked back home with Mrs. Gimble. She talked to Clyde, Harold's brother, and ascertained that there were, indeed, <u>women</u> in his medical school class. The school was just a one-room house in Kirksville, Missouri, but Clyde was so enthusiastic about her interest that she determined to apply. The day she received a personalized, handwritten letter of acceptance from Dr. Still was the happiest day of her young life. And so, in spite of the horrified protests of her friends and family, in September of 1910, Beth set off on her first adventure. It was the beginning of the fulfillment of her heart's desire.

The American School of Osteopathy was everything she had hoped it would be. Small and unpretentious, the tiny building almost burst with the energy and excitement generated by Dr. Still and his new approach to healing the human body. The enthusiasm of the other students was equally contagious, and the moment Beth set foot on campus, she felt as if she had been plugged into an electrical circuit. Sometimes she thought she must be glowing with new ideas, like the newfangled light globes Mr. Edison had invented. She was treated as an equal in her studies, her mind was challenged as never before, and she soaked up knowledge like the desert soaks up the rain.

She met John the first week of classes. A small school is like a

small town, and everyone knows everyone else almost immediately. He was in the class above hers, very intelligent, and active in the YMCA and other church activities, as well as being one of Dr. Still's most promising students. Tall, gangly, and somewhat retiring, he had fire in his eyes when he spoke of the need for a healing ministry among the teeming millions in India.

Beth had always been active in her church group, and knew that the central theme of her heart's desire was to not only help people, but also to serve the Lord in whatever capacity she could.

And so, between classes and exams and church meetings, they found themselves inexorably drawn to each other. Gently and harmoniously they fell in love, and when John proposed on May 18, 1912, Beth joyfully accepted. He graduated that year and began a practice in his hometown in Kansas, while Beth completed her degree. They saw each other as often as possible, but it was still a long, cold, lonely winter. Her studies kept her too busy to pine, however, and when spring finally arrived, she and John determined to apply to the church board for appointment to the India Field Mission.

The year of 1913 held three major events for Beth. First, in January she was graduated with honors and personal commendation from Dr. Still as one of the first female Doctors of Osteopathy in the world. Then in May she and John were accepted by the church as missionaries to India. And that August, in a small but deeply joyful ceremony in Cincinnati, she and John were joined in what was to be a lifelong bond of purpose, vision and love. It was a very good year.

They knew they would have to wait at least a year for their mission appointment, and since eye disease was rampant in India, John applied to the medical school in Los Angeles for training in ophthalmology. Classes started in September, so, being highly practical, they decided to incorporate their honeymoon into the road trip to California.

Meanwhile, John's younger sister, Belle Taylor, had been feel-

ing poorly due to a chronic respiratory complaint. Her doctor said it would clear up if she could spend time in a sunny, warm climate such as Los Angeles. And so Belle became a third party to the happy couple's cross country adventure, sharing the excitement of the open road, clowning with Beth for the camera in Arizona's Petrified Forest, sharing their California bungalow under the palm trees on the little street near the university. For the next year, while John studied and dissected eyeballs, Beth and Belle cemented what was to become a lifelong friendship. They took trips to the beach and spent long, lazy afternoons basking in the golden orange blossom air of the City of the Angels. They all became very active in the local Presbyterian church, and the entire congregation celebrated with them when their call came in the spring of 1914. John and Beth were ordered to leave for India that coming November.

As Beth was already pregnant, they left Los Angeles in time for the baby to be born in Cincinnati in July. Her family and friends were once again horrified at the news that she would be travelling so far, to such a distant and uncivilized place with a new baby. But Beth and John knew only excitement and commitment. The call had come and they would follow. With Belle's help, they packed up the baby and their few belongings, took the train to New York City, and from there, they set sail across the rough and stormy North Atlantic, through the heart of war torn Europe, and on to India.

John & Beth's Wedding photo
August 13, 1913

Belle & Beth in the Petrified Forest
September 17, 1913

Chapter 2

November 1914

Atlantic Ocean

*I*t was in the winter of 1914, and the devil had seized Europe in his claws. The Kaiser had declared war upon goodness and upon sanity. His black, flaming shadow stretched across the Atlantic, threatening to enslave the world. His talons were the U-boats, his breath the zeppelins. The world was facing the Great War, and Beth and John were sailing into the arms of the monster.

Due to the strongly contested isolationist stand that President Wilson had taken, America had not yet joined the conflict. The U.S. was still a relatively peaceful land. As they sailed away from New York Harbor, Beth felt as if they were leaving the shores of heaven and leaping directly into the maw of hell.

She had always been a vitally healthy and vigorous person, but the movement of the ship immediately brought on such seasickness that she was confined to their cabin for the first four days. The only time she appeared on deck was for the daily mandatory lifeboat drills, at which time she would gamely attempt to follow orders, but would always end up hanging over the rail, retching weakly. Thank the good Lord, baby John was an angel. He nursed or slept most of the time, becoming upset only when Beth's bouts of nausea left her weak and trembling, barely clinging to consciousness. John was a dear and he tried to help with the

baby, but Beth knew that men were never meant for childcare, and there were no other women on the ship. As the storm-tossed seas buffeted them, Beth lay in bed. The stuffy cabin reeked of vomit and sour milk, and her mind wandered in a wilderness of nausea and fear.

As if her sickness and exhaustion were not enough of a trial, she couldn't stop thinking of the U-boats, terror from under the sea. These unseen monsters lurked in the black depths, waiting to blow their tiny boat to pieces. She tried to pray, but for the first time in her life, her faith seemed to fail her, and she could see nothing but flames, and blood, and frigid, fathomless water closing over her head.

They had been at sea for five days when Beth awakened one night, sensing a difference in the movement of the boat. She sat up slowly, expecting to feel the nausea ripping through her, but her insides were miraculously quiet, as was her cabin. The winter storm had released its grip, and they had sailed into calm seas. Making sure that the blackout curtain covered the porthole, Beth lit a small candle. John and the baby were sleeping the sleep of the innocent, and suddenly Beth desperately needed some fresh air. Pulling on her heavy winter coat and wrapping a woolen muffler around her head, she silently crept out of the cabin and up the stairs to the main deck. The ship was in full blackout mode, as it had been every night since they left the haven of New York. No moon was in the sky, for it had set hours ago. They were a tiny spot of black upon the endless blackness of the sea, and Beth shuddered at the cold, and the emptiness, and the dark. Eyes cast down, she slowly shuffled to the railing, held tightly to the cold metal, and allowed herself to take a deep breath of the icy, still, salt-damp air. Her lungs filled with life as she hung onto the rail, flung her head back, and opened her eyes. Never, as long as she lived, would she forget that moment. Stars blazed like diamonds flung across the black velvet cape of night. More stars than she had ever imagined, each one burning as brightly as the brightest hope; jewels of the angels. She was looking

directly into the face of God. Her breath was swept away and she was completely overcome by this vision of His magnificence and love. The tiny boat, her tiny life, seemed at once totally insignificant yet individually and molecularly blessed, as if God had reached out a hand and touched every cell of her being. Softly, unable to help herself, she began to sing her favorite hymn:

> For the beauty of the earth,
> for the beauty of the skies,
> for the love which from our birth,
> over and around us lies...

And her faith returned to her in a tidal wave of love. Somehow she knew they would be safe. The world would be safe, and evil would be conquered by good; the certainty of that settled in her heart and comforted her soul.

Every night from that time on during their voyage, after her little family was asleep, Beth would stand on the deck, in the blackout, with her head flung back, tears of joy in her eyes, rejoicing in the eternal magnificence of the Heavens. And for the rest of her life, no matter the depth of her torment or pain, the sight of a night sky full of stars never failed to bring her comfort, peace, and a renewal of her faith in the goodness of God.

They arrived in Liverpool, England, at noon on a sunny day. Beth was so happy to have the earth solid under her feet that she fairly danced her way through customs and onto the train for London. Being naturally gregarious, she struck up conversations with the other people in their compartment, and was amazed by the staunch courage and unfailing good cheer exhibited by the British. It was as if each person was fighting tyranny on a personal level, fighting with the only weapons they had – humor, hope, faith, and courage, and an indomitable belief in freedom. They filled Beth's heart with admiration and love. Although she had always believed herself a pacifist, when

troop trains filled with bright young men passed by, she hung out the windows along with everyone else, cheering and blowing kisses. With tears in her eyes and prayers in her heart, she thanked God for brave hearts and gentle people.

Once in London, they were billeted into a cold hotel room and met the group of missionaries with whom they would be traveling the rest of the way. Presided over by a nervous Senior Missionary, Beth felt like a gosling in a flock of geese, bustling about the war-torn streets. Back at the hotel, they were told to stay in their rooms, observe the blackout, and not for any reason to venture out into the streets. They were to travel to Bombay on a mail boat, but were not even told the time that the boat train would leave for the pier. Secrecy was the order of the day.

Finally the call came for the boat train. Father Goose, frantically flapping his wings, herded his flock onto the small mail boat that would take them on the final leg of their long journey. They were to be escorted as far as Gibraltar by British naval vessels, but from then on, through the Mediterranean, the Red Sea, and the Indian Ocean, until they arrived in Bombay, they were on their own. With God's help, of course. And for Beth and John, in the hugeness of their faith, that was enough.

As long as she lived, she would never forget the night they went through the Suez Canal. They arrived at dusk with the sun setting over the Mediterranean, turning the cobalt water molten gold. As they moved slowly through the locks, one of the crew members described the fascinating process of movement through a man-made canal of this sort. Not only God makes miracles, Beth thought to herself.

As the sky deepened towards night, the boats traveling the opposite way on the canal began to light up like giant floating lanterns. Through the still desert air, above the sounds of yelling stevedores and rushing water, had come, faintly at first, then increasing in strength, the sound of men singing.

"It's troop ships from Australia and New Zealand." "They're on their way to the Dardanelles, come to help us fight the Bloody Kaiser." In all, 40 ships passed by, carrying 40,000 young men to war, to what would become the slaughter at Gallipoli. The boys called back and forth from ship to ship, so close Beth could hear their harsh Australian accents. And every once in a while they would burst into song, tens of thousands of lusty young voices singing fierce anthems, tender ballads, songs about bravery, and courage, and war. The full moon shone down upon them, and Beth reveled in the intoxicating energy, as the babe slept at her breast and John, safe and warm, stood by her side.

"It's a long way to Tipperary, it's a long way to go…" the soldiers sang, and they laughed, defiant of the future. Once again, Beth was blinded with tears, and her heart broke with love for these brave young men. She prayed, oh, how she prayed for them, "Let them come home to their mothers, Lord, let them return safely to their wives, 'to the sweetest girl I know.' Bless them, protect them." She watched until they were out of sight, and all was quiet once more. But for the rest of her life, whenever she heard men's voices raised in song, she would remember the heart-breaking beauty of that night, and the unquenchable spirit of those brave young men, doomed to die far away from home.

The stars hung low in the green velvet dawn when she caught the scent of India for the first time. Before there was a smudge of land on the horizon, the pre-dawn wind brought knowledge of her new life. Rich with the fragrance of spices: cinnamon, cardamom, and others too exotic to recognize; the scents of flowers and rotten fruit, unwashed bodies and cow dung, were all mixed up in a perfume that sent its tendrils wrapping around her heart, seducing her like a lover. And beneath it all, the unbearable charnel house smell of dead animals, washed down the filthy streets into the ocean, rotting in great masses at the mouth of the harbor.

Bombay was taking vague shape over the water when John came up behind her, startling her out of her musings. In a rare display of affection, he wrapped both arms around her and bent to kiss the top of her head. "Baby John is still asleep," he told her, gazing out over her head at the rapidly approaching city. "Our new home," he said. "I wonder what adventures God has in store for us."

Beth leaned back against his stalwart strength, reveling in the safety and warmth of his arms. "Whatever they are, we'll face them together," she replied.

The sun rose like a ball of liquid fire. The smells of the waterfront grew stronger, and the flotsam and jetsam grew more prevalent, until the boat was slowly wending its way through an ocean of garbage. Already they could hear the sounds of the harbor, rising above them, almost visible in their intensity. A swarming cloud of noise and smells enveloped them, wrapped its great arms around them, and brought them irrevocably into the wildly beating heart that is India.

<p style="text-align:center">⁕</p>

For two years after they arrived, John and Beth were itinerant missionaries, learning their trade. Moving all around the country, working in missions and hospitals, treating the sick in the abysmally poor villages, the couple learned to rely upon each other and upon their faith. In order to learn the languages and dialects they would need to be effective among the people, they enrolled in a language school in Landour. Located 150 miles north of Delhi in the foothills of the Himalayas, Landour was a suburb of the British Hill Station of Mussoorie. Their classes were held during the summer. Being in Landour felt like a lovely holiday, for while most of India sweltered in the blistering heat, the foothills were blessedly cool. During the soft lazy evenings, John and Beth strolled through the whispering pines, holding hands, making plans.

Finally, in October of 1916, they settled in the Presbyterian Mission Compound in the town of Rourkee, which became their primary base of operations. Soon Carl was born, then Margaret. And now this new one, Gladys, feisty and loudmouthed, sure to be a delight.

The murmur of voices brought Beth out of her reverie. She stretched, yawned, and looked around in contentment. All four children were asleep in the other room, Ayah and Dar were talking softly in the kitchen, and all was peaceful, and so quiet. She had begun to drift back to sleep when she was startled almost out of her skin by the explosive sound of a metal teakettle crashing to the brick floor.

"Tauba tauba," Dar hollered, and Beth leaped from her bed in an instinctive reaction.

"What's wrong?" she cried. The room began to spin wildly. The floor rose up and hit her in the face. Everything went black.

When she came to it was the next afternoon. She was back in bed with Ayah and John hovering around anxiously. Apparently her sudden movement had brought on a massive hemorrhage and she'd almost died. John and Dr. Woodard had finally stopped the bleeding, but she was weak as a kitten, and too debilitated to be able to nurse little Gladys. Unable to find a wet nurse, they were forced to feed the hungry child buffalo milk. But the problem was how to get the milk into the baby. There were no baby bottles in Fatehgarh in 1920. John unsuccessfully tried several ingenious ideas before he hit upon the solution. He searched through the Fatehgarh bazaar until he discovered a tiny toy teapot, made of metal, with an elongated spout. He poked a hole in the rubber bulb of a medicine dropper and tied it to the spout. They filled this makeshift bottle over and over with milk from the protesting water buffalo, and the baby sucked happily away.

This was Gladys' first experience of her father's knack for "making do with what you have." The ingenuity and determination with which he approached life affected Gladys deeply as she grew. He taught

her to see the difficulties in life as exciting challenges, and to never, ever give up. "Don't be a quitter," he would say, and the words became a mantra to her, sustaining her through the hardest times of her life.

John in village with patients

Gladys with Ayah
2-1/2 mos. old

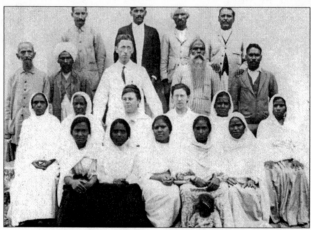

Beth and Dr. Woodard with hospital staff

Chapter 3

Spring 1925

Rourkee, India

*I*t was Easter Sunday morning, and all was quiet in the Reformed Presbyterian Mission Compound. The morning service had begun, and everyone was crowded into the tin-roofed church building, listening intently while the *sahib* delivered his thunderous weekly sermon. Hindu and Muslim converts filled the pews to overflowing, the women on one side, men on the other. Those who could not fit into the seats settled comfortably on the floor. It was a more natural and comfortable place to sit, anyway.

Although it was only nine o'clock, the hot morning sun beat down relentlessly upon the metal roof, turning the small building into an oven. The windows were all open, but not a breath stirred the thick, still air.

Beth sat in the front row with the children, holding baby Gordon on her lap. He was, thankfully, sound asleep. Carl sat on her left, flanked by Ayah, while little John was placed on her right. The strategy was to separate them from interactive horseplay during the service with the bulwark of their mother. So far, it was working.

Next to John was Margaret; no need to worry, there. The six-year-old sat demurely upright like a lady, small feet crossed at the ankles, clean hands clasped in her lap. Her light brown hair fell in a neat

Buster Brown around her face, and a dreamy smile played across her lips. Her eyes were fixed firmly on her father, towering above in the pulpit.

The same could not be said of the rumpled, squirming, four-year-old girl next to Margaret, and Beth rolled her eyes in loving exasperation. Gladys! What was she going to do with her? They had barely snatched her from death two years ago when she had contracted malaria, complicated by a severe case of hepatitis and jaundice. Through many grueling days and nights they had battled the angel of death for her bright spirit, and finally they had won. Beth remembered the days of the child's convalescence with a kind of nostalgia, for Gladys had been too weak to get out of bed, so she had stayed clean and quiet for hours at a time.

Now she was healthy as a horse, fat and sassy and entirely delightful – when she wasn't driving them to distraction, which was most of the time. Like now. She should have had Ayah sit on the other side of Gladys, but it was too late now.

Earlier this morning she had knelt in front of the child, fixing the last ruffle on her new dress. It had come from the latest mission box filled with used items that had been donated in the States and sent across the seas, to be distributed to the missionaries. Beth's seamstress skills and the new treadle sewing machine stood her in good stead and she altered, mended and stitched until the entire family had good Sunday clothes, at least.

Gladys' new dress was one of her best efforts. It was a cornflower blue ruffled pinafore over a crisp white cotton blouse, with the cutest puffed sleeves and several fluffy petticoats. A blue ribbon filched from a bedraggled hat completed the ensemble. Perfect!

When Ayah finished dressing her this morning, Gladys looked the perfect little angel. Her dimpled elbows, knees and hands were scrupulously clean and the unruly mass of shiny, chestnut brown curls

was for once under control, brushed back from her shining face into the bright blue ribbon. Shoes were polished, socks were clean. Beth had sat back on her heels and surveyed her youngest daughter with maternal pride into which was mixed a certain amount of trepidation.

"I know you'll get dirty the minute I turn my back, Gladys, but you really must stay clean, at least until church. It's Easter Sunday, after all. Won't you please stay inside with Margaret instead of playing outside with boys?" she had pleaded.

Gladys had looked back at her with those big brown eyes, a sincere expression on her face. She was absolutely adorable, this fearless child, with her small, sturdy body, round flushed cheeks, and determined little mouth. She had reached her tiny hands up to pat Beth's cheeks reassuringly.

"I'll stay clean, Mama, really I will. I'll just go sit on the porch and be so good. I won't go play with those bad ol' dirty boys!" She'd nodded in determination and tripped off to settle herself among the banks of Easter lilies gracing the front steps of the bungalow.

But the "bad ol' dirty boys" had taken a couple of their pet rabbits out of their pens and were attempting to race them across the yard. Despite all best intentions, Gladys found herself gleefully tumbling in the dirt with her brothers, laughing and shrieking, while Margaret watched from the porch with a jaundiced eye.

And now here she was in church, ruffles torn, blue ribbon drooping down her back, socks, shoes and face filthy. She was squirming restlessly and swinging her feet back and forth, back and forth, back and...

"Mama," Margaret whispered, "tell her to sit still."

Beth looked over at the intent expression of concentration on her youngest daughter's face, sighed, shook her head, and whispered, "She can't, Margaret – she just can't."

For her part, little Gladys felt that she was doing a pretty good

job of sitting still. She felt so alive this morning! Her body wanted to run and jump and dance, but she was making herself sit still, like a good girl, acting like a lady – except her feet just had to move. Maybe no one would notice if she swung one foot, then the other, touch the hymnal with the tip of her toe, the pew with her heel. If she slouched just right she could do it, swing the feet back and forth, back and forth…it was a good game, but one that was starting to get boring when she heard a "psst!" from behind. She turned around and peered through the horizontal slats in the bench.

Hooray! It was her best friend, Helen Mihilal, all dressed up in her finest eye-of-the-peacock blue *sari,* with thick gold embroidery all along the edges. She looked like a tiny *maharani,* sitting demurely next to her mother who was intent upon the sermon. Gladys started a new game. She called it "Make Helen Laugh" and she mugged the new funny faces that Carl had just taught her.

No response.

Helen sat there with a prim expression on her face, being infuriatingly good, although a smile tugged at the corners of her mouth, and her eyes danced.

Gladys checked to make sure that neither her mother nor Ayah were watching, turned all the way around on the seat, rotated her head to the side, and slid it through the space between the slats in the back of the pew. Then she turned her head straight again, looked up at Helen, stuck out her tongue and crossed her eyes. Carl had spent days teaching her to do that, and even though it gave her a headache and Ayah said that her eyes would get stuck that way, it never failed to make people laugh. And today was no exception. Helen burst into a giggle that was stifled into a snort and Mrs. Mihilal, disturbed from her concentration, shot the girls a stern glance.

When Gladys heard her mother hiss her name, she realized she'd gone too far. She tried to pull her head out from the back of the

pew – somehow the opening had grown smaller or her ears had grown bigger, and her head got stuck halfway out! She yelped and pulled harder, tried to stand up on the bench, thereby getting well and truly trapped. Frightened and mortified, she began to howl.

John looked down from his pulpit with deep resignation. He had just been getting into the swing of his specially prepared Easter Sunday sermon; he had the congregation in the palm of his hand, and now this! Lord, give me patience, he thought. His sons were rolling off their seats with suppressed laughter, and Beth was gazing at him with a pleading look, both hands full of baby Gordon. Margaret, deeply humiliated, was trying to disappear into the back of the pew; and Gladys! Ach, that child! All he could see was her ruffled bottom and the backs of her plump little legs kicking and struggling, trying to disentangle herself from this latest mishap.

There was nothing to do but to stop the sermon. In the appalled silence of the church, broken only by her increasingly frantic screams, he stalked down from the dais, reached over the pew, turned her little head and none-too-gently popped it back through the slats; then he plunked the miscreant back down on the seat and returned to the safety and sanity of his pulpit, tugging the shreds of his dignity around him. As he resumed his sermon, he looked down at her grubby, tear-stained face. In the aftermath of her trauma, she was sitting very still, and being very good. But not for long, he knew.

The service ended on the triumphal notes of an Easter hymn, and the congregation boiled out into the dusty compound. Children went running off in all directions, while adults lingered in the cool shade of the neighboring orchard of guava and mango trees, catching up on the latest gossip, and exchanging news of the surrounding countryside.

The five-acre mission compound in Rourkee was the place Gladys called home, and it was a wonderful place to grow up.

The orchard offered shade and excellent mango fruit to eat,

plucked fully ripe and devoured without regard for the sweet sticky juices that ran down your chin and dripped off your elbow. There were peacocks, and dogs, and pet rabbits. There were houses for the workers, the infirmary and the church, all perfect places for hide and seek.

Their bungalow was big, and airy, and cool, with a wide veranda across the front and huge white pillars holding up the roof. In summer they were allowed to sleep on the veranda, safe under mosquito netting in the heavy, flower-scented darkness. The circular driveway in front was bordered on both sides by three-foot hedges, also perfect for hide and seek, and the home of many fascinating bugs, beetles, spiders and snakes.

And best of all, at least as far as Gladys was concerned, there were her mother's flower gardens. They were nestled around the main bungalow, a wealth of flowers and secret paths to explore. There were poinsettias taller than she was, reaching their laughing crimson faces to the sky. Brilliant bougainvillea lavishly covered the garden fences, clambered up the face of the house, and embraced the stark white walls with purple, pink and magenta arms. Honeysuckle and *chambili* (jasmine) vines, entwined in a sweet-scented embrace, tumbled over trellises and wrapped themselves around windows and doors. Ramblers and rose bushes of every color, with trunks as big as Gladys' legs, grew everywhere, huge lethal thorns protecting the velvet perfection of the roses. There was Queen of the Night, which the Indians call *rat ki rani,* with its waxy white flowers that opened only after dark. When they sent their perfume wafting into her bedroom window, Gladys dreamed she was dancing through starlit gardens in a gown fashioned of moonlight and flower petals. The chrysanthemums had little scent, but their flowers were bigger than her head, and they nodded on their stems as if agreeing with her every word.

Her mother's pride and joy were the hundred pots of Easter Lilies that she tended almost as carefully as she tended her patients.

Somehow Beth always managed to coax them into bloom a week before Easter, at which time she and the *malis* and the children would carefully haul the heavy pots from the back of the garden and arrange them on the wide front steps of the bungalow. To Gladys they looked like white robed, sweet smelling angels, guarding the gates of heaven. Easter would not be Easter without them.

On this particular Easter morning, Gladys slunk out of church, chastened by her humiliating experience. Her brothers scampered off in the other direction, but she stayed behind, scuffing a rock through the dust and hiding behind the hedge. Soon she spied Helen standing absently next to a group of chattering adults. Quick as a flash, she was out from behind the hedge, grabbing her best friend's hand and hauling her off to their favorite secret place.

There was a magical hiding place in the garden that no one else knew about, fashioned from huge canes of rambler roses, entwined with honeysuckle and *chambili;* sweet nectar fairly dripping from the roof. Overlaid with brilliant magenta and scarlet bougainvillea, Gladys had discovered it one day while following a small green snake. The entrance was disguised by a thick, low-hanging branch of honeysuckle, which had to be lifted and held aside to afford entrance to the cool, sweet smelling sanctuary within. The floor was carpeted with a soft, green, moss-like plant, and the thorny ceiling hung so low that only a small child could comfortably stand upright. It was a perfect hideout for the two little girls, one in which they could talk, and dream, and imagine.

They had rolled a great rock into their erstwhile shelter, a perfect one with a flat, smooth top to sit upon, big enough for both of them, side by side. They had painstakingly positioned it so that they could look out through a gap in the roses, as if they were gazing through a picture window. The girls sat with shoulders touching, quiet for once, entranced by the living picture set in its frame of flowers. They looked

out, over the dusty houses and compound walls, over the great plains of Dehra Dun, to the greatest mountain range in the world, the Himalayas. The mountains began as low, soft shoulders of hills covered with jungle, green and teeming with life. Then inexorably, peak upon icy peak, they raised their magnificent heads above the world. With every moment of the day their colors shifted and changed. The highest ranges burned golden in the sunrise, and held the crimson glow of sunset long after the first stars burned bright in the night sky.

Now at midday, the huge, snow-covered peaks were blindingly white, in vivid contrast to the deep purple-black valleys and razor-sharp ridges on their lower slopes. Gladys knew what snow and ice were. A long time ago, when she was just a baby of three, her family had gone on furlough and they had spent the winter in Cincinnati, in America. So she knew all about snow and icicles, and how snowballs quickly and regrettably melt when brought into the warm house. This had created a great question in her mind. She could not figure out why, even though she and Helen were wrapped in the immense heat of the Indian noon, the ice mountains never melted, never changed shape. Though the hammer of the sun beat upon them from morning till night, they stayed eternally covered in snow, like a goddess in a white diamond dress reclining across the top of the world.

So why didn't the mountains melt, like a snowball brought into a warm house, or like a spoonful of *ghee* left in the sun? The little girls had spent hours talking about this, promoting theory after theory, one more wildly impossible than the last.

The puzzle of the never melting ice mountains was solved one day when, during a sermon, Gladys' father mentioned the Pearly Gates. Of course! That's what the great and beautiful Himalayas were. The gates to Heaven! More beautiful than all earthly delights, never changing, always floating in the sky in their eternal magnificence. The girls had no doubt that they were looking directly at the Pearly Gates, and that

God and Jesus and all the angels were there, waiting to welcome them home.

This explanation also dealt with the question of how They knew when a child did something wrong. The mountains were so huge they filled up half the sky, and you could see them from everywhere. So it stood to reason that if you could see them, the angels could see you. And from that vantage point, not only could They guide and protect you (hence the term Guardian Angel) but They could also see everything you did, especially the bad things.

It was at this point that Gladys realized that she would never be able to get away with anything. The strictly ethical code by which she would live her life was first created in her child's mind by the knowledge that the angels standing on the peaks of the omnipresent mountains had their field glasses trained on her.

Her faith in their benevolence was unlimited. She knew that if she ever needed help, an angel would see it and reach out a heavenly hand to protect her. But on the other side, she realized that there could be no secrets, and impeccable honesty became a basic tenet in her lexicon of life.

On the veranda of the Rourkee bungalow (L-R) Margaret, Gordon, Gladys

Easter lilies in the background

*Rourkee
Bungalow
1920*

The Himalayas

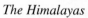
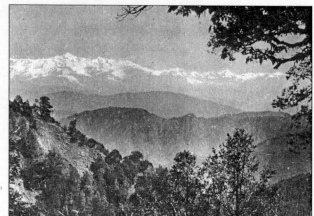

Rourkee Church, 1924

30

Chapter 4

\mathcal{R}ourkee in 1925 was a town of some 6,000 people. Located in Northern India, it clung to the grassy banks of the Upper Ganges Canal like a tick on the back of an elephant. The great canal had been built in 1847 by the ever-industrious British engineers, and was used for irrigation of the sweltering, arid plain between the Ganges and the Jumna Rivers. Its source was the Ganges, in Hardwar, twenty miles away. It measured 150 feet wide and stretched for 300 miles, bringing life-giving water to the parched plains and thirsty villages of the Utra Perdaish. The Saharanapur-Calcutta Railroad Bridge crossed the canal a mile to the south of Rourkee, and on the north, the city was bordered by the swampy Salani River with its quicksand and crocodiles.

The town itself was a typical small Indian city, with most of the structures built from local brick, handmade from native clay and straw mixed with water, then baked in the sun until rock-hard. There was a municipal hall and a civil hospital, as well as several schools and a small university. The large iron foundry which, in 1847, made the heavy machinery used to dig the canal, was still operating. On the other side of town, many of the *sonars* (gold and silver smiths) now made precision tools instead of the fabulous, finely wrought jewelry so loved by the *maharanis* of yesteryear.

Also inside the city limits, but in a walled-in compound of its own, there existed a small leper colony, built around 1860 by the British Mission to Lepers. It was a city within a city, having its own primitive sanitary system and septic tank, piped-in water, and several small brick houses. About twenty people afflicted with leprosy lived there, some in the houses, some in squalid mud hovels. All of them were inmates in the prison of their disease, all of them carried life sentences. The city provided the colony with a small handful of *rupees* every month to buy food and other staples. This was an unsuccessful attempt by the municipality to keep them from begging in the bazaars, where the horrifying sight of the rag-wrapped beggars and the stench that attended them sent people diving into their pockets for a few coins to throw, then hurrying away as fast as possible so as not to contract the dread disease.

Leprosy, or Hansen's Disease as we now know it, has always been looked upon with great superstitious dread and horror. Little was known about the process by which it was contracted, therefore lepers were scrupulously restricted from contact with the rest of the populace through the ubiquitous leper colonies, and the social proscription that whenever a leper went into healthy society, he or she must sound a bell or clapper to warn people, and call out *changa, changa* (unclean, unclean) to announce their presence. Those infected with the disease lived lives of such extreme squalor and misery that it was shocking, even in a land where abject poverty was accepted as the norm.

The pathological process of Hansen's disease affects the peripheral nerve endings, causing extensive numbness, and making it difficult for the infected person to realize when they cut, burn, or injure themselves. In India in the 1920s, where sanitation was so primitive as to be non-existent, this neglect resulted in severe infections, necrosis of tissue, and often gangrene. Fingers and toes, which are most often cut, burned or bumped, were the most vulnerable. They became infected,

and if not treated, became gangrenous and eventually dropped off. This also happened with noses and ears. Lepers would wrap themselves in rags to hide their disfigurement, but the stench that exuded not only from the corruption of their flesh, but also from their particularly repugnant breath, could not be disguised.

Although it is a hideously deforming disease, it is not necessarily fatal in and of itself. Lepers often lived for many years after contracting the disease. They fell in love (with other lepers, of course), got married and had children. Babies are not born with the disease. In fact, it is now known that, like the HIV virus, it is only mildly infectious and transmitted through bodily fluids. But it was known that babies raised in leper colonies would eventually become infected, and it was this fact that spoke to Beth and John.

The small leper compound in Rourkee was the first real contact they had with what was to become an extension of their life's work – creating a children's home to which lepers could bring their as yet uninfected babies to live and be cared for, providing them with an environment in which they could grow up loved, nurtured and healthy. The first children's home they created was in Bhoghpur, with John's sister, Belle, and when that became filled to overflowing they started another one, then another, until there were four homes, each caring for 400 to 500 children of all ages. All of the children were healthy, happy and well-loved.

But I get ahead of myself.

By 1925, John and Beth had established a yearly routine that seemed to work well.

One by one, the children were growing old enough to go to school. Woodstock School in the Hill Station of Mussoorie had an excellent reputation for educating the offspring of diplomats, missionaries and princes. John was able to purchase a villa in Landour, about a mile up the mountain from the school. The children were therefore able

to live at home in the villa with Beth, trudging the mile downhill in the mornings, even during the pouring rain of the monsoons, and leaping and bounding uphill in freedom after classes were over for the day.

The Landour villa was large, rundown, and charming. With typical Scottish industriousness, John soon had it fixed up, and Beth had dahlias and roses growing in profusion.

John spent most of his time down on the plains, at the Rourkee Compound, completely involved with the mission there. He visited his family in the foothills about once a month throughout the school year, during which time he would cut everyone's hair in the classic "bowl cut" and attempt, in a kindhearted way, to reinforce paternal discipline. School lasted from late March through November. In September, when the worst of the heat was done, Beth always returned to Rourkee to help John with the medical missionary work there, and the children became boarding students in the Woodstock dormitories for three long months. It was a cold, regimented existence, as Woodstock was a proper English boarding school, and Gladys hated it. But when it was finally over, and the children were joyfully reunited with their parents, they would all troop noisily back down the mountain to spend the winter in the plains around Rourkee. They camped first in one village, then another, treated the sick and preached the gospel. The Rourkee compound was their home base, but they spent much of their time "in the field."

They would pack all the tents and camping supplies on ox carts and *tongas*. While the boys pedaled alongside on their bicycles, the rest of the family would jounce slowly down deeply rutted roads in the old Model T. When they arrived at their destination, the tents would be erected and a comfortable camp magically set up, usually on the edge of a village, with small, *nunga-punga* (naked) children and stray dogs underfoot at all times.

The family and their small entourage spent about two weeks in each village, treating hundreds of people each day. The patients came

from miles around, plodding barefoot down hot, dusty roads, or winding their way through the thick, steaming jungle, often with sick babies or children in their arms. The very ill were carried to the doctor *sahib* on stretchers, balanced on the shoulders of strong young men. Beth and John each had a treatment tent, and the local people hunkered down in long lines, waiting for their turn, with patience and humor.

The treatment tent was open to all – caste or social standing did not matter. And to people whose lives were still ruled by the Hindu caste system, this was an amazing thing. The treatments were free and freely given, and often seemed like a miracle to people who had never heard of quinine or sterile procedure. Even the very ill were extremely stoic, while no matter how young, the children tolerated pain silently, for the most part. Treatments were usually fast and efficient, yet offered with compassion, tenderness, and humor. Laughter was often heard ringing out over the campsite.

From young men with massively infected abscesses covered with maggots and flies, to old women in need of cataract surgery, the doctor *sahibs* turned no one away.

Gladys reveled in the excitement, the dust and the heat of the camps. Even the millions of flies did not bother her. When she wasn't helping her mother in the clinic, she was off making new friends among the village children. She loved the feeling of sleeping out of doors, in the tent with Margaret and her parents, surrounded by the sounds of the dark, nocturnal jungle. Often her mother read them to sleep at night. The little girls snuggled one on each side of Beth on her small camp cot, visions of Heidi or Jo, Beth and Marmie dancing in their heads.

And after they fell deeply asleep, John would pick them up, cradling them in his strong arms, carry them to their own beds, and tuck them into their bedrolls, kissing them safely good night.

Other times Ayah would turn the lamp down low and sing them to sleep as she had been doing since they were born, sing in her soft,

beautiful voice, in the liquid syllables of Hindustani, that most beloved of Hindu lullabies –

Nini bébé nini (sleep, baby, sleep)

Roti makin chini (bread, butter, sugar)

As the night song cast a spell of sleep over the children, they drifted into dreams of innocence, sure of their safety and surrounded by love. Although only a thin wall of canvas protected them from the roars of hunting leopards and tigers, and the maniacal laughter of the hyenas, they were never afraid. The sounds outside the tent were, to Gladys, her jungle lullaby, and she invariably slept deeply and well, awakening each morning leaping with excitement for the wonders the day was sure to bring.

Early one morning, in late February, 1927, Gladys' eyes popped open just as the new day was beginning to light the canvas walls of her tent. She lay in bed, watching the shadows shift and glimmer on the soft golden cloth, in an unusually pensive mood. She had turned six a few months ago, and in another month she would be entering school for the first time. The older kids all loved Woodstock, but she just wasn't sure how she would feel about it. Would she miss her parents, Ayah and Dar? Would she like her teachers? Would she make any friends at all? A million questions buzzed like mosquitoes in her brain, persistent and annoying.

As usual, it didn't take long for her to become impatient with abstract problems that could only be solved by the passage of time. She quickly resorted to action, jumping out of her cot, and poking Margaret to awaken her.

"Wake up, sleepyhead!"

"Mmph," said Margaret.

"Rise and shine!" (poke, poke)

"G'way, Gladdie, I'm still asleep."

"Good morning, merry sunshine." (sung loudly)

"Just a few more minutes, please, Gladdie."

"Oh, Margaret, you're such a lump-lump! If you don't get up you'll miss the whole day. Remember, today we get to go to the *zennanah* at the *maharajah's* palace with Mama, again. The *maharanis* loved the Bible stories yesterday. Maybe today Mama will tell about Ruth and Naomi, that's one of my favorites."

She paused for a breath, not really expecting an answer from the inert pile of bedroll that concealed her sister. Undaunted by the obvious lack of response, Gladys rattled on.

"I love going to the *zennanah,* it always smells so good, like incense and roses and sandalwood. But can you imagine being cooped up all day, even if you do get to sit on gold-embroidered pillows. The palace women are never able to look outside except through those carved-wood screens. I'd go crazy!! And their *chai* was different than what Dar makes; I think they used more cinnamon. What d'you think, hm, Margaret?" Still no answer. Giving it up as a lost cause, Gladys stopped harassing her sister and began to throw on her clothes.

Now, Beth had long since despaired over Gladys' total disregard for her personal appearance. As long as the child had some kind of clothes to put on in the morning, it mattered not a whit to her whether they fit, matched, or in any other way met the standards of fashion. Whereas Margaret was fastidious about her presentation, for Gladys it was a result of whim and convenience. When she bounced out of bed in the morning, she grabbed whatever clothing was closest to hand, as long as she liked the colors. Often as not, she ended up with startling and unsettling mixtures of hues and styles, since most of their outfits came from the mission barrels, in which the castoffs of all social classes and financial levels of parishioners were represented. The one thing that all of the mission box clothes had in common was that they were worn, to one degree or another. Some were less tattered than others, and the most raggedy ones were dissected by Beth's sewing scissors and

resurrected by piecemeal into dresses like those seen in magazines, thanks to her skill as a seamstress and the treadle sewing machine.

This morning Gladys struggled into the burnt-orange jodhpurs she'd grabbed from the last mission barrel, and as she buckled the waistband, she tried to imagine the girl who had worn them. It was a favorite game of hers. It seemed to make the clothes friendlier, more of a gift than charity.

The pants were hardly worn at all, and they were such an unusual color that Gladys decided they had been part of a school uniform for the dressage team. The girl who had tossed them so cavalierly into the box at church probably had long blond hair, and a perfect nose, and she was fabulously wealthy and attended an English boarding school in some place like Upper Hampshireford. Her name was Emily and she was captain of the riding team and most incredibly beautiful. But at heart she was sad, because her mother and father ignored her, and she didn't have an *ayah* to sing her to sleep or Dar to laugh and dance with. Poor Emily! She shook her head, sent out a little prayer that someday Emily would be happy, and returned to the task at hand. She donned her blouse, an oversized, scarlet plaid boy's work shirt, rolled up the sleeves, and tucked the tails haphazardly into her pants. Then she sat down on the edge of her cot and began to vigorously shake out her shoes. She couldn't be bothered to find socks that matched, but one thing she was <u>very</u> careful about was putting on her shoes. She knew from close personal experience that scorpions loved to sleep in the toes of all kinds of footwear. She vividly remembered the painful shock of stuffing her foot into an already-inhabited boot last year. Her foot had swelled up to the size of a *pumalo* and she was unable to walk. Her brothers had to push her around the Rourkee Compound in their old outgrown baby carriage, arms and legs dangling dangerously over the sides, as often as not capsizing while careening around corners.

So these days she always shook out her shoes.

Two rules were paramount while the family was in the field. The children had to wear shoes at all times – they were absolutely forbidden to go barefoot, and they were required to wear the *topi,* or sun helmet, from dawn 'til dusk, to guard against sun stroke. These rules even Gladys obeyed.

Ayah had already awakened and silently left the tent while the girls were asleep. Her bedroll was neatly folded on the cot. At home in Rourkee, Ayah and Dar had a small house to themselves in the compound, and she slept there as long as there wasn't an infant or sick child to necessitate night vigils in the bungalow. Gladys would often steal over to their house after dinner, while Dar and his friends sat in a circle in the twilight, playing the *dholuk* and the *tablas* (Indian drums), singing songs and telling stories. She loved to get in the center of the circle and twirl around, dancing and singing nonsense songs about bed bugs or butterflies, complete with gestures, and accompanied by laughter and shouts from her audience. She would join them while they ate their dinner of curries so hot that tears would run down her cheeks. She used her fingers to eat in the Indian manner, and sometimes fell asleep cuddled in Dar's lap, a contented, curry-stained smile on her small face.

But in camp, Ayah sometimes slept with the girls, and as Gladys finished tying her shoes, she determined to find her, and maybe get some breakfast in the bargain. Donning her small *topi,* she poked her head inquisitively out of the flap of the tent, and surveyed her world.

The smoke from the early morning cook fires lay upon the still air like transparent silk scarves, and the rising sun sent God-like fingers of light through the branches of the great jungle trees. Remnants of the cool night remained in the shadows, and she breathed deeply of the combined scents of smoke and sacred-cow dung, damp fragrant jungle and raw human waste.

Oh, how she loved it all! "Boy-oh-boy," she said to herself, gleefully employing the new slang phrase Carl had secretly taught her. "Boy-oh-boy, I feel go-o-od today!"

She did a little dance in the dust, then wandered over to the cooking fire, where Dar was making morning tea and chatting quietly with Ayah. Without conscious thought, Gladys snuggled into her nurse's lap, and felt the dear, familiar, soft hands stroke her forehead, and wrap her in an embrace that was, to her, the epitome of security, tenderness, and love.

"Our girl looks happy this morning, my wife," said Dar, smiling at Gladys and handing her a cup of *chai,* the sweet, fragrant, Indian tea.

"Yes, my husband," softly replied Ayah, "our girl slept deeply and well, and no lions or tigers came near our tent to give her fright."

Gladys smiled at their murmured conversation, dreamily listening to their plans for the day, and watching tendrils of smoke chase each other through the sunbeams.

The morning passed quickly, sped on its way by the usual comforting routine of camp life. Gladys helped out in the treatment tent, played games with the village children, or argued with her brothers. After lunch, in the hammering heat of midday, everyone took refuge in the shade for the traditional afternoon nap.

Most days Gladys fell asleep immediately, lulled by the heat and the monotonous drone of the flies around their rent. But today her eyes just wouldn't stay closed, and she tossed and turned as the minutes crawled by. She shot a resentful glance at Margaret, snoring softly on the cot next to her, and suddenly she could stand it no longer.

Slipping quietly from her bedroll, she put her shoes on and tiptoed across the tent. At the last minute she grabbed her *topi,* then ducked out the door and let the canvas flap fall silently behind her. She pretended she was a tiger stalking its prey as she furtively stole across

the deserted campground. Flitting unseen across the clearing, she breathed a sigh of excitement and relief as she stepped into the green and shadowed jungle. She knew it was dangerous to be here alone, and against all the rules.

"I'll just stay here at the edge of the trees," she whispered to herself, trying to quiet her guilty conscience, "and not go out of sight of the village." In this manner she wandered for a time, climbing over fallen logs, chasing a group of monkeys that moved slowly from treetop to treetop.

She stopped at the edge of a sun-dappled clearing to watch a sambar doe nursing her spotted fawn. They were completely unaware of her presence, and she crept closer. Finished with his meal, the baby nuzzled his mama, who began to lick him with her rough pink tongue. Gladys was entranced.

Suddenly the doe flung up her head, nostrils twitching, and in a moment both deer were gone, bounding through the underbrush into the darkness of the jungle. Gladys heard a slight sound to her right, and a slither of fear ran up her backbone. The hairs rose on the back of her neck as she slowly turned to face that which had startled the deer into such precipitous flight.

She froze, mesmerized by the sunlight coldly reflecting from the viper's black eyes and gleaming white fangs. The king cobra was coiled two feet away from her, hood spread wide, as tall as she, swaying in the murky light of the jungle, tongue flickering in and out.

Time stopped as the snake hypnotically held the young girl's gaze. It reared its head back to strike.

The shotgun blast came from directly over her left shoulder, deafening her for days, and spraying bloody cobra bits all over the underbrush.

Her father grabbed her, pulling her back into his arms, exclaiming in his mild-mannered way, "My, that was certainly a big one. It

almost got you, my girl. Thank the dear Lord I was doing patrol, or we might have lost our Gladdie."

He brushed her off, as if to ascertain that she still had all her arms and legs. Then he put his large hands on her shoulders and shook her gently.

"What were you doing out here all by yourself? You know that you are never to go into the jungle alone. You get on back to your tent, now, and go to sleep."

That was the last thing Gladys wanted to do. She knew from the look in his eye that she was going to "get it" later, but right now her scientific curiosity overcame her better judgement. The bottom half of the snake was still twitching, and she needed to know why.

"Why is it still moving, Papa?

"Go to bed, Gladdie!"

"But Papa, it has no head and it's still moving! Why is it doing that? And what's inside it? Is it the same as a grass snake's guts? Look at how black the blood looks – is there snake venom in the blood?"

"Gladys!" he said, in an ominous voice.

She planted her feet.

"But Papa, what are you going to do with the rest of the cobra… oh, look over there, most of its head is in one piece and the fangs are so long – can I have it for my collection?"

Her father fixed her with a baleful glare. "Go back to bed, Gladys Louise, <u>NOW</u>!" he bellowed. She knew the law when she heard it.

Adults were so unfair!

All she wanted to do was get her hands on the fascinating corpse of that giant viper and dissect it completely. Who knew what she might learn? A doctor had to take every opportunity to investigate scientific information. Even she knew that.

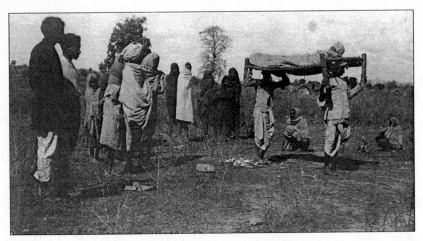

A family bringing a patient to be treated.

Gordon
Beth
Gladys
Indian worker
w/baby

Gordon on John's bike
Gladys on Carl's bike
Margaret on her own
Roorkee, 1924

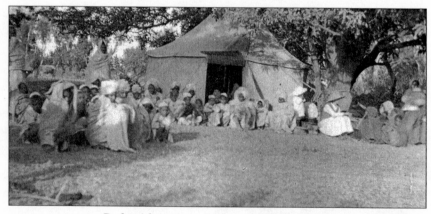

Beth with patients in front of medicine tent

Chapter 5

*U*nlike many who struggle to understand their place in the world, never completely sure what they want to be when they grow up (even when they're all grown up), Gladys was blessed with that knowledge from birth. She was born knowing she was a doctor. She didn't "want to be a doctor" – she <u>was</u> one.

As soon as she could form recognizable words, in her lisping Hindustani baby-talk, she told Ayah that she was a doctor, "a doctor like Mama."

When she finally but reluctantly learned to speak English, in preparation for the family's first furlough to the U.S., she was two years old. They were in the field, and Beth was in the medicine tent, tending to a nasty gash on the arm of one of the villagers. As she carefully set the last stitch, she looked up to see her youngest daughter toddling purposefully towards her. The child came to a stop in front of her mother, her head barely reaching as high as the treatment table. Everyone watched with undisguised affection, for even at two she had that special spark of personality that is called charisma; she drew people's attention without really trying, and she could light up a room simply by entering.

Gladys gazed up at her mother, big brown eyes peeping earnestly from under the rim of her tiny *topi*.

"Gladdie doctor," she intoned, and upon the table she placed her sister's new rag doll that had been dismembered during a tug-of-war between John and Carl yesterday, causing Margaret great wailing distress, and the boys several hours of solitary confinement. Gladys had taken a more practical approach. She had rescued the far-flung, amputated limbs and head, and had bound them back onto the pitiful torso with several lengths of bandages filched from the dispensary. The result looked like an Egyptian mummy, a little grubby and worse for the wear, but with all appendages anatomically correct, and the bandage wrapping done with a skill that seemed far beyond a two-year-old's ability. Astonished, Beth looked down at the proudly beaming little girl.

"Gladdie doctor," she repeated, with a determined nod of her head, and there was no doubt in anyone's mind as to what she meant. She had the hands and touch of a healer; the heart and soul of a physician in the sacred sense of the word. And as she grew, the compulsion to heal grew as well.

From earliest childhood, she searched for wounded creatures as a hungry child searches for food, and if she could not find a bird with a broken wing or a dog with a thorn in its paw, she would splint and wrap the healthy legs of the long suffering pet rabbits, just for practice. Of course, her brothers never appreciated her efforts and, to the rabbits' great relief, tore the meticulously applied bandages away almost as soon as they were applied.

But that didn't faze Gladys. No, sir! She continued to wrap, splint, bandage and tend to every ailing creature she could get her hands on. And, strangely enough, none were damaged in the least; rather, cuts healed quickly, wings were mended perfectly, abscesses miraculously disappeared. Soon all the children in the area were bringing their wounded pets to her, and she treated everything from the sore paw of the local *zamadar's* (village headman) tame monkey, to a sick pony from the nearby British cantonment. She was a pint-sized phenomenon.

When she could not find living things that needed her help, she satisfied her ravenous scientific appetite by cutting up dead rhinoceros beetles, or snakes that had been impaled on the sharp blade of the grass cutter's scythe. She felt compelled to see what was inside, what made up the miracle of a living thing. She was repulsed by nothing, and fascinated by everything that was, or had ever been, alive. Machines held no interest at all for her – it was not worthy of her study unless it lived and breathed, unless it was animated by that spark called life; indefinable and elusive, so easily extinguished yet so strong, resilient, omnipresent.

She believed in God, not only because her entire reality was based on faith, but also because, even in her child's mind, she understood that only something as omnipotent and magical as God could create the intricate, diverse creatures she saw all around her: scurrying beetles, obnoxious brothers, gorgeous peacocks, huge elephants. Only a being as great as God could heal a cut, or mend a broken bone making it as good as new.

She knew, even then, that she was merely the facilitator of a divinely guided process. She could do her best on the physical level, but beyond that, she could only step back and pray that the intrinsic spiritual power of the individual, that which was far beyond her frail human efforts, would take over. Throughout her life, this was her personal Hippocratic Oath, this was her credo as a physician: to set to right those things over which she had control, and then to let go, and love, and allow the holy alchemy of healing to take place.

Family passport picture, 1921
Gladys, 3rd from left

In Kanasa with cousins, 1923
Gladys on left

Chapter 6

March 1928

Woodstock International School, Mussoorie, India

It was the first day of her second year of first grade, and Gladys had never been so miserable. She hunched down in the tiny wooden desk, avoiding the eyes of the other children, and brooded upon the injustices of life.

She had flunked first grade. Flunked! <u>Nobody</u> flunked first grade. And no Taylor had ever before flunked <u>anything</u>. But she had. And she knew why.

It was because of Miss Noland. Miss Noland, her nemesis, cruel dictator of first grade, with her high-pitched nasal voice and beady black eyes. She hated Gladys, for some unknown reason. She had spent all the last year poking and prodding at her, and at the end had ignominiously held her back, forcing her to repeat first grade.

"It's not just that I get my letters mixed up," Gladys had told Helen in one of their last heart to heart talks before she left for school, "it's that she just doesn't like me. I know she doesn't! She looks down that long pointy nose and makes fun of me in front of everybody."
Gladys, being a natural born mimic, stuck her nose in the air and pinched the bridge of it, re-creating the annoying pitch of the teacher's voice.

"Sa-a-y, Gladys, your spelling is as bad as your arithmetic.

49

Sa-a-y, Gladys, can't you walk without tripping over your own feet?"

"And, Helen, in the lunchroom last year, she came up behind me and said, loud enough for everyone to hear, 'Sa-a-y, Gladys, what a mouthful!' and everyone laughed! I know she hates me and I never did <u>anything</u> to make her feel that way, except get my letters backwards and I can't help that 'cuz I truly try to do it the right way. I must be stupid! I must be stupid, <u>stupid</u>, <u>stupid</u>, and I'm big and ugly, too!"

"Stop that, Gladdie!" Helen exclaimed, trying to shake her friend out of her morose and gloomy mood. "It's Miss Noland that's stupid if she can't see what a wonderful girl you are."

"But now I have another whole year with her and she'll prob'ly flunk me again. I'll never get out of her class." Gladys was warming to her subject. "I'll be really old like Aunt Clara and have only two teeth like your mother, and I'll <u>still</u> be in her class. I'll be the oldest child ever to attend Woodstock, and she'll say, "Sa-a-y, Gladys, come up here to the blackboard and spell 'dog' and I'll hobble up the aisle like the old men in the village and I'll <u>still</u> spell it g-o-d!" She was wailing now.

Gladys' personal vision of hell was to spend eternity in Miss Noland's classroom.

A sudden thought struck her.

"Maybe she doesn't like me because I punched Claudia Knowles in the nose last year. How was I to know she was teacher's pet?"

The offense had occurred at lunchtime during the first week of school last term. Claudia, spoiled daughter of a British diplomat posted to Bombay, sat at the old wooden refectory table and described her life in great detail to the unfortunate children sitting around her. Her thin blonde hair was held back from her high white forehead with a wide blue velvet ribbon. She had colorless lips, lash-less eyes, and liver-colored freckles splashed across her face. Her attitude a mixture of arrogance and contempt, she droned on and on about her life at home

and her parents. Apparently her father was richer than anyone else on earth, and her mother was more beautiful.

Gladys listened to the monologue first with polite interest, then with disbelief, fading into angry impatience. "Well," she broke in when Claudia finally took a breath, "my parents are both doctors, and last year my mother saved the life of the richest and most powerful *maharajah* in India!" Which was more or less true, although to be strictly truthful, Gladys didn't think that the boil on his neck would have killed him, no matter how painful it was. Still, he was very grateful for the treatment, and had sent Mama several gorgeous lengths of gold-embroidered sari material as a token of his appreciation.

Claudia turned her pale eyes on Gladys. "That's a lie," she exclaimed. "Both your parents can't be doctors. Women aren't doctors. Your mother is a nurse!"

"She is not," Gladys insisted, "she's a doctor, the best one in the world!"

"Is not!"

"Is so!"

"Is not!"

Claudia's eyes got big when Gladys punched her in the face. Then she started wailing. Children scrambled to get out of the way and Miss Noland waded into the fray. Gladys was sent to stand in the corner. Claudia Knowles sniveled in triumph.

Yes, when Gladys thought back upon it, that must have been the root of her teacher's antipathy. Stupid Claudia Knowles.

Now it was the first day of school, and here she was again, the oldest first grader in the world sitting in the horribly familiar classroom, staring at the same scuffed cement on the floor, crammed into the same little wooden desk that seemed to have gotten even smaller since last term. And she was surrounded by innocent, naïve, bright-eyed children, shyly saying hello to each other, unaware of the evil monster that

stalked the halls in the form of Miss Noland, ignorant of the bleak future that awaited them.

All of a sudden the door was flung open. The laughing chatter of the students died immediately.

And SHE strode in. Twelve feet tall, dressed all in black, preceded by the musty, unwashed smell that was hers alone. Red knobby hands in which she held her weapon of choice – the wooden ruler. Her stringy black hair was pulled severely back into a knot at the base of her skull, and she had thin, cruel lips, a long pointy nose, and small, close-set pig-like eyes that scanned the classroom and pounced upon Gladys like a hawk on a field mouse.

The gray lips stretched in the mocking facsimile of a smile. "Sa-a-a-y, Gladys, I see you're back with us for a second year. Maybe I can pound something into your thick skull this time. Boys and girls, this is Gladys, and she flunked my class last year. I hope every one of you turn out smarter than she is. In the meantime, Gladys, why don't you come up to the blackboard and spell dog for us, hm-m-m?"

Gladys was struck by the fact that Miss Noland's lips never seemed to move when she talked. It was almost as if she talked through her nose, for her nostrils quivered, flared, and pinched together with each word. The teacher was looming over her now, and she was forced to look directly up into the twitching orifices. She was frozen with horror.

"Well, girl, well?" her tormentor continued, "Up to the blackboard with you, and try not to trip over those gunboats you call feet."

The other children were watching with wide, terrified eyes, and a few of the braver ones tittered, as Gladys hauled her sorry self up out of the desk. She tried to walk with dignity up the aisle, wondering how much longer this could go on, and living for the moment the final bell would release her from this purgatory, at least for today.

Little did she know that in the dark and forgotten secret corri-

dors of her mind, the hulking figure of Miss Noland would stalk her for the rest of her life. Every time she felt inadequate, or clumsy, or unequal to a task, she would hear the taunting words, "Sa-a-ay, Gladys, who do you think you are?" No matter how great her accomplishments, that hated voice would still berate her, question her choices, point out where she fell short of expectations. Over the years she would learn to live with it, then ignore it and eventually to talk back. But never has Gladys been entirely free of that inner tyrant, and the indelible lesson of self-doubt that she taught so skillfully.

When the long awaited bell finally rang that afternoon, Gladys was one of the first students to explode from the great front doors of the school. She saw Margaret coming purposefully towards her, a big-sisterly glint in her eye, so she turned and ran as fast as she could across the playground, not stopping until she reached the shelter of the fragrant pine trees.

Last year, when she was just a child of six, she had had to walk back up the hill with Margaret or the boys. She was much older this year, much more independent, and she was allowed to come home by herself. She wasn't about to let Margaret spoil her first day of freedom. Besides, she had a special, secret place in mind, one she had discovered at the end of term last year, and she felt it calling to her.

She wandered along one of the many paths that led up the steep slope towards the British Cantonment and their home on the top of the mountain. In truth this was merely a foothill, 7000 feet high, with the massive snow covered peaks rising in regiments behind the settlement, like sentinels on the top of the world. But to Gladys, this was her mountain, and she loved it even more than the sleepy, flower-draped compound in Rourkee, the endless, open, dusty plains, or the mysterious, steamy jungle.

She took a deep breath of the sharp pine-scented air, and stopped to examine a great swath of lilies of the valley, the miniscule

white bells scenting the air with a sweetness so intense that it brought tears to her eyes. The tiny flowers were everywhere, scattered across the forest floor, pure white blankets for the angels to lie upon.

The same sun that so relentlessly blazed down upon the plains shone with a soft, gentle gaze upon the giant trees. Golden rays of light came tumbling through the branches and landed with careless abandon on the masses of wild rhododendron marching off into the distance. They were blazing torches of crimson, scarlet and pink, twenty times as tall as she was, breathtaking in their beauty.

She stopped under one of her favorite trees, a mammoth 200 foot oak with a girth at least as big as a house. The ferns grew waist high all around, and a stream bubbled and sang its way along next to the path. She jumped the stream and exuberantly hugged the tree, looked upwards, open-mouthed, marveling at the orchids draped over the branches like ropes of pearls on a Hindu bride. Some were as small as her little fingernail, other blossoms were bigger than her whole hand, each flower sculpted by the Master's touch, each perfect in its own way. Just like people, she thought.

Except for Miss Noland, she added, darkly.

Back on the path, she ran through the forest and followed an overgrown deer trail until she finally arrived at her destination.

Another huge oak tree grew at the very edge of the steep hillside, stretching its strong limbs out into thin air, for the cliff dropped vertically beneath it into the blue distance. The tree clung to the mountain with immense, convoluted roots, and Gladys began climbing over them. She hitched up the skirt of her school dress, tucking it into her belt, and swarmed up the trunk, agile as any monkey, finding finger and toe holds in the cracks of the ancient bark. The oak had flung its arms up and out over the abyss; Gladys straddled one of them, inching out slowly to the end of the branch.

There she could lie spread-eagled, arranging herself so she

became a part of the tree. She tucked her skirt under to keep it from flapping in the wild cold wind that whipped across the top of the world. It brought with it the scent of snow-covered peaks, and pine forests. It spoke to her of dreams.

She rested her head upon a soft green pillow of moss. She could see forever. She felt as if she were floating in the air far above the earth. In truth, she might as well have been, for the cliff dropped away 1000 feet, and she was cradled in the gentle hand of the primeval tree, suspended high above the hills and forests falling away on all sides.

She could see the silver slices of streams as they cut through the jungle, and fluffy piles of crimson where the rhododendron groves were in flower. This was truly a magical place, a place to which she could bring her hopes and plans, her fears and heart breaks. Over the years, that moss pillow soaked up many a hot tear, and the old oak heard secrets never whispered anywhere else.

She could look out, far across the jungly forest, down into the plains. Beyond the dark green, red, and silver of the hills, the land flattened into the plains; stretching into the dusty distance, wavering in the heat of the sun, finally fading into the golden violet brown horizon. She imagined she could see the Rourkee compound, and Helen's house, and even the sparkle of the gray green Salani River.

Up here no one could hurt or embarrass her, not even Miss Noland. No brothers could tease and make fun of her, calling her *dhober* (clumsy bucket) and making her cry.

Up here she could fly. She felt as beautiful and graceful as the brightly colored birds and butterflies that swooped around her head. She was weightless and free, yet totally protected and safe.

She drew strength, inspiration and courage from her tree. Often, after she was grown, and always, in the darkest parts of her life, she revisited this secret place in her heart, and was comforted.

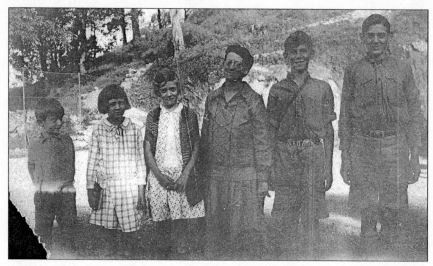

Beth with all of the children, 1929

Landoor Villa in Tall Trees

*Beth and her children
on the hillside, 1927*

Chapter 7

Landour Villa

1928

*W*hen Gladys finally climbed down from her tree, the shadows were long beneath her, and the sharpening breeze told her that evening was coming on. Retracing her steps back to the main path, she made her way up the hill, to home and dinner.

She came to the edge of the British cantonment just as the swift Indian twilight fell. A single star like a great diamond burned in the translucent green of the evening sky.

"Star light, star bright," she chanted, "I wish I could be a good girl like Margaret. Also, I wish I had her hair." She always wished two wishes. Who knew, maybe the angels who perched on the first star, the ones in charge of granting wishes, were feeling generous tonight. It never hurt to try. She knew that both wishes were long shots, but she was feeling especially hopeful tonight. And happy to be home.

Turning a corner, Gladys headed up the path towards home. The lamps had just been lit, and the windows glowed softly golden with welcome. She felt an overwhelming sense of joy as she gazed up at the villa, for she thought it the most beautiful house in the world.

Built more than 100 years ago for a self-important British general, it was placed well back from the other officers' quarters, and commanded the best view of all. The walls were over a yard thick, built of native

stone chiseled into great blocks that fit together perfectly. One approached the house from the back, for the front was nothing but a huge verandah, looking out over a short stretch of garden and then down, down the mountain, over the red rhododendron and green pine trees, all the way to the hot, dusty plains in the distance. Papa had enclosed the front porch with glass, and had turned it into the boys' bedroom. But Gladys and Margaret knew that as soon as their brothers went back to the U.S. for college, it would be theirs. They could hardly wait.

The villa had so many rooms that her parents had divided it into three apartments. They lived in the central part, with the Wymans on one side, and the Johnsons on the other. Rev. Johnson and his wife were missionaries, too, but they had no children and lived a quiet life, always kind to everyone, but unremarkable in most ways.

The Wymans were a different matter. Mr. Wyman was attached to the army somehow, and both he and his wife were quite proper. They had two daughters, Valerie and Betsy, the former being close to Gladys in age, and another unfortunate recipient of her right hook.

Valerie spoke with an upper-class English accent that tended to set Gladys' teeth on edge. But she usually tolerated her, and even played with her when there was nothing else to do.

The Unfortunate Incident occurred on a lazy afternoon while the two girls were sitting on the communal back porch, waiting for something to happen, and talking about their families, for want of anything better to do.

"It's ever so sad that your mama has so many children," Valerie announced, with a sly look in Gladys' direction. "I do feel ever so sorry for you."

"Exactly what do you mean by that?" came the ominous reply.

"Well, everyone knows that when a woman has a whole pack of children, she doesn't have enough time to give them all the love and

58

attention that someone with a civilized number of children, like one or two, is able to give. When I grow up, I'm only going to have one child, so I can be a good mother."

Gladys was starting to grow red around the ears, but she tried to hold her temper, and replied to this inflammatory speech in a very reasonable way.

"Well, I'm sure you don't have to feel sorry for me, Valerie! My mama loves me more than anything, and she says we're lucky to have a big family because the more people you have to love, the more love you have. It's like the multiplication tables."

With a superior sniff, Valerie disagreed, "Well, you run around in those awful castoffs because your mother doesn't have time to make sure you're dressed like a lady. My mama would never let me out of the house looking like that. It's obvious that she loves me more than your mother loves you."

Gladys was now seeing red, but she tried again, with great effort of will, to discuss the problem rationally.

"My mother lets me wear what I want to wear," she said hotly, through clenched teeth. "She always dresses like a lady, but she loves me enough to let me choose my own clothes. She says I have my own sense of style." Gladys was standing now, with her fists bunched at her sides. Not a good sign.

"Style? Hah! I'd say, rawther, neglect! It's obvious that my mother loves me more than your mother loves you, you poor thing." Valerie repeated maddeningly, with her little nose pointed in the air and a sneer on her aristocratic lips.

"She does not!"

"She does too!"

"Does not!"

"Does too!"

"Does not!"

That did it. The last "Does not" was delivered along with a punch in the face for Valerie.

It was inevitable, really, and Valerie should have known she was pushing too hard, but when all the screeching and sniveling was over and done with, Gladys was in solitary confinement for the rest of the day.

Now, this may seem like odd behavior for the child of strongly pacifistic missionary parents, parents who believed deeply in loving one's neighbor and turning the other cheek. But Gladys was born a bluntly outspoken Sagittarius, with strong personal beliefs and a quick, hot temper. Hyper-sensitive to criticism, taller than the other children, with arms and legs that would never seem to coordinate, she was teased unmercifully and soon developed a distinct "attitude problem."

Add this to the fact that she grew up scuffling with her brothers and learning to, "put 'em up" in self-defense, and the results were quite predictable.

In addition, the children had been raised under the loving and indulgent eye of their *ayah*, who became upset only if her girl got the worst of a tussle. Behavioral standards are very different in a country where most children had to fight for a stale *chapatti* or a few grains of rice.

And while her brothers and their friends could pummel each other with good-natured glee and walk away laughing and joking, Gladys never actually hit someone unless her emotions were deeply engaged and then only with the driven, hopeless attitude of an alcoholic falling off the wagon.

Her brothers had taught her how to defend herself, but they hadn't taught her how to control her temper. Beth, long-suffering and patient, tried her loving best to instill non-violent behavior in her little hoyden. John reluctantly tried stronger methods, sometimes resorting to tanning her backside, but in the end, when pushed too far, Gladys would leap into the fray, both arms flailing, and usually end up on top.

She knew it was wrong, but she couldn't seem to help herself.

Later that evening, after Ayah had sneaked dinner to her on a tray, she lay on her back in her bed, deep in thought. She watched the setting sun play shadows across the ceiling and reluctantly came to some very uncomfortable conclusions. She'd been thinking about school and suddenly realized that she had become something of an outcast.

"Boy, Gladys, you really are a mess!" she sternly lectured herself. "You have no friends. Nobody at school really likes you 'cuz they're all afraid of you. One wrong word and pop! You punch them in the nose. Why can't you learn to be nicer to people?"

She flung her arm across her eyes to stem the treacherous tears leaking down the sides of her face, and thought, "I don't want to live like that the rest of my life, always fighting, always hurting, always angry. How can I stop myself from getting so mad and upset all the time?"

She sat up in bed and, wrapping her arms around her legs, pursued this line of thought.

"Who do I know that has lots of friends? Someone who people really like to be around?" she asked herself, thinking hard and chewing on her lower lip. Then it occurred to her.

"Mama! That's who! She has friends everywhere: here in Landour, in Rourkee, even in Cincinnati and Kansas. Everyone loves her because…because…why? When she gets upset, does she go and slug someone? Of course not!"

Gladys had never even seen her mother swat a fly. She thought long and hard about her mother's response to the vagaries of life. When the answer finally dawned on her, it seemed so simple. "That's it! She laughs! She can see the funny side of things. No matter how bad something is, she can just about always find something to laugh about. And she can make almost anything fun. <u>She</u> doesn't let other people get her

goat. I know she tries to see things through the other person's eyes – she's always saying 'don't judge someone until you've walked a mile in their shoes.' I think I know what that means, now.

"And she sees the very best in people. Even in Carl. Even in me. Instead of concentrating on what makes her mad about someone, she focuses on their good points. That is so different from what I do. It's almost as if I actually look for the things I <u>don't</u> like in a person and then that's all I can see. No wonder no one likes me – I don't like them!"

Gladys was in the middle of an epiphany. She was seeing things more clearly than ever before. Actions, motivations and results were fitting together in her young mind like the last few pieces of an intricate jigsaw puzzle. She rested her chin on her knees and stared out the window at the pine trees dancing in the evening breeze, her mind racing to some startling conclusions.

"Maybe if I didn't take everything so seriously and personally, it wouldn't hurt as much, and I wouldn't get so mad. And if I look really hard for something to like in other people, maybe they'll like me more. From now on I'll try my best to see the funny side of things, especially when I start to get mad. Laugh, instead of socking someone. And when I don't know what else to do, I'll sing, just like Mama. She sings all the time. I bet it helps her to feel better. Yep! That's what I'll do from now on!" she vowed with the fierce determination of the young.

And from that moment on Gladys was truly a changed person. When an epiphany grips an eight-year-old girl, it can change the entire course of her life. It's like taking a different fork in the road at the beginning of a journey – one ends up in an entirely different place.

The seeds of compassion and humor had been planted long ago, and now they burst into full bloom, transforming her personality in a marvelous way. She had never been one for half-measures, and this was no exception. She jumped in with both feet, and submerged herself in

this new awareness.

In the coming years she would fall off the wagon a few times, but for the most part she would become a delightful companion. She would learn to inject laughter into situations that previously would have drawn blood, and would encourage friendship and loyalty by forcing herself to believe in the best in other people. She would hone these skills as she grew, and eventually, love, compassion, laughter and song would become the cornerstones upon which she would build her life.

Gladys
Ayah
Helen
Margaret

Gladys and Beth
The back of Landour Villa

The front of Landour Villa
Gordon climbing, Margaret on left, Gladys on right, Ayah at top of stairs

Chapter 8

In the Field, Northern India
January, 1929

The morning dispensary had closed; John was off on a hunting trip, and the children were playing quietly. Whispering a prayer of thanks, Beth had just laid her tired body down for a short nap. It seemed she had barely closed her eyes when the rhythmic ringing of an elephant bell outside the tent began to insinuate itself into her dreams. She was reluctantly awakened by the increasing sound of the chattering villagers, gathered in a curious crowd.

"Yes? Come in," Beth called, hurriedly pulling on the clothes she'd discarded only moments before. Ayah was scratching on the tent flap, apologizing profusely for having interrupted *memsahib's* rest.

"I am very, very sorry, *Memsahib*," the nurse said in her heavily accented English, poking her head into the tent, "but it seems that there is a very urgent elephant here. Yes, a very sick elephant, and the *mahout* is saying that he is the rajah's most important hunting elephant, and he is begging the doctor *sahiba* to look at this most painful hurt foot."

Taken aback, to say the least, Beth stopped lacing her boot to stare at her.

"An elephant! My goodness! I can't treat an elephant! Why in the world would he bring an elephant here? Tell the *mahout* to take him to one of their own people who can care for animals!"

"I am again begging your pardon, *Memsahib,*" Ayah earnestly replied, "but the *mahout* is most insisting that he must speak to the doctor *sahiba*, and that the ones who care for animals in his city are fools, worse than fools! And this is the prince's most especial favorite elephant, and the rajah has decreed that the *mahout* may not return home until the elephant has been treated. He is begging me to bring you to him."

"Oh, all right," Beth sighed, donning her *topi* with resignation and shaking her head, "but I don't know what I can do for an elephant! Oh, and Ayah, please go get Gladys. She'll want to see this."

When Gladys arrived, running swiftly on her gangly eight-year-old legs, she found quite a scene. The great bull elephant rose like a gray mountain in the midst of the crowd of fascinated villagers, while her mother and the *mahout*, dwarfed by the huge beast, stood in front of him, arguing with great animation. They were the same size; the tiny white woman and the small, dark-skinned barefoot man. He was clad only in a loincloth and a turban, as was traditional for the *mahout*, or elephant boy, who was the personal trainer, best friend, and closest thing to a family that domesticated elephants had. The two were arguing in Hindustani, and the boy was pleading with Beth not to send them away.

"For the rajah has told me not to return until the elephant has been treated by the doctor *sahib*, for he is a favorite with the entire palace, and most especially well-mannered. I, myself, trained him, and he is indeed a most marvelous beast, smarter than any other elephant, and as gentle and biddable as a child."

By way of demonstration, he had the animal kneel, then sit up on his hind legs, lifting his trunk into the air and trumpeting. This, in turn, made the villagers squeal and run in different directions, like an anthill that had just been kicked. Gladys stood stock still in amazement, watching while the *mahout* ordered the elephant to lift him onto his

back with his trunk, then gently set him down again. The great pachyderm performed these tasks at a single word or gesture from his trainer, in spite of the obvious pain his injury caused. He seemed sweet natured indeed, and very gentle, although he towered above Gladys, three times as big as a house, and had tusks that were as long as she was tall. She sidled up next to him and began softly stroking the wrinkled, dusty, leathery skin. She didn't flinch when his trunk came seeking her acquaintance, snuffling her all over. It kind of tickled, and left dirty slime marks, but she just laughed.

The wound was on his right front leg, a raw and ugly, suppurating sore, and the *mahout* explained that it had happened on a tiger hunt. The rajah had been riding him through a strip of jungle in which a storm had broken down a number of trees. The sharp end of a fallen tree had caught the elephant's leg as he was thundering by with his long, swinging stride. It had torn the tough skin and left a splinter in the flesh, and in the heat of the hunt had not been noticed until later. The *mahout* had removed a large splinter, but the wound had begun to fester in spite of his ministrations.

The huge patient was so docile and in such obvious pain that Beth finally acquiesced, spreading out her medical kit and telling Gladys to run go get her a basin of potassium permanganate solution. Gladys knew exactly how to prepare it, and by the time she returned, trying not to slop the bright purple liquid over the sides of the basin, Beth had begun probing the wound. She was talking softly to the elephant, and gently patting his massive leg with one hand, while the other deftly wielded a pair of long forceps. With a small cry of triumph, she slowly extracted a four-inch splinter, and bloody pus began to ooze out of the fist-sized wound.

She then filled a foot-long copper syringe with the solution from Gladys' bowl and began squirting the disinfectant in a steady stream into the center of the wound. She continued to syringe the open-

ing, cleaning out the gore, and effectively cauterizing the surface, thus discouraging the flies that had been driving the animal to distraction. Gladys faithfully clutched the basin and watched the proceedings with wonder, amazed that the elephant moved not a muscle; only his rolling eyes and twitching trunk gave evidence of his discomfort.

Ayah was sent to fetch some ointment from the dispensary. After lavishly smearing it on the sore leg, Beth packed the rest in a small pot, and gave it to the grateful *mahout*, instructing him to apply it twice a day, and to return in the morning for a check up.

For seven mornings thereafter, Beth tended her huge patient. Since it was too far for them to return home each day, the *mahout* and his charge camped outside the village in a small clearing down by the river. Nothing in the jungle can hurt a full grown bull elephant, and the boy was completely safe sleeping curled up between the great forelegs of the slumbering pachyderm.

"Hathi," the children called him, for that is Hindustani for elephant, and they were completely fascinated by everything about him. Hathi, in turn, developed an obsession with Beth, for she had taken away the terrible pain in his leg, and had touched him with gentleness and love. He had tumbled trunk over tail in love with her, all eight thousand pounds of him, and he followed her everywhere. If she stopped moving for a moment, he would reach out his great trunk and wrap it around her waist – the original elephant hug. She'd slap it and say, in an indulgent tone, "Now, be a good boy and let go, do!" He would reluctantly comply by lumbering back and releasing her, but nothing could keep him from trotting devotedly after the object of his adoration wherever she went.

Nothing, that is, except the prospect of a bath.

Every morning, after his treatment, Gladys and the other children crowded around, hoping to be one of the lucky few who were lifted onto the elephant's back by his long, snakelike trunk, and carried

down to the river. His back was big and flat, and warm, and the bristly hair scratched their bare legs, but oh! it was glorious to be up so high. Trooping down to the riverbank, they were led by the *mahout* and surrounded by the other children, and when they got there, they all played in the water for hours. The squirming pile of delighted children laughed and screeched when Hathi lifted his trunk high in the air and showered them with the warm water. It was a rare treat, for normally they were forbidden to swim in the river, on account of the vicious *muggars*, the man-eating crocodiles that lurked in the shallows, and the pythons that dropped in deadly coils from the overhanging trees. But an elephant, in all his great gray gargantuan glory, can crush a *muggar's* skull as easily as a ripe cantaloupe, so the predators kept their distance, and the children played freely through the long hot days of that magical week.

At last the wound was healed to Beth's satisfaction; she gave her adoring patient a clean bill of health and sent him on his way. The children took one last ride on their Hathi and then he was gone, plodding disconsolately down the dusty road. The *mahout* rode astride the great neck, calling back effusive thanks and promises of everlasting service.

Gladys sat in the dirt and cried, heartbroken.

A few weeks later, by way of appreciation, the rajah sent several bolts of the finest *sari* cloth, embroidered with gold and silver, and flashing with tiny round mirrors.

But Gladys remained inconsolable and moped about with a long face until her *ayah* took her to task.

"Oh, certainly sure, the *hathi* is gone from here, back to his home where he is needed, but he is most assuredly not gone from your heart. Do you think, my little one, that simply because he is not here in this place, do you think you cannot visit that most especial place in your heart where he is still dwelling? That place where you are still laughing and playing with him?"

Ayah wiped the streaks of tears from Gladys' grubby cheeks with the edge of her *sari*, and continued in a softer tone.

"Listen to me, my child – when you love something, you can never truly lose it. This is the truth I am telling you, and you would do well to learn it, and smile and be happy again. For truly, once you have wrapped someone in the love of your heart, and have memories to visit, nothing can take that one from you – not death, not distance, not even a broken heart. Now, come, stop this great *tamarsha* and eat your curry, for it is getting cold. And give your Ayah a smile, for I want my sunshine back again." Gladys took the wise words to heart, and was soon herself again, laughing and clowning and fighting with her brothers.

And to this day, the image of an elephant reminds her of childhood laughter and sun on the river, and of how the wisdom of a simple woman helped heal her first broken heart.

Chapter 9

Rourkee and environs, late winter

1929

"*H*arry! Harry Dean!" Gladys yelled at the top of her voice. She pelted across the compound and threw herself on his leg, latching on like a hungry leech during the monsoons. "Take me on your bicycle. Please, please, please take me riding. I promise I'll sit still and be good. I promise!"

The last time he had taken her up behind him on his bicycle, she had promptly, and against all orders, stuck her foot in the spokes and sent them both flying head over heels into the dust.

"I'll follow orders this time – I'll be good and sit still and I won't kick my feet or bounce around. I'll be as good as Margaret was when you took her riding yesterday. Please, please, puh-leeze, please take me!"

She gazed up at him, her big brown eyes overflowing with adoration and a touch of guile. She knew he could never refuse her when she looked at him like that, especially if she set her lower lip trembling ever so slightly.

Harry Dean shook his head in defeat, an indulgent smile twitching the edges of his mustache.

"Oh, all right, me girl," he replied, in his heavy cockney accent, "but you must sit as still as a stone and do exactly as I says. Now you

just wait right 'ere while ol' Harry gets his bike."

He left her doing a little dance of glee in the dust and headed back toward the compound gates, a bemused look on his weathered face.

He was only a British Tommy, stationed at the large cantonment in Rourkee, and a little flabbergasted at this new family that had taken him in, heart and soul.

Born in the London slums, Harry had joined the army as the only way out of the grinding poverty of his childhood. As a dirty urchin roaming the streets, he had been known as a deadeye with a slingshot, dropping the huge London rats at fifty paces with perfectly placed stones to their heads.

Being an adventurer at heart, Harry was gratified to be assigned to India, one of the most exotic jewels in the far-flung crown of the British Raj. He started as a bugle boy and moved up in rank quickly. When he arrived in Rourkee, he put his natural talent to use and learned to shoot the different rifles used for hunting game. His skill became an established fact, and Harry was named First Hunter of the Regiment, assigned to the duty of keeping meat on the tables, providing sport for visiting dignitaries, and protecting the local natives from marauding animals.

When he had been there almost two years, the general requisitioned a peacock for his Christmas dinner. There are no turkeys and very few geese native to India, so for traditional feasts, Westerners had to make do with the nearest facsimile, a peacock. Actually, a peahen was preferred, being a bit more tender and succulent than the male of the species. After two days of beating the bushes in vain, Harry despaired of bagging the requested bird in time for Christmas. He returned to the cantonment with a plucked, trussed vulture, which he gave to the general's cook with a defiant air. The cook rolled his eyes, but being a peaceful man, made no demur. He cooked and presented the

dubious bird as if it truly were a peacock, right down to the full spread of tail feathers which adorned the serving platter.

On Boxing Day, when the general saw Harry on the parade ground, he thanked him for the bird, but mentioned that it had been a bit tough. Harry just smiled enigmatically and went on cleaning his rifle.

He and John Taylor first met each other when they were both called upon to rescue a village that was being held hostage by a vicious man-eating tiger. Two of the inhabitants had escaped over the thatched roofs of the village, and they had begged for help from the white men, for only they had the guns that were necessary to hunt such a dangerous beast.

John and Harry Dean were two of a kind, yet from completely different worlds. They met on the trail to the beleaguered village, *shirkaris* trailing behind, and sized each other up with a glance. The prospect of facing the "Man-eater of Chilla," as the tiger had come to be called, filled them both with great excitement, tempered by caution and respect for the dangers of the situation into which they were entering.

India in the 1920s was still a wild, majestic and primitive land. The mountains had not yet been deforested by encroaching civilization, and the rhododendron and pine forests high in the foothills transformed into endless *deodar* and bamboo jungles as they lost elevation. The green hands of the jungles reached long, tapering fingers into the brown skin of the plains, as if grasping for water. And at the tips of each finger, the once joyous streams of the mountains seeped sullenly into the thirsty dust, and the trees were no more.

For centuries, the natives had built their tiny, thatched-hut villages in the open land between these green fingers, eking out a precarious existence, and visiting the fringes of the trees only for water and small game. They seldom dared the depths of the jungle, which extended for

hundreds of miles, untouched by the hand of man, untrod by even the bare feet of her native people. For the jungles were still ruled by the great cats: *sher-babar*, the majestic, dark maned Asian lion, and *kehri-sher*, the fierce, red-gold tiger.

By the turn of the century, the British Raj had put a strict ban on shooting the *sher-babar*, as it had already been hunted almost to extinction. At the time of our story, lions were seldom seen, and never hunted.

Not so with the *kehri-sher*. Tigers abounded in India, and although hunters needed a pass to shoot them in 1925, a license for four tigers cost only the equivalent of six dollars. In fact, there was often a booty placed on the heads of the more notorious man-eaters.

It is said that an unmolested tiger is the most sportsmanlike gentleman in the jungle. Held by the Indians to be the true rajah, the King of Beasts, he knows that he is master of all he surveys. If he comes suddenly upon a human in close quarters in his domain, his usual reaction is to simply snort, glare contemptuously, and pass regally by, disappearing into the shadowy trees. No matter that an unarmed man is the easiest prey of all; he seems to consider such easy meat beneath him, and ignores the trembling creature in favor of more worthy, tastier prey.

On the other hand, a tiger which has been wounded or otherwise molested by humans, begins to hate them with a raging intensity. A man-hater becomes a man-eater after it first kills a person and tastes his blood. It is generally believed that the salty taste of human flesh, combined with the ease of the kill, produces the craving to stalk and eat more of the pitiful bipeds.

A man-eater is a threat to all. They are usually the oldest cats, having passed their prime. In their relative feebleness, with dull and broken teeth, they are unable to bring down their preferred prey such as the swift antelope or great sambar stag. Most have also been wounded

at one time or another, and their hatred for man increases with every passing day. And although they seem enfeebled when compared to a magnificent tom tiger in his prime, their very age makes them huge. And crafty. And most times, enraged.

John and Harry Dean knew all this when the men from the village of Chilla came, imploring their help. They knew that the villagers had no way of dealing with man-eaters, and that it would take their combined skill and the firepower of their trusty hunting rifles to save the village.

As the two native men led the hunting party through the hot, steamy jungle, they recounted the horrifying details of the tiger's reign of terror.

The first attack had occurred about a week ago, they said, in broad daylight. The headman had been plowing a field with the community's two oxen, and the beast had attacked and killed him, in preference to the cattle. This, they said, was a sure sign he was crazy, since the great cats are like all felines: nocturnal, secretive, and very selective when it comes to food. They normally prefer the sweet meat of a herbivore, such as oxen, to the dubious taste of carnivorous man.

The second incident had occurred a few days later, when an old man had been dragged, screaming, out of his hut at the edge of the village and had been eaten alive, in full view of his horrified neighbors.

Now the tiger had returned and killed both of their precious oxen, devouring them in the open field, in full light of day. The bravest among the villagers had tried to chase him off with sticks and stones, but the maddened cat drove them back into their huts, where they had barricaded themselves. They were running out of food and water. The huge tiger ferociously charged anyone who set foot out of their door. He had terrorized them for three days and three nights when the men made their escape over the rooftops. He uttered warning growls and roars periodically to remind the besieged villagers that death still

stalked their village.

The hunting party, comprised of John, Harry Dean, and their two *shirkaris*, arrived at the scene in the late afternoon. Harry had his favorite double-barreled 12 gauge shotgun, while John carried his trusty .357 magnum. The village appeared deserted, not a soul on the packed-dirt streets, but a few frightened, wild-eyed faces peered out of the doors of the huts to see what was happening. Warily, several over-joyed people crept out to welcome their would-be saviors.

When asked where the tiger was, they pointed to a ravine running next to the village. Noiselessly, the four men followed the faint trail in single file, guns at the ready, safeties off. The stalker had become the stalked, and the great cat must have sensed the change, for he let go with a huge rumbling roar that echoed off the dry, rocky walls of the ravine.

John, in the lead, cautiously rounded a corner and caught sight of the red-gold hind end of their prey just 25 yards ahead. He silently motioned for Harry, and, at the same moment, the tiger saw them. Whirling around, the *kheri-sher* gave a great leap onto the biggest rock in the open.

The setting sun back-lit the deadly beast, setting every hair afire, as he paused to utter a ferocious, ear-splitting roar. His stripes glowed purple in the twilight, and he seemed to be surrounded by a flaming aura of red-gold light. It was a fearsome sight.

The adversaries stared into each other's eyes for an eternal moment. Then, leaping into the air like a massive coiled spring, the tiger broke the spell. With claws outstretched and razor teeth ready to snap the hunters' spines, five hundred pounds of roaring death came flying through the air at the fearless men. John stood his ground, Harry stepped forward, and both men squeezed their triggers simultaneously. The thunderous double report brought the tiger up short and he fell just a few feet away from them, as magnificent in death as he had been in

life.

When the *shirkari* measured him, he was found to be almost eleven feet long, and weighed in at 527 pounds. He had a mass of old buckshot surrounded by bloody scar tissue in his tail and rear flank, which fully explained his raging hatred of men.

The villagers erupted from their huts, chattering, singing and making merry, heaping gratitude and praise upon their deliverers. A celebration began on the spot, and the hunters were invited to join in the nightlong revel, complete with potent rice liquor and the best curries the village could offer.

Both men declined; they knew they were needed elsewhere. But that hunt marked the beginning of a life-long friendship, and the inclusion of orphaned Harry Dean into the warm and generous bosom of the boisterous Taylor family.

Most days would see Harry pedaling his bike the seven miles from the cantonment to the missionary compound. Once there, he would often go hunting with John and the boys, help Beth with simple chores, or just play with the children. He soon became an idol to them, with his merry laugh, infectious enthusiasm, and stories of his colorful life. He usually stayed to dinner, and many memorable hours were spent in the warm lamplight, lingering over cups of hot *chai,* eating *julabies* or *gulab jamen*, the sticky sweets of India, and listening to Harry and John spin tales.

On those nights there were no children clamoring to be excused in order to get in one more game of hide-and-seek in the lingering twilight. Instead, they would sit as if riveted to their seats, long after licking the last bit of dessert from their fingers, entranced once again by the oft-told tales.

On this particular night, Gladys and Harry Dean had returned from their bicycle ride to find dinner already on the table. There was vegetable curry, of course, and fragrant rice spiced with cloves. Dar had

killed the mean old rooster, so there was also chicken curry tonight. Glistening bowls of homemade mango chutney sat next to platters of hot *chappattis* and *puris*, the flat Indian breads fresh off the griddle, soft and steaming. Bowls of yogurt and cucumber salad, *raita*, which cools the tongue and balances the fiery heat of the curries, stood next to a huge tureen of *dal*, the thick lentil soup which, when mixed with the curry and rice, creates a delicious combination of flavors.

The children hurled themselves into their chairs, mouths watering, stomachs growling. They paused automatically with heads bowed, while John said grace, then attacked the food as if they hadn't eaten in days. The feast was consumed with great rapidity and enjoyment; amidst hilarity and high drama, stories of each one's day were recounted and appreciated all around. The meal ended, as always, with the production of dessert: *jalabies* tonight, squiggles of sweet batter cooked in heavy syrup, served with hot *chai*.

The sun went down in a blaze of glory, and the lamps came up, flickering and golden. Gladys heaved a sigh of deep contentment and looked around at this scene that was so dear to her. The high white walls were hung with treasures from their travels; the wide windows framed twilit views of the slumbering mountains, and laughter and love were evident on the faces of her family. As the evening darkened the corners of the room, Gladys could see Ayah and Dar leaning against the kitchen door, distinguishable from the shadows only by the reflection of lamplight in their eyes. They enjoyed the stories as much as the children.

The *punkha*, hanging from the ceiling, flap-flapped in rhythm. The Indian version of a ceiling fan, it consisted of long strips of cloth attached to poles on the ceiling, kept moving back and forth by the endless, lazy efforts of the *punkha walla*, the young native boy seated on the porch outside. His job was to slowly pull the rope that moved the poles that flapped the cloth that kept the air moving in the hot, still Indian night. The rhythm of the *punkha* served as a background to the stories

and tall tales, and the children all called for their favorites.

"Tell about the twenty-foot long *uzdaha*," begged Carl, "the one that reared up ten feet tall in front of you and tried to get you!" The boys always wanted to hear about pythons, *uzdaha*, because the stories were preceded by a graphic and grisly description of the giant snake's eating habits.

Uzdaha can reach thirty feet in length, and measure up to two feet in diameter. They drop onto their victim from trees or lie in wait along the muddy banks of the gray-green rivers, looking exactly like gnarled tree roots. After throwing his coils around his prey, effectively immobilizing it, the *uzdaha* begins to ingest the animal headfirst. Due to great amounts of elastic tissue around the jaws and mouth, the python can swallow almost anything, even a full-grown sambar stag. The massive coils break the antlers off first, and then, beginning with the head, the snake begins to swallow his prey. This slowly and painfully smothers the victim, and *uzdaha's* fangs, which all curve backward, make it practically impossible to pull free before complete asphyxiation. As the elastic tissue around his mouth stretches, the python gulps more of the head and neck. After this, he will often lay around for hours, a contented expression on his face, while he squeezes the rest of his meal into a sausage-shaped, pulpy mass. Gradually, *uzdaha* swallows the rest of his dinner, and takes about a week to digest it, after which he slithers out of his hole again, searching for more victims.

Gladys didn't want to hear all that tonight – it always gave her the creepie-crawlies. And besides, they had heard that story the last time Harry had come to dinner.

"Tell about the time you almost stepped on the *muggar*," she piped up, and the other children chorused their agreement.

John and Harry glanced at each other and nodded. Everyone settled back while John put on his best story-telling manner and Harry turned the lamps down for atmosphere.

"Now, this particular time, during the monsoons it was, and Harry and I were coming home, tired and sore and hungry. The hunting had been spoiled by the rain, and we were walking, single file, down a muddy path next to a small river that had overflowed its banks, stepping around puddles, trying to find a place to cross over so we could get home in time for dinner. Our stomachs were growling and my mind was on hot *chuppattis* and Dar's curry and rice. The sun had gone down behind the Himalayas, and the full moon was peeking her face through the tops of the trees. I was in the lead, followed by Harry, then came the *shirkaris*, Edgar and Dil Das. In the fading light I spied a dry strip in the middle of the water. It looked like a good place to ford the river. As I got ready to leap, I flashed the beam of my flashlight on it and at the last second, realized that the pebbly surface was not a fortunate path, but rather the corrugated back of a huge, twelve-foot-long man-eating CROCODILE!"

John was a consummate storyteller. The same histrionic talents that made his sermons legendary were applied with great effectiveness to his hunting stories, and although the children had heard them dozens of times, they still squealed and jumped on cue.

Now his eyes flashed in the lamplight and his voice sank to a low whisper.

"A tingling sensation began at the base of my skull, and traveled down my spine and out to the ends of my fingers and toes; why, children, I tell you – my hair stood straight up on my scalp and wiggled, and my eyes almost popped out of their sockets."

John waited while the children giggled, and then he resumed his story.

"I saw an evil, beady eye flicker, and it opened its great, huge, horrible jaws wide. I could see the rows of sharp, white, glistening teeth as well as I can see your faces! Then it emitted a blood curdling, thunderous, gurgling roar, 'Grraugh! Grraugh'!"

All the children cringed as John did a perfect imitation of an infuriated *muggar.*

"It echoed off the rocky cliffs surrounding us. Time seemed to stretch, and things began happening in slow motion, as they do during times of great danger. I sensed a slight movement of the *muggar's* tail and suddenly remembered that a croc often uses it to slap his victim into his mouth. So I jumped up high into the air, just as his tail swooshed mere inches below my feet. I hit the ground running backwards, and that ol' croc spun completely around, just like a Christmas top!"

Harry Dean now took over the storytelling, and all eyes turned eagerly towards him.

"Meanwhile, I'm moseyin' along behind ol' John here, and I hears a ferocious roar – I'm tellin' you, it sent shivers up me spine! And, 'coz of the echoes, it sounded fer all the world like an enraged tiger tom comin' on me from behind, so I starts runnin', high steppin' as fast as ever I can, away from that tiger that I thinks is in the jungle behind me. Then what does I see but yer dad, here, high-steppin' <u>backwards</u>, as fast as ever <u>he</u> can! We looks at each other in mid-air, and he yells, 'No, Harry! No!' and grabs my hand, yankin' me back. 'Coz by that time, that ol' croc had righted hisself and was comin' at us, as fast as ever <u>he</u> could, with that disgustin' wrigglin' run, belly slitherin' on the gravel, jaws gapin', throat gurglin' – ugh!"

There were general shudders and exclamations of horror all around the table.

"Well, just as yer dad yanked me back, that ol' *muggar's* jaws snapped shut on the ghost of me right foot! I can still feel its breath – ooh! it was horrible! But by now, Edgar had figgered out what was goin' on, so while we kept back steppin' he unloaded both barrels into the croc's shoulder. That stopped him all right, and like a flash, yer dad turns around and gives the final shot. Right between the eyes, it was.

And that's how yer dad snatched me from the jaws of death!" Harry chortled, as he and John slapped each other on the back in mutual congratulations.

John continued with the story. "It was too dark to skin the beast that night, so we came back the next day. And when we opened up that old rascal's stomach, what do you think we found?"

Well, truthfully, all the children knew exactly what they found inside the crocodile's stomach, on account of having heard the story at least a dozen times. But, "Tell us, tell us!" they chorused, as if it were the greatest mystery in the world.

In his deliberate manner, John replied, "First, we found a turtle, about as big as this dinner plate, bleached as white as the table cloth. It had been swallowed whole, and the muggar's stomach juices had leached all the color from the poor thing. Next, we found the bones of a small child, probably one of the native children who had been playing in the river, in spite of his mother's warnings." He sent a significant glance round the table.

This oft repeated story was quite probably the source of Gladys' continuing nightmares about crocodiles – the long deadly snouts and rapacious teeth erupting suddenly from the water, being swept inexorably towards the gaping maw by the reptile's powerful tail. Swish! And you were dinner for the beast. The horrible dreams woke her shuddering in the night, but she never, ever tired of the stories.

"And what else do you think we found," exclaimed John, "all tucked away in the corner of that ugly ol' croc's stomach? Well, we saw something glinting in the sunlight, and when we pulled it out, what do you think it was, but a *maharani's* jewelry! There were beautiful necklaces, and rings, and bangle bracelets, about five pounds of it. Quite valuable, really. We don't want to think about where that came from!"

In spite of this adjuration, they were all silent for a moment while gruesome visions of the chomping of a beautiful young *maharani*

flitted through their minds.

"Anyhoo," Harry Dean continued, breaking the spell, "we put those jools in a sack, and when we turned to pick up the digested turtle, it was gone! It had righted itself and crawled away! It wasn't dead, no, not by a long shot. How long do you think he lived in that ol' croc's stomach, just waitin' patiently to be rescued? It just goes to show ya', you should <u>never</u> give up hope."

"Just like Jonah and the whale," John said with satisfaction, which was the way he always ended this particular tale. "Now off to bed with you, all of you, but remember: when things look dark and you're tempted to just give up, think back on that turtle, and just hang on a little while longer. For if the Lord cared enough to rescue a turtle, think how much more He'll care for you."

With those heartening words, the children were sent to bed, the table was cleared, and Harry Dean said his farewells and rode away down the dusty road in the moonlight.

When John finished walking the perimeter and checking the latches, he could be heard chuckling to himself and repeating, as he blew out the last lamp, "Just like Jonah and the whale! Yessir! Just like Jonah!"

Fireplace with leopard skins in Rourkee

Harry Dean on Rourkee front veranda with dog and children
Gladys on right

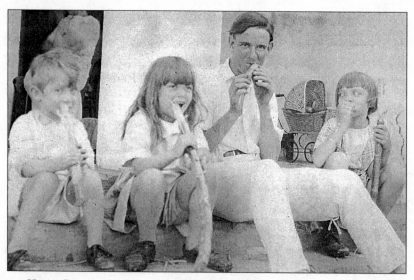

Harry Dean eating sugar cane with Gordon, Gladys and Margaret

Chapter 10

March 1930

Hardwar, India

The bullock cart wound its slow and tedious way down the dusty road into the outskirts of Hardwar. Even at the edge of the city, the byways teemed with white-robed pilgrims, for Hardwar is a holy city, set like a dirty jewel on the banks of the Mother Ganges. In 1930 it was home to the Maharishi, and the faithful came from all over India to study at his feet, or to ceremoniously bathe in the sacred waters of the river. In addition to the common people, hundreds of *fakirs* and *sadhus* stalked about, pious and filthy, having renounced all worldly possessions, as well as basic hygiene, in the name of righteousness and the old gods of India.

The cart plodded to a stop in front of a large group of tents that comprised the missionary encampment. The small figure sitting next to the driver immediately leaped out and began tugging at the large carpet bag stowed under the seat. The driver helped her disengage the bag, and after she had thrown it down in the dust, she held up her hands to carefully receive the oversize basket that had been balanced on the seat between them. The handmade basket was covered with an old piece of cloth, but the driver handled it as if it were as fragile and precious as glass. It took both hands for the woman to carry the basket, so after thanking the driver in fluent Hindustani, she left her carpet bag in the

road and staggered into the closest medicine tent.

The Taylor family had been camped outside of Hardwar for over a week, and the steady stream of sick and injured people had only grown larger each day. The dispensary was closed for the midday break, and Beth, Gladys and Ayah were just finishing with clean up when the woman burst into the tent. She carefully placed her basket on the nearest table and, after removing her *topi* and wiping her brow with the back of her hand, flung her arms open wide in anticipation of her welcome.

"Belle! What a marvelous surprise!" Beth exclaimed, while Gladys, with an inarticulate cry of delight, launched herself into her aunt's embrace. Then the two older women fell into each other's arms, laughing and talking all at the same time. Belle was the first to break away, surreptitiously wiping the tell-tale moisture from her eyes.

Lorena Belle Taylor was small in stature, yet large in presence, with whispy salt and pepper hair that would do nothing but stick out in all directions. She was not a beauty and glad of it, because she felt she had enough sins with which to struggle, without adding vanity to the list. Her eyes, however, were beautiful; deep, dark, and piercing to the degree that when she bent her gaze upon you, it felt as if she could read your mind and see every desire written upon your heart. Her generous mouth smiled often, and burst into song at the least opportunity. Her skin had turned nut brown and leathery from the unmerciful tropical sun, and her hands, though rough, were gentle and kind.

Unmarried as yet, and happy to be so, Belle had followed in her older brother's footsteps and had taken Dr. Still's training, receiving her D.O. degree a few years after Beth and John had left the States. She had come to India in 1922, and was now nearing the end of her first term of seven and a half years with the United Presbyterian Mission in South India. But her fiercely independent spirit did not do well hedged in by bureaucracy, and she was, in her own words, "Fed up with those fools!"

She had been her own woman since the day she was born, in 1883, and had done her own thing before there was a term for it; a term other than "outrageous," or "odd," or "strong-minded," or "too forward." She had a sharp tongue, but a loving, tender heart, and she followed God's plan, as she understood it, with a single-mindedness that brooked no opposition. And she never did it silently.

Beth stepped back and held her sister-in-law at arm's length. "Bless you, Belle, I'm so happy to see you," she exclaimed fervently, "and John will be so pleased! But what brings you all the way up here so suddenly?"

"It's the most wonderful thing, Beth – I have had a Revelation, sent directly from On High, and the Good Lord has shown me the direction my work is to take. I left the mission because those fools down south know nothing about God's True Work – it's all talk and filling out forms. They're afraid, is what it is – afraid to get their lily white hands dirty. So I up and left; I just couldn't stay and keep my mouth shut anymore. Especially after God sent me the Sign!" Her voice rang with zeal, and her eyes flashed in the dimness of the tent.

A small sound issued from the covered basket and Gladys, bursting with curiosity, inquired, "Aunt Belle, what's in this big ol' basket?"

"Ah, that!" Belle exclaimed with great relish, "<u>That</u> is the Sign from the Lord!"

She whipped the cloth from the basket to reveal a tiny baby girl, with skin the color of hot *chai* and enormous brown eyes that blinked in the sudden onslaught of light. Her arms and legs began kicking madly as all four females bent over her, uttering adoring noises and exclamations of delighted surprise.

"Her name is Dorcas and she came to me as a Sign that my True Work is in caring for the forgotten and abandoned children in this heathen land. The Good Lord and I are going to start an orphanage! Let's find

John and then I'll tell you all about it."

Gladys and Ayah played with the baby, while the two women plucked a happily surprised John from his nap and brought him back to the medicine tent. Then Belle began her story.

"I was going about my business one morning a few months ago, getting ready for another day of useless paperwork, when a knock came at my door. I opened it to see a group of native workmen, all talking at once, and the one closest to me was clutching what looked like a bundle of rags. I finally got them to calm down, and their leader told me that they had been on their way to work that morning, passing a large cactus patch, when they heard a baby cry, very weakly. At first they thought it was a bird, but it sounded like no bird he had ever heard, so he insisted on investigating. They laid a board down to make a path through the sharp thorns and Lo and Behold! There in the thickest part of the cactus lay this *nunga-punga* newborn baby girl."

Even at nine years old, Gladys knew about some of the more horrifying customs that had been woven into the tapestry of her beloved India since the beginning of time. She knew that the birth of a girl was an unwelcome event, while boys were considered great blessings to the household. Girls were felt to be worthless and a burden; another mouth to feed, as well as having to be supplied with a dowry when they married. Therefore, it was common practice to expose them to the elements immediately after they were born, or to abandon them on the banks of crocodile infested waters. No matter how hard she tried, Gladys could not understand how a woman could bring herself to murder her newborn child. Equally incomprehensible to her was the custom of *suttee*, in which widows were burned alive on their husband's funeral pyre.

Both customs had been righteously banned by the British, and vigorously condemned by the Christians. But old ways die hard, and their roots grow deep into the bedrock of a society.

As far as Gladys was concerned, God loved everyone, and it

didn't matter to her whether He was worshipped in a Hindu temple or a cathedral. She had deep, inborn tolerance for all faiths, and she saw little essential difference between them.

However, these two ancient customs filled her budding woman's heart with horror, and she was fiercely glad for Aunt Belle and her parents, who were trying to make a difference, saving lives and preaching love.

She reached her hand into the basket, and the baby grabbed her finger with a tiny brown fist, gurgling in delight. Belle watched them with a sad smile on her face and continued with her story, shaking her head in dismay.

"Luckily, the leader of the workmen was a recent convert to Christ, and he insisted upon rescuing the babe. The others were content to let her die of exposure, if the hyenas didn't get her first. They didn't know what to do with her, so they took her to the local police. And the police sent them to the mission. When they put her into my arms, blue and shivering with the morning cold, I knew beyond a shadow of a doubt that this was a Call from the Lord. I decided to call her Dorcas – isn't that a beautiful name? A beautiful name for a beautiful baby." She smiled indulgently down at the cooing child. "But she wasn't so beautiful then! She was shivering, barely alive, and she had cactus thorns lodged in every inch of her little body. I spent the next few days removing the largest ones, and I'm still extracting the tiny ones that were driven deep into her skin. They erupt like a boil and when I lance it, out comes another wicked thorn. That's the only time she cries."

"I finally got her warmed up, but she was so frail, she contracted pneumonia and was on the brink of death for a month. When she finally recovered, I turned in my resignation and made my way north, to you. I want to start the orphanage up here in the U.P., possibly Bhoghpur, or even here, in Hardwar. What do you think?"

John and Beth entered into the discussion with great enthusiasm,

as the prospect of their favorite sister living and working close to them was extremely appealing. John even remembered that there was a small mission orphanage in Bhoghpur. It was run by a Lithuanian woman who had written to him, requesting help. He promised to put Belle in touch with her, and the three adults continued talking, lost in their plans.

As for Gladys, she was entranced. She hunkered down next to the baby and, after having obtained permission from her preoccupied aunt, lifted her out of the basket and began cuddling her.

Dorcas gazed up at her with complete trust and serenity, in spite of the terrifying experience she had endured. Her huge brown eyes were heavily fringed with black lashes, and her face was heart-shaped, with pink rosebud lips and miniature ears that reminded Gladys of translucent seashells. Her skin still bore the memory of the vicious cactus thorns; angry red scars and tiny pustules scattered here and there marred the perfection of her soft little body. She was beautiful, with the classic loveliness of a royal Indian princess. Gladys had never seen such beauty up close, and her heart wrapped warm wings of love around the little girl. The bond between them was formed and cemented in those few hours, a bond that would last throughout their lives. Dorcas became Gladys' adored little sister and, although she lived with Belle in Bhoghpur, she was adopted by the entire Taylor clan, and thought of them as her own beloved family.

Belle stayed with them for a short time, during which Gladys was never far from Dorcas' side. When it indeed proved to be true that the small orphanage in Bhoghpur would welcome them, Aunt Belle and the baby moved to that city and she took over, in her inimitable style. The orphanage was not backed by an organized church, and it depended solely on private donations for sustenance. As the two women took in more and more children, their resources, ingenuity and faith were oftentimes pushed to the limit.

Many nights would see Aunt Belle vigorously saying her evening prayers, which for her often bore more resemblance to a stern lecture than a pious supplication. John used to say that Belle was the only person he knew who could get away with reading God the riot act.

"Now listen here, Lord," she would say, kneeling by her bed in the circle of lamplight, "in your infinite wisdom, you have given me these children to feed and care for and love, and I'm doing my poor best. There are forty of them now, and it takes a lot of food to keep them fed. I love every one of them dearly, and would give my life for them, but my life won't buy rice – only money will do that. And we have only one *pisa* left. That's all!"

She held up a calloused, accusatory hand, in the palm of which rested one small copper coin, as if showing it to God in proof of her statement. "You've given me these children. Now you'd better send some money to feed them. And I don't mean next week; I mean <u>NOW!</u> In the name of Jesus Christ our Lord and Savior, amen."

Then she would hop into bed, to sleep impatiently until she could be up and about with the dawn, enthusiastically saving the world, one child at a time. And more often than not, when she went to the mailbox, a contribution would have arrived, with enough money to carry them on for another week or two.

Many of her children were orphans, abandoned in the city streets, but more and more, as the years went by, were the healthy children of lepers. Most orphanages would not accept them, for fear of contagion. Belle called that ridiculous and opened her arms in true imitation of her chosen Savior. "Let the little children come to me, for of such is the kingdom of heaven."

She took them in, as many as arrived on her doorstep. The lepers would creep to the house in the dead of night and place the sleeping child on the porch, then retreat to the surrounding bushes and hide, watching as the sun came up and the *memsahib* opened the door to dis-

cover another lamb added to her fold. She would quickly take the child out of its bundle of filthy rags, kicking them to the side to be burned later, and, holding it close to her meager bosom, scan the shadows for a glimpse of the grieving mother.

"Do not worry about this child," she would call in Hindustani. "I will love her and raise her as if she were my own. She will be well fed and cared for, and because of your sacrifice, she will stay healthy, and live a full and happy life. We will pray for you every day, and I will not let her forget you. God bless you, now, and know you have done the right thing."

Thus, the Children's Home in Bhoghpur grew and grew. One foresighted donor gave Belle a small flock of chickens, to her great and everlasting delight. She had the older boys help her build a chicken coop from the bamboo that grew wild around the house, and in true biblical style, the chickens were fruitful and multiplied. They provided an endless supply of eggs, and the occasional holiday chicken curry.

One night Belle was awakened in the wee hours by a tremendous commotion of squawks and screeches. She immediately realized that the jackal that had been skulking in the neighborhood must be attacking her precious flock. Grabbing her flashlight, she leaped from her bed and raced out of the house, dressed only in her nightshift. Throwing open the door of the coop, she came face to face with a huge gray jackal, a wildly flapping, screeching chicken held firmly in his mouth. The jackal's yellow eyes gleamed wickedly, and his lips pulled back in a snarl, as he silently commanded the puny woman to get out of his way and let him get on with his dinner.

Aunt Belle would have none of that! Instead, she drew herself up to her full height, eyes flashing, index finger pointing imperiously at the beast, and in ringing tones, commanded, "In the name of Jesus Christ, DROP THAT CHICKEN!"

Never before having been confronted by anything quite so

daunting as the specter of Christ in the form of an outraged missionary woman, the jackal did, indeed, immediately drop the chicken. He turned and, with a small whine, crawled on his belly through the hole in the fence by which he had gained access. Belle sat up the rest of the night, grimly guarding her precious flock, but the jackal, wisely, never returned.

Gladys would always remember the time she had stayed with Aunt Belle for a week, and discovered the older boys busy making adobe bricks behind the main house. When asked what the bricks were for, Belle replied, in her matter-of-fact way, "Well, my dear, they're for the cow shed, of course. Bamboo would never do for a large animal like a milk cow – she would push it right over. So I'm having the boys make bricks, and with a little of that wood I've salvaged and a few nails, we should be able to build a nice, snug little home for our Bossie."

Surprised, Gladys looked around curiously and said, "Goodness, Aunt Belle, I didn't even know you <u>had</u> a cow."

"Well, there's where faith comes in, my dear. I <u>don't</u> have a cow. Yet. But you can bet your buttons that if I build a cow shed, the Lord will send me a cow."

And to the astonishment of everyone except Belle and, apparently, the Lord, a few days after the last brick was laid and the manger finished and filled with hay, a cow wandered into the yard. Her udders were heavy with milk and, as if she knew exactly what she was doing, she stepped into the shed and gratefully began munching.

With an enigmatic smile, Belle closed the bottom half of the door and uttered a fervent prayer of thanks, sinking to her knees in the dust. Then she got up and brushed off her dress, and went about her duties, as if a miracle happened every day.

Which, in Aunt Belle's world, it did.

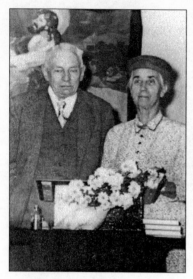

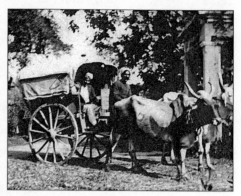

Ox cart in front of Roorkee Bungalow

Uncle Ed and Aunt Belle

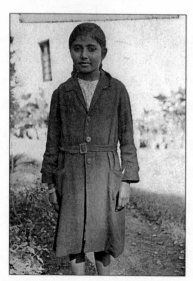

Dorcas, Age 8

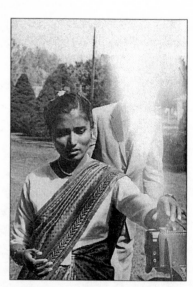

Dorcas, college graduation

Chapter 11

Woodstock International School, BHS Mussoorie, India
Early November 1934

\mathcal{G}ladys poked her head from beneath the sparse covers of her bed, blinking sleepily, snuggling deeper into her little warm cocoon. It was so cold in the upper standard girl's dormitory that her breath hung like fog in the air. She really did not want to get up this morning. The wake up bell had not yet rung, so, yawning hugely, she pulled the blankets up around her chin and indulged in Contemplating her Life.

She looked around the stark white dormitory room with distaste. Nineteen other cots, each one filled with a snoring girl, lined the walls, and the few windows were shuttered against the cold of the night. This was the part of her life Gladys disliked the most. For three months, while Mama closed up the Landour villa and went down to the plains to work with Dad, the children were incarcerated in Woodstock. Accustomed to the warm, relaxed, loving atmosphere she enjoyed at home, the strict rules of an English boarding school were hard to bear, indeed. But, she thought philosophically, there were only sixteen more days until they were rescued. She could put up with anything for sixteen days.

She knew it was still very early, for the light coming through the shutters was gray with the first light of dawn. Satisfied that she still had plenty of time before Miss Gaspar descended upon them, ringing

her bell and throwing the shutters open, Gladys began to reflect upon her last few years at school.

She had finally made it to upper standard, and thank goodness for that. After her first two terrible years with Miss (shudder) Noland, she'd graduated to second standard with Miss McGee, her rescuing angel.

Margaret McGee had seen a kindred spirit the first time Gladys had opened her mouth in her classroom. She saw the intelligence and the fire for learning that oozed from every pore, just as she saw the difficulty the child had with reading, spelling, and numbers. Having been cursed with the same problems herself, she recognized dyslexia when she saw it, even though it would be fifty years before that particular learning disability would be given medical nomenclature and status. She passed along the tricks that had allowed her to get through school with flying colors, and Gladys was soon soaking up knowledge like a sponge. Miss McGee had even been able to cajole the fledgling extrovert into taking part in the school play. And wouldn't you know, she'd stolen the show, cast as the talking frog, dressed in an old union suit which they had dyed a virulent green. She received her first standing ovation when, instead of gracefully leaping over the "lily pond," fashioned from an old galvanized watering tub draped in more green-dyed fabric, she tripped over the edge and fell headfirst into the water with a great splash! She sat there, green dye bleeding, wailing with tears of mortification. This brought the house down, and everyone, especially her brothers, thought it completely hilarious. Everyone, that is, except the soggy green frog herself. She continued to bleed green dye and sob until she saw the audience surge to its feet and then, remembering the value of laughter, the natural born ham in her took over. She scrambled to her feet, executed a deep bow, stepped regally out of the lily pond, and dripped slowly off stage.

Miss McGee helped her find her stride, and that year, to her

great surprise, she was elected governor of her class. She was also chosen to do an oral report at the end of the year, in front of the entire school. Her brothers couldn't let her know how proud they were, so instead, they ribbed her, saying that her knees had knocked so hard they almost clapped. Of course she was terrified, but inwardly she was thrilled, and half-way through her presentation realized that she absolutely, positively loved being on stage.

Directly after that, in the spring of 1930, her family left on furlough to the U.S. It was a long furlough, (much too long for Gladys) owing to the fact that, at the end of eighteen months, the church did not have enough money to return them to India. It was in the middle of the Great Depression, and to Gladys it seemed as if Kansas held no colors, no laughter, no joy. Everywhere she looked, all was gray and sad, cold, colorless and worn out. How she longed for the life and the heat and, yes, even the smells that were India.

She was nine when they left their home in Rourkee, and twelve when they finally returned. The three intervening years blurred together in Gladys' mind and memory, an endless stream of tasteless church potlucks and thin, drab children in silent gray schoolhouses. But there were two memories of those lost years that stood out in her mind, like tropical flowers blooming in a field of ash. They stayed in her heart, clear and bright, as different from that sad, monochrome world as was the Land of Oz from Kansas.

The first happened just as they were leaving India, on the train from Delhi to Bombay. They had been traveling for quite a while and her eyes, swollen shut from her tearful parting with Ayah and Dar, had returned to normal. She was sitting at the window of their car, morosely watching the land she loved rush by, when she realized that the train

was beginning to slow down. The road that ran along next to the railroad tracks was filling up with people, all festively dressed. They seemed to be rejoicing, following a procession on the road far ahead. A *maharajah*, Gladys thought, or maybe a royal wedding.

The crowd outside grew thicker and thicker, children dancing in the dust, throwing flowers in the roadway. The train slowed down even more, and everyone moved to the windows on her side, throwing them open and leaning out. Carried away by the mounting excitement, Gladys leaned out, too, peering up the road, trying to identify the source of the celebration. She looked up and down the train; in the first-class cars, where the British rode, all was quiet, the windows remaining fast against the blowing dirt and heat. Not so third class, at the other end of the train, where the common people, beggars and untouchables rode. People were actually climbing out the windows, as if pulled by an irresistible force, dropping to the ground and running to join the crowd, or swarming up to the roof of the cars to get a better look. She wished she could join them, but her father, as if reading her mind, grabbed the back of her dress with one hand while he held onto Carl's shirt with the other. So she was forced to content herself with stretching her neck, trying to see around her greedy brothers who had co-opted her window, and asking, along with everyone else, "What is it? Who is it?"

The answer came, first as a whisper, building to a great roar, "Ghandi! It is Ghandi! Mahatma Ghandi!"

And Gladys realized that the small man at the head of the crowd was, indeed, the Mahatma, or "great man," of whom she had heard so much. He was much shorter than she had imagined, and he wore only a simple white *dhoti*. Even in the midday heat he walked with a lively, springing step. The people swarmed about him, hungry honeybees around a flower of extraordinary purity and sweetness. He was the greatest man in India, the leader of the movement to free Her from British oppression.

She had heard her parents discuss his precepts with many dinner guests, and she would always listen closely, fascinated by the idea of non-violent non-cooperation, its power and its ramifications. She strongly believed, along with her parents, that Ghandi was right. Violence breeds violence. Hatred kills. Love heals.

She also agreed that it was time for India to be free from oppression of all kinds. And that included the cruel and destructive caste system. The Mahatma abhorred the fact that the upper caste Hindus had, for centuries, dominated and exploited the impoverished millions, the "untouchables." One of the first steps he had taken to restore India's self-respect and unity was to begin the liberation of these lower classes. He gave them a different name, *Harijan*, or "Children of God." He taught by personal example; he lived and ate with the *Harijan,* and when asked why he always rode third class on the trains, he replied simply, "Because there is no fourth." He saw that it was the poor who suffered most from British domination, and so it was for their sake that he had been drawn into the struggle for India's liberation.

The train chuffed to a halt, and the passengers all watched the *tamarsha* with great fascination. They didn't know it yet, but they were witness to history; this was Ghandi's Salt March, his strongest statement yet for a free India.

Most of the third class passengers, as well as some of the people in her own car, leaped out of the windows and doors or climbed down from the roof of the train. They left their intended destination behind, to join the throng of followers. Rejoicing. Singing. Marching for freedom.

A child ran into the roadway and stopped in front of the great man. With a shy smile, she held up a flower, an offering of love. Ghandi stopped and bent to receive the precious gift.

The brilliant noonday sun poured molten light into the air, changing dust motes into a golden nimbus that surrounded the two, old

man and child. Hope, devotion, adoration, unconditional love – all were contained in the moment his hand touched hers. With a gesture like unto a shepherd with a lost lamb, he lifted her high into the air, then settled her on his hip and turned to walk on. He paused, his eyes traveling over the heads of the great crowd. And it seemed to Gladys as if he looked directly at her. She felt a shock of recognition, a benediction like the hand of a healer. She fell into a bottomless, free flowing well of pure spirit and love. Then he smiled his famous, gap-toothed smile, and it was as if the sun had come out on a cloudy day.

Freeze frame. Gladys took the picture with her heart, and it remained with her always. Framed in her mind, a still shot of memory, a place of comfort and inspiration that she could visit by closing her eyes and imagining the smell of hot rails and trampled marigolds, dust, sweat and hope.

Her mother had a song that she sang when she felt especially moved:

> Into my heart's treasury
> > I slipped a coin
> That time cannot take
> > nor a thief purloin
> Better than the minting
> > of a gold-crowned king
> Is the safe kept memory
> > of a lovely thing.

That moment on the train to Bombay was the first coin slipped into her heart's treasury during that endless furlough.

The second was minted just after they arrived in Kansas in the summer of 1930.

It was hot, but not with the clean, embracing heat of the Indian plains. The sun spoke sullenly through white, muggy skies. The people scurried for shelter as if afraid of incurring more of its displeasure.

Even the dirt and dust were different. Indian dirt had always seemed somehow alive to Gladys, an extension of the earth upon which she played, an integral part of life.

In America, dirt was something to be avoided or conquered, an enemy to be overcome. But in the middle of summer, in the farmlands at the edge of what was to become the Great Dustbowl, the dirt had become fine gray dust, and the dust had vanquished all hope.

After a few months of sending them here and there, with John preaching guest sermons and Beth presiding over the slide projector at Sunday night meetings, the church had installed the family in a ramshackle farmhouse that had been deserted when times started getting tough.

Gladys remembered the fervor with which her mother had set to cleaning the place, top to bottom. The boys were put to work on the debris-filled yard and decrepit exterior of the old wood frame, while Beth, Margaret and Gladys attacked the filthy interior. Apparently, the kitchen had been used by the previous occupants as a coal bin, for every surface was coated with thick black dust.

The two girls were given a pile of rags, a bucket of water, and orders to clean up the kitchen, starting with the floor. Gladys got the bright idea of tying the rags to her feet and pretending to be a figure skater. Margaret allowed herself to be pulled into the scheme. Soon the boys, hearing the laughter echoing in the cavernous kitchen, and never to be left out of a good time, were leaping and pirouetting, too. When Beth returned from reconnoitering the upper floors, even she joined in the hilarity. She wrapped rags from an old pair of red flannel pajamas around her feet and skated to the middle of the floor. Linking hands with the children, they played crack-the-whip and cha-cha line, until they ended up in a laughing, exhausted heap on the floor, covered with coal dust and love.

Freeze frame. Another memory for Gladys to slip into her heart;

the picture of her mother's face, grimy and flushed with joy, eyes sparkling and hair tumbling down, arms wrapped around her precious children, in that one moment of perfect stillness when duties were forgotten and a mother's love remembered.

Margaret, Beth, John, Gordon and Gladys on board
ship back to India, 1933

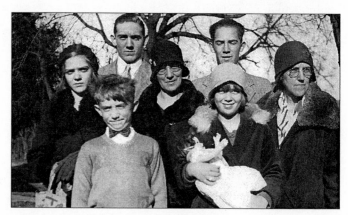

Christmas Day 1931
Margaret, Gordon, John Jr., Beth, Carl,
Gladys and Aunt Clara in Kansas

When the family finally returned to India, in 1933, Gladys was jubilant. Her life in America had felt like a monochrome pen and ink drawing, but back in the country of her birth, everything was in full color, beautiful and warm. They came home to the Landour Villa, and the children attended Woodstock again. So here she was in the seventh standard, and quite able to keep up. Gladys was finally enjoying school, seeing it as a stimulating challenge, rather than dreading it as a punishment. Gone were the days when she hated it, and tried anything and everything to get out of it.

She still felt mortified remembering one of her more moronic stunts: someone had told her that if she peeled an onion and cut it in half, then put one half in each armpit and sat in the sun for several hours, it would make her sick and she wouldn't have to go to school. Of course it hadn't worked; she didn't get sick, she just ended up smelling so bad that no one wanted to sit next to her. Now that was stupid, she thought. And embarrassing, she added to herself, as she watched the dawn grow lighter. Just then, the wake-up bell rang and the other girls came grumbling awake, tumbling out of their beds and vying for their turn at the water basin.

Finally having had enough of Contemplation, Gladys jumped out of her cot, dashed water on her face, and struggled into her dress.

Breakfast was porridge, as usual, and her first class after that filling but uninspiring meal was German, taught by Fräulein Hahn.

None of them knew quite what to think about Fräulein Hahn. She looked like a sugar bag tied in the middle. She was a short woman, stern of feature, with icy blonde hair swept back into a severe bun on the back of her head. Her smile never reached her light blue eyes, but there was a cold fire that burned in them, especially when she told the children stories about Germany. "The Fatherland," she called it, and,

according to her, it was the most wonderful place on earth. Everyone who lived there was beautiful, tall and strong. They were all happy, laughing, singing young gods and goddesses.

The children knew this because the Fräulein, instead of teaching them nouns, verbs, and how to say, "Excuse me, where is the library?" showed them slide shows and taught them exciting German songs. It was a fascinating class, and the most thrilling part of it was that they were pledged to secrecy.

On the first day of class, Fräulein Hahn, after introducing herself, had come around to the front of her desk, sat on the edge, and leaned forward slightly, as if about to tell them something important. She had confided to them, in her perfect British accent, that her teaching methods would be fun, but unconventional. If they told their parents or the other teachers about the slide shows and the songs and the games they were going to play, then the headmaster would make her go back to teaching in the ordinary way. Conjugating verbs. Nouns on the blackboard. Sonorous repetition. Boring, boring, boring.

So the children vowed to never say anything. It was like an exciting, slightly naughty secret, and they kept it scrupulously, with just a pleasant tingle of guilt.

Today, as soon as the class was seated, the teacher closed the blinds and turned on the slide projector. She showed picture after picture of handsome, clean, blonde teenagers, laughing and playing together, singing fervently and marching in formation.

"This is one of the many summer camps that the Führer has set up all over the Fatherland," the Fräulein said, with a zealous look in her eye. "The young boys and girls come here to these camps to play and dance and sing, and to become tall and strong. Wouldn't you like to be there with them? Don't they look happy and healthy?"

Indeed they do, Gladys thought. They look like they are having the best time of their lives.

The girls all sported fat yellow braids, flashing white teeth and bosoms that put her poor flat chest to shame. And the boys! Well, each was the kind of flaxen-haired Adonis that thirteen-year-old girls dream about.

"These summer camps are free to all. Even if you are not German! The Führer (Gladys had learned that the Führer was the Maharajah of Germany) wants every one of you children to come, and have fun, and meet these young people, and learn how to be as happy and beautiful as they are. But remember – don't mention this to your parents. They probably have other plans for you that could never be as exciting as this. But when you get a little older and can make your own decisions about your life, come to Germany. Join a youth camp. I promise that you'll have a better time than you've ever imagined.

"Now let's sing the song I taught you yesterday, and today we'll march while we sing it." Fräulein Hahn started singing, *"Deutschland, Deutschland über alles"* and as the first martial notes of the Nazi anthem filled the air, the children eagerly sprang from their seats, singing the song of war and domination at the top of their combined lungs. Their teacher demonstrated the goose step and, as if she were the Pied Piper, the enthralled children imitated her, marching around the room.

It must have been an eerie and frightening sight: the children of Rajahs and missionaries, British diplomats and aristocrats, innocently and unknowingly mimicking the evil dance of the serpent of the burgeoning Third Reich.

They finished the hour, as usual, with a rousing "Heil Hitler!" When the bell rang, they straggled into the hallway, each one keeping the exciting, guilty secret, each one fantasizing about the fun they could have if only their parents would let them.

It wasn't until several years later that one of the children broke the pledge and told her parents what the ersatz German teacher was

doing. Upon investigation, it was discovered that she was one of Hitler's private secretaries. She had been sent out, with hundreds of others, into the upper class schools of the world, to indoctrinate young people into the savage beliefs of the Nazis. She was immediately sacked and sent back to Germany, but she and her cohorts touched the lives of many, many children. It was only the strong and loving structure within which she had been raised that kept Gladys from hopping a train and enrolling as one of Hitler's youth. (Who knows what happened to the other children.) But Gladys knew her parents would never permit it, and there was something about the clandestine nature of the classes that made her wonder. If she couldn't talk about it freely with her parents, then there must be something not quite right. So she had her doubts. Yet she didn't voice them, and went on about her day, attending classes, eating the terrible food.

After lunch was her favorite class, English literature. Not only did she love the subject matter, but she got to sit next to her best friend, Peter Riddle. His parents were missionaries from New Zealand, and they lived in Oakland Cottage, on the next hilltop over from the Landour Villa. The two of them had become friends long ago. He never laughed at her or ridiculed her like her brothers did, and he shared her passionate love for the mountains, valleys, and people of India. Dark-haired, dark-eyed, soft spoken and wise beyond his years, Gladys felt safe sharing her secrets with him, as he felt safe with her. He wanted to be a teacher with the same intensity that drove her to become a doctor. They would talk about it for hours, spinning their dreams under whispering pine trees, or lying flat on their backs in the great Himalayan flower meadows, watching the sky fly by. The other kids teased them and called him her boyfriend, but they both knew that their connection went much deeper than that. She had missed him terribly during their extended furlough in the U.S., and had come home to find him quite grown up, but still the same sweet-hearted boy underneath.

Peter was in two of her classes, English lit and math, and since the children were always seated in alphabetical order, he sat near her in both classes and made math at least tolerable.

Her main problem with the whole idea of alphabetical seating was that "T" came right after "S", and that meant that she had to sit behind Partab Singh in every class. Not that she didn't like the kid – he was actually quite nice, and very polite, in spite of the fact that he was a real prince. It was just that his royal turban was so big that she could hardly ever see the blackboard or the teacher. It was quite inconvenient, but at least it was pretty.

Partab Singh was the first son of the Rajah of a neighboring Princely State and next in line for the succession. The aforementioned turban was always of the finest silk, its brilliant color changing each day, and always decorated on the front with a beautiful jeweled pin. He was a nice enough boy; a little impressed by his own importance, but who wouldn't be, Gladys mused, if he rode in a *dandi* or on horseback every day to school, and had two huge stone-faced body guards following him around and stationed in the hallway outside the classroom to protect his Princely Person.

Impressed as he was by his own magnificence, Partab Singh still wanted friends, so he was actually quite approachable, and he always invited his classmates to his birthday party. This was one of the most anticipated events of the year.

As far as Gladys was concerned, the absolute highlight of the party came when the servants strung up the great piñata. Everyone knew that the Prince was expected to deliver the killing blow, so the boys and girls merely played at missing it. Then Partab Singh would take the bamboo staff and with a great THWACK! break open the treasure trove. The skies rained *ladoo* and *barfi* of all kinds. Trinkets and pull toys, and, most wonderful of all, real *rupees* came tumbling down upon the astonished faces of the delirious children.

It was always just about the best party in the world. And next to the remembered luster and future promise of those magical parties, the inconvenience of Partab Singh's big head seemed paltry, indeed.

Classes continued until five o'clock, when the children had an hour to play or rest until dinner, tasteless and unpalatable, was placed on the great refectory tables at 6 p.m. Usually the students gobbled the meal as quickly as possible and then beat it to their rooms, where they would study or gossip until the final bell rang at 8:30.

Not so tonight. They lingered in the dining hall, playing word games and stalling, until they were driven out by their exhausted teachers. They all went reluctantly, dragging their feet, for tonight was Friday night, bath night, the most dreaded event of the week.

Luckily, they only had to take a bath once a week, since it was such an ordeal. There was no running water in the dormitories, so it had to be carried upstairs in great water skins by the *bhishtis* and poured, scalding, into the galvanized bathing tub.

Miss Gaspar, the dormitory matron, was a small, round woman with a will of iron and hair to match. She presided over the baths with her stopwatch, and each girl had exactly two and a half minutes in the tub.

The girls stood in line, shivering, barefoot on the cold floor. The shutters had been closed against the night, but the pine scented snow wind blowing across the top of the world still found its way through every crack, and nipped at the bare ankles of the girls waiting their turn, wrapped in nothing but their thin, skimpy towels.

When Gladys' two and a half minutes arrived, she popped in quickly and started scrubbing, trying to ignore the stinging pain from the chilblains that cracked and bled on her knuckles. Most of the other children were plagued by them as well, for it was cold, cold, cold in the dormitories, high in the foothills, with winter coming on. The small pot bellied stove tried its poor best, but in November, just below the snow-

fields, true, spine-melting heat was a memory and a dream.

At least she didn't have chilblains on her ears, like poor little Gordon. She shuddered at the thought as Miss Gaspar called "time" and she clambered out of the tub, drying off as fast as ever she could. Jumping into her nightgown, then leaping into bed, Gladys fought off the shivers and soon had created a warm cocoon for herself. As soon as all the girls were in bed, the *bhisthi* came and emptied the tub, Miss Gaspar blew out the lanterns, and night descended on Woodstock.

Her mother had told her that she should try to fall asleep with a smile on her face, so she would have happy dreams. After she said her "Now I lay me down to sleep," she practiced that and, sure enough, she dreamed of her *ayah's* hands and her mother's laugh, the heat of the sun on the Indian plains, and the scent of *chambili* blossoms in the moonlight.

Margaret
Ayah
Gladys
1935

Gladys and
Margaret
1934

110

Chapter 12

Northern India

December 1935

*H*er thoughts drifted, slow and lazy as the dust motes. Floating, spiraling down, they were catching the sun, then pirouetting, dancing, and finally coming to rest on the iridescent silk of Partab Singh's peacock blue turban. The afternoon sun slanted through the tall windows of the classroom and stalked across the scuffed wooden floor, turning the air thick and warm. Her eyelids felt heavy, so heavy, and the drone of the Latin teacher became bees buzzing in the high Himalayan meadow. She rested her head on her hand and let her eyes close, just for a moment. She began to nod off.

Gladys was daydreaming about going home. In just three days her dad would arrive, and she and Gordon would pile into the Model T and jounce down the mountain; no more teachers, no more books. They would go directly to the village where her parents were encamped, not even stopping in Rourkee, because John would need to get back as quickly as possible. Her parents were still in the field, would be until a week before Christmas, and thinking of the change from the rigors of boarding school to the liberties of camp life had Gladys giddy with anticipation.

Besides, they always celebrated her birthday in camp the first night she returned from school. She had turned fifteen a week ago, but

her birthday had left a lot to be desired. Not that her girl friends hadn't tried, but it was hard getting anything past the dorm matron, and they'd had to content themselves with a fat square of guava paste on a plate, studded with peanuts instead of candles. They had giggled under the covers and stuffed themselves with the sweet, gooey confection, but Gladys never felt like she'd had a real birthday until she arrived in camp. Dreamily, she started counting the hours until her liberation.

Peter's foot nudged her awake just as the headmistress threw open the door, hurried across the room, and said something in an urgent undertone to the teacher. Her hazy daydreams fled when both sets of eyes turned towards her. She was seized with a sense of impending disaster and she knew, even before a word was spoken, that something was horribly, terribly wrong.

"Gladys, the headmistress needs to speak with you in the hallway," her teacher said gently. She stumbled to her feet, lightheaded with premonition. The other children watched as she followed the headmistress out the door with the terrified air of a condemned prisoner. The buzz of speculation was cut short when the teacher announced, "We will now have a quiz on the verbs we've just conjugated." The communal groan drowned out the sound of the door closing behind her like a death knell.

Peter looked for her everywhere after class, as she had never returned, and finally found her in the dorm, frantically throwing clothes into an old, battered valise.

"Gladys, what is it? What's wrong?" he demanded, as he came up behind her and put both hands on her shoulders. She turned and threw herself into his arms.

"Oh, Peter, it's Mama and Papa," she sobbed. "They have the

smallpox. Smallpox!" she repeated, with a rising note of hysteria.

Peter's blood ran cold, and his arms tightened around her. "But Gladdie, how could that be? They got vaccinated, didn't they, before you left the States?"

"Of course they did, but it must have been an old batch of vaccine, 'cuz Mama got sick after she treated a baby with the pox, and Dad got it from her. And they say I can't go to them since I got vaccinated with the same batch, so I could get it, too. But I have to go, 'cuz there's only Ayah and Dar to care for them and they can't do it all. They want me to go with Gordon to Aunt Belle's – she's downstairs right now, waiting to take us to Bhoghpur. But I can't go there; I must go to Rourkee!" Gladys tore herself from the comfort of his arms and continued to frantically throw things into the carpetbag. "You have to help me, Peter." She looked at him with wild eyes. "I have to go to Mama!"

Peter turned her around and gently forced her to sit down on the bed. "Gladdie, sit down. Take a breath. Look at me." He took both her hands in his. "Talk to me."

She struggled for a second, then gave up, took a deep shuddering breath, and looked up at him with huge, terrified eyes.

"Smallpox, Peter! Oh dear God, what shall I do, what's going to happen? What if they die? I have to help take care of them, I just have to!" She wrenched her hands from his and wrapped her arms around herself, rocking back and forth in her distress.

Peter sat down on the bed beside her, searching for the right words. "Of course you want to go to them, Gladdie, of course you do. But we both know you must not. They would never want you to put yourself at risk like that. They're strong, and the Lord needs them here. They'll get through this, you'll see. Ayah knows what to do; she's nursed smallpox before. And what if it <u>was</u> a bad batch of vaccine, what if you're not immune? If you went to them you'd get sick, too, and then

Ayah would have three patients instead of two. You must do as they said, and go to Bhoghpur with Aunt Belle. Everyone will pray for them and they'll get better real soon, I just know it."

The soothing words soon worked their magic on the frantic girl. She stopped rocking and let her head fall on his comforting shoulder.

"Now, let's get you packed, and I'll walk downstairs with you. Maybe Aunt Belle has more news. And you know, with her praying for them, God wouldn't dare let anything bad happen."

With a watery chuckle she shook her head and they stood up and stuffed the rest of her meager belongings into the old valise. Peter hefted the bag and supported her down the stairs with a comforting, brotherly arm around her shoulders.

Gordon was already in the vestibule, holding tightly to Belle's hand, all big eyes and pale cheeks, lips trembling with barely suppressed tears. Peter threw their bags into the *tonga* cart and gave Gladys one last hug goodbye. "It'll be all right, you'll see," he reassured her, but as he watched the carriage bounce down the rutted driveway, he shook his head in despair. He had a bad feeling about this. A very bad feeling.

※

It was night in the deserted Rourkee compound, and Ayah was desperately worried. Mama-ji did not look good, no, not good at all. It had been a week since they had returned home, with Mama-ji already delirious in the back of the bullock cart, and Papa-ji collapsing the moment he stumbled in the front door. Dar had half dragged, half carried him to the children's room, where they had laid him down on the bed and she had begun stripping his sweat-drenched clothing from him. The pustules were beginning to erupt, which meant that the disease was very contagious, but she had not been worried for herself and Dar –

114

they had both survived the pox as children and were therefore immune. But everyone knows that it is much more serious when an adult is infected, and both the doctors were still weak from their bout with the malaria last year.

John was very sick, but not nearly as ill as his wife. Dar had had no trouble carrying Mama-ji to her room – she was light as thistledown, so small, so sick. She had nursed the sick baby day and night until she fell ill herself, and by that time had become massively infected. The pustules had come with a vengeance upon her, and, as the days crawled by, Ayah watched in growing horror as every inch of her skin became covered with the virulent, oozing sores.

Now the nurse wept as she looked down at the beloved face, unrecognizable even to her eyes. She had no ice to hold back the fever, no medicine for the pain. And Mama-ji could not drink, could barely open her poor lips, for the evil sores had covered the inside of her mouth, too, and were probably all the way down her throat. They had been forced to tie her wrists to the bed to keep her from scratching, and she struggled against her bonds in the flickering lamp light, muttering and crying out for water.

Beth wandered in a nightmare of pain. Surely this must be Hell. It was hot, her skin was burning, and she was thirsty, so thirsty. There was a pool of cool, fresh water at her feet, but when she bent to drink of it, the water burst into flame, and she was drinking, breathing fire. "God, my God, what have I done that you punish me so?" she cried in her extremity, but there was no answer, just the crackle of the evil flames on the water, and the silence of the roiling red sky above.

Ayah had nursed smallpox before, but she had never seen it this bad. She reached for the small bowl of boiled water that she kept by the bed, and dripped a few drops between the cracked, oozing lips, as she had been doing every few minutes since the siege began. She could do nothing else. Oh, she could sponge Mama-ji down and change her sheets, although the water was tepid and did nothing to combat the fever, and they were running out of clean sheets. She could sing lullabies and hymns, softly, for that seemed to quiet the delirium, and she could pray, which she did every moment. She dripped a few more drops of water on the poor, swollen tongue and began once again to sing Mama-ji's favorite hymn:

> "And He walks with me
> And He talks with me
> And He tells me I am His own"

The simple tune soothed her patient, and she fell into a fitful doze. Ayah, greatly relieved, closed her eyes to pray, but exhaustion overcame her and she slept, kneeling by the bed, while dawn grayed the windows and the night birds, unaware of the crisis, sang with joy.

In 1935, smallpox was still rampant and deadly in the world at large. Due to the development of the vaccine, the disease was close to being eradicated in the U.S., but in India it was still quite prevalent. The fatalism and acceptance that characterizes the Indian's belief in karma led to a somewhat cavalier approach to treatment. When an outbreak occurred, the village was loosely quarantined, and the sick were nursed by those who had survived the disease in the past. But conditions were far from ideal, and survivors were few.

When handled correctly, smallpox, while extremely contagious, is only thirty-five percent fatal. However, the prescribed treat-

ment was impossible to come by in India and the other impoverished countries of the world. The vaccine was extremely effective, for both prevention and cure, but there were no vaccines in these countries, either. Pain medication was needed, not only to control the excruciating pain from the fever and body aches, but to help the patient resist scratching the lesions that itched intolerably. But there was none to be had.

Death is oftentimes secondary to rampant systemic infection. If conditions are not sterile when the pustules break open, microbes of all kinds quickly invade the debilitated, dehydrated system, and death is swift and merciless. But even barely sanitary conditions were an impossible dream in the villages and towns of India in the '30s.

Finally, if the patient survived the ravages of the primary infection, he or she was left with horribly disfiguring pockmarks and a severely compromised immune system. They easily fell prey to more common bacterium during the extended recovery period, and antibiotics to control the secondary infections were unknown.

Miraculously, Beth clung to life despite the poor conditions and loving but rudimentary care. Throughout the long, terrifying days and nights while Ayah nursed her, Dar cared for John. His fever had been high, but not high enough to send him into delirium, and he stayed conscious enough to resist the intolerable itching. When he finally passed the acute stage and slipped into the exhausted sleep that is characteristic of recovery, Dar was able to leave him for long enough periods to give Ayah a few hours of relief, or to make a little food for themselves, and beef tea for the invalids.

Beth had, long ago, dubbed it beef tea, although it was not a tea at all. It was prepared by stuffing chunks of raw beef into a large jar,

placing the jar in a pan of simmering water, and cooking for several hours. Beef was not easy to come by, but not impossible, either, for although the cow is sacred to the Hindu, it was simply dinner to both the Muslims and the British. It was never tender and had to be cooked for hours and hours, but it was red meat and therefore, highly prized. Harry Dean, thrilled to be able to do something besides worry for his dear friends, had no trouble procuring a small bit in response to the note left at the gate of the quarantined compound. Dar cooked it down, strained the liquid, and threw the tasteless fibrous remainder outside the walls for the wild dogs. The precious juice contained all the amino acids, vitamins and minerals that a recuperating body needed, and the patients swallowed spoonfuls eagerly, for it was delicious.

Slowly, slowly, Beth pulled back from death's door. Her indomitable will would not let her die with so much of her work left undone, and after five weeks of delirium, the fever finally broke. When she opened her eyes one morning and smiled up at her nurse, there was great rejoicing, and they immediately sent word to Bhoghpur. There were no telephones, but the news was carried almost as swiftly by Harry Dean on his motorcycle. Recovery would be long and difficult, but their parents would both surely recover. However, it would be best if the children stayed with Belle for another month, until the invalids were a bit stronger.

Gladys had been beside herself with worry, and had derived little comfort from her aunt whose attitude was a combination of faith, ("the Lord is my shepherd"), fatalism, ("what will be, will be"), and confidence, ("your father is a tough old buzzard"). This seemed a bit insensitive to the hormonally imbalanced teenager who could not eat or sleep and spent most of her time in tears.

Christmas had come and gone unnoticed. By the time the news about her parents' recovery arrived, Gladys had exhausted herself with worry. Belle, hopeful that she would calm down and perk up, was

distressed to see that the child continued to fret despite the good news. She gave it a week, but when Gladys continued to ply her with "what-ifs," she decided to take action. She looked at her niece's wan face and preoccupied demeanor and announced that she needed a Project to Keep Herself Busy.

Pulling an ugly brown silk slip from the latest mission box, she called Gladys in and sat her down at the old treadle sewing machine.

"You just stop moping around, now, child. You'll wear yourself to a frazzle with your worrying. You have to let go and know that the Good Lord has your mama and papa held close in His loving hands. Why, He wouldn't let anything happen to them! They're too important to His Plan. So, to help you take your mind off it, I think it's time you learned to sew. This is a nice piece of silk, hardly even used. We're going to cut it up and make a blouse for you to wear at Easter. Now where did I put my good shears?"

Belle began rooting through a box labeled "sewing supplies" while her victim stared in horror at the sewing machine. The silk slip, draped over the ancient black Singer, was a mud brown color, and still smelled faintly of camphor, mothballs, and genteel perspiration. Gazing at the pile of rumpled material, Gladys' fertile imagination conjured up a clear picture of the previous owner.

Mrs. Gorgon of Cincinnati, Ohio. Matronly and stern-faced, she ruled her house with an iron hand and wore only brown: sturdy brown shoes, serviceable brown calico housedresses, and brown tweed overcoats. Brown hats with no flowers, and only a single strand of dingy pearls, handed down from her grandmother. Her only pretence to luxury were her silk slips, worn until a seam gave out and then right-eously (but discreetly) placed in the mission box at church.

Gladys felt the familiar sinking sensation typical of anyone in the general vicinity of Belle when the idea for a Project came upon her. It was as if she was being tumbled, head-over-heels, out of control

down a river during the monsoons. She knew she was in for it.

So she forgot her worries in her resentment of the slippery, smelly brown silk and in her loathing for the vicious little machine that ate the material as if it were a starving beggar, exhausted her legs, and was absolutely incapable of sewing a straight seam. Day after day she sat in the hot, airless little room, hunched over her task, and hated the entire project with a fervor akin to sin. Every muscle in her body ached. The silk became discolored, not only with Mrs. Gorgon's sweat, but also with Gladys' tears. When Belle inspected her work and told her to rip out this seam or that dart, the girl would quietly go into the next room, close the door, ferociously ball the material up, throw it on the floor, and jump up and down on it, teeth clenched, hands fisted, murder in her heart.

But she had no time to fret.

And that was Belle's intention.

When the blouse was finally finished, the last buttonhole set and approved, Gladys looked around and blinked her eyes, as if awakening from a bad dream. She realized, with astonishment, that weeks had gone by, and her parents were almost fully recovered. She and Gordon would be going home to Rourkee for the month of February, and then, of course, back to Woodstock in March for her final year.

The night before they were to leave for home, Gladys lay wide awake in her small bed, working her way through a familiar problem. Evening prayers with her aunt had been getting longer and longer each night, and now that her parents were better, the focus had turned to Preparation for the End of the World.

Belle had come to believe, for reasons best known to herself, that the world was going to come to a painful and fiery end sometime in the year 1937. Whether she had read it in the book of Revelation or had heard it directly from the mouth of God, no one knew. But she believed it with all her might, and she had convinced both children of

the veracity of the information and of the need for complete reform and absolution of sins before Judgement Day.

Now this worried Gladys, and not just a little bit. Belle held long prayer and discussion sessions with the two of them every night, and Gordon, in his wide-eyed innocence, told of dreams in which Jesus threw his sins like popcorn into the fire. Poof! He was washed clean with the Blood of the Lamb, and when the world ended, Jesus would pick him up in His fiery chariot like an old friend and they would ride off, laughing, into Heaven.

The same could not be said for our beleaguered heroine. Not only did she never, ever, once have a dream that came close to Gordon's for God Points (as she secretly call them), but she could not seem to make it through even one day without sinning at least once, usually many times. Mostly they were small sins, such as taking an extra helping of curry when no one was looking (gluttony), or daydreaming about being a world famous doctor who discovers the cure for leprosy and is invited to the White House for tea with Eleanor Roosevelt (sloth and vanity). But sometimes she would commit the Big Ones, like lying (No, Aunt Belle, I don't mind ripping out that seam again) or blackening her heart with hatred (for sewing machines and brown silk).

So she knew, with a certain resigned fatalism, that she was lost. When the end of the world came, she would be waving goodbye to Aunt Belle and Gordon and her parents as Jesus carried them to Heaven and she was left to roast.

This was the problem that plagued her night after night, and this, her last night in Bhoghpur, looked to be a long and sleepless one. But at some point during the wee hours, she was struck with inspiration.

Maybe she could invoke grace. Now grace, as she figured it, was the suspension of the law of cause and effect through the medium of eternal love. And she knew that if God was everywhere, if He could see everything, He could surely see into her heart and know that no

matter whatever else happened, she meant well. She tried. She had to. Walking the thin line of sinlessness didn't come easily to her (as it did to some people, not mentioning any names). So she should get God Points for trying, at least. She needed to convince the Lord that she was worthy of redemption, just as she was. Pray for the intervention of grace, as it were.

An old familiar hymn popped into her head, "Just as I am, without one plea." Perfect. That was perfect! She decided, then and there, to sing herself to sleep with the hymn every night until the End, and maybe God would hear her and let her tag along.

So every night from then until 1938 dawned, that was her lullaby. Even when the world didn't turn into a ball of fire and she realized she was safe, she kept it up for a long time.

It couldn't hurt. A girl needs all the help she can get.

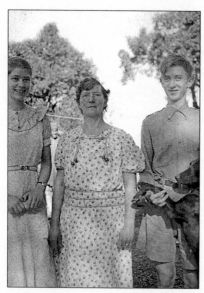

Gladys, Beth (after recovery from smallpox), Gordon 1936

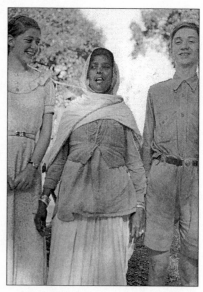

Gladys, Ayah, Gordon 1936

Chapter 13

Northern India

December 1936

The old Model T rattled into camp, uttered a loud wheeze like a dying jackal, and stopped completely. Before the cloud of dust had begun to die down, both doors flew open. Its occupants tumbled out, screeching in excitement, the added din scarcely noticeable in the general noise of the encampment.

In reality, only one of the recently disgorged occupants was screeching. Two of them were quietly going about the business of unpacking the valises from the boot of the car. Both Gordon and his Papa looked relieved to be done with the long drive from Woodstock, silently grateful to be home.

Gladys, of course, was the one who exploded from the car, and raced into the village, leaping over obstacles, screeching at the top of her lungs, "Dar! Ayah! Mama! Where are you? I'm home! I'm finally, finally back home! I'm so glad to be back! I missed you so much. Oh, Ayah, there you are!" She grabbed her old nurse in a bear hug and swung her around, jabbering all the while. "You look beautiful. I missed you absolutely every moment I was away. Will you sing me to sleep tonight? Oh, and there's Dar!"

During her last year at Woodstock, she had been forced to take ballet. She had been a miserable failure, for no one had ever said she

was graceful. But the one thing she was good at was the "jetté" – great leaps across the gymnasium floor, just like a sambar stag when startled at a water hole. So she practiced her "jetté" across the compound to the campfire where Dar was squatting in front of the campfire oven.

"Leap! Leap! Leap! Now curtsey!" She executed a deep bow, then flung herself upon the grinning cook. He allowed himself a moment to return the hug, so happy was he that this, the child of his heart, was home again.

"Oh, Dar, I missed you so much. No one can cook the way you do – is that birthday cake I smell? Can I have a taste of the frosting?" Recalled to his duties, he slapped her hands away from the bowl of icing: canned milk beaten with white sugar, or *chini*, ready to be poured over the top of the cake as soon as it was taken from the oven.

"Now, child, you must keep your hands away from the bowl of most especial frosting, and you must be leaving me alone now, so that I may check on this birthday cake, or it will most possibly burn to a crisp."

He made sure the bowl was safe from her marauding hands, and turned back to his oven. This ingenious device was a large metal dishpan turned upside down, placed on a piece of sheet metal over a fire made of cow dung. More burning cow patties were piled on top, until the oven was hot enough to bake a cake or a pie, cookies or bread. Dar tested the temperature of the oven by carefully thrusting his hand into the interior with a studious look on his face, then piling on more embers or brushing some off, adjusting the heat accordingly. He had created the oven some years before and he guarded it jealously. It was generally believed that he could bake anything in it, and he always, always made a cake to celebrate Gladys' birthday on her first night home from school.

She pestered Dar for a few minutes more, then looked up to see her mother hurrying across the camp, an eager look on her face. With a

cry Gladys was up and running, launching herself into her mother's arms.

Unfortunately, now that she was sixteen, she was bigger and taller than her diminutive mother, and if Gordon hadn't happened to be there to catch them, they would have tumbled head over heals backwards into a tent.

Laughing and crying, riding the emotional teeter-totter of the teenager, Gladys burbled all over her mother's clean shirtwaist. Beth led her over to a table that had been set up in the shade of an *imli* tree, and made her sit down in one of the canvas chairs grouped about. It was the closest thing they had to a living room, and John was already ensconced in his favorite chair, watching the goings-on with a smile. Beth poured a cup of water from the *sarahi* that always sat on the table, and sat down beside her, gently admonishing her to take a sip of water and a deep breath.

"Gladdie, Gladdie, calm down! We're all here, and we're just as happy to see you as you are to be home. Now, just sit back, close your eyes and relax. We're not going anywhere. And when you get your breath back, you can tell us all the news of Landour."

But Gladys couldn't sit still. She was seized with a desperate desire to keep moving, to walk around the camp and the small village, absorbing all the details, drinking in the sights and sounds and smells, because she knew that this was the last time.

Ever since her birthday two weeks ago, she had been obsessed with the fact that she would be going to the States next summer to begin college. She had completed all the prerequisites for admission to Muskingum, the school in Ohio that all her siblings were attending, and had been accepted as a part of an accelerated program. Although she was much younger than most college freshmen, and hadn't actually even graduated from Woodstock, it had been decided that she would leave India next July, to begin her higher education.

Therefore, and with characteristic single-mindedness, she had determined to suck every bit of juice from the next few months, as if life were a piece of sugar cane, and she a child with sticky juice running down her chin. She intended to collect and hoard her memories of this land she called home, so that, in the cold winter nights to come, she could take them out, like Silas Marner with his pieces of gold, and run them through the fingers of her mind, bringing comfort to her broken heart.

Even thinking about it made her cry. So she walked around the camp and into the village visiting with people whose eyes lit in recognition of her smile, with a *nunga-punga* child planted on one hip and the mangy pack of village dogs skulking behind.

And always in her mind, the mantra, "This is the last time I'll see this village, the last time I'll carry little Sita in my arms. I was there last year when she was born, and I remember how happy her mama was, even though she was a girl. Maybe I'll never, ever, see any of them again."

And later, after dinner, to herself she repeated, "This is the last time Dar will ever bake me a birthday cake, the last birthday dinner I'll ever have here, with the jungle all around, and the stars so bright over head. We've always celebrated my birthday like this but no more, no more. This is the last time, the last time."

She was so torn between the love she felt for her life and the grief she anticipated, that all during dinner and the birthday celebration following, she laughed until she cried, then, in turn, cried until she laughed out loud.

Things were already different, she thought, as she looked around the circle of faces glowing in the lantern light. Her older siblings had, one by one, left the circle, and, although she felt her brothers' absence at gatherings such as this, it was Margaret she missed all the time, and with an unexpected fierceness.

She had thought she would revel in having the bedroom in the Landour Villa all to herself. Instead, she found herself longing for the late-night whispers, the warmth and security of her sister sleeping next to her in the big bed. She felt bereft without Margaret's soft voice and quiet strength. She quickly came to realize how much she had depended on her sister's counsel and emotional balance, for Margaret was still water to Gladys' babbling brook, soft moonlight to her morning sunshine. The only good thing she could see about setting off for college next summer was that they would be reunited. And judging from the heartbroken letters they had received so far, her big sister felt the same way. Margaret desperately missed India and her family; she spent many hours writing long, tear-splotched missives, while cold autumn rains plastered leaves against her small dormitory window, and she dreamed of the feel of hot sun on her upturned face, and blue skies that reached to the top of the world.

But, in spite of the fact that her brothers and sister were absent, Gladys' birthday party was a rollicking success. When dinner was over, the last crumb of cake devoured, John looked at Gladys over the rims of his glasses.

"Well, Gladdie," he said with a fond smile, "it looks to me as if you're fairly well grown up. Sixteen! You're pretty close to being an adult, now, aren't you?"

"Well, yes, Papa, I guess so," she replied, using her childhood name for him, loving him so much her heart almost burst.

"So, now that you're sixteen, I expect it's just about time for you to go on your first hunt. There's a leopard that's been marauding the village just south of here. I'm thinking you're big enough to come along, maybe bag your first big cat."

Gladdie was a bit taken aback. Much as she loved her father and wanted his approval, she wasn't completely sure she wanted to come along and "bag a big cat."

She knew that a first hunt was a momentous occasion, and considered to be an important rite of passage into adulthood. The boys had been trotting along behind Papa and Harry Dean since they had each turned twelve, and even Margaret had met the challenge two years ago, soon after her sixteenth birthday. She had bravely set off, her rifle slung across her shoulder. With her excellent aim and calm sense of purpose, she had returned with pale cheeks and a neatly shot young leopard. But she had never asked to accompany the hunting party again.

Gladys' ambivalence stemmed, not from fear, but rather from a collision of deeply felt ideals. She loved and honored her father and wanted to emulate him in every way. He clearly saw it as part of his duty to protect the villagers from danger, and man-eaters were legitimate threats to the lives of the children and old people, especially. But Gladys felt no such clarity of purpose.

She just couldn't imagine killing anything. And the big cats were so magnificent, so beautiful, so free. They burned with such fierce light, she couldn't imagine extinguishing it forever.

But then again, she knew that the leopard in question was a notorious man-eater and had dragged a child from the village just last week. The villagers had no guns. It was up to the *sahibs* to protect them, to make sure no more children were eaten alive.

Therein lay the conundrum.

She struggled with her decision for a few moments. Then her natural sense of adventure and her vow to never shrink from new experiences took over, and that's how she found herself, the next night, sitting in a tree, waiting for Death to arrive on padded feet.

The *shikari* had built the hunting platform in the tree earlier that day. Late in the evening Gladys and her father tied a goat to the bottom of the tree and climbed up onto the impossibly small *michan* to await their intended prey.

So far, she really hated it. She felt sorry for the poor goat,

nervously bleating and shying at every rustle in the grass – she could smell the sharp scent of its fear, and prayed that they would be able to get the leopard before he got the goat.

And what she hated even more was that she had to sit completely still and not move a muscle. For hours. Her back itched and her legs had fallen asleep years ago. Her mouth was dry and she badly needed a drink of water. She started to scratch her nose, but the quick, sub-vocal "shhh" from her father stopped even that minor relief. She knew that if the leopard attacked before the moon rose they would have no chance of bagging him, for it was pitch black. It was so dark she couldn't see her hand in front of her face. Not even if she wiggled her fingers.

Maybe a scientific experiment would while away the time: she squinched her eyes tightly shut, then opened them wide as possible. Squinch, open, squinch, open...nope. No difference whatsoever. She sighed with boredom and discomfort, and received another sharp, soft-pitched "shhh" for her efforts.

She would have rolled her eyes, but it was too dark to bother.

Both Gladys and the goat had fallen into a nervous doze by the time the first beams of the rising moon whispered through the trees, illuminating the small clearing below.

She was startled awake as John's hand closed silently on her shoulder, alerting her to the change in the air. The goat needed no such prodding – he was up on dancing hooves, eyes white-rimmed, jerking at the tether as he scented death on the wind.

The hunters waited silently.

The moon rose higher: she was a week past full, lying on her back low in the sky, but her beams were still bright enough to make shadows at the edges of the trees and to pick out the twin lamps of the leopard's eyes, while the rest of him faded into the night, indistinguishable from the jungle floor.

Without a sound, John raised his rifle and Gladys raised hers, sighting along the barrel. After a moment of confusion, she remembered which eye to close when sighting a target.

The children had all learned to handle and shoot rifles at an early age, but when Gladys was first learning, her shots went consistently and dangerously wild. It drove her father to distraction, until he realized that she was closing the wrong eye to sight her target. John made her eat dinner with her left eye closed for an entire week until she got the picture, and in time her aim improved, and she became an adequate shot.

So she told herself, "LEFT eye closed." With her right one, she sighted through her scope as the leopard began to creep into the clearing.

The goat was, by now, bleating in terror and yanking on the rope. The leopard's tail flicked over his back and held still, a sure sign that he was about to pounce.

Time stopped.

Gladys stared in open-mouthed wonder at this, the first big cat she had ever seen alive and up close – so close that she could see him breathe, watch his lips curl in a silent snarl. He was completely in the clearing now, a magnificent, fully-grown leopard, moonlight glowing on his coat, his spots an extension of midnight.

Her heart surged into her throat, and then broke. How could she kill a creature such as this – beautiful, graceful, perfect? How could she stop a life, when she knew she had been put on this planet to save lives, to heal? She came within a hair's breath of throwing down her gun to run screaming through the treetops, but her father's sharp elbow digging into her ribs recalled her to her duty.

She forced herself to remember that if she didn't shoot, the cat would surely kill the poor goat, and, in time, most probably carry off more innocent children. She had to shoot, she told herself. She had to. So she got up her gumption, and as the leopard leaped, she shot.

But she couldn't help it. On reflex she shut both her eyes right before pulling the trigger. And of course her shot went wild, but it was followed, as if by an echo, with the report of her father's gun, and the leopard fell dead, a foot away from the gibbering goat.

"Good shot, Gladdie!" her father crowed, patting her on the back and jumping down from the tree. He forevermore insisted that she had been the one to deliver the killing blow. He called it "Gladdie's leopard" and to this day, she has the skin, preserved and mounted, covering the top of a bookcase in her living room, the evidence of her first and only kill.

She was happy that her father was proud of her, and basked in his praise, but she knew who really shot the leopard. And it had been a good experience, braving the nighttime jungle, bonding with her father. A successfully completed rite of passage, but nothing she would ever want to repeat.

They returned to Rourkee the next day. Gladys was unusually quiet and subdued, bursting into tears for no reason and clinging to her moroseness the way only a teenager can.

But soon the dear familiarity of the everyday routine comforted her, and besides, Christmas was coming. She was still enough of a child to be seduced by the magic of the season.

December is a beautiful month in the high plains of Northern India. The monsoons have come and gone, their torrential rains washing the air, leaving it clean and fresh. The nights are cooler, the stars softer, and the flowers throw themselves into paroxysms of bloom. The days, while still quite hot, become tolerable, and the pace of life quickens imperceptibly.

Christmas dawned a perfect day – the sky vaulted blue as glass overhead, the air so crisp you could taste it. Along the horizon, the jagged ice peaks of the Himalayas glowed golden pink, and struck sparks from the rising sun. The missionary compound had festooned

itself with flowers, the bright reds of the poinsettia trees, bougainvillea vines and rose bushes singing "Joy to the World."

To Gladys it seemed a little strange without her older brothers and Margaret, and more than a little bittersweet, this being the last time and all. Still, it was filled with the joy of the season; Christmas carols sung in Hindustani, the great *imli* tree that Dad and Harry Dean had cut in the jungle and dragged home in a bullock cart to be set up in the living room and decorated. Beth had half a dozen blown glass balls, fragile and exquisite, that she had brought from the States, and she always hung them last, and with great ceremony. The rest of the tree was filled with strings of popcorn and the homemade ornaments the children had created over the years. Everyone agreed it was the most beautiful tree ever.

"Bara Din Mubarik Ho" they all called out on Christmas morning, and *"Nyah Sal Mubarik Ho"* they cried a week later, when 1936 turned to 1937, and everyone got ready for Sports Day.

New Year's Day had taken on a different tradition in this country. It had come to be called Sports Day because the denizens of the compound joined with the children from Belle's orphanage and many of the local residents to participate in a day of races, shooting contests, and other games. Belle always brought the children to visit for a week right after Christmas, and they camped out in the compound, waiting with barely suppressed excitement for the big day, since besides the fun of the races and games, there was another important event that took place.

The lepers came to see their children.

It happened only once a year, for a few short hours. They traveled to Rourkee from wherever they lived, walking barefoot along the dusty roads, armed with their bells and clappers, but wrapped in their best rags, saved especially for this occasion.

They came as if drawn by an irresistible force, ashamed of their disfigurement and calling, *"Changa, changa."* But they were welcomed

by the people at the Rourkee compound, and unerringly they found their own child. Sitting cross-legged a foot away from their son or daughter, the signs of their disease hidden by the skillfully wrapped rags, they were content.

They did not touch their children, could not kiss them, or brush their hair back from their foreheads; they allowed themselves no small gestures of affection such as we take for granted with our own families.

And the children knew that they could never touch their parents. Never be kissed goodnight, or held and rocked to sleep. Never have her mother wrap the red sari around her at her wedding, nor have his father teach him how to hunt or proudly throw an arm around his young shoulders.

But the heart needs no touch to express itself. The compound echoed with laughter from the little family groups seated everywhere on the ground, and love was as heavy in the air as the scent of *rat-ki-rani* on a moonlit night.

For three hours the children visited with their parents, telling them of their year, and demonstrating new skills such as writing or reading or adding and subtracting numbers. Then Beth rounded up the children and lined them up on the steps of the bungalow, just as they'd practiced, and they sang songs for their entranced audience. Christmas carols and hymns in Hindustani, their young voices ringing with the familiar strains of "Jesus Loves Me" and "Away in a Manger." And then, more tentatively because these were in English and had to be learned syllable by syllable, popular songs of the day – "You Are My Sunshine" and "Smile Awhile and Bid Me Sad Adieu."

The concert was always a rousing success.

Next came the holiday feast. Platters of chicken and vegetable curries, mountains of rice spiced with cloves and lentils, great bowls of mango chutney and other special condiments – raisins, sliced bananas, *raita* and *dal*. There were piles of *chupattis,* fresh and hot, and *gulab*

jamen for dessert. The lepers were served from separate platters, but they ate their fill sitting next to their children. As they politely belched their thanks at the end of the meal, they called down blessings on the heads of the *sahib-log* for giving them the chance to live an ordinary life this one day each year.

All too soon it was time to take leave of their little ones, longing to touch and be touched, but knowing it could never be. They took up their clappers and went back to the world in which they were shunned and reviled. But for a few hours they had existed in a dream of normalcy, in which their children had loved them unhampered by their disease. It was a Christmas gift beyond price.

Winter moved quickly into a brief spring and Gladys went back to Woodstock for a final semester. As the time for her departure approached, she returned to Rourkee for a last visit. She spent her days consciously imprinting India in her memory, to take with her into the exciting yet terrifying world towards which she was bound.

She lingered as long as she could in bed in the mornings, listening to the jungle birds outside her window, the creak of the water wheel, and her mother singing to her lilies. She spent time with Harry Dean, laughing and reminiscing, sucking sugar cane, storing up the sweetness.

She sat for hours watching Dar cook, or talking to Ayah as she helped with the daily chores. She revisited her mother's garden, and found that the special place she'd shared with Helen so many years ago had long since overgrown. She spread a blanket out and lay down anyway, under the rosebushes and *chambili*, reveling in the scent of the garden, the blast of the sun, the memories of childhood. Gladys existed in a golden bubble, filling herself up for the famine and long dark nights that she knew were ahead of her.

For not only was she leaving India, the warmth and safety of home, but she was headed into a world gone mad. Europe was on a sui-

cide path, the entire planet careening towards destruction. War was inevitable. And all she could do was pray and carry on.

So when the time came, she mounted the steps to the train with a heavy heart, blinking to focus through the tears in her eyes.

There was her family standing in the dusty sunlight, waving goodbye. Her mother, dwarfed by her father, hair beginning to turn gray, smiling with determination to not break down. Papa supporting Mama, thin as a scarecrow, eyes sad, but filled with love. Ayah with a sari cast over her head, weeping unashamedly. And Dar, stolid and solemn, his trembling lips the only clue to his grief over saying goodbye to this, the daughter of his heart.

She faced the future with determination and not a little excitement, but she sobbed out loud as she waved frantically and called, "Goodbye, goodbye," craning her neck to see them until the train chuffed away. Cinders and dust obscured the station, carrying her from childhood into the uncertain future.

Ayah and Dar
1937

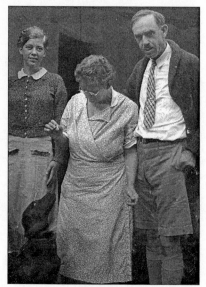

Gladys, Beth and John
1937

136

Part 2

Ohio

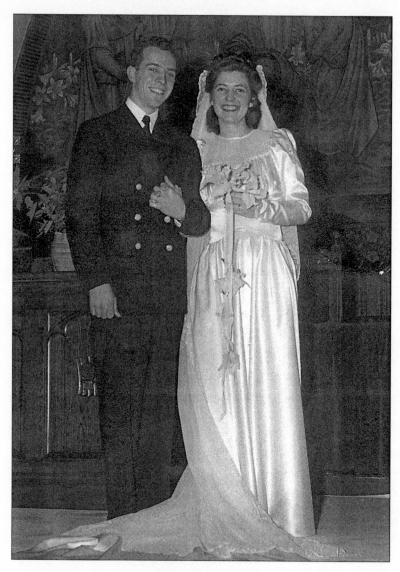

Bill and Gladys
Wedding Day
December 20, 1943

Chapter 14

Muskingum College, New Concord, Ohio
September 1937

The gymnasium echoed with girlish laughter. Gathered in groups at one end of the basketball court, dressed in regulation bloomers and crisp white shirts, the girls leaned their heads together, giggling and gossiping, already scrambling for their place on the social ladder.

It was the first day of the first semester for the class of 1941, Muskingum College, and everyone already seemed to be old friends.

Everyone except Gladys.

She had tried to enter into the general gossip, but she didn't care about the movie stars they were dissecting, and didn't know enough social artifice to pretend that she did. Their smart hair styles, freshly bobbed and crimped, made her feel out of place, as did their fashionably milky complexions.

She stood miserably at the edge of a small group, having been discretely elbowed out of the circle after an unfortunate remark about her family's Thanksgiving traditions. Shifting from one foot to the other, she hunched her shoulders, feeling for all the world like a giant troll among elfin princesses.

She was a tall girl with strong legs and the look of the outdoors about her, totally unaware of the aura of power that surrounded her. With that unfashionably tanned skin and those long braids pinned in an

old-fashioned coronet around her head, she was as different from the other girls as is a tropical orchid from a daisy. Her chin had a regal lift, for her eyes were used to sighting long distances across the searing plains, or looking up from the green foothills to the snow capped gates of Heaven. She belonged to a different world, and, with the unwitting primal instinct of a pack of monkeys, the other girls knew this, and shunned her.

Such has always been the dilemma of the powerful woman. By drawing awe, she draws derision. Those around her, certainly in the 1930s, had no idea what to do with a woman who radiated the unknown force Gladys did. She looked at them with an unwavering gaze, deep brown eyes surmounted by a crown of auburn hair, like a Greek goddess, or an ancient queen. Her outlandish comments were uttered in a clear voice, pitched to carry across a jungle clearing at night, and flavored with the slightest hint of a British accent, garnered during sunny days spent at Woodstock, or pestering Harry Dean and the other Tommys. Add to that a body that was sinuous, long limbed and sun browned to the color of afternoon tea, and she became quite daunting. Certainly not the kind of girl who had a crush on Cary Grant, or swooned over Robert Taylor, like everyone else. So when she proudly said that her dad would be shooting a peacock for her family's Thanksgiving dinner, they collectively raised their plucked eyebrows and turned away, leaving her to shuffle her monstrous feet on the scuffed wooden floor, wishing she could die.

A melodious, thickly accented voice startled her out of her glum ruminations. "Hello. My name is Jadwiga. And you are?"

"Gladys. My name is Gladys, and I'm glad to meet you!" she replied, unaccountably pleased at finally finding someone to talk to. She smiled, and surveyed the owner of the beautiful voice. The girl was tiny, pale, and very thin, with ice-blue eyes and a smile that shone like the sun. And most important of all, her hair was braided and wrapped

just like Gladys'. They recognized each other as kindred outcasts, and immediately fell to talking.

It seemed that Jadwiga was Polish, and had recently come to the U.S. as part of a children's choir touring the cities of the eastern part of the country. The director of the group had spoken to the president of the college and had made arrangements for her to attend on scholarship. She was only sixteen, just like Gladys, and they bonded instantly.

Their friendship bloomed quickly and they spent most of their free time together. They loved to go walking in the hills around the college, skipping along the well-worn paths, jumping in piles of fall leaves. It was all so different from the foothills of the Himalayas, but Gladys appreciated the beauty, and thought the dissimilarity fascinating.

And Jadwiga was enraptured. The two girls would run to the top of a hill, with the well-ordered view spread out below them, the deep blue sky pierced by flaming trees above. She would throw out her arms, as if embracing the whole world, and burst into song. Her voice was rich and strong, and so beautiful that, more often than not, it brought tears to Gladys' eyes.

"I love it when you sing, Jadwiga," Gladys would say, and the smaller girl would reply, with shining eyes, "I sing because I'm free!" And they would run, tumbling down the hill, like children.

Life soon fell into a familiar routine. Classes and studying took up most of her time, and what was left over, Gladys spent with Jadwiga or on her own. Margaret had little time for her, being an upperclassman now and deeply involved with her own activities.

Gladys liked her classes. They fascinated her and, having learned to adapt to her dyslexia, she consistently pulled A's. She was appreciated by her professors for her intelligent comments and fervent participation.

But she didn't date much.

She was so different! At a time when the American ideal of

femininity was soft and helpless and purposely vague, Gladys felt, once again, like she would never fit in. Boys were used to girls who fluttered their eyelashes and never ventured an opinion of their own. Gladys looked them directly in the eye and listened intently to what they said. She knew this flattered and gratified them, but then – she just couldn't help herself – she completely ruined it by opening her big mouth and expressing her honest opinion, frankly challenging anything she didn't agree with.

Sometimes she felt as if the words had a mind of their own, and she would watch, in helpless horror, as they marched out of her mouth and worked their inevitable havoc upon her audience. She learned quickly that it was impossible to unsay something.

And so, her combination of intelligence, honesty and offbeat beauty intimidated most would-be suitors. Except Herb Buck.

Herb was a farmer from a family of farmers. He walked as if he had one foot on either side of a corn row, and he fell for Gladys the minute he saw her striding across campus on her strong, beautiful legs. She reminded him of an egret moving through a flock of crows. After a few weeks of watching her from afar, he plucked up his courage and asked her out one Wednesday night. They walked down to the local dairy and drank milkshakes. She talked nonstop all evening about things he didn't understand, and shook his hand goodnight with a firm grasp, but she was so beautiful! And she agreed to another date next week. Soon their weekly trip to the dairy became a regular thing, and Herb was besotted. He lived for Wednesday night.

As for Gladys, she was in bliss. Herb was a very nice young man, tall and dark, with deep brown eyes that looked at her as if she were something special, which she knew she wasn't, but heck, why not let him think it? Especially since she liked him a lot, he never argued with her, and he bought her a milkshake every Wednesday night.

Every cloud has a silver lining, her mother always said, and she

figured that milkshakes were just about the biggest silver lining she'd ever seen. They were a little slice of heaven that she had never bargained for, in this exile from all that was home to her.

Thick, rich chocolate or creamy vanilla, they were made by the rosy-cheeked waitresses with huge scoops of pure delicious ice cream, and poured out of the frosted silver shaker, into her greedy glass. She drank it with her straw or spooned it, with reverence, into her mouth, letting it slide slowly and lusciously down her happy throat. She had never, ever tasted anything so good. Herb always let her finish his, and she slurped the bottom of his glass as devoutly as she polished off her own. She dreamed of the dairy in the dorm at night, and counted down the days until next week. She, too, lived for Wednesday night.

As time went by and the other girls became accustomed to her frank manner, she settled in quite well. The food was good, especially the bread, which was always hot and freshly baked, and the big jugs of cold milk and slabs of yellow butter were endless. Fresh dairy products had been unknown to her in India, for the Hindus didn't milk the cows, only worshiped them, and buffalo milk tasted like, well, water buffalo. But this! This was bliss. This was paradise. She updated her version of Heaven to include a steady diet of everything with a high butterfat content.

So she ate and drank her way through her first semester, and the only real problem she had was that her clothes kept shrinking. By Christmas, all of her clothes were so small that she could barely button her coat.

She complained about this to Margaret while they were sitting next to each other on the bus on their way to spend Christmas with the Aunts in Cincinnati. Her sister just looked at her, rolled her eyes, and said something cryptic about milkshakes. But when they arrived on their Aunts' doorstep, she was in for a rude surprise.

The little brick house on the tree lined street looked just like a

Christmas card. Snow was falling softly as the two girls opened the gate and skipped up the brick path, as they had so many times before.

Their beloved maiden aunts lived in the greatest harmony together, none of them having been married, and all three content with the arrangement. They were Beth's sisters, and the entire family fondly referred to them as "The Aunts." Clara and Lydia were retired school-teachers, soft spoken and gentle, kind as the day is long. Lou was a different story. She had strong opinions on every subject, and expressed them without reservation. She spent most of her spare time writing to congressmen, senators, and even President Roosevelt. Her letters to the editors were a fixture in the local paper.

The house had been decorated for the holidays with great swags of greenery and holly from the trees out back, and the soft glow from the windows illuminated Gladys' flushed face as she knocked eagerly on the door. The red bow on the wreath fluttered in warm air as the door swung open to reveal a small woman, with gray hair pulled back into a bun, cheeks as pink as Mrs. Santa Claus, and a puzzled expression in her bespectacled gaze.

"Yes?" she inquired politely, looking at Gladys as if she'd never seen her before.

"Aunt Clara, it's me! Gladys!"

Her aunt's expression went from puzzled to startled, as she recognized Margaret standing behind this cheery looking but very plump girl who, now that she thought about it, did resemble her quick-silver niece around the eyes and, yes, the smile was the same.

"Gladys! My, my, child! I never recognized you, not for a minute. But come in, come in. My heavens, it's snowing again. Hang your coats on the rack and come into the parlor. Girls! The children are here. And it looks as if we'll have a white Christmas." She chattered on and on, more flustered than her nieces had ever seen her.

The two other aunts rushed in and were brought up short. Lou,

the eldest and always the most outspoken, gasped, "Dear heavens, child, what have they been feeding you at school? You're fat as a Christmas goose! I wouldn't have believed my eyes if I hadn't seen you standing next to Margaret, here. But never you mind, we're all together and it's Christmas. That's what's important. Let's go in and have some cocoa, and you can tell us all about school."

Aunt Lydia shooed them into the cozy sitting room, where a fire burned brightly and the Christmas tree, decorated with tinsel and blown glass ornaments, stood in the corner. As Gladys settled into her favorite chair she realized, with great mortification, the real reason why her clothes didn't fit her anymore.

She, who had always been thin as a whip, had gotten fat! The trips to the dairy each week, the desserts every day, and the gobs of butter on warm bread had done this to her. She had been used to running up and down the mountain, being active from morning 'til night, and eating more from necessity than from enjoyment. Now that she merely sat in a chair all day, demurely walking from class to class, she had blown up like a Himalayan Black Bear just before hibernation.

Her newfound awareness didn't stop her from partaking of all the delights of her aunts' holiday feast; after all, how much weight can a person gain in three days? But as soon as she returned to Muskingum, she went to the nurse's office and weighed herself. "Holy cow," she thought to herself, "I've put on thirty pounds in three months. That must be some kind of a world record. I guess I better do something about this."

With characteristic firmness of intention, she immediately cut herself off from the dairy products and desserts she'd become so fond of, and broke it off with Herb Buck, since she found it impossible to see him without triggering the intense gastronomical need for a milkshake. She began taking long walks every day and found that, unless there was a snowstorm, she enjoyed it more than she could have ever imagined.

She couldn't go out when the snow was falling, due to the fact that her only shoes had holes in them, which she'd fixed by putting postcards in the soles. They didn't stand up well to snow or rain, so on the days when the snow fell fresh and wet, she elected to stay inside and keep her feet warm.

But every other day would see her bundled up and striding down the freshly shoveled paths with the late sun sparkling on the icicles and her breath a white cloud around her head.

In India, snow was a legendary thing, eternally covering the towering peaks, seldom descending to the foothills, certainly not a common, everyday experience. But the snow-covered campus of Muskingum was a different matter altogether, and Gladys was entranced. She usually walked by herself, since few other girls wanted to brave the freezing temperatures. Often she invited Jadwiga, who sometimes came, but was unable to enter into Gladys' transports about the rainbow sparkle on the trees, or the fun of making a snow angel. She looked at the snow as if it were an evil entity, and Gladys always wondered why.

She found out one lazy Saturday afternoon in late February, when the two girls had decided to stay cozy and warm inside due to a fresh fall of snow. They were curled up in blankets next to the window in Gladys' room, as the sun poked its head around the storm clouds and flashed on ice crystals piled on the trees outside. "Oh, Jadwiga, isn't the snow just so-o-o beautiful!" Gladys exclaimed.

With a shudder, Jadwiga replied in a low voice, "No, I'll never think it so. To me it will always be an enemy, and will remind me of the terrible time when my dear Mama died."

It was something that had never been mentioned before, and Gladys was speechless; she gazed at her friend's withdrawn, terrified face and said softly, "Please tell me, Jadwiga. Tell me what happened to your mother."

And because, even then, Gladys was the kind of person that

people felt safe telling their deepest secrets to, Jadwiga spilled her heart. In a heartbreaking monotone she began:

"When I had five years, my family fled Russia. There was great unrest and my father fell out of favor with the government. He was killed. I do not remember that, thank God. What I do remember is the terrible cold, and the snow, holding my older sister's hand and struggling to follow my mother through drifts of snow that were taller than we were. Mama was carrying our baby sister, and we stayed as close to her as we could, for she broke the icy wind and if we stepped in her footsteps, the snow was not quite so deep, nor so hard. To me it seemed as if we were walking forever. Finally we came out of Russia into Poland. Truly, I do not know how my mother kept going. We discovered a small, deserted shack." Jadwiga shuddered, as the memories flooded back, and Gladys reached out and gently took her hand. The storm had come up again, and the smaller girl stared out the window into the driving snow. She pulled the blanket tighter around her shoulders and continued.

"Everyone we had met on the road and in the villages was poor and starving, but my mother had begged some bread from passing travelers the day before. When we found that the shack was empty, we closed ourselves in and it seemed like a palace, for the wicked wind was shut out and, although there was no wood for a fire, at least it was dry. The baby had stopped crying long ago, and I remember my mama weeping bitterly as she held the small bundle in her arms and said, 'Your sister is dead. We must find her a bed for her final rest.' We found a broken wooden box and lined it with her ragged blanket and then tucked her in, as if she were just going to sleep. I kissed her sweet face good night – it was so cold and stiff, and she had been so warm and alive before. We put her in a corner of the room. My mother could not bear to put her outside, and I was glad of that, for there are snow wolves in that country, and I loved her still, and wanted her safe. Then Mama

wrapped her arms around my sister and me, and we fell asleep. When we awakened, I thought someone had built a fire, because I was warm for the first time since we left our home in Russia. But it was nothing so wonderful as that. It was my mother, and she was burning up with fever. My sister had seven years and was, to me, quite grown up. She told me we needed to put snow on Mama's forehead to bring the fever down. So we took turns going outside and bringing in handfuls and packing it around her. We prayed that she would get better, that she would look at us once again with her soft eyes and tell us how much she loved her little angels. We sang to her the lullabies that she used to sing to us. But I suppose that neither prayers, nor tears, nor handfuls of snow were enough, because sometime during that endless night she died.

"She had been so hot and restless, and now she became so cold and oh, so still. When my sister said, 'Our Mama is dead,' I remember looking all around for some kind of warmth, and there was none. Our hands were frozen and we huddled together. We could not even cry.

"And that is why I hate the snow, Gladys. Because my mother died from grief and terror, but most of all, from the endless, endless snow. And I could do nothing to help. Nothing."

Jadwiga fell silent, lost in her terrible memories, and there were tears on both girls' cheeks.

Gladys reached out and tucked a curl of soft hair behind her friend's ear, letting her hand come to rest lightly on her shoulder.

"What happened then?" she asked, hoping to rouse her from her nightmares.

"Huh? Oh! What then?...well..." Jadwiga shook herself and turned away from the window and, sitting up straighter, she continued with her story.

"I do not know how long we stayed in the shack – possibly a day, maybe two. We had finished the bread and were very hungry, but

we were afraid to go outside. We were discovered by some hunters who had built the shack to use overnight when they were hunting wild boar. God finally smiled on us, for they were kind, and they buried Mama and the baby beneath the deep snow to keep them safe from the wolves. They took us home with them, but their village was too poor to take on another man's children. We were sent to Warsaw and placed in different orphanages – I do not know why they separated us and I have never seen my sister again. I was so very, very sad for a long, long while. The only comfort I had was my music and when I sang, I forgot my sorrow for a time. So I joined the choir at church, and was chosen for the children's chorus and to tour America. Once again, God smiled, because the director of our group made it so that I could stay here and come to this beautiful college. And now I have met you, my friend, and I finally know what it is to be happy. And to be free."

Gladys slipped her arm around Jadwiga's shoulder and, with their heads resting against each other, they gazed through the frost rimed window to watch the snow falling, falling....

Muskingum College

Gladys, Margaret, Jadwiga at college

*Gladys
in college dorm
with her
leopard*

Chapter 15

Muskingum College, New Concord, Ohio
1939

"O! Muskingum is a college in Ohio!
It's the place to get your knowledge in Ohio!"
The autumn sky was cobalt blue, and the school song spiraled around the bleachers and up into wood-smoke scented air.
"Students gather in the fall.
They assemble one and all.
O! You can't count them all in Ohio."
Young men wrestled the pigskin to earth on the playing field, while their fellow students cheered them on to victory
"Dear old Muskingum
Kind old Muskingum
There's no place in Ohio
Quite so dear."
Led by the frenetically jumping cheerleaders, the crowd swung into a chant that rocked the seats.
"M – U – S with a K
K – I – N with a G
G – U – M with an M-U-S with a K-I-N with a G-U-M
Muskingum! Yeah, yeah, yeah!"
Gladys absolutely adored football games. The cold, crisp air,

the sharp scent of chrysanthemum corsages, sharing the excitement and frenzy with everyone, friend and stranger alike – it was all a part of her life now, and it thrilled her down to her toes.

College life was great, and Muskingum was the best. She had come to feel very happy here, and at home with her classmates. She'd carved out a niche for herself and was occupying it quite gladly.

She was at the football game with several of her sorority sisters, and she was having a ball, now that she was an upperclassman and entitled to the privileges thereof.

She had spent her sophomore year living off campus with Margaret, in an attempt to save money. They had shared a small room in a big house, and had done all their cooking on a tiny stove in the basement. They had nearly starved. Gladys could care less about cooking, and Margaret, albeit a good cook, had very little to work with, due to their lack of grocery money. They had been hungry all the time, but Gladys finally dropped the last of her milkshake-induced extra weight, and she figured that was the silver lining.

Margaret had graduated in June, and had left to go east to nursing school before going back to India as a nurse. So, at the beginning of this, her junior year, Gladys had moved into the FAD house and was having the time of her life. It was so much fun, like having a whole bunch of sisters who all shared the same close-kept secrets. No one outside of the sorority knew what FAD meant. They were sworn to secrecy for their entire lives. When they linked arms and sang their songs, her heart swelled with sisterhood, and she felt a part of something greater than herself. It was a wonderful feeling.

Sitting in the bleachers, surrounded by her friends, she realized that she finally felt truly accepted by the other students. She remembered how, when she first arrived from India, she'd felt so left out and ostracized. She tried to recall exactly when she started to see the other kids as her allies, rather than as the enemy, and smiled to herself,

because it was easy to pick out the exact moment.

It was the first day of the second semester of her freshman year. Public Speaking 101. Gladys had been excited about her new roster of classes, and none more so than this one. She knew it would be great fun to have assignments in which she was supposed to talk, and as the class settled down for the first time, she had looked around with great interest.

The professor said that they were to take a few minutes to compose one or two sentences to introduce themselves. Then she had demonstrated the correct way to approach the podium, and the proper way to exit. The others seemed to be struggling to put together their introductory remarks, but Gladys had no trouble at all. All she had to say was that her name was Gladys Taylor, she had grown up in the wild jungles of India, and just last year she had shot a man-eating leopard. That ought to get 'em.

The approach and exit seemed quite simple, so now she could relax and look around.

She knew only a few of the kids from her other classes. None of them looked precisely thrilled to be here. There was a girl sitting next to her with a wonderful smile; her name was Juanita and she'd been quite friendly. There was a boy across the room that kind of reminded her of Peter, but before she could get a really good look, the professor had rapped on the podium.

"All right, class, come to order. Now, remember – one by one, you will – correctly – arise from your seat, approach the podium, introduce yourself clearly and succinctly, and exit in the accepted manner. Are you ready?"

Reluctant nods all around.

"Very well. To begin, we will take volunteers."

During the last semester, Gladys had developed a policy to go first as often as possible. That way, she got it over with and could enjoy the rest of the class, and more importantly, if she was first, there was

nothing to measure her against. So her hand had shot up and she was duly called upon.

She stood, surreptitiously adjusting her skirt. She had been depriving herself of bread, butter and Herb Buck for several weeks, but her clothes were still uncomfortably tight and had an unfortunate tendency to hike up around the thighs.

Assuming a look of careless importance, she strode confidently towards the podium.

There was just one small problem. She didn't see the step that led up to the platform, and, true to form, with assurance and style, she tripped. Trying vainly to catch herself, she spun around, and, while the class held its collective breath, she fell, landing flat on her behind, cracking her head loudly on a desk, and splitting her skirt halfway up the front to above the knee.

Horrified, she sat with stars dancing before her eyes for about a thousand years, while silence echoed loudly in the room.

Then, quick as a flash, she leaped up. Pulling the edges of her skirt, as well as her tattered dignity, around her, she approached the podium.

Looking out into the sea of stunned faces, she gave her biggest, brightest smile and said, "The first thing a speaker must do is to get the attention of the audience. My name is Gladys Taylor, and I hope you enjoyed the show."

She sat down in triumph, amidst a hail of applause and laughter, well pleased with herself.

In fact, the episode had become the stuff of campus legend and, even now, kids would walk up to her in the hall and say, "Hey, Taylor – hope you enjoyed the show." Hahahaha down the hallway.

Her quick thinking and ability to laugh at herself had turned the entire speech class into her compatriots, and she knew that it had been worth the torn skirt. She never had liked that outfit, anyway.

154

Gladys was wakened from her memories by a rousing cheer. Muskingum had won the game twenty-eight to twenty-one, and the fans were yelling and waving pennants as they quit the bleachers and swarmed out onto the field. Her group of friends stayed all together and ran to the parking lot, where it was easy to spot her car.

Yes, she had a car. It had first belonged to John and Carl, then Margaret. Gladys had proudly inherited it when her sister had graduated last June, and it was her most splendid possession. It was envied by many, although, she had to admit, it wasn't exactly stylish in the classic sense. It was an old Model A Ford, and when John and Carl had bought it, it had been a strange, putrid gray-green color. Thus, it became known as the Green Gopher, because it would "go for" no apparent reason. When the car became hers, she decided to paint it, and came up with the idea of a jungle mural, keeping the signature color as the background. She had spent the entire summer at the Aunts' house in Cincinnati up to her elbows in paint and turpentine; by August she had transformed the Gopher into a work of art. Banyan trees and bamboo arched over the roof, and a huge tiger prowled along one side, its tail curled around the boot. She'd put monkeys and a peacock on the other side and a some-what stylized elephant on the hood. It was quite distinctive, always easy to spot in a parking lot, and she loved it.

The gaggle of girls raced to the Gopher and piled in. The whole of Saturday night stretched before them. They were young and free, and they had a set of wheels. What could be more divine? Now to decide what to do. After throwing around a number of ideas, Marion piped up from the back seat. "Let's go over to Cambridge and see a movie. I think *Desire* is playing this month." She batted her eyes and leered. "You know, the one with Dietrich and Gary Cooper."

In one concerted breath the girls sighed, "Gary Cooper!" There was a reverent silence, then Gladys chunked the car into gear and cried, "OK! Let's go!"

It was fifteen miles to Cambridge, the home of the only movie house in the area. Barring a breakdown or a flat tire, it took forty-five minutes to get there, and they sang all the way.

The Gopher would backfire if you pulled the choke out at a certain angle, so Betty, the music major, always sat in the front seat next to Gladys and beat out rhythm with the backfires. It was great fun.

None of the girls had steady beaus, so they spent a lot of time together. The others talked about boys all the time, but Gladys just hadn't found anyone she was interested in.

Oh, she'd had a brief crush on a boy named John Glenn, but he was a year younger and very popular, in addition to being almost engaged to a very nice girl named Annie. He had been in her math class last year and had helped her with some of the more difficult algebra. He was good looking and genuinely nice, and she had entertained a few fantasies, until she became friends with Annie and loyalty overcame infatuation. Besides, she had discovered that he was sort of loony because he had told her, in a brief moment of confidence, that his greatest dream was to fly a rocket ship into outer space. Strange how people could look so normal, yet be ever so slightly off. Genius walks the razor's edge of madness, she mused.

She didn't know what the big fuss about boys was, anyway. All the other girls fell in and out of love so fast she couldn't keep track of it. But she just didn't have the time, nor the inclination. After all, she had a plan for her life, and Gladys was nothing if not strong-minded. She needed to graduate from Muskingum with excellent grades in order to get a scholarship to medical school. After four years of med school and a two-year internship, she would return to India as a missionary. And as far as she could tell, having beaus only served to take one's mind off one's goals, unless the goal was to find a husband, as was the case with many of her classmates. But she had Other Plans.

To be quite truthful, however, sometimes she did dream of a

home and a family – six children would be perfect. Her husband's face, in these fantasies, was quite vague, but his character was always imbued with the same fire and determination that fueled her life, and his goals were the same as hers. So, until this paragon appeared and swept her off her feet, she felt that the whole romance thing was just too much of a bother.

Driving to Cambridge on a Saturday night, laughing and singing "Shine On Harvest Moon" (bang, bang) with her friends – this was enough of a social life for her. It was simple and uncomplicated, yet totally fulfilling. "Life," she thought as they pulled into the parking lot at the theater, "is very, very good."

A touch of home for Margaret and
Gladys. Muskingum 1938

Gladys, Gordon
and Margaret
Muskingum1939

The Green Gopher before paint job

Two Years Later

She stood in front of the mirror and surveyed her new look. How would her parents feel about her haircut? They were arriving today, back from India on furlough, just in time for her graduation tomorrow.

She really didn't know why she'd felt the need to cut her hair. Maybe because it would be easier to take care of now, and she knew that in medical school she would need all the extra time she could get. Or maybe as a symbol of her passage from child to adult, who knew? She had just been so tired of her thick, heavy braids, and had felt reckless, in need of some kind of statement about her new phase, the latest accomplishment in her Life Plan.

"Medical school," she gloated. She stared hard at herself in the mirror and decided that she did, indeed, look more like a medical student with short, carefree hair. She just couldn't wait! She'd dreamed about it all her life, and now she'd been accepted at Women's Medical College in Philadelphia, and she was so excited she could hardly stand still.

She was also scared, but in a good way, and the fact that she'd be able to live with her parents for the first year helped. Since they would be on furlough for the next 18 months, they'd decided to set up housekeeping in Philadelphia so Gladys could live with them at first.

Thinking of her parents reminded her that they would be here in time for dinner. Shaking herself out of her day dreams, she bent over the washbasin and poured water over her head, then scrubbed it vigorously with shampoo. It felt so funny to have just this little bit of hair! Trying to keep the soap out of her eyes, she refilled the jug with water and just a little bit of vinegar (to make it shine, all the girls said) and then rinsed carefully. She dried it with a towel, then combed it out. Using a brand-new card of bobby pins, she put her newly shorn locks up in pin-curls and tied a bandanna around her head, like she'd seen the

other girls do. She figured it would only take an hour or two to dry, especially if she sat in the sun on the back porch of the FAD house. She ran downstairs and planted herself on the top step. Soon the porch was filled with her sisters, and it was bittersweet, this last evening of their college lives. All of them were feeling nostalgic, and they sat on the steps or draped themselves over the railings, leaning their heads together and reminiscing, singing old songs until the sun fell behind the maple trees and they scattered one last time, like leaves before the wind.

Soon her parents arrived to take her out to dinner, and it was beyond wonderful to see them again. To her great surprise, they loved her new hairdo. They said it made her look grown-up and ready for the serious business of medical school. She felt ready for med school, ready for life, ready for anything.

Her class graduated the next day with full pomp and circumstance, their excitement and hope tinged with uncertainty and a dread anticipation.

For Europe was once again at war, and no one knew what the future would bring. They didn't know that in six short months Pearl Harbor would be attacked, and America would throw herself into the battle, shrieking for revenge. They couldn't know how many of the young men, with their futures shining so brightly in their eyes, would face instead the freezing beaches of Normandy, or the bloody sands of a South Pacific island, their lives over before they had even begun.

When the ceremony ended, the graduates threw their caps high into the white summer sky of Ohio, while their parents thanked God for their youth and innocence and prayed for their future.

Half a world away, the Blitzkrig screamed, and youth and innocence seemed gone forever.

FAD housemates
Gladys, front right

Chapter 16

Philadelphia, PA
Spring, 1942

\mathcal{L}azy afternoon sun streamed through the bedroom window, throwing thick golden squares across the floor. Medical textbooks – pathology, anatomy, human physiology – were strewn across the desk, spilling onto the bed. Gladys reclined on the quilt next to them, pen in hand, mind and heart far away.

She was supposed to be studying. There was an anatomy test tomorrow, and a lab report due. Her mother was hosting a tea party downstairs for several members of the ladies' club at church, and she had used her schoolwork as an excuse to absent herself from it. But she really didn't feel like studying. She felt like daydreaming.

Voices drifted up from the parlor. She shook her head ruefully when she realized that her mother was trying to scandalize the ladies' club again.

"Gladys would love to join us, but she's studying for an anatomy test. Medical school is so very difficult, you know."

Pause. Chink of china teacups, subdued murmurs of agreement.

"She has no time for anything but her books. Getting through medical school, especially for a woman, takes brains, dedication and sacrifice. But most of all," she paused again and Gladys winced, knowing what was coming next, "what it really takes is…guts!"

She said it with great relish, as if it were a cuss word.

"Oh my!" the ladies gasped, and Gladys chuckled to herself, wondering why they kept coming to tea at the admittedly eccentric missionaries' home. The last time they'd been here, the house had been permeated with an odd, unpleasant odor. The well-bred noses of the ladies had twitched uncomfortably, and when one of them had courteously inquired as to the source of the strange scent, Beth had assured them, with a devilish glint in her eye, "Oh, that's nothing. Just my daughter boiling human bones in the basement."

Which was true. It had so happened that Gladys' cadaver had, upon dissection, offered up a perfectly shaped femur which she and her lab partners had decided would make an excellent gavel for the meetings of the medical sorority. Macabre humor has always been the release valve of the medical student, and in the '40s there were no laws as to the sanctity of body parts. So she had taken it home and boiled it in an old galvanized pan on the canning stove in the basement. The cartilage and tendons had fallen cleanly off after about twelve hours in the pot and, polished and cut with a hacksaw to a useable length, it had proved to be a great success at sorority meetings, and was used for many years thereafter.

The tea party had come to a screeching halt and, as soon as was politely possible, the church ladies had taken their flustered leave, edging out of the front door, fairly bolting down the steps.

But they kept coming back, and today they stayed on. The civilized sounds of their conversation formed a comforting background noise, rising and falling like the sea. Gladys drifted away.

She had been trying so hard to apply herself to her books, but, as was happening more and more often lately, she was being inexorably pulled into delicious romantic fantasies. Giving up on her attempt to memorize the arterial supply of the brain, she rolled over on her back, pillowed her head on her arms, and gazed out the window. The sun

struck the new leaves on the branches outside, gilding them with an unearthly light.

"I'm like one of those leaves," she thought dreamily, "opening up to love, opening to see the world for the first time." Softly she caressed the stack of letters, tied with a blue ribbon, that sat in a place of honor on her nightstand. Throwing scholarship to the wind, she succumbed. Sweet memories overcame her, and once again she re-lived the moment she met...him.

Four days after graduating from Muskingum, she had attended a church meeting in Cincinnati to apply for her medical school scholarship. And that was where it all began.

She sat in the pew directly in front of the only other young person in the congregation. He was a dark haired, blue-eyed dreamboat who caught her eye just as she was sitting down, and smiled a smile that sent a blush all the way to her toes. She was acutely conscious of him all during the meeting. He sang the hymns with the voice of an angel and when he came to the front to explain why he was there, he looked directly at her, as he told of his desire to become a minister. She felt that he was speaking to her alone.

Afterwards, he waited for her on the steps of the little church.

"Hi," he said with a devastating grin. "I noticed you sitting in front of me in there. My name's Bill McGarey."

Of course she knew that, since he had told the whole congregation his name. It was engraved in letters of fire on her heart. Dumbly, she nodded. Her tongue seemed stuck to the roof of her mouth. She couldn't breathe and, probably for the first time in her life, she was unable to utter a word.

Gallantly he continued, "I know your name's Gladys. I've always thought that was a beautiful name. It just seems so...happy, if you know what I mean." He chuckled and paused, waiting for her to respond.

But she was incapable of speech. Her mind was completely blank, except for the thought that his eyes were exactly the color of the Mediterranean Sea just off the coast of Capri. She stood staring up at him, hugging her hymnal to herself, while her whole body flashed hot, then cold.

It was a perfect night. Red roses enveloped the little white church in the first riotous bloom of summer, and the soft evening breeze wrapped the two young people in their sweet, sweet scent. The rest of the congregation had left, casting significant glances their way, and it felt to Gladys as if this moment, this utterly significant moment, would last until the end of time.

A million years later, he was still looking at her, patiently waiting for her response, a question in his eyes, a gentle smile on his lips.

She shook herself out of her reverie. "Um um," she gulped, as she tried to force her tongue to form intelligible words. That traitorous member lay, numb and unresponsive, in her mouth, betraying her once again, but this time, instead of running away with her, it just wouldn't work at all.

Thankfully, he came to her rescue. Tipping his head toward the sanctuary, he said, "In there, when you stood up and told about yourself, you said you'd been born in India. That's fascinating."

She nodded, still mute.

"It just so happens," he continued doggedly, "that a college buddy of mine was born there, too. I go to the College of the Ozarks in Arkansas. I think I already said that. Anyway, my friend's name is Bill Hatch. Do you know him?"

Now, there were 500 million people in India, and not one of her acquaintance was named Bill Hatch. But she knew it was now or never, and so, in a monumental effort, she drew herself up, took a deep breath, and opened her mouth. Luckily, words came out. Regrettably, they sounded stupid, ridiculous, inane.

"No, er, I mean, I know a lot of Bills, well, not exactly a lot, maybe two or three, well, three or four, now that I know you, but none of them is named Bill Hatch."

"Oh," he said, clearly disappointed, and the conversation stalled ominously.

Then she was struck blind with inspiration. "But I bet my brother does!" she blurted triumphantly.

"Oh well, that's great. Just great!" he replied a little breathlessly. She realized that he'd been holding his breath and it occurred to her that maybe, just maybe, he was a little nervous, too. The thought gave her a modicum of control, and she looked directly into his gorgeous eyes.

"I could ask him," she said daringly.

"Oh, that's great, just great," he repeated, then, twisting gloves in hand, "maybe I could write to you and find out."

She had her conversational feet underneath her again and, with an offhand gesture, she pulled a pen and paper out of her purse.

"Let me just give you my address here in Cincinnati. I'm staying with my Aunts until I get settled in Philadelphia."

Eagerly he took the small piece of paper, folding it and placing it with great care in his wallet. He smiled his blinding smile.

"So you're moving to Philadelphia to start medical school. That's wonderful! I've never known a girl who wanted to be a doctor. You must be as smart as you are beautiful."

Gladys had never flirted in her life, but with atavistic female instinct, she took the ball and ran with it.

"Oh, no, not <u>that</u> smart!" she replied with a toss of her head, and they both broke into uproarious laughter.

He walked her back to the Aunts' house, courteously shook her hand goodnight, and, a week later, true to his word, she received his first letter. It was eight pages long, very well written, and full of information about his life. And, after signing off, "Very truly yours, Bill," he

had added a P.S., "Does your brother know Bill Hatch?"

That was how it had started. She had immediately written back, and now they wrote daily. She kept his letters next to her bed, and she kissed them goodnight every night. They had seen each other briefly at Christmastime and he had been as handsome and gallant as she remembered. Now it was almost Easter, and since they both had spring break at the same time, they had plans to meet in Cincinnati. She would visit the Aunts. He would visit his Uncle Albert and Aunt Louise. They would spend the whole week together. She was so excited she could hardly sleep.

They had gotten to know each other quite well during their extensive correspondence. The letters that flew back and forth were full of dreams, philosophical thought, great plans. After a few months of communication, Bill had realized that his calling was to medicine, rather than the ministry, and had applied to medical school. He was to start next fall and Gladys felt as if she'd been an inspiration to him, a heady thought.

She knew that for her, it had been love at first sight. His high ideals, heartfelt letters, and wonderful sense of humor, not to mention his astounding good looks, served to sink her ever more deeply into the ocean of bliss that is first love.

She would always be grateful to Bill Hatch, whoever he was.

The only thing she found difficult and somewhat distressing about the whole situation was that, while she was dreaming about Bill, her studies suffered. And when she became lost in her studies, (which still happened quite often, as they were absolutely fascinating to her), she would later feel guilty that she had forgotten him, even for a short time.

The juxtaposition of love and responsibility was to become a recurring theme in her life. The tug of war in her heart would become most pronounced during the '50s and '60s when she was trying to strike

a balance between the joys of being a wife and mother, and the equally deep satisfactions of her medical career. Especially in the early '50s, a woman who freely chose to be a working mother was a rare bird, indeed. She was instrumental in opening those doors. But all that comes later.

Gladys' Dream Boat

Gladys, 1941

e✐✐✐

Spring Break 1942
Cincinnati, Ohio

When Gladys' bus arrived at the station in Cincinnati, it was raining like a monsoon cloudburst, pouring in sheets down the windows of the Greyhound; the heavy kind of spring rain that drenches everything and lingers in deep puddles where snow banks had been just weeks before. She had left Philadelphia immediately after her late class, and it had taken all night to get to their destination, due to the flooding caused by the storm.

Running through the rain to catch the streetcar, Gladys felt like a refugee, for she had no umbrella, and her raingear consisted of an old brown trench coat (several sizes too big, having been handed down from Carl) and a brown bandanna tied around her hair, which was much worse for the wear of an entire night spent catnapping on the bus.

A tall young man with deep blue eyes watched the arrival of the bus from Philadelphia and scanned each passenger as they alighted. He had only seen Gladys two times so far in their eloquent courtship and he was eagerly looking forward to spending more time with her. She didn't know that he had come to meet her. They had a date later on that evening, but he wanted to surprise her and he didn't like the thought of her having to hop a streetcar in such a storm. But it seemed, to his intense regret, as if she had missed the bus, for the last passenger splashed down into the puddle in front of the steps, and she had still not appeared. Then he looked more closely at the bedraggled girl, all wrapped in brown, who grabbed her faded carpet bag and with a shriek of, "Wait, wait!" pelted through the pouring rain towards the streetcar. She didn't look anything like the girl he remembered, but when she ran, something about the way she moved was familiar, and, as the wind

blew the trench coat open and her long legs flashed, he realized that yes, those were her legs. Yes, that was Gladys. He took off after her but she had already leaped aboard the trolley, and it was pulling away from the curb. He was left standing, hatless, on the corner in the rain, staring after her, a hungry look in his eyes.

If all went well, he thought, if she truly was the girl she seemed to be from their long and frequent letters, sometime during this week he was going to ask her to marry him. He had no money for a ring, but he could give her his whole heart, and he hoped that would be enough.

Bill McGarey and his two brothers had been raised reluctantly by their maternal grandmother, after their mother had died of consumption when Bill was just seven years old. He remembered his mama only as a soft pale woman with gentle hands, whom he was permitted to see infrequently, for only moments at a time. She had been confined to her bed, then to a sanitarium, for his whole life, and he had no memories of lullabies at night, picnics on summer days, or laughter by the fire on a winter evening. After her funeral, their father, mute with grief, deposited John, Bob, and Bill on their grandmother's doorstep and disappeared for years. She was a cold woman at best, poor and tired, and she bitterly resented the imposition of three needy, dirty little boys.

Times were hard in the little steel mill town of Wellsville, on the Ohio River. She took in laundry to augment her husband's meager pay, but there was never enough money. Beneath her unwilling roof the boys huddled together like a litter of abandoned puppies, and they learned self-sufficiency, if not tenderness, and determination, if not love. When Bill turned ten, their father took the boys back into his care, but that was an existence, if possible, even colder and poorer than before.

Everett Lester McGarey had loved one thing in his life, and that was his wife, but Anna had been taken away before they had even begun to live. Now he was left with nothing but three hungry mouths

to feed. At least they were boys and old enough to work, which they did, for pennies a day. It was 1929, the Great Depression had blanketed the country with misery, and it seemed as if the whole world was desperately poor and starving.

Somehow, the boys grew themselves up and, with intense focus and sheer firmness of will, Bill put himself through school. He applied to college, and received a scholarship to the College of the Ozarks, deep in the Ozark Mountains of Arkansas. He didn't mind shaking the grimy dust of Wellsville from his feet, and he was immensely gratified and quite proud to be a college man. But there had been little joy and no tenderness in all of his twenty-two years of life.

Until one magical night, at a church meeting, he looked into the laughing brown eyes of a young woman seated in the pew in front of him, and saw in them the promise of a life he'd never allowed himself to dream of – faith in love, joy of family, dedication to something greater than oneself. And he, who had always been the suave ladies' man, the guy with the smooth line and the knock-out smile, was reduced to the pathetic come-on line of, "Do you know Bill Hatch?" Oh, brother. He watched the trolley disappear around a corner and, tipping his head back into the rain, laughed out loud.

Gladys In Love

Later that week, standing on the Aunts' front porch, once again he laughed at himself, this time silently. He was nervous as a schoolboy at his first dance, his legendary self-possession just a memory. Tonight was The Night, and it had to be perfect. He'd planned dinner and dancing at a restaurant downtown, and although it would take the last of his savings, it would be worth it if only she would say yes. He'd never proposed before, and he rehearsed his speech in his mind until the door flew open and all three Aunts converged on him, pulling him into the vestibule and fussing over him like broody hens battling over a lone chick. It warmed his heart, but did nothing to allay the butterflies in his stomach.

Meanwhile, upstairs in the guest room, Gladys was putting the finishing touches on her new outfit. This was absolutely the most beautiful dress she'd ever had. It was a present from the Aunts. She posed this way and that in front of the mirror, trying to see it from all angles. The sleeveless blue silk sheath showed off her figure to perfection. There were tiny rhinestones set in embroidered rosettes around the modestly scooped neckline, and they were repeated in the trim of the terribly chic bolero jacket. She wore gloves, of course, and her shoes and bag were the same lovely powder blue as her dress. Earlier that afternoon, in a frenzy of preparation, she had washed her hair and set it with silver crimping pins to encourage a fashionable wave. She'd spent hours buffing her nails to a soft shine, and now she was ready. She wore no makeup, but as she sailed out of her room, she pinched her cheeks and nibbled on her lips to bring up her color. Not that she needed it, she thought. She was sure she was flushed with excitement and a heady anticipation. She knew that tonight would be special – she only dared hope that it would be the night of her dreams. She flew down the stairs, feeling beautiful, as she always felt around him.

Her Aunts looked stunned when she rounded the curve of the banister, and Bill's face lit up when he saw her. Slowly, regally, she reached the bottom of the steps and held out her hand in greeting, smiling what she hoped was an alluring smile. But before he could help her with her overcoat, Lydia grabbed her hand, and Lou and Clara swarmed around her, chattering like a pack of monkeys. They herded her towards the mirrored coat rack, and when she glanced at her reflection, she nearly had a heart attack. Rhinestones and pink cheeks notwithstanding, the shiny silver crimping pins were still bristling from her head. In her excitement, she'd forgotten them completely.

"I need to get something from my room," she gasped, and fled up the stairs. Berating herself, she flung the offending pins from her hair and combed it out so it fell, soft and wavy, around a face burning with embarrassment. He was waiting patiently for her when she finally came back down, and seemed completely unaware of the mortifying faux pas.

Later, she asked him if he had noticed the pins. Endearingly, he said that he had just thought that it was a new style, and who was he to question the mysteries of women's fashion? It made her love him all the more. Dinner was lovely; dancing was divine. They left the restaurant and walked through the park under a full moon.

Beneath the flowering fruit trees he stopped and pulled her into his arms. When he asked her to be his wife, Gladys felt that her heart would surely burst with happiness. Throwing her arms around his neck, she answered with a kiss and an irrepressible gurgle of laughter. They strolled slowly through the April evening, hands linked. It was the spring of their lives, and all things were possible. Eagerly they planned their future: six children and a beautiful, happy home bursting with laughter. They would create a practice together and share all aspects of their lives. They would grow old together, play with grandchildren and even great-grandchildren. All through their lives, they would be

strength and support to each other, love each other endlessly, and never fail in their dreams.

This they pledged, with their first kiss.

This she believed, with all her heart.

Bill and Gladys - 1st Date

Chapter 17

Cincinnati, Ohio
December, 1943

*I*t was a telegram from Texas. "Dec. 19. Have been bumped – stop – Trying to find another flight but so far no luck – stop – Will keep trying and let you know – stop – Love, Carl & Mary"

Sharp disappointment punctured the bubble of bliss in which Gladys had been living. She and Bill were to be married tomorrow – tomorrow! – and she had never been happier. In between classes at medical school, she had planned her wedding down to the last detail.

The ceremony would take place in the church in which they had first met, Immanuel Presbyterian. Bill's Uncle Albert, the minister of the church, would officiate and Aunt Louise had graciously offered to hostess the reception at their home.

Her parents and Margaret had returned to India last summer, so in lieu of her father, she'd asked her brother Carl to give her away. His bride of ten months, Mary, had turned out to be one of the most delightful people Gladys had ever met, and she had asked her to be Matron of Honor.

Unfortunately, they had been held up in Brownsville, and although Carl had been sure that they would be able to make it back to Ohio in plenty of time for the wedding, it looked like the war was interfering with their travel plans. Military personnel had been given their

seats, and they had been stranded, forced to scramble for another ride. But Carl was nothing if not resourceful, and Gladys' disappointment was assuaged an hour later when the ringing doorbell announced another telegram.

"Found a ride but not booked clear thru. Stop. Will keep you informed. Stop. C&M"

Gladys and Jadwiga were staying with the Aunts, and spirits soared in the little house at 25 E. McMillan St., only to be dashed after dinner by a long distance telephone call. The travelers had landed in Dallas, but were having trouble finding another flight, and it was too late to take a bus or a train.

The phone calls continued through the night and into the next morning; first, "We'll be there," then, "No luck."

The wedding was set to begin at 4 p.m. Finally, just after lunch, when everyone had given up hope, the phone rang again. "We're here, we're here," Carl cried. "Come to the airport and get us!"

They arrived at McMillan Street triumphant and somewhat worse for the wear from more than twenty-four hours of traveling. While Carl and Gordon retired to the downstairs bedroom to get ready, Gladys, Jadwiga and the Aunts swept Mary upstairs, laughing and crying and talking a mile a minute.

Mary was carrying a somewhat bedraggled cardboard box with a perforated lid, which she placed with great care upon the bed, then turned and took her sister-in-law into a huge embrace.

Being hugged by Mary was an all-encompassing experience, for she was a woman of truly great heart. When she wrapped her arms around you, it felt as if the Earth Goddess Incarnate had taken you in. She was a bit taller than Gladys, a strong, sturdy woman with dark hair and snapping eyes. Travel-stained and smelling of airplane fuel, she nevertheless was beautiful, and her legendary smile lit up the room. After a long and joyful embrace she stood back and studied Gladys'

face. Satisfied with what she saw there, she wiped a tear from her eye and said, "I brought you something, Gladys. It's for your bouquet."

Gladys had given up on a bridal bouquet, since it was December and there were no flowers in the garden. Even if she'd had money to purchase some, there were very few at the florists, since the war had made such luxuries unavailable. So she had made a posy out of ribbon, and had sternly told herself that a bouquet didn't matter, not with all the hardship in the world right now.

Hope flared in her eyes as she turned towards the ungainly box on the bed. The women gathered round in breathless anticipation, while Gladys reverently lifted the lid.

Sweet breath of jungle flowers at dawn filled the room, and they all gasped in wonder. Nestled carefully in tissue paper there lay six magnificent white orchids, glistening in their perfection. Tucked in among them were another half dozen perfect gardenias, the source of the heavenly smell. Luxury beyond price, a gift fit for a queen.

I wanted to keep them fresh for you, so I put each stem in a little balloon filled with water – see?" Mary told her enthralled audience. "I made Carl carry everything else, even my purse, so I'd be sure they were safe. I held them on my lap the whole time. Most people didn't pay any attention, but one woman who sat in front of me on the plane kept turning around and looking at the box as if it were a viper, or maybe a bomb. I finally got so tired of her that I tapped her on the shoulder, pointed to the box and said, 'Baby chicks.' That shut her up!" Laughing at Mary's story, they gently took the balloons off each delicate stem, and assembled the flowers into the most elegant bouquet Gladys had ever seen.

The problem of Mary's outfit was solved when they pawed through her suitcase and came up with a beautiful sleeveless rose-patterned sheath, floor length and regal, recently purchased in Panama City. They borrowed a cream-colored bolero jacket from another outfit

which matched the dress perfectly. They all agreed she looked ever so smart.

It was almost time to leave for the church. The Aunts bustled off to get ready, and the girls, in a ritual as old as time, began to prepare the bride. First they brushed her hair until it shone with auburn highlights. It had grown out in the last year, and now curled above her shoulders with a beautiful natural wave. A little makeup – powder, lipstick, and dots of the lipstick on the cheekbones, rubbed vigorously to blend, made an excellent rouge. They clipped earrings of carved ivory from India on her ears, slipped her dressing gown from her shoulders, and turned to face the wedding gown.

It hung on a dress form near the window and shimmered in the golden rays of the afternoon sun like a living thing. Elegant in its simplicity, it was made of white satin, lustrous and rich, like heavy cream. The long sleeves came to a point at the back of her hand and were buttoned with tiny pearl buttons up the wrist. The satin formed a sweetheart bodice, carried up to a high neckline with diaphanous netting, then sewn with seed pearls all around the throat.

It was the most beautiful wedding dress in the world. Gladys was sure of it. She had bought it in a tiny shop in downtown Philadelphia for twenty-five dollars, and although it had taken her entire savings, it was worth every penny. She justified the expense, knowing it was sure to become an heirloom, and she dreamed of seeing her daughters and her sons' brides wear it as well.

The girls reverently slipped the dress over her head and buttoned up the long row of tiny buttons in the back. The veil was a cloud of fragile lace, hand-made and sent from India by the mother of the bride, with great longing and not a few tears.

Finally they were ready. While Mary carried the bouquet and Jadwiga the veil, Gladys gently gathered up the long train and they set off for the church.

It was a small yet deeply heartfelt wedding. The little white church was decorated with evergreen branches and holly, freshly picked from the Aunts' back yard. Uncle Albert performed the ceremony, while Aunt Louise sat next to Clara, Lou and Lydia; they passed one soggy hanky back and forth between them. Gordon, now in seminary, had come from Cedarville, Ohio, for the occasion. Jadwiga sang like an angel. Her voice, almost visible in its purity and sweetness, soared into the air and wrapped the lovers in beauty. Bright winter sunlight poured through the stained glass windows and fell in sparkling jewels: a queen's ransom strewn across the white satin train of the wedding dress.

Gladys had been afraid that she would burst out crying, or be unable to speak her vows, or trip on her way to the altar. Instead, she felt such happiness welling up inside her as she had never known, and it was all she could do to keep from laughing out loud.

Gordon ended the ceremony with a prayer, which closed with, "God bless this boy and girl." This statement coming from her baby brother struck Gladys as so hilarious that she began to giggle. For that reason, when Bill was told to kiss his bride, he found himself kissing her laughing teeth, instead of her soft lips. His look of surprise was so comical that everyone joined in, and thus, in laughter and love, the two were wed.

The reception was a lovely affair. Aunt Louise had somehow saved enough ration coupons for butter and sugar to make a wedding cake, and her already immaculate house had been scrubbed within an inch of its life. Her exquisite collection of cut glass sparkled in the light of dozens of candles, lit against the early midwinter dusk. The newlyweds were toasted and prayed over, but after just a few bites of cake, they took their leave in a hail of rice and well wishes, for Bill had classes the next day.

The happy couple enjoyed a short but fervent honeymoon.

Gladys had finished her exams on Saturday and had arrived in Cincinnati on Sunday, the day before the wedding. However, Bill still had a week of class left, and was to be taking the first major exams of his medical school career. He had had a lab on the afternoon of the wedding, which he had cut at 2:30, arriving at the church just in time to say, "I do." The lab professor, noting his absence, looked directly at his lab partner and asked, "Mr. Gilmer, I see you're all alone at your bench. Where is Mr. McGarey?"

Bob, loyal and resolute, quickly lied. "Oh," he said, looking around in surprise, "I guess he just went to the bathroom, or something."

The professor snapped back, "Don't you think you can fool me, young man. I know he's getting married this afternoon."

Final exams started in earnest the next day. The bride and groom had rented a small room on the third floor of a boarding house near the school for their week-long honeymoon. Bill tore himself away from his bride early each morning and rushed back to her at night. As often as possible, they would have lunch together, and Gladys passed the intervening hours in a dream.

At 6 a.m. on the morning after the wedding, she kissed her new husband goodbye, and fell back asleep. She wandered blissfully downstairs around 9 a.m., and the woman at the desk politely inquired, "Are you Mrs. McGarey?" The name was so new to her that, without thinking, she immediately answered, "No." Startled and shocked, the concierge huffed, "Well, miss, you signed in as Mrs. McGarey!"

Gladys corrected herself and tried to explain to the outraged matron, but her blushes were nothing compared to Bill's mortification when she told him of the incident at lunch that day.

All things considered, he did quite well in his exams. He flunked histology, after a particularly frolicsome night, but all his other classes he at least passed, though not necessarily with flying colors.

They both breathed a sigh of relief when Christmas Day

excused them from the world, and their first holiday together was a magical white one.

During the hours Bill spent in class, Gladys had decorated their little room with pinecones that she had gathered and painted bright colors, then hung here and there with red ribbon. An upright pine bough served as a somewhat bedraggled Christmas tree, strung with popcorn and cranberries, festooned with more red ribbon. She arranged their few wedding gifts under the tree, and they passed the day snuggled warmly together, wandering in dreams of a future filled with children and love and a shared purpose, while the snow blew against the small window and insulated them from the world outside.

When that unforgettable week was over, reality descended with crushing force. Gladys climbed aboard the bus to Philadelphia, waving goodbye to her new husband with tears running down her cheeks. They would be able to see each other only infrequently, and the little apartment that she shared with her friend Margaret Peters looked empty and forlorn. The gray desolation of the war years enveloped her, and if it hadn't been for her studies, she felt she might have gone mad. But her classes were so demanding, the work so incessant, that she had little time to think about anything else.

The Wedding Party (center): Bill, Uncle Albert Hjerpe, Gladys, Gordon, Mary, Carl

Chapter 18

Philadelphia, PA
May, 1944

𝒜 moment of stillness fell upon the six hungry young women gathered in great anticipation around the kitchen table. Fragrant steam rose from the centerpiece of the meal, a huge pot of chicken curry, while a big bowl of overcooked rice sent off its own delicious smell. Mouths watering, stomachs growling, nevertheless no one dug right in. They all paused to eye the food somewhat dubiously.

The first to speak was Gladys, of course.

"You know, when you actually think about it, this could kill us! I mean, who knows how long they've been giving this old rooster that drug, how much has actually built up in his tissues, and how that will affect us. Maybe it'll send all our uteruses into terminal contraction, or it could have a similar effect upon other smooth muscles in our bodies. I know we're hungry," she observed darkly, "but are we hungry enough to risk a painful death?"

A resounding "yes" arose from the group.

"O.K. We'll eat it. But I think we should sign a pact that says we ate it of our own free will." So saying, Gladys jumped up, retrieved a pen and paper, sat back down and wrote:

> We, the undersigned, being of sound mind and body,
> do solemnly swear that we ate this chicken of our
> own free will, and if we suffer death, or other dire
> consequences from it, no one is to blame.

Each one signed it, solemnly. Then, throwing caution to the wind, they attacked. After all, it was ten o'clock at night, and they had been waiting for this all day. They were so hungry they could eat old shoes. But everyone was hungry most of the time these days, with the war dragging on and on, and everything being rationed. Well, not exactly everything. The girls had planted a victory garden, but there was only so much you could do with carrots and radishes. Meat coupons were scarce, and used up quickly; therefore, chicken in the pot was a feast beyond words.

If it didn't kill them.

Which it might.

The bird in question had been a research animal in the medical school lab, and had been used for many years to test a substance called Ergotrate, which was used during labor and delivery to help contract the uterus. On Friday, Margaret Peters had discovered that the old rooster was about to be decommissioned and destroyed. She told Gladys and her other four lab partners, and they had formed their plan. They got permission to take him from the lab Saturday morning, over-joyed at the thought of a chicken dinner.

They showed up as soon as the janitor opened the building, and, in the first floor hallway, allotted jobs. Gladys would cook the bird, with the help of Margaret. She had proposed chicken curry, reasoning that if the drug had left a strange taste after all these years, perhaps a strong curry flavor would disguise it. Susan and Elizabeth would be in charge of plucking and preparing it for the pot, and the lot of execu-tioner fell to Doris and Betty, two girls from Brooklyn who had hinted at vague connections to the Mob. No one really knew how to kill a

chicken, but the New Yorkers were game to try. They headed upstairs with a bloodthirsty look in their eyes, while the others waited impatiently, growing hungrier by the minute. After much squawking and thumping, the two reappeared, harried, frustrated and chickenless. They had tried murder by several methods, including scissors, but they hadn't been able to do him in. Luckily, a fellow student who had been raised on a farm in Iowa happened by, and when pounced upon and questioned, rolled her eyes and said, "You just grab it by the head and swing it around." Thus instructed, the dirty deed was quickly done, and they lugged their soon-to-be dinner back to Gladys and Margaret's apartment.

Gladys was still living in the little apartment with Margaret Peters, even though she'd been married last December, since Bill's school was in Cincinnati and she still had two more years to complete in Philadelphia. She missed him every day, but she was grateful he hadn't been shipped out. He was in the V-12 program, which provided for school in exchange for military service after he received his degree. And it meant that she could see him at least once in a while, for now.

They got the chicken back to the apartment, and as soon as they arrived, the designated pluckers began their job. It was much more difficult than they had anticipated, so they all took turns, feathers flying everywhere.

Blowing a feather off her nose, Gladys observed, "There must be an easier way to do this. I wonder if Mrs. Osborne next door has a recipe book that would tell us."

Consulted, Mrs. Osborne's well-thumbed *Joy of Cooking* suggested dunking the bird in boiling water, which actually worked quite well.

The bird was summarily plucked.

"Do not puncture the gall bladder," the book counseled, "for the bitterness of its fluid will ruin everything it touches."

Hmmm. They, of course, knew where the human gall bladder was located; hopefully avian anatomy was close enough. Carefully, but

ruthlessly, they gutted the bird and finally, about two o'clock in the afternoon, it was ready for the pot.

Gladys sautéed the onions and curry powder, then gleefully tossed the chicken into the pot. Covering it with water, she began to stew the bird.

They could hardly wait.

Two hours later, the meat was still tough as leather, so they simmered it some more. They cooked that bird and cooked it. At eight o'clock Gladys hopefully tossed in a bunch of carrots and prepared the rice. At ten o'clock they threw restraint to the wind and decided to eat it, even if they had to cut it with a paring knife.

Finally, after having signed the suicide pact, they dug in.

It was delicious! Still tough but tasty, that old rooster gave the girls the best meal they'd had in months.

No one died, or even got sick.

And two years later, when Margaret moved out of the apartment, she discovered chicken feathers still hiding behind the bookcase.

<p style="text-align:center">⟡</p>

January, 1946

Gladys was awakened from a dream of marching pencils and looming textbooks by the strident ringing of an alarm clock much too close to her head. She knew the routine by now, so she just stuffed her pillow over her ears and waited. Thuds and muffled French curses erupted from the next room, and grew louder and louder until her bedroom door was flung open and a wild-haired apparition staggered in. It paused to look around frantically, then threw itself on the floor, crawled under her bed, and with a final *"merde"* the malicious alarm was cut off. Gladys watched with a bleary eye while her roommate literally crawled out of her room into the bathroom across the hall, slamming the door

with her foot.

She sat up, yawning and shaking her head. She was used to her French roommate's strange ways by now, after having lived with her for two years, but sometimes it all became a bit much. Especially when Jackie hid the alarm clock under Gladys' bed.

Jackie Chevalier had fled wartime France to study medicine in the U.S. She had married a professor in Einstein's math department at Princeton, about the same time Gladys and Bill had been married, and the two girls had moved into a small three-bedroom apartment at the beginning of their junior year.

Jackie had a thick French accent, knew more swear words than Gladys had known existed, and was trying to quit smoking cigarettes. So she smoked cigars instead.

She also had an almost impossible time getting up in the morning. She was famous for her late arrivals in class because even though she faithfully set her alarm, when it rang in the morning she would roll over and smash it off with a mutter and fall asleep again. After having been called on the carpet innumerable times for tardiness, she devised a plan. She would set the alarm and then hide it, thereby necessitating a frantic search for the offending clock. By the time she found it, she would be awake enough to stagger to the bathroom and splash cold water on her face. It actually worked quite well for Jackie, but it certainly was a jarring way to begin the day for Gladys and their other roommate, Olga.

Olga had been born and raised in Cuba, and her Spanish accent was as thick as Jackie's French one. They all got along well together, the only drawback being that Jackie and Olga couldn't understand each other to save their lives. One girl would say something and the other would try to puzzle it out for a moment, then usually give up and turn to Gladys, asking, "What deed she say?" Gladys would repeat it, and so it would go.

Life was never dull around here.

And now it was January, and exams were over, and all that was left was the posting of final grades at noon today.

Less than a year had passed since the bombing of Japan had brought an immediate end to the war. Everyone rejoiced that the nightmare was over, yet many people, including Gladys, were horrified by the consequences of the act. When the public had been polled in August, a few days after VJ Day, eighty-five percent of the populace approved. It was later, after full casualty reports were revealed, that people began asking, "Why a city? Why not the great military base at Truk or some other military installation? Why didn't they demonstrate the might of the bomb on an uninhabited area?" Such questions tormented Gladys and others in the medical community, people trained to save lives, not destroy them. To many, many people, the wanton destruction of innocents was horrific, unconscionable. The war had ended, the boys had come home, but Gladys had not found it in her heart to rejoice. She had rather buried herself in her studies, looked towards the future, and prayed every night for all the flaming victims of the insanity of war, in Japan, in Europe, even on the home front.

She shook herself out of her dark musings and lurched out of bed, to take her turn in the bathroom and gulp down a cup of the coffee that Jackie always made strong enough to stand up by itself.

By eleven o'clock, the auditorium was filled with nervous young women. You could almost hear them sweat. They sat at the refectory tables, sandwiches untouched in front of them, eyes glued to the door of the dean's office.

Gladys toyed with her food and felt nauseated. Jackie was chain-smoking cigarettes today, due to the general outcry that arose when she tried to light up a cigar. Many of the other girls were smoking, too, and the room slowly filled with a blue haze. Every once in a while someone would leap up and run for the bathroom. Jackie watched

the latest green-faced girl race by, shook her head ominously and said, "I weesh they would *enfin* put the goddamn grades up and stop weeth the suspense – *c'est toute comme Madame la Guillotine!* A few more hours like theese and we'll <u>all</u> be squirting at both ends."

Graphic but true, Gladys thought.

"What deed she say?" Olga asked.

The door to the Dean's office opened. Slowly, ominously, the secretary came walking out, importance in every step, deliberately drawing out the suspense.

Every eye was glued to the bank of mailboxes on the front wall. They were arranged in alphabetical order by last name, one box for each letter. The grade cards were placed in the boxes. White meant passing, pink cards were for repeating the year, and the loathsome blue meant failure.

In slow motion, with infinite care, Miss Perkins slid the cards into the boxes. No one was allowed to approach until she was entirely done. There was complete silence in the hall, broken only by the sound of another girl retching and running for the bathroom.

Gladys felt frozen with fear, and could do nothing but pray. Silently. "Oh God, please let us all pass. We've worked so hard, tried our best. Oh, no! That's a pink card she just put into the M box – and that's a blue! Oh God, forgive me for being selfish but please don't let it be mine. Please let me pass. Please! Please! Please...."

Miss Perkins finally finished and stalked out of the room, a self-satisfied smile on her ghoulish face. For a moment, no one moved. Then two or three of the bravest among them got up and handed out the cards. Gladys' card was white, thank you, God, but her shout of relief was quickly silenced by the agonized cries of those unfortunates who found themselves holding a blue one.

Medical school is the boot camp of the medical profession, with the faculty in the role of drill sergeant. To the raw recruit it seemed as

if the intention was to intimidate them, destroy their self-confidence and individuality, and ultimately, take them out, by gleefully flunking as many as possible. And the end result was the same, for those who persevered and finally graduated, having been through the fire, were tempered like steel. All the excess has been forged into a single-minded force for healing.

In 1944, this was the only women's medical school in the country, and the intent to intimidate was more vicious, the culling more severe, because the professors knew from bitter personal experience the difficulties faced by a female doctor on the front lines of the war on disease.

Women had only recently been allowed to hold the degree of Medical Doctor. Each and every one of them had to prove their worth over and over again to sanctimonious, privileged men who were oftentimes much less skilled in the art of healing than the women they despised. They called their female counterparts, "ball busters" and "man-women," and they intentionally made an already difficult profession nearly impossible for them.

But these women were the shock troops of the feminist movement, and they, like the suffragettes of earlier decades, fought day by day and moment by moment for equality and for their place in the tents of the healers. They were not content to follow behind. They wanted to lead the charge, and they knew they could do it. In the face of derision and name-calling, covert machination and outright stonewalling, the women marched on, and claimed their right to heal. With bleeding hands they clawed their way up the ladder of the profession until today, gender is not an issue (or so we tell our daughters) and a woman doctor is no longer an oddity, but rather, a gift. Therefore, the faculty at Women's Medical College in Philadelphia made it tough on purpose. Their theory, in essence, was this: you are going out into a man's world, and you have to be tougher and better than the men to survive.

Many years later, someone observed, "Ginger Rogers did everything Fred Astaire did, but she did it backwards and in high heels." These were the expectations under which the students labored.

No one was given a second chance. A man might have been able to party his way through medical school, depending upon family connections, to become the kind of doctor who shows up in the O.R. with two stiff shots under his belt and proceeds to amputate the wrong foot.

But not the ladies. They were subjected to stringent moral and social rules, as well as the highest academic expectations. Fully half of Gladys' class couldn't stay the course. There were fifty bright-eyed eager young women on the first day of class. Four years later, only twenty-five weary yet triumphant survivors donned the cap and gown. When they eagerly grasped their diplomas, their eyes, dark-ringed with fatigue, glowed with purpose, determination and pride, for they knew that they were being given grudging entrance into one of the oldest and best kept fortresses of male power.

Roof of Woman's Medical College, Gladys 2nd from left
Summer, 1942

Gladys in Medical School

Chapter 19

Deaconess Hospital • Cincinnati, Ohio
July, 1946

The X-ray table was hard, cold and uncomfortable, but at least it was a horizontal surface. Gladys groaned as she stretched out her aching body, and prayed that she'd be able to get some sleep. Fat chance.

It was 3 a.m. Monday morning and she'd been on call since Friday at 7 a.m. She was more exhausted than she could ever remember being, and the fact that she was three months pregnant didn't help a bit.

She was in the middle of the surgical rotation of her internship at Deaconess Hospital in Cincinnati, and, as Jackie would have put it, it was a bitch. She and Bill were finally living together in a small apartment near the medical school, but it seemed as if they saw less of each other than ever before. The nights she wasn't on call, she'd crawl home and fall whimpering into bed before Bill had finished studying, then be up and back at work before he had even begun to awaken. She was on call at the hospital every third weekend, from Friday morning until Monday night, in addition to twenty-four hour call every third night during the week.

It was a grueling schedule, and she'd expected it to be so. But she hadn't counted on experiencing severe morning sickness, on top of having had the misfortune to pull Dr. Hausen as her head resident.

Hausen had been a captain in the army, and, like many veterans, still longed for the days of camaraderie, spit and polish. A woman's place, as he saw it, was in the home or in a nurse's uniform, and he had no use for females out of their place. That a woman had been assigned to his surgical team was horrifying to him, and he made it his business to show her clearly that she did not belong. Gladys was the first woman intern ever to be accepted at Deaconess Hospital, and most of the senior staff wanted to make sure she was the last. She was assigned all the early morning surgeries, was on call for all holidays, and was humiliated and berated as often as possible.

"Dr. McGarey," Hausen would sneer during rounds, "let us hear your diagnosis." Never mind that the patient in question had baffled the entire staff with symptoms that followed no known course. Whatever she answered was held up to criticism and outright derision. His insults cut deeply, but she cultured a stone-faced expression that said she didn't care. But she did care, deeply, especially when he ripped her apart in front of the patients and staff, and left her bleeding, repeating to herself her new mantra, "I will not let him see me cry."

Her pregnancy made it worse. Not that she had informed anyone of her condition, but the hormonal fluctuations made every emotional situation more so, and it seemed as if she was on the verge of throwing up, sobbing hysterically or falling asleep on her feet one hundred percent of the time.

So as she stretched out on the X-ray table with the small, lumpy pillow under her head, not even bothering to remove her shoes, she breathed a great sigh of relief. Covering herself up with the skimpy blanket, she realized that her picture of heaven had once again changed. Now it consisted of a huge soft bed in a dark room, in a world where telephones and alarm clocks and head residents had never even existed. She yawned hugely and immediately fell into a death-like sleep.

Forty-five minutes later the call phone jarred her out of her

coma, and she leaped off the table, hightailed it down the long hallway, and grabbed the receiver.

"Intern to room 212 STAT," came the command. As she hung up the phone, the severe nausea of early pregnancy overcame her. Before she could make it to the bathroom, up came her meager dinner, all over the floor.

She collapsed on her knees in the middle of the mess, crying uncontrollably.

"There, there, don't you mind a bit, honey chile," a soft voice came from behind her, and a cool washcloth was pressed to the back of her neck. Small strong hands reached down to help her gently to her feet.

It was Lucille, the maid who worked the night shift on the surgical floor. Gladys looked up at her through the tears swimming in her eyes, and to this day, swears she saw a halo around the older woman's head.

Lucille was tiny, but strong as an ox, a black woman in her fifties, born and raised in Cincinnati. She'd worked in housekeeping at Deaconess her whole life, and sincerely loved her job. She had moved to the night shift when her children were small, so she could be with them during the day, and her husband, a maintenance worker at the railroad, could care for them at night. The children were grown by the time the war hit, and she had lost Sam, her youngest, in the attack on Pearl Harbor. He'd been a cook on board the USS Arizona, and so proud, so handsome. It like to broke her heart. But she went on working the graveyard shift, because it helped with her grief, and because there was something special about the hospital at night. When the lights were dimmed and the doctors gone, she was free to do much more than just mopping and cleaning.

Lucille liked to think the Lord put her there to do His secret work. In the midnight darkness of the hospital, when fear walked the

corridors unchecked, she lit her small candle of hope. The doctors seemed indifferent to suffering; the nurses were much too busy. They had no time to hold the hand of Mrs. Anderson, crying in her bed in the dark, mourning the babies she would never know, now that the surgeon had taken her womb. But Lucille understood. She knew from bitter experience how it felt to lose a child and, wordlessly, they grieved together.

Countless other patients had known the gentle touch of her calloused hand, the quiet comfort of her bony shoulder while they sobbed out their sorrows. She never said much, mostly listened, and in her heart, called upon all the Heavenly Hosts to wrap this poor child up in love.

The silent solace of her nocturnal visits was never mentioned by the patients, for most of them thought she was a dream, a figment of their imagination called up in their extremity. Others knew she was an angel, and her appearance a secret gift, never to be spoken of.

Now here was another lamb to her fold, and a pregnant one, at that. Lucille knew morning sickness when she saw it, and the scrawny little thing was shaking like a leaf and white as a sheet, with big dark circles under her eyes. She reached down to help Gladys to her feet.

"Now, you just never mind this mess," she said, as she took the washcloth and gently wiped Gladys' mouth, then repaired some of the damage done to her lab coat and blouse. "There. Now you look jus' fine. Go on off with you now; Lucille will clean this up. You do your job and I'll do mine, and somehow this ol' hospital will keep doin' what it's supposed to do."

Feeling as if she'd just been snatched from the jaws of death, Gladys nodded and smiled a tremulous smile, then made her way to Room 212. When she returned, the floor was clean as a whistle, and Lucille was nowhere to be seen. She staggered back to the X-ray table, praying for a few hours of uninterrupted sleep before the 7 a.m. surgery

call.

Hausen always scheduled her for the early morning surgery, which meant she had to be scrubbed and ready by 6:30. The worst part about the early slot, she thought to herself as she climbed upon the table and punched the rotten excuse for a pillow, was that the cafeteria didn't open until eight o'clock, so she never had anything in her stomach to quell the morning sickness. Early surgeries were always the most complicated, and therefore the longest, so she had to battle the overwhelming nausea and exhaustion, as well as the pointed barbs and critical comments of her head resident for three, sometimes five, hours. But the stubbornness that had caused her so much trouble as a child now became her ally, and she absolutely refused to let him see her break. She vowed that she would fall over in a dead heap before she'd let that happen.

When the hospital came to life the next morning, she stumbled down the hall and glanced up at the assignment board. Her mouth dropped open in stupefied wonder. Carl Ferber, the other intern, was scheduled for the first surgery. "Hallelujah, God is good," she thought, profound relief washing through her. "I can change my blouse and go EAT BREAKFAST!" She danced down the hallway, happier than she'd been in a long time.

Every day for the next week she was scheduled for the 9 a.m. surgical team, and she said many private prayers of thanks that Hausen had apparently had a heart transplant.

She was disabused of that notion when he stopped her in the break room on Friday.

"Dr. McGarey..." He always said it with such sarcasm. He stood, blocking her path in the doorway, looking down his thin nose at her, a tall man with chiseled features and sandy hair that was already thinning on top. His hands were skilled but his heart was hard. He had the soul of a technician and the personality of a crocodile lurking in the

shallows.

His lip curled in a sneer and he looked at her, she thought dispassionately, as if she was a roach he was about to step on.

"Listen here. I'll thank you to keep your meddling little hands to yourself, and stop rearranging the surgery schedule so you can get your beauty sleep. Not that it helps," he added with a nasty chuckle.

Gladys was honestly shocked. "I wouldn't ever do a thing like that, Dr. Hausen," she asserted. "You must know how much I enjoy the challenge of the more difficult cases, and," she added untruthfully, "I always learn so much when I assist you."

Carl Ferber had told her to try that approach, and apparently it worked, for the self-satisfied look returned to his face. As he harrumphed away down the hall, Gladys shook her head in wonder at the man's monumental ego. He'd actually swallowed it! Amazing!

She was on call that night and was headed back to "bed" at 3 a.m. when she happened to glance down the darkened hallway to the nurses' station. It was deserted except for one small figure. Lucille was standing on tiptoe perched on a chair which she had dragged over to the scheduling board. Gladys watched in fascination as the other woman erased her name from the 7 a.m. slot, replacing it with Carl's and carefully wrote McGarey in the space for the 9 a.m. surgery.

"Yes, there are angels here on earth," she whispered to herself, "and I'm looking at one of them now."

She hoisted herself up on the hard table and, with a grateful smile on her face, fell into a deep, dreamless sleep.

Christmas Eve, 1946

"I still can't believe that we have three days off – together! I don't know how long it's been since that happened," Gladys said hap-

pily, as she eased her great bulk back into the car seat, trying in vain to find a comfortable position.

"Actually, I think it's been since our honeymoon Christmas. Remember that little room, and those painted pinecones you hung everywhere?" Bill recalled with a fond smile, carefully pulling out into the snowy street. He peered through the windshield wipers and drove slowly down McMillan Street, past houses bright with holiday lights. "Boy, the Aunts still know how to put on a feast. I'm so stuffed I could burst."

"You're stuffed!" she replied without rancor, "You should try having a child growing to full adulthood inside of you!"

Bill chuckled. "Now, honey, the baby's only a few days late, you know that's normal for a primipara. But, really, are you feeling OK? You didn't eat much." His voice became full of concern, and his hand was warm as he clasped hers on the seat between them.

Now, Gladys had heard her patients describe their ninth month of pregnancy in many imaginative and sometimes profane ways. But to her, the term Pregnant Elephant seemed to cover it all. She didn't walk; she wallowed. She couldn't tie her own shoes – heavens, she hadn't even seen her feet for weeks now. Luckily, her last rotation had been obstetrics, and she and the patients had spent a lot of time commiserating. She'd been the butt of the staff's good-natured jokes, but she hadn't minded for she had been gripped by the euphoria that sometimes accompanies the last trimester. She was overwhelmed by the wonder of it all. She was the creator of life, mother of the species. She'd spent the two weeks since the completion of her internship lost in a dream world, sleeping and taking long walks, in between bouts of frantic house-cleaning. Nesting, they called it. Whatever it was, she loved it and felt blessed beyond all women, lavishly fertile, mysterious, miraculous.

She shook herself out of her fantasy world and replied to his question. "Oh, I feel just fine – well, as fine as I can feel with Little Doc

doing a tap dance inside. I just couldn't eat much because there's no room left anywhere. And, I don't know, I've been having gas pains all afternoon. Maybe it was the pickled tongue." She shot him a sly look and giggled.

Playfully, he batted her on top of her head.

"No fair! It's not my fault we had that anatomy review last week. When I saw that ol' beef tongue all sliced up and spread out on that plate, I just couldn't help but identify structures. How could I eat it after that?"

They both laughed as they remembered how he'd stared, transfixed, at the slab of pickled tongue that Aunt Clara had placed on his plate, poking it with his fork, lips moving silently as he flashed back to his anatomy lab. Unable to eat a bite, he'd slipped it to his loving spouse, who had polished it off for him. But since then she'd been having intermittent, stabbing gas pains.

"Oh, there's another one…oh ay yi yi, that hurts!" She put her hands on her huge belly as the pain continued. Through her foggy haze of contentment she felt the unmistakable sensation of a uterine muscle hardening, moving up into a contraction. Shifting quickly into doctor mode, she checked her watch. Her eyes widened as she realized what was happening. The contraction lasted for 10 seconds, then eased off. Fifteen minutes and three contractions later, they pulled up in front of their apartment, and she felt the wave of another one cresting. She hadn't said anything to Bill yet, but this was a really big one. She felt gripped in a vise, unable to move. Bill had gotten out, come around and opened her door, and was holding his hand down to help her to her feet. But this one lasted for 45 seconds and she knew it was time. She sat back in the seat, breathing quickly and, looking up at her unsuspecting husband, said gently, "Bill, honey, go up and get the bag I packed for the hospital. I think Little Doc wants to be a Christmas present."

As realization dawned upon him, Bill's eyes got wider and

wider and he turned instantly from a blasé, cavalier, highly educated medical student into a raving lunatic.

"What? What?" he cried, "Now? Oh no! You're sure? Now? Oh no!"

Now, Bill McGarey had often watched frantic fathers-to-be pacing the waiting room, and had smugly believed that he would never be like that. Complacent in his superior knowledge, he'd planned each move he would make, each response. He reasoned that since he had observed three deliveries and assisted in another, since he knew the physiological progression of labor, that he would be the perfect expectant father: the rock for Gladys to cling to, the steady one. Concerned, yes, but confident and knowledgeable enough to be calm, understanding, strong and supportive.

Instead, he stood rooted to the curb in the snow, and Gladys took pity on him.

"It's O.K., Bill, really. The contractions are still five minutes apart, but they're getting longer and more severe. I think we should get to the hospital. Now, why don't you just go upstairs, take the key and unlock the door, and get the little blue suitcase that's on the floor in the hall closet." She spoke to him as if he were a small child. "Then come right back down here, and you can drive me over to Deaconess."

"Right, right," he repeated, while the snow fell all around.

"Close the car door, now, dear, and just go upstairs. Blue suitcase. Bring it to me. Now. Do it." She reached out and slammed the car door, the sharp noise of which sent Bill leaping up the steps to the apartment building. Within moments, he was back, suitcase in hand.

They arrived at the emergency entrance to the hospital soon thereafter. Since the entire staff felt they had a proprietary interest in her pregnancy, Gladys was greeted with great excitement, and was soon installed in her room.

And, of course, her labor promptly stopped.

She held court for several hours, while Bill paced back and forth. Everyone who worked at Deaconess, as well as many of the patients, stopped by to see how she was doing.

"Bill, this is just silly," she burst out after three hours without a twinge. "It must have been false labor. Let's go home. You know we've got John and Ada coming over for Christmas dinner tomorrow, no, today! And I've got a turkey to cook and the house to clean. Oh my gosh, how will I ever get it all done? Help me find my shoes, I gotta get out of here!" Frantic, she lumbered out of bed against Bill's protests and immediately doubled up against a mighty contraction. "Oof" was all she could say, as they helped her back into bed, and labor started in earnest.

She labored all Christmas Day. Her entire being became focused on riding the waves of pain. She knew she couldn't fight it, that the best thing she could do was to step out of the way of the massive contractions of this muscle, completely out of her control, which rhythmically threatened to break her in half.

These were the days of physician manipulated labor, general anesthesia, and twilight sleep. Routinely, even with healthy young women, doctors used ether, high forceps and ruthless epesiotomies. The mother to be was prepped by having every inch of her perineum shaved and having to endure several enemas.

The last thing Gladys remembered that night was throwing the bedpan at Carl Ferber as he waltzed into the room with an enema tray, laughing like a crazed hyena.

Now, she and Carl had shared a lot of things during their year of internship, and usually they gleefully traded macabre jokes and irreverent comments. He had kidded around about prepping her for labor, and she had laughed at the time.

She wasn't laughing now.

His fiendish laughter echoed in her head. Through a red haze

she saw him stalking towards her, enema bag in hand, and all she could do was scream.

"Oh no you don't," she shrieked, as he ducked the bedpan. She grabbed the clock on the bedside table and chucked it at him, followed by everything else she could get her hands on.

The tray went flying and Carl ran for his life, swearing. Exhausted, Gladys flopped back in bed and everything after that became fuzzier and fuzzier.

The next thing she knew it was two days later.

"Honey, wake up and meet your son." Bill's beloved voice roused her and slowly, she opened her eyes.

Her mouth was as dry as the Sahara Desert and her body felt bruised and battered, but the room was bright with winter sunlight and Bill was sitting next to her, face alight with happiness. She was wearing a little yellow bed jacket made of quilted satin, and holding a wiggly, warm, blue-wrapped bundle in her arms.

William Carl McGarey looked up at her with huge brown eyes, and immediately began rooting for the breast.

Oh, miracle of miracles, this surely was the greatest of them all. Ignoring the baby's loud protest, she inspected him greedily. Yes, he had all his fingers and toes, he was perfect! She marveled at the tiny dimpled elbows and nuzzled that sweet, sweet place at the nape of his neck.

Bill told her that it had been a brow presentation and she could see for herself that he had an unusually large head, so the marks from the forceps were even more pronounced than usual. With gentle fingers she touched the bruises on the fragile skin, and vowed she would never let anything hurt him again. Finally, she put him to the breast, where he began suckling noisily, and joy flooded through her and carried her away. She fell back asleep, content, complete, and as happy as she'd ever been in a life that was progressing just as it should.

Gladys with baby, Carl

Chapter 20

Cincinnati to Wellsville, Ohio

June, 1948

Gladys drove through a perfect summer day, windows wide open, the rich, warm fragrance of June rushing in on the wind to embrace her. Scents of new-mown grass and lush green earth mingled with the lavish perfume of roses and sweet peas, honeysuckle and wall-flower. Every breath filled her with delight.

Sunlight flashed through the branches of the great elms that arched overhead. Here on the outskirts of Cincinnati the streets were wide and gracious, and some of the houses had picket fences laden with rambler roses in their first riotous bloom of summer.

Gladys was singing at the top of her lungs. The world was her oyster, and she was enjoying every bite.

"Zippedy doo-dah, zippedy ay!" she caroled, fervently, but somewhat off-key. "My, oh my, what a wonderful day!" She reached over to pat baby John's diaper-clad bottom. He was sound asleep in his cardboard box, scrunched up on his tummy, little teeny bottom in the air. The box was lined with a blanket, and sat snugly on the passenger seat next to her.

He was the sweetest thing, she mused, letting her hand rest gently on his tiny back. He stirred and murmured in contentment. Only three months old, and already there was such wisdom in those big blue eyes.

His birth had been easy, and so far, he was the most amiable baby she'd ever seen. He smiled easily and often, hardly ever cried. When he was hungry or wet, he just got a sad look in his eyes, and quietly, patiently, waited to be helped out.

Quite a difference from Carl, that little tough guy. Round and roly-poly, he had always let her know, loudly and in no uncertain terms, exactly what he needed. Since he had begun talking, his comments and demands were, while monosyllabic, even more unmistakable. He'd started walking six months ago and now he was everywhere all at once. He never let anything stand in his way, just put his big ol' little head down and rolled right over it, like a baby elephant in August on his way to a waterhole.

She sang because she was happy, and in love with her little family, and because they were on their way to a new life. They'd hitched a trailer to Bill's 1940 Plymouth and packed up all their belongings. With Carl bouncing on the seat next to him, Bill had led the way out of Cincinnati. Gladys and the baby followed behind in her old '36 Chevy, which she'd recently bought from Aunt Mary for $100.

Bill's internship at Cincinnati General had just ended. They were moving across the state to Wellsville, his hometown, to open their first practice.

Gladys had spent the past year immersed in motherhood, but also working part time with a plastic surgeon, repairing congenital deformities and severe scars. She had found it to be very rewarding and had briefly considered specializing in it. But in the end, she had decided to go with General Practice, like Bill, and now they were a husband and wife team.

Leaving the outskirts of Cincinnati behind, the road narrowed, winding up into the hills. It was still early in the morning, and it felt as if they were the only two cars in the world. Hardwood forest took the place of green lawns as they left civilization behind.

Ohio

Bill started to put on speed.

His loving wife's happy smile began to fade as she watched her speedometer creep up to thirty miles per hour, then thirty-five. As the needle neared forty, the trailer in front of her started to sway when they whipped around curves.

Two thoughts occurred to Gladys simultaneously.

The first was that Bill had mentioned with a shrug a couple of days ago that his speedometer was broken.

The second was that the trailer hitch had already been broken and repaired once before – what if it broke again?

As their speed kept increasing and the trailer began rocking ominously around each turn, the mother in her could clearly see the disaster that was surely about to happen. The poorly repaired hitch would snap, the trailer would go flying over the cliff, and the Plymouth would plummet into the stream that ran merrily beside the road. Her husband and first-born would be thrown from the car, and Carl would go bobbing down the creek like a cork, smashing against the murderous rocks. She would squeal to a stop and leap in after them, saving Carl first because, of course, he couldn't swim.

But what if she couldn't find him?

And how could she leave Johnny alone in the car, to be crashed into by the first passing motorist?

And what about Bill? He could bleed out before she'd be able to get to him.

Her life would be over before it truly began. She would...

"Get hold of yourself, Gladys," she said sharply to herself, out loud. Don't just sit here, watching that maniac destroy your life. Do something."

She began to honk the horn and yell, leaning out the window, trying everything she could to get his attention.

No dice. Her old Chevy couldn't even keep up, much less pass

him and force him to slow down. The Plymouth flew down the road, going at least forty-five miles per hour, with the treacherous trailer lurching behind, and disappeared around a bend far ahead.

Gladys prayed with every fiber of her being. She prayed that the patron saint of foolish men would keep her child safe, and keep her husband alive until she could kill him herself.

When she finally came into the small town of New Washington, he was pulled over to the side of the road in front of a café, waiting for her.

Controlling herself with great difficulty, she parked the car. Then, trembling with suppressed rage, she snatched Johnny out of his box, slammed her door, and approached the Plymouth.

Bill didn't see her as she stalked towards the car. With great satisfaction and a huge grin, he was saying to his son, "Car go fast!"

Carl, the little monkey, chortled with delight and repeated, "Car go fast," and then added that sound the male of the species seems born knowing, "Rmm, rmm, rmm," accompanied by appropriate hand and head gestures.

As she loomed like an avenging angel over the car, Bill rolled his window down the rest of the way and looked up at her innocently.

"Want to get some breakfast?" he asked, while Carl jumped up and down on the seat next to him.

"Car go fast!" he squealed, "car go fast! Rmm, rmm."

"Bill McGarey, just what do you think you were doing? That's my firstborn son in the car with you! You must have been going sixty miles per hour! If you ever do that again, I promise you I'll..." she sputtered, searching for a threat grave enough to convey her meaning. "I'll...I'll...I'll chop your head off! And that's no joke!"

His blue eyes widened imperceptibly, whether in justifiable fear or hidden mirth she did not, nor did she care to know. He nodded, suspiciously docile, while Carl kept laughing, "Car go fast!"

"After breakfast, I'll take the lead," she announced, hoisting Johnny over her shoulder and stomping off into the restaurant.

"Urp," said Johnny.

"Rmm rmm," said Carl.

"Oops!" said Bill.

<center>❦</center>

They set up their first practice on Main Street, a block away from the Ohio River. Sometimes, when the sun was early in the sky, the great rolling body of water reminded her of the Ganges. She would steal a moment to wander down to its banks and remember standing on the bridge at Hardwar, dreaming.

They rented two suites for a good price in the old building that housed the grocery store and pharmacy. Their offices were on the second floor, and from the waiting room one could catch a glimpse of the river. They purchased their equipment, also for a good price, from a local doctor who was retiring, and placed their favorite piece, a hundred-year-old iron exam table, in the first of the two examining rooms. The suite also offered the luxury of a separate office in the back with a large closet, which they turned into their own lab.

Wellsville was Bill's hometown, and he knew every inch of it. It had a population of 7000 individuals, most of whom worked in the local pottery factory or for one of the ubiquitous steel mills. A typical Ohio River town, it huddled miserably along her banks, brick buildings grimy from coal smoke, inhabitants hardworking but poor, expecting little from life, receiving less. The town boasted five doctors, three grocery stores, a pharmacy, and a brand new Tastee Freeze.

Bill's brother John, always the entrepreneur, had bought the Tastee Freeze franchise a few years ago and set up shop at the edge of town. It had a neon sign that said, "McGarey's Drive In, The Best Chili

Dogs Anywhere," and "Soft Ice Cream." Fast food was a new concept, but proving very popular, especially with the young folk. As a result, John and his wife, Irma, were well on their way to becoming prominent citizens. They lived on the hill, right next door to the O'Haras. Arguably the town's wealthiest family, Del and Janet O'Hara owned the local pottery factory, which was world famous and supplied dishware for most of the resorts in the Adirondacks, as well as many hotels and restaurants in Philadelphia and even New York City.

Bill and Gladys bought a cozy two-story brick house on Aten Avenue. It had a large back yard and a small front porch. They considered themselves lucky to have an electric furnace rather than a coal burner which had to be stoked constantly, like most of their neighbors. There was even a wringer washer in the basement, and plenty of room to string clothesline to dry diapers in the winter.

They settled in quite quickly. Bill, being a local boy, was accepted readily as the new doctor in town, and his practice filled rapidly. He treated everything from cuts, bruises and broken bones to serious illnesses. The charge for office visits was two dollars, and house calls were five dollars. They charged seventy-five dollars for home deliveries and twenty-five dollars for hospital births. One day, during a flu epidemic, Bill did anesthesia at the hospital, saw patients in the office all day, and made twenty-two house calls.

But Gladys had quite a bit more difficulty becoming accepted. Wellsville was a rural town, and most of the inhabitants had never seen a woman doctor before. None of the men would even consider accepting her as a physician. At first, she was relegated to women's care, obstetrics and pediatrics. All of these she loved, but she chafed at the restrictions placed upon her. She persevered, however, and after having treated the mayor's lacerated elbow in her kitchen on an emergency basis one Sunday, began to be more universally accepted.

She soon became pregnant again, and determined to work until

the last minute, in order to not lose the practice she was just beginning to build. They had hired their next door neighbor, Mrs. Caine, to care for the boys during the day, and she was happy to help with the housework as Gladys became more and more bone-tired and cumbersome.

Vacation Time, 1949
Gladys and Bill
with Friends

Aten Avenue home
Wellsville

June, 1949

Gladys ducked into the office bathroom and closed the door firmly. Pushing her damp hair back from her face, she leaned her forehead against the cool mirror, turned on the cold water, and ran it over her wrists. It helped a bit, but she was still miserable. Eight months pregnant and mean as a wounded leopard, she felt like screaming, but she forced herself to breathe and calm down.

Things weren't going well.

In the first place, she'd been in pain ever since she'd torn her pubic symphsis on that house call last week. One of their poorer patients had gone into labor and had called at 9 p.m. Bill was out, so she had grabbed her bag and called Mary Ellen from down the street to babysit. When she had tried to haul her huge bulk and her heavy

medical bag up her patient's rickety stairs, she saw that one of the steps was missing. As she stepped up and over it, she felt, as well as heard, the cartilage in her interpubic joint rip. Now she was unable to walk without pain, and nearly any small movement caused tearing agony to leap up her swollen belly and down her legs, raging like fire all through her body.

In addition, it was ninety-five degrees outside, and the air was so thick with humidity you could almost swim in it. Inside these packed rooms, she'd wager it was at least 120 degrees. The waiting room was full. Patients came in the morning without an appointment and just waited until they could be seen, sometimes packing a lunch against the long delay. Bill and Nina Lee, his nurse, were busy all the time. Gladys did her best, lumbering from room to room, enduring kicking children and comforting weeping women.

But Mrs. Anderson had nearly sent her over the edge just now.

Seventy years old and known far and wide for her gossiping tongue and evil disposition, Edith Anderson had woken up this morning with a sharp pain in the lower right side of her abdomen. She'd had to wait for hours in the stifling heat, listening to howling brats and distraught mothers. And when the pretty nurse had finally called her into the room, who should walk in but a pregnant woman, calling herself a doctor.

Edith was shocked speechless.

"Hello, Mrs. Anderson. I'm Doctor McGarey. Let's just have you lie back on the table and we'll see if we can figure out what's going on. Show me where your pain is."

Edith shrank back against the wall. "Don't you touch me you…you <u>woman</u>!" she hissed. Why aren't you at home with your children? You have no business being out like this! You're no doctor!"

Patiently, Gladys replied, "I assure you, ma'am, I've been fully trained as a physician and am as highly qualified as my husband. I went

to medical school in Philadelphia and did my advanced training in Cincinnati. My diploma is right there, hanging on the wall.

"Now, from the way you've described your symptoms to the nurse, I'm pretty sure you have appendicitis, but I won't be able to be sure until I do an exam. And if it is appendicitis, you need to get treatment right away, so please, let me help you."

"Get back, get back!" Edith shrieked. "Don't you come near me! That the world should ever come to this! I never! Women pretending to be doctors! I've said it before and I'll say it again, it's that Eleanor Roosevelt's fault, you can be sure of it. Just leave me alone. I'm getting out of here!" And with that she grabbed her clothes and, with frantic movements, started to get dressed.

Hippocratic oath notwithstanding, Gladys had wanted to slap her, had entertained dark fantasies of grabbing her pinched, hate-filled face and ripping it off her body. Instead, she'd pulled herself together and silently seethed out of the room. It wasn't until she got into the bathroom that she let herself break down and cry.

"Too much, too much. Sometimes it's just too much," she sobbed. She knew she had to get out of there, or she'd not be responsible for the consequences.

She wiped her eyes, told Nina Lee she was leaving, and fled for the comfort of home.

Mrs. Caine welcomed her at the front door, a concerned look on her face. The house smelled like baking bread, and the front room was dark and blessedly cool, for the curtains had been pulled all day. The housekeeper uncharacteristically fussed over her. Laying her down on the old brown sofa, she removed the shoes from her swollen feet, and went into the kitchen to get a cold washcloth for her aching head.

Gratefully, Gladys closed her eyes and breathed a prayer of fervent thanks for the woman. She was a tower of strength.

Mrs. Caine was a German immigrant and had come to the

States many years before the war. She had watched in helpless horror as the Nazis terrorized the world and had endured prejudice and ostracism as a result of her thick German accent. But she baked the best bread and Parkerhouse rolls to be found anywhere, and after her husband died, supplemented his steelworker's pension by selling baked goods to her neighbors.

She lived in a neat white house directly behind the McGareys, and when she had offered her services as babysitter and housekeeper, Gladys had leaped at the suggestion. Although she was eighty years old, she was still strong and robust, and apparently well able to handle two toddlers while keeping the house up to the standards of her German ancestry. For someone like Gladys, whose housekeeping skills were unenthusiastic at best, this was luxury beyond price. She felt pampered and self-indulgent every time she noticed that the furniture had been waxed or the floor scrubbed and she hadn't had to lift a finger.

Mrs. Caine bustled back in, white hair neat as a pin in a bun on top of her head, crisp apron tied over her freshly ironed house dress. With gentle fingers she placed the wet cloth over Gladys' weary eyes.

"My poor lamb," she muttered. "You work much too hard, Mama. This baby, she will fall out on the floor if you carry on much longer, thinking you can keep up with those men, and you in your state. You need to rest and get strength back, so when labor comes, you will be strong enough to push out our baby girl. Then we'll all be happy."

Mrs. Caine was doggedly rooting for a girl, rather than another rambunctious boy.

"Bless you, Mrs. Caine. You're an angel." Gladys sighed. "I guess I will just lie here for a while, it feels so good. How are the boys?"

"Oh, they do fine. It's almost naptime for them. And you, too – you go to sleep for a little while. I'll take care of everything. *Nein nein,* you boys, you go back into the kitchen. Your mama is sleeping now.

Shoo! Shoo!"

John and Carl had come tumbling into the room, and she herded them back through the swinging door. Gladys listened until they trooped up the stairs, then began to drift off. She placed her hands on her hugeness and prayed that the baby would come soon. Mrs. Caine's certainty about the sex of the child had communicated itself to her. She, too, thought a girl would be just dandy. A sweet little girl, hopefully just like Margaret, quiet and biddable, with Bill's blue eyes, and his charming smile. She drifted off into the forbidden deliciousness of an afternoon nap.

She dreamed she was back in Kentucky. For six months after his graduation from medical school, Bill had apprenticed to a Dr. Baker in his small rural practice outside Berea. It had been a halcyon time for her. Carl was newborn, and she had spent most of her time in a rocking chair on the front porch, nursing him and daydreaming. Doing nothing for once in her life, nothing but caring for her husband and her babe, and tidying up the cabin once in a while. It had been sheer heaven.

In her dream, she was on the front porch again, sun filtering through the encircling pines, soft breezes teasing wisps of hair around her face. She was wearing her favorite old calico housedress, and holding a little girl in her arms. Carl and Johnny were playing with toy trucks in the patch of ground that served as a front yard. She was rocking and singing lullabies.

Suddenly, as often happens in dreams, everything changed. Now the ayah was standing next to her, and the cabin had become the Rourkee Compound. She was on the front porch, surrounded by her mother's Easter lilies, and her sons were playing kick ball with her brothers. They were all of the same age, and were laughing, tumbling around, having such fun. The ayah placed a tender hand on her shoulder, and Gladys looked up into the beloved face, much older now, with grizzled hair and few teeth, yet still beautiful to her nursling.

"Yes, my little sweeting," her old nurse said, "you have made handsome babies, and they are wonderful and full of delight. However, you must always remember, these are not your only children. Your children are many, and you were born to care for them all."

Gladys became aware that she was now holding two babies, with another sitting on her lap. Children were everywhere, crawling on the verandah floor, playing on the steps, running around the hedges in the hot sunlight. To her amazement, the compound became a great open field filled with people. Not just children now, but rather every age: old, young, and in between.

In unison, they all lifted up their arms, looked at her and said, "Mama."

With a start, she awakened, feeling confused, overwhelmed and intensely fulfilled all at once. She took a shaky breath and heard, in the background, the reassuring murmur of Mrs. Caine reading a bedtime story to the boys. Marveling at the strangeness of dreams, she put her head back down and dozed off again, this time into a dreamless slumber.

Chapter 21

Wellsville, Ohio

August, 1949

\mathcal{T}he luminous dial on the clock next to her bed read 3:30. She opened one reluctant eye in response to the insistent whisper and small prodding finger of her first-born.

"Mommy, Mommy! Wake up!"

Gladys forced her other eye open and lifted her head.

Two-and-a-half-year-old Carl stood inches from her face, cuddly pajama-clad form quivering with urgency, brown eyes wide with fear. Johnny was pressed close behind, also in pjs, clutching his big brother with one hand and a bedraggled stuffed lamb with the other.

She'd gotten home from her ten-day-long post-partum hospital stay just yesterday, so she was feeling well rested. She had no trouble coming instantly awake in response to the plea in her children's eyes. She sat up, careful to not awaken Bill, and looked down at her sons. She'd missed them so much! They stood in the soft glow of the nite-lite, all sturdy and sweet, with complete trust shining in their faces. The rush of love she felt for them was like a fist to her heart, snatching her breath away. They were so impossibly adorable she just wanted to eat them. But it seemed that they had something more on their minds than a bedtime tickle.

"Mommy," Carl announced in a sibilant whisper, "there's a

animo in my room!"

Johnny nodded vigorously in agreement. He agreed with every-thing his adored big brother said and followed him around like a puppy.

"What?" she asked, completely mystified.

"There's a animo in my room. Come see!" He tugged on her nightgown and there was nothing to do but comply. She eased herself out of bed – Bill didn't move a muscle – and quietly padded into the hall behind the two little boys. Closing the door silently, she knelt down so she was on a level with the two pairs of eyes, one pair brown, one blue.

"Now, what's all this *tamarsha*?" she asked with a smile. She wrapped her arms around them and pulled them close, inhaling deeply the smell of small boy: crayons and dirt, and a lingering whiff of Ivory soap from their bath this afternoon. They hugged her back with their chubby arms, then Carl, never one to be turned from his purpose, pulled his face back and held it an inch from hers, insisting, "Really, Mommy, really! There's a big ol' animo in my room!"

"Grrr, grrr," explained Johnny, shaking the hapless stuffed lamb by the nape of its neck.

"Well, let's just go see about that." She stood up, holding both boys' hands, as the door to the extra bedroom opened and her father poked his head out. Stepping out into the hall and closing the door behind him, he gave a wide-awake grin and asked, "What's going on?" Now in his late sixties, John Taylor was still a tall, strong man, in spite of the myriad diseases and infections he'd endured in his beloved India. He and Beth still ran the Children's Home where there were 400 young-sters under their care. But they'd been given furlough a month ago, and the timing had been perfect for them to come and help out while Gladys was in the hospital with her new baby. They had arrived in Wellsville on the twenty-third, just in time for Annie's birth, after having spent two weeks in Baltimore with Aunt Belle and her husband, Uncle Ed.

Yes, Aunt Belle had finally married. Ten years ago, the Lord had told her to leave India and return to the States. This she had immediately done. Packing up her battered old carpet bag and saying a tearful farewell to her children, she had walked, hitchhiked and ridden every kind of conveyance from Northern India, across Pakistan and into the wild, beautiful hills of Afghanistan. There, stymied by the incessant bloody feuding of the local war lords, she was almost turned back. Refusing to be checked, she accosted two young American journalists in a café and announced that the Lord wanted them to accompany her through the disputed territory. Such was her conviction that, although quite startled, they acquiesced immediately. After thanking the young men for their help, she took the train north into pre-war Germany, for the Lord had also told her that she was to meet with Hitler and convert him to the loving precepts of the Prince of Peace. She tried her very best, but failed to obtain an audience with the Fürher. She barely made it out of Germany and across Europe, and by the time she stepped off the boat in New York, she had no suitcase or clothes left, for she had given them all away to those less fortunate.

It was at a revival meeting that she met Uncle Ed, an evangelical minister from Baltimore, and, seeing in each other kindred spirits, the two married within a month. They settled down in Ed's big house on the outskirts of the city and were visited quite often by various members of the family.

Gladys and her brother Carl had visited them during her third year at Muskingum. They had attended Uncle Ed's church on Sunday, and in the midst of the "Hallelujahs" and "Praise the Lords," Carl had leaned over and whispered in her ear, "Looks like someone came in here and said, "Stick 'em up!" This struck them both as incredibly funny and, luckily, at that very moment, someone across the room fell into foaming spasms, proclaiming in tongues. All attention was turned to her, and the two irreverent young people were able to sneak out,

snickering, and collapse in laughter in the small graveyard next to the church.

John and Beth had spent a pleasant two weeks in Baltimore, filling Belle in on the news from India. They had arrived in Wellsville just in time to take Gladys to the hospital. They planned to stay for at least another month.

"Gampa, Gampa!" Carl ran over and grabbed his hand, looking earnestly up into his face. "There's a animo in my room!"

"Well, my boy, your Grandpa's certainly the one to come to when you've got a wild animal in your room. Is it a *kheri-sher*? Or a *sher-babar*?"

"Dunno, Gampa. Come see!"

Johnny nodded so hard he almost fell over.

The small entourage trooped down the hall into the boys' bedroom. Sure enough, a strange, rhythmic whistling murmur filled the room. Gladys walked over and peered into the cradle that held the newest addition to their family.

She was snoring.

The two adults laughed softly.

"It's not an animal, Carl, it's just your little sister."

The boys were cowering in the doorway. "No, no, it's a animo! Babies don't go grrr!" Carl asserted.

"No, honey, really, it's just your baby sister. She's snoring! Come look."

But both boys refused to budge, or to believe that the terrifying noise could be coming from anything other than a dangerous beast.

"Tell you what," John said, always the hero, "I'll take that ol' animal into my room, then you boys can safely go back to sleep."

He picked up the cradle, infant and all, and carried it into his room. When he put it down next to the bed, Annie awakened and started to whimper. Gently, he began to rock the cradle, and the soothing

motion, along with the creaking of the old wooden rockers, quickly lulled her back asleep.

Breathing a prayer of thanks, Gladys finally got the boys back to bed.

For the rest of their visit, Annie slept in her grandparents' room, snoring loudly. When quizzed as to whether she was keeping them awake, they replied, smiling, "We've slept through worse." And if the baby awakened crying in the night, John would stick his hand out from under the covers and give the cradle a rock, until she fell back into slumber. A deep bond was created between the two of them during these midnight hours, one which was to last a lifetime.

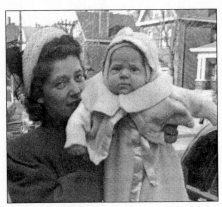

Gladys with baby Annie

March, 1950
On the road to Florida

"I gotta go potty!" All three little boys in the back seat were howling now.

In the front seat, their mothers looked at each other in silent desperation. In concert, they pleaded, "Just hold it a little while longer." Irma was driving. Gladys was holding Annie, who had been crying loudly since the last pit stop, and, mercifully, had fallen asleep mere

moments before. If they stopped, she would wake up, and that would be that. The eight-month-old had been unbelievably crabby ever since they left Wellsville this morning, and they still had three days to go.

They were on their way to Florida. An old friend of Bill's had talked him into investing their savings into a run-down diner on the Atlantic Coast. Who knew why men made these decisions. He seemed to think it would pay off one hundred fold, once he got it fixed up and running. But he'd been spending every spare moment down there, pouring more and more money into the ramshackle place.

Gladys had never seen it, so she had talked Irma into driving down with her, to get away from March in Ohio and have a small holiday, while inspecting Bill's pride and joy. John was quite frankly dubious of the plan. The thought of two women and four kids gallivanting across the country alone scared the living daylights out of him. But he couldn't get away from the restaurant, so instead, he insisted that they take his new car – a 1949 powder blue Chevrolet. Then at least he could be sure they wouldn't have a break-down, and the chances of a blow-out were much less with four brand new tires.

And so, with Carl and Johnny tumbling around in the back seat, along with their cousin, John B, affectionately known as Butch, the two women had set out from Aten Avenue, with Annie in the trusty cardboard box between them.

The first pit stop found them abandoning the box, since she would not, under any circumstances, allow herself to be put in it. She seemed to have only two modes: asleep in someone's arms or wailing. Once she finally fell asleep, they would do anything to keep her from waking up. And the thing most sure to cause her to pop her eyes and her mouth open was stopping the car.

Unfortunately, with three boys under four, potty stops were frequent and prolonged.

"Butchie and me really, really have to go potty, Mommy! We

can't hold it any longer," Carl pleaded.

Not to be outdone, Johnny piped up, "Me too! Havta go potty NOW!"

"Should I stop?" Irma asked, torn between necessities.

"No, we can't! She just fell asleep. If she wakes up again I won't be responsible for my actions!" Gladys said ominously. "Wait! I have an idea!"

Carefully, she reached into the food bag at her feet and extracted the jar that Mrs. Caine had filled with milk that morning, so the boys would have something to drink with their sandwiches. It was almost empty. Gladys removed the lid, drank the rest of the milk, and then passed it back to the little boys.

"Here, you guys! Pee in this. Carl, you're in charge. Make sure nobody misses. Then, when you're all done, pass it back to me, very carefully."

Fascinated, the boys did as instructed. Boys of all ages are enthralled with bodily functions. Raptly they watched as each took their turn at filling the jar. Then, with an intent look on his face, Carl passed the jar, slowly and carefully, back to his mother. Breathing a sigh of relief that the baby was still asleep and the boys' needs taken care of, she took the jar with her free hand and dumped its contents out the window.

Unfortunately, since it was a warm afternoon, the back window was open and the results predictable.

After that, they made sure that Johnny, who sat next to the window and had gotten the worst of it, was reminded to roll the window up before successive dumpings. It took both hands and a lot of grunting to work the handle, but he seemed to enjoy the challenge, and beamed his baby-toothed smile each time he completed the task.

They spent four days on the road, then a week in Datona Beach. The weather in Florida was beautiful. Mock's Diner was an unholy

mess, but Bill seemed happy banging and scraping, and entertained them in the evenings in the small beachfront motel with stories of how the diner would, somehow, someday, make them all rich.

He stayed on for another week. Gladys and Irma left, sunburned and rested, to drive back home, employing the same piddle-jar strategy that had served them so well on the trip down.

The journey was an unqualified success for everyone except Uncle John. When he filled a bucket with his special car wash solution and began carefully to cleanse the dust of the journey from his precious automobile, he discovered that the paint on the passenger side, all the way back to the tail lights, was corroded to the point that it peeled off in great flakes.

He was devastated and horrified, and he read them the riot act in no uncertain terms, but Gladys and Irma just looked at each other and smiled that secret women's smile. They knew that a sleeping baby and a peaceful car was infinitely more important than some silly paint job. Men!

Mock's Drive-In Daytona Beach, FLA 1948

Christmas 1950 Bill, Carl, Anne, Gladys, John

Chapter 22

June, 1952

These were precious times, she thought, as she rocked back and forth in the summer twilight, one babe held to her shoulder, another snuggled on her lap.

"Nini bébé Nini," she crooned, singing the lullabies her Ayah had sung, and the slow rhythm of the rocking chair matched the rhythm of her song. Carl and Johnny had fallen asleep already, curled up together like puppies. On her lap, Annie had finally stopped squirming around. The tiny eyelids drooped as she rested her head against her mother, soothed by the evensong and her mother's heart beat. Gladys cradled her newest baby, Bobby, over her shoulder, patting his small back in rhythm with the rocker, silky hair soft against her cheek. There were tears in her eyes from the joy these children brought to her heart, and a catch in her voice as she sang the next song in her litany – "Bye baby bunting, Daddy's gone a hunting".

Yes, these were the precious times, all too few these days, so busy was she now that Bill had been called back into the service.

Once again the world had gone crazy. Insanity on the home front with that Senator McCarthy and his witch hunt, and insanity abroad, fighting and killing in Korea. Another war, more husbands and sons dying, and for what? She would never understand it, no, not if she

lived to be one hundred.

Bill had been called up a month ago. He was now stationed in San Antonio and she missed him terribly. That is, when she had time to indulge in personal feelings. Usually in the bathtub, if she was lucky enough to have time for a bath at night before toppling into bed like a felled tree. There were only two other doctors left in Wellsville and both of them had limited their practices for health reasons. That left her to pick up all the slack – twenty-four hour call, seven days a week, and hospital rounds before and after a full day at the office. Oftentimes she was even alone at the office, since Nina Lee's mother had been taken ill and she had been out of town more often than not.

Thank goodness for Mrs. Caine, who practically lived with them now, and cared for the house and the children as if they were her own. Gladys desperately wanted to be able to spend more time with her babies, but it was literally impossible. That was why moments like these, with her children sweetly sleeping all around her in the soft dusk, were so inimitably precious to her.

Thank the dear Lord her health was back, she ruminated, absently stroking the delicious softness at the nape of Bobby's neck. She'd had two kidney stones while pregnant with him, the second of which had had to be removed under anesthesia. She'd been incapacitated for a long time after that, and he had been born two weeks early while Bill was away at the Republican Convention. Her friend, Edith Gilmore, an M.D. from nearby East Liverpool, had delivered the baby – in fact, she and her husband Bill had come to the house when Gladys went into labor and had taken her to the hospital. Oh, she was so blessed with good friends and her children were happy and healthy and beautiful. For what more could she ask?

"A little time to myself," a voice inside her instantly replied. She berated herself for the ignoble thought.

She could only pray that the town stayed generally healthy, and

no flu epidemics or suchlike broke out, for she was being run off her feet with just the regular practice.

But tonight there had been no house calls, only a few people to see at the hospital, and she'd gotten home in time to relieve Mrs. Caine of evening duty.

They'd had dinner together – Bobby, at one year old, was in the high chair stage, throwing food everywhere but in his mouth. Carl and Annie chattered away, while Johnny inserted a, "Yep!" here and there. Then she gave all of them a bath together, adjuring them to be careful of the baby, while soap bubbles and laughter floated in the warm moist air.

And now, this was her favorite time of all, rocking her children to sleep as the evening fell.

"Day is dying in the west,

Heaven is touching earth with rest."

She sang softly; they were all sound asleep by now, but still she continued, until it was fully dark and she was nodding off herself. She knew that children were small only once and was jealous of every moment. She imprinted the feel of their small bodies on hers and held on tightly, for she knew that the time would come, all too quickly, when she would have to let go and watch them walk into their own lives, and moments like these would be but a memory. But not yet, not yet.

"Tura lura lura, that's an Irish lullaby." She laid Bobby down in his crib, and kissed the older boys goodnight. Annie was sleeping deeply now, and she carried her into her room and tucked her in under her beloved Raggedy Ann quilt. Then, stumbling into her own room, she barely had time to change into her nightgown before sleep over-whelmed her. But an hour later the phone rang. Helen White was in labor. And it all began again.

In her later years, when she looked back upon her life, she would believe that the years between 1952 and 1954 were the hardest two years of her life. Dog-tired day and night, she was barely able to meet the demands placed upon her. She was awake at dawn with the kids, to snatch some time with them. Then all day long and, more often than not, far into the night, she tended her patients. She came to bless the names of those who helped her – Mrs. Caine, John and Irma, the Gilmores. Mary Heaton, Zona Miller and a few other good friends put their heads together and devised a plan to give her a few needed breaks. Every week, two of them would come to the office with an imaginary complaint. And, when they got Gladys alone in the treatment room, out would come the thermos of coffee and the cookies wrapped in wax paper and they would force her to sit and rest and have a cozy chat, as Zona liked to say.

However, she found her nemesis in Thelma Jones, the local telephone operator. As in any small town in the '50s, the operator was the one person who knew everything about everybody. And she made it her personal mission to know where Gladys was, day and night. A patient only had to lift the receiver and ask for Dr. Gladys, to be given her exact location. It was like having an involuntary answering service. Gladys simply could not get away from her.

One night in early fall, she had a few hours of freedom, and decided to go see a movie. She drove to John and Irma's and parked on the street. Then the three of them drove to the movie theatre in East Liverpool in John's car. They had just settled down with their bags of popcorn; Doris Day was singing "On Moonlight Bay" and Gladys had begun to relax.

Suddenly the music was interrupted by the loudspeaker. "Dr. McGarey, please come to the ticket office. A patient needs you." Severely disappointed and completely baffled as to how she had been located, Gladys responded, and their stolen night out was cut short.

Irma was indignant. She took it upon herself to investigate the occurrence and, a few days later, told Gladys what had happened over the phone.

"You just won't believe it, honey! Thelma tried to call you at home, but Mary Ellen wouldn't tell her where you went. She kept saying she didn't know, which was the God's honest truth, us not having decided between *King Solomon's Mines* and *Moonlight Bay* when we left. So Thelma, that old busybody, called the police."

They both heard a shocked gasp, and knew that the operator in question had been listening in.

"Yes, and that's just what you are, Thelma Newcombe," Irma continued with relish, "an interfering old busybody and I don't care if you do hear me say it! Now you just pry your ear off this line and go stick your nose in someone else's business!" A sharp "Hmph!!" was followed by the click of a disconnect, and Irma carried on with a satisfied note in her voice. "Anyhow, she called the Wellsville police. Hank and John were on duty that night and since they seem to have nothin' else to do but stick their noses in other people's business, they left the donut shop and drove around until they found your car parked in front of our house. They saw that our car was gone, so they put two and two together (which must have been a stretch for those dunder heads) and figured we'd all gone out together. And when they couldn't find our car anywhere in Wellsville, they drove over to East Liverpool, and found it parked outside the theatre. Did you ever in all your life? As if Mary Jean Wheatley's constipated baby was worth all that!"

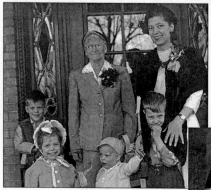

*Mrs. Cain, Easter Sunday,
1952
with the family*

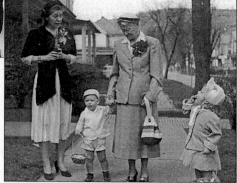

*Gladys, Bob, Mrs. Cain and Annie
Mother and daughter opinions differ*

*1953 - Bill and Gladys
in San Antonio, Texas*

*John, Annie Lou and Carl
Christmas, 1951*

230

September, 1954

Gladys' prayers for the continued general health of the town were not granted. Rather, the Powers That Be seemed to delight in offering up just the opposite.

Jenny Anderson, six years old, was visiting cousins in Wheeling and contracted the mumps. She passed it to her entire first grade class. And from there it ran rampant into a full-fledged epidemic. Gladys, of course, was on the front lines, diagnosing and treating all the children in town as well as her four.

Growing up in India, Gladys had survived typhoid, rickets, hepatitis and malaria, but she'd never had the mumps.

She had them now.

In children, mumps, while extremely contagious, is a trifling complaint, uncomfortable and inconvenient, but easily treated. However, in adults, it can have severe complications and actually become life threatening. Gladys almost died.

When she first became critically ill, Mrs. Caine moved into the extra bedroom to care for her and the children. Her head swelled up so much that the kids were afraid of her, and when John and Irma came to pay a sick call, John took one look and almost fainted away.

After a week in delirium, the swelling and fever came down enough for her to be able to arise from her bed, under stiff protest from Mrs. Caine and Edith Gilmore. She knew that her patients had been sorely neglected and when Ruthie Farmer, who was pregnant with her first child, began hemorrhaging, Gladys made a house call, hoping to prevent a miscarriage. By the time she returned home, her fever had shot up alarmingly and she was crippled by intense low back pain. Completely incapacitated, she crawled up the stairs into bed while Mrs. Caine, after first delivering a thundering scold, called Edith. That good doctor took one look at Gladys, bundled her into the car and immediately admitted her to the hospital with a diagnosis of mumps nephritis.

That should have taken care of it, but Dr. Gladys was, if anything, too well loved by now. Thelma told all her patients that she was in the hospital and they began sneaking up the back stairs and popping into her room. Each one felt that, although she should be left alone by those who were just her patients, they were more than that. They were her friends, and they always brought a bunch of flowers or a jar of homemade jam along with their questions and complaints. The floor nurses were forever shooing people out of Gladys' room. Edith finally decided that the only thing to do was spirit her away, and this she did. Gladys spent the last two weeks of her convalescence in the Gilmores' beautiful home, ensconced in their luxurious guest room, with the IV bag strung up to the canopy over the bed.

By the time she returned home, quite recovered, the mumps epidemic had worked its way through the community and was now a thing of the past. Unfortunately, and as so often happens, it was followed by an even more pervasive measles epidemic. Every child in the county under the age of six contracted them. Luckily, she did not, but all four of her kids did. They were laid low for a few days, but recovered quickly. All except Johnny.

To her dismay, he became severely ill and ran fevers so high that she was beside herself. When his temperature finally came down, they discovered that his illness had left him with petit mal epilepsy. It almost broke her heart.

To the uninitiated, a petit mal seizure looks like nothing more than a long lapse of attention – the individual will be doing something and suddenly will stop in the middle of it, stare fixedly into space, body freezing in mid-action. After a minute or so, he will snap out of it and continue the interrupted activity. Grand mal seizures, with the accompanying convulsions, are not usually present, but petit mals arise from the same neuronal dysfunction in the brain, and neurologically are just as serious, although less obvious.

She became more and more distressed each time she watched him try to do something, only to be arrested over and over again by a seizure. One night she counted seven episodes in a single trip across the living room. Carl was almost eight, but too young to understand exactly what was happening. He just knew that his little brother was still sick and he became gentle and patient with him and fiercely protective. Bobby and Annie, at three and five respectively, intuitively understood that Johnny needed extra care. They picked up dropped toys, patted him on the back, and waited quietly for him when necessary.

One night she admitted to herself that she just couldn't do it alone anymore. She wrote Bill, begging him to come home, and applied to his C.O. for compassionate leave. This was quickly granted and he returned for two weeks to fix things up at the office and restore some semblance of health to his household.

He arrived, resplendent in his uniform, to find his wife gaunt and hollow-eyed, his medical practice in chaos, and his once plump, noisy children scrawny and subdued. He was especially distressed over Johnny, so sick, so distressingly frail.

And on the night before he returned to his post in Kansas, after the kids were in bed, he took the phone off the hook and asked Gladys to sit down. He had something he had been needing to tell her.

The next morning Gladys took him to the train, then showed up at Irma's door. She'd left the kids at home with Mrs. Caine, then driven blindly up the hill to her sister-in-law's house. Stumbling down the hallway into the big kitchen, she collapsed at the table and pillowed her head on her arms, while shuddering sobs wracked her body.

Irma, seriously concerned, put aside the egg noodles that she'd been rolling out and came to stand beside her.

"Honey, what is it?" she demanded. She had never before seen Gladys so completely devastated.

Moments passed. The only sounds were those of Gladys' tor-

ment and, in sharp contrast, the song of a bird outside the window, blithely unconcerned with human sorrow.

Eventually the storm was spent. Then Gladys, finally able to catch her breath, looked up at Irma and wailed, "It's Bill. He…he wants a divorce!" She was overcome once more by despair.

Irma's legs gave way and she fell into the chair next to her sister-in-law, speechless.

"I asked him why and he said he needed something different from his life. Something different!" she repeated, wild-eyed, "something different than our family, and our life? How could that be? I asked him if there was someone else and he said no, of course not, and I know that's true because if there was, I'd know it, wouldn't I?"

Rather than reply, Irma got up and busied herself pouring two cups of thick black coffee from the battered percolator that always sat warming on the back of her stove. She had her own ideas about the possibility of another woman. She had seen how much Nina Lee primped and simpered around Bill, and John had remarked more than once that his brother had better keep his hands to himself around that nurse or he'd make a mess of his life. And wasn't it strange that, ever since Bill had been called up, Nina Lee was so frequently out of town. So much for her sick mother! Irma thought with disgust. The local gossip mill was rife with speculation. But Gladys had heard none of it and Irma was not about to bring it up to a woman so blinded by love that she couldn't see it herself. And who knew for sure, anyway. Maybe they were all wrong about Bill. But she didn't think so.

Wordlessly, she put the coffee on the table and sat down again.

Gladys warmed her hands around the thick white mug and said in a small voice, "If it's not another woman, it must be me! But Irma, I just don't know how to be different than I am! I just don't know how to make him happy."

Irma fished a hanky from her apron pocket, and, commanding

Gladys to blow her nose, asked, "Well, honey, what did you tell him about the divorce?"

"What did I tell him? What could I tell him? Of course I said no. We can't get divorced! What about the kids? And Irma, he made me so mad! He said he wanted to take Johnny because he's so sick and he thinks that he'd be better equipped to take care of him! Did you ever in your life? And then he said I could have the rest of the kids, like he was dealing out a…a pack of cards or something!" She fumed silently for a minute, then continued.

"He thinks he doesn't love me anymore, but I know he does," she said stubbornly. "He's just going through some kind of a phase or something. I told him, in no uncertain terms, that before I even considered it we need to see a marriage counselor and at least try to work things out. And I know we can work it out. Bill and I belong together." She used the hanky ruthlessly, then hugged Irma in thanks and left.

To the eyes of the world, she led her life as before, focusing on her patients and her children.

But in her quiet moments, the questions tortured her. At first she'd been stunned, incredulous. She'd felt completely blindsided, unable to cope. Then, grief had hit like a tidal wave with every breath or, alternately, rage swept her away like a volcano spewing rivers of vengeful, molten fury.

Finally, at the end of her rope, she turned to her faith for answers. Comfort came seldom, but deeply, and always at the end of her prayers when she would hear her mother's dear voice counseling her, "Remember, Gladdie – all things work together for good for those who love God." And she would feel, for a fleeting moment, the wings of angels wrapped around her in benediction. And she knew that this, too, would pass, and she would be stronger, a better person for it.

Comfort came, too, from the hymns of her childhood. When she was alone with her pain after a house call on the back country roads

at midnight, she would roll down the windows and sing at the top of her lungs.

She was comforted, too, on Sunday afternoon drives with the children, a tradition never to be missed. After church the small family would drive along the river for hours, and end up at John and Irma's for Sunday dinner, "The Ed Sullivan Show" and "Disneyland." As she drove, she would sing those hymns, and the more tears threatened, the louder she sang. But at times they spilled over and the words caught in her throat. It was these times that were very nearly her undoing. The children would crowd around her, Annie sitting on her lap, Bobby standing next to her, patting her gently with his baby hand. Johnny and Carl, in the back seat, would fling their arms over her shoulders and tell her stories of Sunday School, trying to make her laugh – anything to keep their mommy from crying.

After a month or so, Bill wrote and said he'd found a marriage counselor, so she flew to Kansas, determined to do whatever was necessary to keep her family together.

She returned a week later, much more hopeful than before, but still troubled and uncertain as to the future of her marriage.

Gladys sat in the steamy comfort of Irma's kitchen, absorbed in her task. She was painting a set of china plates and monogramming them in gold with "McG." It was full Ohio winter outside. The freezing wind and blowing snow were in sharp contrast to the world Gladys was re-creating with her paintbrush – India, the land of her childhood. She painted from memory with tiny precise strokes: images of elephants, peacocks, and young maidens dancing with bells on their ankles, flowers in their hair.

She painted because she had to do something with her hands,

that or go crazy. She'd started the project while she was recuperating from the mumps, and by now she had almost a complete place setting for twelve. The work was enjoyable and creative, and it soothed her, helped calm the questions and doubts that swirled through her mind.

The china was from the O'Hara's pottery factory and was of the finest they produced, not the thick white pottery sold to restaurants across the country. Irma brought it home. She worked there in the winter when business at the Tastee Freeze was slow. It was fine bone china, eggshell white, with a translucent green border the precise color of an Indian twilight sky. Gladys could almost smell the jasmine and honeysuckle, the underlay of decay and dust.

As she painted, seated at the kitchen table, the children would wind themselves around her legs, staring in fascination at the magic flowing from her paintbrush – a whole world created before their eyes. Eventually, transfixed, one or more would try to crawl into her lap and she would tolerate it until her elbow was jogged while painting the spots on a leopard. Then she'd chase them all out of the kitchen with exasperated affection, crying, "If you kids don't get out of here, I'll chop all your heads off! Go on now...Isn't that "Disneyland" I hear on the television?"

Sunday night at Irma and John's had become a tradition, and she and the kids wouldn't have missed it for anything. John owned one of the three televisions in town and it was a continuous source of amazement for them all. If the kids sat quietly through "Ed Sullivan", they got to watch the enchantment of "Disneyland" unfold, absorbed and motionless for a full hour.

On this particular night, Irma had fixed fried chicken and mashed potatoes for dinner. The house was redolent of that, as well as of the huge pot of chili simmering on the back of the stove, ready to be trudged, steaming through the cold morning, down to the diner. Chili dogs and hot chocolate were more popular than ice cream in this weath-

er, but the Tastee Freeze was still open every day except Sunday.

So while Tinkerbell sprinkled fairy dust on the castles of Fantasyland, the two women had a moment of peace and privacy to talk. Gladys was finally able to tell Irma all about her trip to Kansas.

"We saw the marriage counselor almost every day," she said, while a part of her mind enjoyed the intricate work of painting peacock feathers on a serving bowl. "He was pretty nice, I guess. Mostly he asked questions and said, 'Mmm,' a lot. One time he'd talk to me, then the next to Bill. Then he'd talk to us both together. At the end of the week, he saw me alone again. He sat down, looked at me over the top of his glasses, and said, 'Mrs. McGarey, after full consideration, I've determined that the problem with your marriage is that you are too strong. You dominate your husband, and no man wants that. You need to learn to submit to his will. Ask him what he wants in any given situation, then do it. This is what you promised in your wedding vows. This is what you must do. If you want your marriage to work, it is completely up to you. You, as the wife, are one hundred percent responsible for the recovery of your marriage. You must surrender your needs and wishes to his. You must make him feel strong and in charge. If you do all this, your marriage has a good chance of succeeding.'"

Irma had dropped into a chair from astonishment, and she sat across the table, mouth half-cocked, speechless with outrage.

"Well, honey," she finally asked, "what did you say?"

Gladys was bent in concentration over a serving platter, putting the final touches on a scene of *Hathi* and his *mahout* playing in the river. Momentarily, she was back on the riverbank, overwhelmed by the scents of an Indian afternoon: wet dirt and sun on elephant hide and the surprisingly sharp scent of brown water on hot river rocks. She shook her head and painfully returned to her present troubles.

"What could I say?" She smiled wryly, "I know I've always been bullheaded and probably too independent. Everyone knows that's

not what most men want. I guess I just thought Bill was different. And it took this to make me realize how wrong I've been. The counselor advised me to be a more seemly wife, to let Bill know I respect him by putting his desires above my own.

"So that's what I've decided to do. My marriage and my family are more important to me than anything, and if keeping my big mouth shut and my opinions to myself will fix things, I know I can do it. Bill comes home next month and when he gets here, we'll talk again. I promised him I'd be a better wife if he'd just reconsider. He promised he'd think about it and he kissed me, really kissed me, when I left.

She looked at her sister-in-law with hope in her eyes. "Oh, Irma, I think we're going to work this out."

"Well, honey, if that's what you want, then I hope you do," Irma said darkly, and got up to stir the chili.

Gladys was never to know what went on in Bill's mind to change it, but change it he did. He chose to stay with her and threw away the divorce papers he'd been carrying for months.

In the first flush of their reconciliation, the world looked freshly born and they decided to start their life anew, literally as well as figuratively. They determined to move away from Wellsville.

During his time in the Air Force, Bill had spent several months stationed at Luke Air Force Base in Phoenix, Arizona. He'd loved everything about it: the soft green winter desert, the warm evenings spent drinking beer outside the Quonset huts with other young men, dreaming dreams of tomorrow. While he was there he'd put out some feelers – it seemed that Phoenix was experiencing a massive post-war population boom and the field was wide open for an enterprising young doctor.

When Bill suggested that they move to the desert, Gladys readily – no, joyfully – agreed. She admitted to herself that she was sick to death of the gray-white weather and narrow-minded thinking of the Ohio

River Valley. She couldn't wait to leave it all behind, to stand in the baking sun under an open sky, and begin a new life, full of hope and promise and love.

Father's Day Picture, 1954

Part 3

Arizona

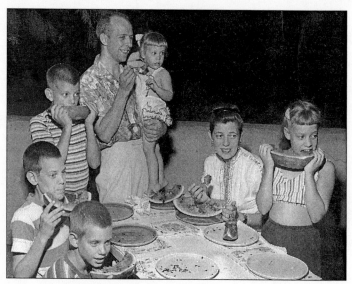

Summer 1958
Bob, John, Carl, Bill, Beth, Gladys, Annie.

Chapter 23

ψ

Phoenix, Arizona 1955

Phoenix in 1955 was a big city masquerading as a small desert town, full of brash young men and their families, looking to fulfill the newly advertised American Dream. They were willing to put up with the manifold discomforts of life on the blistering edge of civilization in order to secure for themselves a place in what they perceived, and rightly so, to be a Golden Opportunity. Whether it was real estate (there were hectares of orange groves and miles of desert just yearning to be parceled out and sold) or technology (the city boasted the largest Motorola plant in the country) or the booming tourist trade, it was a plum ripe for the picking.

Camelback Mountain was a pile of red rocks and scrub cactus, untouched as yet by man. It resembled nothing more than a recumbent camel asleep on the desert floor in the middle of the great valley formed by the encircling mountains. It slept as a sentinel on the far northern border of town, while its namesake, Camelback Road, curved from Scottsdale into Phoenix and marked the boundary of civilization.

Gladys and the kids arrived on June 10, 1955, and stepped off the plane into one hundred and ten degree heat. Sky Harbor Airport consisted of one small terminal boasting a huge mural of the Phoenix bird newly arisen from its ashes, and one of the best restaurants in town,

the Sky Chef. The little family descended the steps and walked across the blistering asphalt, faces getting redder and redder, and stepped into Bill's waiting arms. The sign across the big doorway said, "Welcome to the Valley of the Sun." Gladys welcomed the heat, for it felt so much cleaner than the oppressive humidity of Ohio, and the boys didn't seem to mind – they were playing airplane in front of the huge fans that were set up here and there. Only a few buildings in Phoenix were air conditioned at that time, and the airport was not one of them.

Bill had been in town for several months working at the county hospital and had bought a small four-bedroom-plus-den on Coulter Street near Central Avenue. The house was plain but adequate, with a postage stamp front yard planted in Bermuda grass and a large China-berry tree overhanging the cement slab that served as a back porch. The kids dubbed it the Beebleberry tree after a similar one in their favorite comic book, *Little Lulu.*

Before they left Ohio, during the long, rainy Midwest spring, Gladys had assured the children over and over that it never rains in Arizona. Two days after they arrived, so did the summer monsoon season. It rained every day for two solid weeks. The furniture had not arrived yet so they were all bedded on the floor in the living room and Gladys was nearly driven to distraction with whines of "I'm bored!" and "There's nothing to do!" Finally, nearing the end of her rope, she called up Sears & Roebuck and had them deliver a television set.

After that, summer began in earnest and by August it was 120 degrees. No one seemed to mind except Annie, who griped about it incessantly. But in spite of the heat, it was a wonderful summer. The kids ran wild through the neighborhood in the cooler mornings and holed up inside during the blazing afternoon, watching cartoons with "Wallace and Ladmo" and "The Mickey Mouse Club" on their new TV. Then after dinner, during the long summer dusk, they would play a game called "Spook in the Dook" which was known only to the four of

them and involved much shrieking and thumping in the nether regions of the house.

Carl built a tree house in the Beebleberry tree and carpeted it with remnants from the new living room rug. He liked to say that it was the only carpeted tree house west of the Mississippi.

Gladys took the first year in their new home off in order to get the family well and truly settled and to study for the Arizona State Medical Boards.

She was lying on her tummy on the living room floor one morning in late August, studying neuroanatomy. Medical textbooks and papers were spread haphazardly around her and the kids were out back playing. Everything was quiet. Gladys became aware of the intensity of the stillness and raised her head. The little hairs on the back of her neck lifted in apprehension.

It was too quiet.

Suddenly she heard a concert of yelps and an ominous thud. The back door slammed and a small herd of little boys came screeching to a halt in front of her.

"Mommy, Mommy!" Carl panted. "Johnny fell out of the Bee-bleberry tree and he's dead!" Standing behind him, Bobby could only stare with eyes as big as saucers and a face flushed with the heat of fear. Gladys moved as fast as she ever had in her life and was out the door with the kids running after her in a flash. Johnny was lying flat on the ground under the tree, still as a corpse. Annie knelt beside him, patting his shoulder and crying.

Inwardly Gladys shrieked with hysteria. Outwardly she was the coolheaded physician. Responding to her inner guidance, she told Carl to hold his brother's feet, while she pulled Johnny's arms over his head and tugged smartly. He jerked, inhaled deeply, and fluttered his eyes open. Annie, always the dramatic one, fell on him in tears and Gladys gently picked him up and carried him inside like a baby.

So much for studying. She put her books aside, gathered her cubs around her and didn't let them out of her sight for the rest of the day. They walked over to Uptown Plaza for ice cream, then spent the afternoon under the trees in Encanto Park, watching Carl fish.

So went the days of their first summer in Phoenix. Gladys gained a deep appreciation of full-time mothers, the patience and endurance that is required for twenty-four hour child care. No matter how much she loved them, at times they would drive her nuts, and she would long for the sense of order and control she had always felt at the office and count the days until she could return to the sanity of the work force.

After the kids went to school in September, Gladys finished studying, then took her board exams. She passed easily and began part time work at the county hospital. She and Bill planned to open a joint practice, but not until the spring to give them all time to become accustomed to their new home and to build a reliable referral base.

After the crisis that had threatened their marriage was resolved, Gladys felt they had reached a new level of understanding. They never talked about the conflict that had gone on in Bill's head and heart, but it appeared as if he had worked it out, for he seemed to be in love with her again. He was attentive, enthusiastic and happy, satisfied with his family and his life. She would never be sure what had been at the root of his indecision, nor how he had come to grips with his choices. But he had always been a secretive person and never one to put his feelings out on the table for everyone to see, as was her habit. She gratefully accepted his reversal, tried not to question it, and determined to put into practice the advice given her by the marriage counselor. Let him be the boss. Follow his lead. Listen to him. Never challenge his ideas.

So she listened in attentive silence when he sat with her at night, after the kids had gone to bed, and told her about the new things he was thinking, the books he was reading. Most frequently he talked

about a strange man from Virginia whose name was Edgar Cayce. Apparently he was a psychic, or a medium, or something like that, and he was able to cure incurable diseases.

She had a hard time refraining from derogatory comments about that and an even harder time when he started talking about reincarnation. It sounded like medical heresy to her and her first thought was that her husband was becoming a Hindu.

By force of will she kept her mind open and her mouth shut. In time she learned enough about Cayce to be fascinated, as well, by the unexplainable phenomenon of this simple man. He had been, by profession, a photographer and had but a seventh grade education; yet, while in trance, he spoke as a physician, using medical terms he couldn't even pronounce when awake. She learned that he didn't actually cure diseases, but he was able to give incredibly accurate diagnoses and to recommend treatments that almost always worked. And one of the most amazing things was that he didn't even examine the patient. In fact, he could give long-distance "readings" that were every bit as accurate as those for which the patient was in the same room.

In addition to his medical readings, he accurately prophesied world events and spoke of a mind-body-spirit connection in healing.

When she read Cayce's information on reincarnation and karma, she realized that Bill wasn't becoming a Hindu at all. Rather, she began to feel that the theories made sense, and she adjusted her own personal belief system to include them. Unlike the Hindu religion which teaches transmigration of souls, Cayce's theory was that this earth is a schoolroom and we come into each life having chosen the particular challenges by our past actions.

These things rang true in her soul and, after having struggled for a time with the knowledge that her parents would be horrified by her new beliefs, she gave herself over to her insatiable curiosity and read everything about him she could find.

Every night she and Bill talked deep into the wee hours while the house slept about them and new ideas and unlimited possibilities swirled in their minds. Cayce spoke at length about the effect that diet and nutrition had on health, a concept that was totally foreign to medical wisdom at that time. That, too, made absolute sense to Gladys. She began to read Adele Davis' books and to haunt the only health food store in Phoenix. It was a dark, tiny shop on Indian School Road, filled with cans of Loma Linda meatless hot dogs, vats of honey, and pamphlets on everything from juice fasting to UFOs.

She brought home stone ground whole wheat bread which had to be inspected closely on both sides of each piece for rocks and chunks of wood, and eaten gingerly for fear of breaking a tooth.

She read that blackstrap molasses was chock full of minerals and vitamins, so she made the kids drink a large glass of blackstrap stirred into milk before dinner each night. She told them to pretend it was chocolate milk, and the boys had no trouble, but Annie hated it and began to dread the dinner table.

As Gladys studied more about nutrition, she became convinced that vegetable juice was a perfect way for her children to ingest all the nourishment of bushels of vegetables in one tasty glass. She bought a juicer and began to experiment. Sometimes, when the juice came out thick, green and smelly, even the boys had trouble with it. But after a few dire threats, they held their noses and chugged it down. Annie, however, when forced to drink it, took tiny, excruciatingly distasteful sips, gagging softly after each one, and loudly protesting the whole time.

Bill realized that he had started her on this path; he agreed that correct nutrition was important and he tried to be supportive of her parental decisions. Usually able to be a good role model, he would choke down even the nastiest of juices with an appreciative smile. He didn't mind the whole wheat bread, the stone ground peanut butter, the

raw milk. And, thank goodness, she never made him drink blackstrap molasses in it.

But she pushed him too far the day she made the pig brain soufflé.

Gladys was seven months pregnant and glowing with health. It was July of 1957. She drank a glass of beet juice every day. She was determined to give birth to the healthiest baby ever born on the face of the earth. She'd read, in a very interesting article in Prevention Magazine, that organ meats, and especially brains, were excellent for pregnant women and developing children. "That's us!" she thought, gleefully, and the next time she went to the Bayless Market, she stopped by the meat counter. There, behind the liver and tripe, she spied a container that resembled a large, pink, cottage cheese carton. It was labeled "pig brains." "Great!" she said to herself and plucked it from the butcher's case.

Upon her arrival home, she got out the recipe that accompanied the article in Prevention and set to work. Removing the lid, she dumped the contents of the carton out on the counter and stood back with her hands on her hips to look at it. Sure enough, it was a brain. Smaller than a human brain, but quite similar. Most of the structures seemed to be the same. Pretty disgusting. She got out the butcher knife and stood there for awhile longer, trying to decide where to make the initial incision. The recipe said to cut the brain into one inch chunks. She was hesitating between a clean slice right down the longitudinal fissure, or a decisive cut directly through the central sulcus, from ear to ear, so to speak. Yech!

She put the knife down, took a few deep breaths, and began to lecture herself. "Gladys, get a grip on yourself. You are a medical doctor. You have cut into things that were much more disgusting than this. You've seen and smelled things that make this look like a joke. Don't let this puny little bundle of gray matter get the best of you!

Think of all the vitamins and minerals just bursting out of every neuron. Think of the baby!"

Newly resolved, she placed her left hand on her very pregnant stomach, cried, "This is for you, kid!" and raised the butcher knife in preparation.

The screen door slammed. In trooped Carl, followed closely by the rest of them. His eyes fell on the grisly apparition glistening in a stray beam of sunlight from the kitchen window.

He stopped dead in his tracks and the other kids bumped up against him, one, two, three. Their eyes widened as they took in the scene.

"What's that?" he asked in a voice dripping with suspicion.

"None of your beeswax!" his mother snapped.

Without taking his eyes off the brain on the cutting board, Carl reached over and picked up the pink carton.

"It looks like...like...brains!" he cried. Then he read the label. "It is! It's brains! Pig brains! She's gonna feed us pig brains!"

All four kids started screaming, "Brains! Brains!" and went running off, arms overhead, shrieking, "Brains!" in circles all around the house.

But Gladys was not one to give up on a project, so in spite of this less than enthusiastic reception, she shooed the kids out of the kitchen, chunked up the brain, threw it in the blender, and made a wonderful soufflé which turned out all nice and fluffy.

When Bill came home for dinner and took his place at the head of the table, there was complete silence as she placed the steaming casserole on the trivet in front of him. She sat down at the other end of the table. The kids sat two and two on either side, eyes glued to the soufflé. One of the rules of the McGarey dinner table was that you were not allowed to say you didn't like something until you tasted it. So no one said anything, and Bill, sensing that something strange was going

on, looked at the soufflé and asked, "What's this?"

In one voice the kids all shouted, "Brains!"

Shocked and unbelieving, Bill looked at his spouse, hoping to hear a contradictory answer. When she began to explain the inherent nutritional value of organ meats, he shook his head in dismay.

Gladys dished it out to everyone and they all sat there, staring at the gelatinous brown mass quivering on their plates.

Resolutely, Gladys took a bite. "Mm, mm," she said, without conviction.

Three times Bill picked up his fork and tried to eat. Three times he put it back down, overcome by revulsion. He looked at his children, who were all gazing at him imploringly. Carl whispered, "Dad, please help us." And that did it.

"Do you guys want to eat this?" he asked, bravely.

"No!" came the fervent howl.

"Well, honey, I hate to say this, but I don't want to eat brains, either, no matter how good for me they are. Let's go to McDonald's Golden Arches and have a hamburger instead."

He earned the undying gratitude of his children for that decision and the brain soufflé was scraped into the dog's dish, where it sat for two days. Even the dog wouldn't eat it.

Bill & Gladys
Arizona, 1955

Gladys and Bob
Summer 1955

315 E. Coulter Street, Phoenix
Summer, 1955 under the beebleberry tree

Helene Elizabeth McGarey, affectionately known as Bethie, was born on September 12, 1957, to the endless delight of Annie who had threatened to run away from home if her mother gave birth to another one of "those boys." Gladys had decided to have this baby at home, in keeping with the new ideas they were exploring about natural health. A home birth seemed to her much healthier, happier and more sane than the hospital procedures she'd experienced at both ends in the past.

When she went into labor, the kids were packed off to the next door neighbors. Bill called Betty Kilpatrick, M.D., a colleague and friend, who had agreed to attend the birth.

The three of them labored together far into the night. It was the first time Gladys had been conscious for the birth of one of her children. She was prepared for the pain and for the effort that was required – after all, there is a reason they call it "labor" – but she was totally unprepared for the feelings that overwhelmed her when, with the very

252

last ounce of her strength, she pushed the baby out into the world, heard her first cry, and held her while the umbilical cord still throbbed with life. She felt like the Mother Goddess giving birth to the world. She was exultant, wild with joy, and completely exhausted, all at the same time. Bethie stopped crying immediately and looked up at her mother with wide blue eyes. Her profuse black hair stuck straight up on her head, giving her an undeniably startled appearance.

But she was so beautiful and wide-awake, so alive! Betty cleaned her up and wrapped her in a receiving blanket while Bill went next door to pick up the kids.

They were seated around the table eating breakfast when he arrived. "You have a baby sister!" he said, and with whoops of joy, all four leaped up and raced home.

Jimmy, the neighbor's little boy, tried to follow but was stopped by his mother. "Please, Mommy, let me go see the baby," he pleaded. "I gotta see this! Any kid whose mother has been drinking blood all this time must look really different."

His parents stared at Bill in horror until he explained about the large glass of beet juice consumed every afternoon by the nutrition-mad Gladys.

Meanwhile, the four siblings were crowded around their mother, admiring the new baby. As soon as Annie ascertained that it was indeed a girl, as ordered, she disappeared. She returned a few minutes later followed by a large group of intensely curious children. She'd run to the school bus stop and invited all the kids waiting there to come see her new sister. In they trooped and stood around the bed, goggling at the brand-new baby and her exhausted mother. As Gladys watched Annie carefully carrying the baby from child to child, jealously giving each one a peek, she realized then and there that, in the mind of her elder daughter, this baby belonged to <u>her</u>. And in the future, whenever a new babysitter was hired, Annie would greet her, holding Bethie tightly,

with the words, "This one's mine," and with a negligent wave of her hand in her brothers' directions, "the others are yours."

September 12, 1957
Newborn Beth with family

Chapter 24

\mathcal{G}ladys took two weeks off for maternity leave, then turned the children over to their new housekeeper, Agnes Dunn, and returned to the office. As always, her feelings about this were strongly ambivalent. She loved being at home with the baby, greeting the older ones when they rushed home from school, and doing nothing more than that most important work of being a mom.

But business was booming and things at the office were becoming so exciting. A growing number of patients were asking about natural ways to improve their health and she and Bill had begun to share their newfound knowledge. Nutrition, hypnosis, dream interpretation, the Edgar Cayce material – all of it was so fascinating. She could hardly wait to get to the office each day.

Early in 1956 they'd opened their practice on the outskirts of town, halfway between Phoenix and Scottsdale. They had built the office behind the pharmacy that sat on a large empty lot on the corner of Arcadia Lane and Indian School Road.

The Arcadia Pharmacy was a true old-fashioned drug store. Bill Harper, the pharmacist, really did care about his customers, and there was a soda fountain, racks of comic books, and a friendly, small town air.

The office had been built to their specifications but on a limited budget. It was small but adequate for their needs. There was a waiting room and a small front desk area overseen by Sue Parks, the reception- ist. There were three exam rooms and a tiny back office crammed with their desks, and piled high with charts and medical literature.

They were both happy as clams. Bill was especially interested in hypnosis, how it could be used to treat certain health problems, and the amazing benefits of self-hypnosis. He learned that Milton Erickson, M.D., an internationally known hypnotist, also lived in Phoenix. He contacted Milton, met with him once or twice, and then invited him and four other like-minded physicians to begin a weekly study of hypnosis in the McGarey living room.

The meetings began in late 1956 and continued every week, becoming longer and more intense as the group got to know each other and delved more deeply into the mystery of the unconscious mind. Gladys sat in on most of the gatherings but usually went to bed by 11:00 while the others sat up until the wee hours, discussing, arguing, and hypothesizing. By the summer of 1957 she couldn't take it any more. Massively pregnant and exhausted as only a woman expecting her fifth child can be, working full time and living in the desert heat with no air conditioning, she asked them to take it somewhere else. This was the beginning of the International Academy of Clinical Hypnosis.

In November of 1957 a minor event took place that would eventually lead to the transformation of their work and the realization of all their dreams.

Sue Parks forgot her lunch.

Since it was two days before payday, she had no extra cash to buy a sandwich at the soda fountain, so she hopped in her car and drove home to have lunch with her mother. A few minutes after one o'clock she burst back into the office, waving a piece of paper, ready to explode with excitement.

"Dr. Bill, Dr. Gladys," she cried, "you won't believe what just happened. I was driving back to the office and I passed a car that had a sign on top of it that said, '14,000 words from the unconscious mind of Edgar Cayce.' And there was a phone number but I didn't have time to read it, so I almost wrecked my car turning around in the middle of the street and I chased it down. I started honking like a madwoman and made the guy pull over. His name was Lester Babcoke and he gave me his phone number." She waved the piece of paper under their astonished noses.

"And he said that Hugh Lynn Cayce, who is Edgar Cayce's son, is going to be speaking tonight at Phoenix College!"

The first time they heard Hugh Lynn speak, he told the story of the terrible accident that had blinded him as a child and of the readings his father had given that had completely restored his sight. He spoke of miracles and of impossible things coming true.

That night in the small, stuffy auditorium, he opened their minds to vistas never before dreamed of and presented scenarios that had been possible only in their wildest imaginings.

Gladys was totally enchanted with him. She was struck first by the kindness in his eyes, then by the wisdom behind them. His charming Virginia drawl and his delightful smile captured her heart. By the end of the evening, she had already begun to see him, not as the famous son of a famous father, but as a friend.

Immediately, as a friend.

The lecture was fascinating and afterwards they spoke to him and introduced themselves. They began to talk and couldn't stop. There was a sense of deep recognition, of having known each other for lifetimes, and of picking up the thread of an interrupted conversation. When the janitor kicked them out of the auditorium, they repaired to a local coffee shop where they sat over cups of coffee until well after midnight.

Bill and Gladys had always been interested in aspects of healing that went beyond conventional medicine, concepts that had never been taught in medical school. Gladys had grown up watching prayer work miracles. Her dreams had always fascinated her, and nutrition had become an obsession. Both she and Bill felt that the concept of reincarnation and how karma influences health was a key to a question that had long been ignored. As for Hugh Lynn, he was thrilled to have two medical doctors express such intense interest in the work that had become his lifelong passion.

Their conversation seemed to have barely begun when the tired waitresses began pointedly turning out the lights. They stood outside on the deserted sidewalk, unwilling for the evening to come to an end.

"You know," said Hugh Lynn, "I'm going to be in town for another day or two. Maybe we can have lunch tomorrow."

Struck by inspiration, Gladys replied, "I know! Come and spend the morning at the office! You can see how we work, we can talk in between patients, and then we'll have lunch together!"

So the next day was spent with Hugh Lynn perched on a high stool at the back of the office while Bill and Gladys ran back and forth, alternately seeing patients and asking every question they could think of. He was so full of information, so utterly charming, that they were completely captivated.

The friendship that began that day was to prove lifelong and of immense importance. It was the beginning of their affiliation with the Cayce material, the smooth white stone thrown into the still pond whose ever-widening ripples would, slowly but inexorably, change forever the face of western medicine.

Mrs. Dunn with Baby Beth in front of office

Gladys in office, checking one of her young patients

Chapter 25

ψ

With the birth of their fifth child, the house on Coulter Street had suddenly become much too small. Bill and Gladys had started looking for a new home that would be not only bigger, but more convenient to their new office location. This they found on the corner of 54th Street and Lafayette Boulevard; a historical relic preserved in the middle of a former citrus ranch, now a subdivision featuring new two and three bedroom homes with all electric kitchens and backyards enclosed by gray cinderblock walls. 5401 East Lafayette Boulevard was an original adobe and had been the guest house for the ranch in its heyday. The main ranch house had also been preserved. It sat in its own grove of orange trees several blocks away and was much larger and more elegant.

But for the growing McGarey clan, the smaller guesthouse fit the bill perfectly. It was small only when measured against the Big House (as it was called) for it measured 3000 square feet, had nine doors to the outside, five bedrooms and a huge kitchen-dining room that gave onto a flagged patio. The floors were cement and would never show scuff marks. The great airy rooms had twelve-foot open-beam ceilings and the original adobe walls were a yard thick. It was as close to being childproof as any house could be.

The driveway was guarded by gateposts built three feet square and six feet high entirely of chunks of rose quartz. Oleanders taller than a man hedged the property from the street. An ancient tamarisk tree and several huge eucalyptus towered over the back while the front of the lot (it could hardly be called a yard) ran riot with prickly pear cactus and vicious bullhead thistles. And all around the sides and the back, the house was embraced by orange trees, heavy with luscious golden globes in the winter and floating in a cloud of incredible fragrance in the spring. The orchard was the scene of countless games of hide-and-seek and several ingenious tree houses.

To the dismay of the new owners, during the summer monsoon season the flat roof became a lake which leaked like a sieve, while the driveway became a river. The run-off from Camelback Mountain flowed straight down 54th Street, rushed between the pink quartz pillars and then poured directly into the boys' bedroom. A sudden nighttime thunderstorm would find the entire family awake, putting buckets under the largest drips and building a dam to divert the flash flood. The dams always broke and water would come rushing through anyway, to the loud whoops and hollers of the boys, but such nighttime forays were always ended by hot chocolate and cinnamon toast in the kitchen. Gladys figured that if you have to be up in the middle of the night, you might as well make it a party.

When they purchased the house in August of 1958 for $25,000, the walls were painted a startling bubble gum pink, and the orchard was completely overgrown. But it had potential, as well as an ageless sense of beauty and permanence that appealed to Gladys.

And she loved it. Every square inch. It reminded her strongly of the Rourkee Compound, with its thick walls and deeply shaded windows. It was cool in the summer and warm in the winter. There was even a huge old honeysuckle vine that shaded the porch next to their bedroom, scenting her dreams with memories of her own childhood. It

was the kind of house in which kids could run riot and never hurt a thing. A home as big as her heart. The perfect place in which to raise a family and grow old. She could feel ghosts there, but they were all happy ghosts. It was already rich with history and experience and she vowed that she would make it rich with love.

The roof was fixed yearly, but always in vain, for there were stairs built into the front wall of the hacienda that led up onto it. The kids just couldn't resist. Despite dire threats from their parents, they crept up the stairs to play and inevitably a small foot would go through the tarpaper, creating yet another leak. It was incredibly exciting for all of them to be up so high above the desert floor, spying on people as they walked by – perfect to play James Bond 007 or cowboys defending the fort from Indians. They tied a rope to the tamarisk tree and played Tarzan swinging out of the giant trees onto the banks of the Amazon. It was a house built for living.

Gladys didn't know it, but the truth is that the boundless generosity of her spirit was captured, held, and reflected back to the world by that gracious old adobe, as over the years she opened her heart and her home to countless starving souls and fed them love and a sense of belonging.

Strangers felt at home the minute they walked in the big front door. The house was never neat, but was always clean, and gave the appearance of being well and happily lived in. Dinner around the big oak refectory table usually numbered upwards of fifteen, and it was noisy and fun. And everyone was family.

View of Camelback Mountain
from the front door of Lafayette home

Adobe home on Lafayette Blvd.
Bob, Annie, Bethie, Gladys

Chapter 26

Ψ

January 1959

Morning broke in brilliant glory on the first day of 1959, turning the surrounding mountains purple, then red, then gold in an ever-changing symphony of light. The first rays of the sun lit the top of Camelback Mountain, then slid down its spine and crept across the desert floor. Pale winter beams struck the old adobe house nestled in a small grove of orange trees.

The sun rose higher and streamed brightly into the bedroom window, striking the couple sleeping in the big double bed with brutal force.

Gladys covered her eyes with a shaking hand and moaned.

She never drank alcohol. But it had been New Year's Eve, the Lyon's party had been so much fun and the champagne had looked so pretty with the Christmas lights sparkling through the rising bubbles. She'd had a glass, then danced with Bill, and then another glass and possibly one or two more. She couldn't remember. She'd felt giddy and lighthearted, joyous and carefree.

But not today! So this was a hangover. God! Her head hurt. The sun was so appallingly bright. She tried to roll over, but the movement sent her stomach into whoops, so she decided to lie very, very still…very still. Yes, that was a bit better.

She prayed that the children were still asleep. That she'd have a few more moments to lie here and quietly die.

The frigid January sunrise streaked the sky with beauty. Usually she was outside by now, rejoicing in the glory of the desert dawn.

But today she just moaned and continued to lie very, very still. In the bed next to her Bill echoed her moan. If possible, even more miserably.

Vaguely, in some far-off corner of the living world, she heard banging and slamming in the kitchen. The kids were up but, luckily, the kitchen was separated from the bedroom by the big patio so the noises were mercifully muffled.

An ominous silence fell. Then a deep whirring murmur filled the air.

"What could that be?" she thought, but unless the house began to burn down around them, she wasn't about to even try to get out of bed to investigate.

"Whazzat?" Bill whispered, barely moving his lips, obviously as mystified by the sound as she was.

"Dunno," she replied, amazed at how the simple word sent bolts of pain ricocheting around the vault of her cranium.

They both concentrated on lying very, very still while whatever it was continued to whirr in the background.

Another, even more ominous silence.

She thought she heard giggles and whispering outside their door and prayed that it wasn't true, but, horribly, it was.

The latch lifted and the door burst open to shouts of "Happy New Year!" and "*Nyasal Mubarak ho*," laughter and shrieks of joy.

Gladys and Bill nearly jumped out of their skins. They pulled the covers up over their heads whispering, "No! No!" but the devil-children leaped on the bed, all chattering at once.

Gladys' hypersensitive, nauseated nose caught the whiff of a

thoroughly unpleasant odor. She peered over the sheet at these spawn from hell, the four older kids with the baby toddling innocently behind. The boys' faces were all expectant, gap-toothed grins as they bounced in excitement on the bed.

Bill raised his head enough to hiss, "Don't bounce," then fell back moaning on his pillow.

Still unable to identify the foul smell, Gladys sat up slowly, straightened her nightgown, and looked around.

Standing immediately next to her was her eldest daughter, holding a tray in both hands. Upon the tray were two impossibly huge glasses filled with an evil green murk, visibly reeking. Horrified, Gladys poked Bill until he, too, sat up. Together they stared in stupefication as Annie handed each of them a glass.

"We used the juicer that Santa gave us for Christmas!" she said proudly.

Breathing through her mouth, Gladys tried to smile. "That's great, kids. Uh, what kind of juice is it?"

"Well, it's parsley, carrot and celery juice – it was orange until we put the parsley in. That made it really green. See? It's really, really good for you, Mommy, Daddy. Drink up!"

"And onion!" Carl chimed in. "Don't forget the onions we put in!"

"Oh yeah, we put in a couple of onions."

"The onions were my idea," Bobby put in with great gratification.

"And cabbage! Remember the cabbage we found in the bottom of the fridge," Johnny added.

"Yeah. And cabbage. So we got them all out and chopped them up and juiced it, and now you guys gotta drink it 'cuz it's just delicious and full of vitamins and trace elements."

Gladys shot her daughter a suspicious look, but Annie just

stared ingenuously back at her without a trace of sarcasm in her big brown eyes.

She looked helplessly at Bill, then at the glass in her hand. She took a sip. All eyes were glued to her face as, with the fortitude born of years of facing repulsive things inside and outside the human body, she did not throw up. The green goop slid down her throat into her rebellious stomach and her gorge rose, but she forced it down and smiled a somewhat sickly smile.

"Delicious!" she said. The kids all cheered, even little Bethie, and she turned to her husband. "Really, Bill, it's just delicious." If she had to drink it, so did he. After all, he was the one who had kept filling up her glass with champagne last night. She was not about to suffer alone.

With the desperate look of a condemned man, Bill took a loud, slightly gagging gulp. "Mmmm," he said, unable to find words. "Mmmm!"

"C'mon you guys! Get up! You said we could hike Camelback and go rock hounding today. It's already seven o'clock." Carl reminded them and they all started to tug the covers off their hapless parents.

"OK, OK," Gladys cried. "You go get dressed and Daddy and I'll meet you in the living room in fifteen minutes."

The children raced out like a pack of greyhounds. Bobby stopped at the door and turned around. "Be sure you drink every drop. It'll make you really really healthy."

When the door closed behind him, his parents gingerly got out of bed. When they found that they could, indeed, stand up, they made a beeline to the bathroom. Acting as a single unit, they poured the remainder of the juice into the sink where it glub-glubbed down the drain, leaving a slimy green residue on the shiny white porcelain.

The thought of tramping around the mountain and bending down to pick up rocks made her shudder, but she would have agreed to

anything to get the kids out of their room before they had to drink any more of that stuff. Maybe getting the juicer had not been such a bright idea after all.

$$e \cdot 6 \cdot \sqrt{} \cdot 2 \cdot 9$$

The move to Lafayette ushered in a marvelous time in Gladys' life. The children were an endless delight, her relationship with Bill felt renewed and solid and their work was expanding at a fantastic rate, becoming every day more fulfilling, exciting and hair-raising than she had ever dreamed possible.

A few weeks after meeting Hugh Lynn, Bill received a telephone call asking him to go to Tucson and give a lecture on meditation for the Cayce study groups there.

Never having meditated before, both Bill and Gladys were somewhat at a loss. This they quickly rectified by reading everything they could find on the subject and meditating three times a day for the next two weeks, so that he could speak from personal experience.

The lecture, being Bill's first attempt at public speaking, was predictably terrible. When they got the tape of the lecture, they threw it away without even listening to it.

But Bill was hooked. Undaunted by his less than successful attempt, he continued to speak whenever Hugh Lynn asked him to. Soon the rough edges were polished and he became a noted speaker for the Association for Research and Enlightenment, or ARE, the organization founded by Edgar Cayce to explore the readings. The more Bill learned about the readings, the more excited he became about sharing Cayce's medical remedies and spiritual insights with as many people as possible.

Gladys was content to sit in the audience and lead the applause, until one day Bill was sick and she filled in for him. Nervous at first,

she soon got the hang of it and began, even then, to enchant audiences with her storytelling skill. She had grown up under the tutelage of consummate storytellers. Her dad, Harry Dean and Dar each had their own way of spinning a yarn and she incorporated all their gimmicks into a style of her own. She remembered from her speech class in college how important laughter was, and when she spoke from deep within her compassionate heart, she found she could bring tears to everyone's eyes. She discovered the satisfaction of holding the audience in the palm of her hand and was immensely gratified to receive a standing ovation.

After that, they became a team on the lecture circuit as well as in the office. But they were scorned and criticized in the Arizona medical community for their unorthodox views.

A syndicated columnist, Dr. Frederick Stair, took special exception to their ideas about nutrition. He challenged them to a debate on the local radio station. The program went quite well. Against all expectations, Dr. Stair turned out to be intensely curious and open-minded, despite his Harvard education. They enjoyed him so much that they invited him over for dinner.

Because they wanted to appear sophisticated and secure enough in their beliefs to be flexible, they decided to serve steak to the adults and hamburgers for the children. Red meat wouldn't hurt them once in a while.

Gladys set the big dining room table with her fine china, polished the good silver and picked flowers from the garden for a centerpiece. The kids had their own table – a card table set up on the patio which was separated from the dining room by a short flight of steps and a waist-high divider.

Bill finished grilling the meat, the children got their burgers and the adults sat down to their plates full of delicious T-bone steak.

Dinner was proceeding elegantly. Gladys was feeling quite urbane and self-satisfied when seditious whispers began arising from

the patio. Frederick and Bill were engaged in an intent discussion so Gladys surreptitiously glanced over the divider. The kids had their heads together, plotting something. She decided to ignore it, hoping against hope that it had nothing to do with the present situation.

No such luck.

The whispers increased in volume, then an expectant hush fell. Gladys watched with trepidation as Annie approached their table, a determined glint in her eye. She came to a halt within inches of their guest's chair. Her face was on a level with his and she fixed him with a gaze that was at once innocent, yet calculating.

"Dr. Stair, are you going to eat all that?" she asked, pointing unmistakably at his half eaten T-bone.

"Excuse me?" he asked, completely nonplussed.

Gladys was about ready to fall through the floor. "Annie, sit down! We're trying to eat our dinner. Go on back to your table and finish your hamburger!" she gasped. Bill was shocked beyond words. The boys were peering through the plants that decorated the room divider, silent, completely in awe.

"I said," she replied as though her mother had not spoken, "are you going to eat all that? It's just not fair, you know. My parents are sitting up here with you and you're all eating steak but my brothers and I have to sit down there." She indicated the sunken patio. The boys ducked behind the greenery. "And we have to eat hamburgers. We never get steak because there's too many of us, so if you're not going to eat all that, I'll just take it down there and we can finish it off for you." She batted her eyes and smiled what she hoped was a disarming smile.

Bill and Gladys were speechless with mortification but they couldn't clobber her in front of company and she knew it.

"So if you're full, Dr. Stair, may we please have the rest of your steak?"

Helplessly, he nodded. All three adults watched in stunned silence as she swept his plate off the table. She returned to her co-conspirators in triumph to divvy up the loot with a ruthlessness that would have made Ghengis Khan proud.

It reminded Gladys vividly of the feeling she used to have in Wellsville when her four-year-old daughter would stand on the corner as the ice cream truck went tinkling by, brothers clustered tightly behind her, and yell in a pitiful voice, "Ev'rybody gets ice cream 'cept th' (sob) McGareys!" over and over until a neighbor took pity on them and gave them each a nickel.

Now I know why mothers get gray hairs, Gladys thought, and, writhing with humiliation, poured her guest another glass of wine.

<center>❧</center>

These were wonderful years for Gladys. David was born in February of 1960 and he grew like a weed, getting into more trouble than all his siblings put together. For the first few years of his life he thought his name was No David, but he was such an adorable little blonde laughing person that no one could stay mad at him.

No one except Bethie, that is. She and David, being so close in age, were constantly at loggerheads with each other. Once when the squabbling became too much, their parents separated them bodily and, while Gladys tried to talk some sense into David, Bill took Bethie into the living room, sat her down on the couch and began what the older kids referred to as lecture number 342.

"Now Bethie, you're seven years old now and you're just going to have to try to find a way to get along with David. It's not going to get any easier. He's one of the big challenges you've chosen in this lifetime. Yes, you did choose him. You chose all of us. You know that before we're born we choose our families so that we'll learn certain

<center>272</center>

lessons. You chose to be born into our family and now you're just going to have to learn to get along."

Her eyes looked imperiously and condescendingly into his. "Yes, Daddy, I know I chose to be born to you and Mommy. But that was before I knew <u>he</u> was going to be here!" she said unarguably and flounced away, ponytail twitching in annoyance.

Bill and Gladys sharing the lecture platform

Children growing up in Lafayette home
Anne, John, Beth, Gladys, David, Carl, Bob

Chapter 27

ψ

*A*bout this time, Gladys' great childhood friend, Peter Riddle, came back into her life to stay. When he had graduated from college during the war, he'd returned to India and fought there. In 1945, on furlough to the U.S., he'd stayed a few weeks with Bill and Gladys. She threw a small dinner party in his honor and he sat next to Alice, a nurse at the hospital and one of Gladys' best friends. They had immediately fallen in love and soon thereafter were married. Because money was still tight, Gladys offered to let Alice wear her wedding dress. With a few alterations she looked as beautiful in the gown as Gladys had.

They'd settled in West Virginia for a while but when Bill and Gladys moved to Phoenix, they started considering a westward move for themselves. By the time they finally moved, they had four children, the eldest of whom was Annie's age. They stayed with the family on Lafayette for several months while Peter looked for a job teaching elementary school.

It was a challenging time for both families, but their friendship weathered it well. After the Riddles moved to their new house, the two couples stayed intricately involved in each other's lives and the Riddle kids came to look upon the house on Lafayette as a second home.

The eldest, Douglas Allen, was just three months older than

Annie and, while the two of them loathed each other on sight, Carl recognized a kindred spirit in Doug. They immediately became bosom buddies. They encouraged each other in their stupid stunts, as if a teenage boy needs encouragement to be stupid. The two of them, along with the next door neighbor, Bill Crowley, consistently drove their parents to distraction.

Typical of this era was the time when Gladys was scrubbing carrots at the kitchen sink and she felt, rather than heard, someone trying to sneak past her.

"Carl," she said sharply, "why are you limping?"

Carl and Doug froze. They looked at each other and rolled their eyes. The woman surely had eyes in the back of her head.

"Uh, I'm not limping, Mom."

"Yes you are, Carl," she put the last carrot down and turned to face them. She had to admit, they were pretty cute, Carl with his crew cut and broad shoulders that were just beginning to fill out and Doug with his rakish blonde good looks. They'd be lady-killers someday, but today they just stood there trying to look innocent, but succeeding only in looking more and more guilty every second. But guilty of what – that was the question shrieking in her brain.

"Yes you are, Carl, you're limping and I want to know why."

"Uh, uh, it's nothing, Mom. I just stepped on a bull head or something."

"Well, if it hurts that much, it must be infected. Let me see it."

Carl shook his head mutely and started to back up and Doug intervened, flashing his debonair smile. "No, really, Aunt Gladys, he's fine. We pulled the sticker out and cleaned it up really good. It doesn't hurt at all anymore, does it, Carl?" Carl shook his head vigorously. "See? And he's not limping. Go ahead, show her." Doug shot a significant glance at his buddy who began to whistle tunelessly and attempted to saunter off.

Limp. Limp.

"Sit down and let me see it," she commanded in a voice that brooked no opposition. She was not one to be turned aside by charm or any other distraction ever cooked up by a kid. She'd been there herself. Therefore, she could see right through them.

Resignation written all over his face, Carl sat down at the breakfast bar. Doug, in a cowardly act of self-preservation, snuck out the back door.

Gladys knelt down on the kitchen floor, put the offending foot in her lap and stared down in outraged astonishment at the filthy callused sole. She couldn't believe her eyes. "WHAT IS THIS?" she spluttered, hoping for some kind of reasonable explanation so she wouldn't have to strangle him.

Frantically he looked around for his smooth-talking partner in crime. When he realized he'd been left holding the bag, he tried to explain in a way that would deflect her rage.

"Um, well, you know how us guys are always trying to see who has the best calluses?"

Yes, she did know. It was some kind of teenage macho thing. They ran around barefoot all summer long and she had witnessed many contests that measured how slowly each one could walk across 54th Street in the middle of the hellish heat of an August afternoon. Most of the kids only made it a few feet before they leaped in the air and did the hot foot across the rest of the way. But Carl's calluses were so legendary that he could stroll slowly across with nary a twitch. And Doug was a close runner-up.

"Uh, anyway, to prove whose were the best, Bill Crowley bet us that we couldn't stick a needle into the bottom of our feet."

"Yes, but this – this," Gladys was at a complete loss for words.

"So we both did it and that proved nothing," Carl continued, beginning to get carried away with his tale. "So Doug said that he

would concede the title if I could sew my name onto the bottom of my foot. So I did. Cool, huh?"

Gladys just looked at him and shook her head in defeat.

Across the callus on the heel of his foot, in dirty red thread, was stitched the word "Carl." Unbelievable! Of course he hadn't sterilized the needle, thread, or his foot before he committed this act of blatant idiocy and the embroidery job had become violently infected, with pus oozing out of the punctures and viscous red swelling beginning to crawl up his ankle.

For a moment she contemplated, with vindictive pleasure, the idea of allowing him to die of septicemia. But instead she just doused the foot with alcohol, yanked out the stitches ignoring his yelps of pain, then drove him to the office and gave him a shot of penicillin as slowly and painfully as she knew how.

Kids!

Alice and Peter Riddle wedding

David's 1st Birthday with Carl

Sunday morning - all of the children dressed for church

Chapter 28

𝒯he sixties passed in a kaleidoscope flood of images and experiences into which Gladys, by virtue of her essential nature, could do nothing but dive headfirst. She was forty years old, just entering the first rosy decade of the very prime of her life. Her future stretched before her like the unending snowy peaks of her childhood, golden and glittering, dancing brightly into the invisible distance, in which anything could happen and possibilities were endless.

Time, with its eternal indifference to logic, spent eons exploring a single moment, then conversely, gathered years together, and in a flash, they were gone.

These were magical years during which everything grew so fast – their work, the children, their spiritual knowledge and awareness, their love for each other. Even the tiny palm trees that Bill planted down the length of the front driveway seemed to grow inches a day. Leaps and bounds didn't even begin to describe it.

But growth, as essential as it is to the value and richness of our lives, is not always comfortable, and sometimes barely tolerable. Aunt Belle used to say that in order for there to be the high peaks of the great Himalayas, there must also be valleys as deep as the mountains. And the paths that lead us through the dark, shadowed places are the most

rewarding of all, for they challenge us to move through our fear and to conquer our demons. The greatest lesson of them all is to learn to keep our vision fixed on the glowing peaks of the mountains, while, with the help of the angels, our feet stumble down the dark paths of the deepest valley.

In the fall of 1961, Gladys made her journey through the valley of the shadow of death.

In October she and Bill rented a cabin in Sedona for a week, and the third night they were there she dreamed of a black widow spider, shiny and terrifying, its segmented body etched with the red hourglass clearly visible to her horrified gaze. It was crawling and hopping up her arm and she could do nothing about it. Unable to move, she watched in terror as its legs propelled it forward onto her shoulder. She could feel it on her neck and still she was paralyzed. Feeling its fangs sink deep into her throat, she awoke with a silent scream, cold sweat running down her shaking body.

She sat bolt upright in bed and looked around in a panic. Her breathing returned to normal as she sat back against the headboard, drinking in the beauty around her. Realizing that it had been a dream made it no less frightening, but the magnificent sight framed by the rustic window of their cabin was like a balm to her soul.

The spectacular red rock mesas of Sedona rose in the distance, their fantastic shapes and striations glowing in the light of the newly risen sun. A great host of birds were singing their hearts out in glorious abandon, hopping and flitting from pine tree to oak branch in the surrounding forest. Here in Oak Creek Canyon of northern Arizona, nature embraced them in her gentle arms and the greatness of God seemed very close. Whispering a prayer of thanksgiving, she was momentarily comforted, but then the significance of her dream settled into her body like a shard of ice. She touched her throat where the dream-spider had bitten her. Yes, the nodule was still there. The shard

of ice twisted in her gut.

She'd discovered the tumor a month ago while she and Bill were at a conference at ARE headquarters in Virginia Beach. At that time it was a discrete nodule, no more than one centimeter across, quite hard and suddenly very obvious. She'd showed it to Bill, but they'd remained calm and had agreed to keep a close eye on it. In the next few weeks it had grown swiftly until it was the size of a pigeon's egg and they knew they had to do something. Quickly.

Bill, secretly frantic, researched the readings and found treatments that could be applied, but they were both greatly torn. Should they use conventional medicine – biopsy, surgery, God knew what else – or should they diagnose and treat this condition according to the principles that they'd been learning about and teaching to their patients? Should they walk their talk, or, in their extremity, fall back upon the tried and true?

They knew they needed time and focus to make such an important decision, so they had come to the cabin in Sedona and had spent the last three days talking and meditating, praying for guidance.

The day before they'd left Phoenix, one of their best friends, Betty Robbins, had come over and told Gladys of a dream she'd had the previous night, a nightmare about a black widow that had fallen down from the ceiling onto Gladys' head and had attached itself to her throat.

Now, with this second dream about a poisonous spider, Gladys knew without a doubt that she'd been given the diagnosis of her condition. It was obviously life-threatening, probably cancer. The worst of their fears – a malignant tumor of the thyroid. She put her hand to her throat and began to cry silently, frantically, unable to see the red mountains blazing in the distance or the delicate golden tracery of the sunrise through the pine trees on her bedroom walls. Instead, she looked down a dark tunnel towards death and grieved for her motherless children, for the good work as yet undone, for the rest of her life unlived.

The storm passed and she blew her nose, then lay down carefully next to her peacefully sleeping husband. She wrapped her arms tightly around him and began to pray in earnest. Immediately she fell into a heavy sleep. Once again, she dreamed, but this was a blessed dream of reassurance and comfort from which she awoke cleansed of fear and sure of her path.

In her dream she knew she hadn't eaten for thirty days, but she didn't care because she was sitting under the rose bushes in her mother's garden. The garden was high on a mountaintop; dahlias and lilies nodded their heads and sang to her and the scent of *chambili* and *rat-ki-rani* filled her with joy. Her mother, once again a young woman, walked up to her, leaned over and removed the tumor from her throat, as if she were popping a marble out from under her thumb. It flew up in the air, looking like a fist-sized, curled up spider, and went bouncing away down the mountainside. It rolled through an aspen forest studded here and there with fifty-foot high aloe vera and ocotillo cactus, all in full bloom. And then she was floating on her back in a lake of rich green aloe juice, the smell sharp all around her and the clean, bitter flavor pinching the edges of her tongue. She scooped up the juice with a luminous white shell and drank it and her body became filled with light. And where the tumor had been, now there was white light pouring out of her throat, surrounding her in a sphere of brightness and joy.

Eagerly she awakened Bill and shared both dreams with him. Then and there they made a plan. She would stop working immediately and begin a 30-day fast, drinking only water and aloe vera tea. Bill had somewhere come across a recipe for a cleansing poultice made of fresh, bruised ocotillo fibers mixed with ash from aspen wood. Luckily, both ingredients were readily available, if not easily prepared. They would apply the poultice once a day and would use a castor oil pack the rest of the time, just for good measure.

Gladys started the fast that very day and broke it on Thanks-

giving with the rich scent of roasting turkey in the air and her family gathered all around her. On her plate were three peeled grapes and a slice of papaya. It felt like a feast fit for a queen.

And what of the tumor? It was completely gone. Not a trace was left. And it never, ever recurred.

During her month of fasting, which she privately thought of as her Garden of Gethsemane, she spent most of her time in an altered state, praying, meditating and sleeping. She felt as if she couldn't be there as much as she wanted to for her children and she regretted that. But for the kids, the novelty of having her home all the time offset her preoccupation, at least in their minds and they felt no lack. Although they were worried about her, they turned to each other for comfort, sensing her fragility and distraction. They helped her as much as they could, took care of each other and trusted that soon she would be well – once again the beautiful, strong mother who was the center of their collective universe.

And when worry descended upon her like a black cloud, or the hideous, viciously seductive "what-ifs" and worst-case scenarios overwhelmed her mind, she would remember her own mother and how Beth would refuse to worry, saying, "Worrying is like praying for what you don't want to have happen. When you start to worry, Gladdie, pray instead. Pray for the most positive outcome, for the miracle. Then let go and trust that it will be so."

She would think of what Cayce said in one of his readings: "Why worry when you can pray," and she would take control of her gibbering mind once again.

And so, with a studied attitude of divine nonchalance, choosing a million times a day to fill her body with the lightness of love instead of the darkness of dread, she came through her trial and was reborn.

On that Thanksgiving Day, she offered thanks with every molecule of her being. She feasted on her grapes and on her family's

love and on life itself, and believed herself to be the luckiest of women.

Gladys with thyroid nodule, November 1961

Just two months later, early in 1962, when David was two years old, Gladys did something she'd never done before. She left her children in the capable hands of her mother and father for six weeks while she accompanied Bill and Hugh Lynn on the first ARE sponsored trip to Egypt and the Holy Land.

What an incredible experience it was, especially the ten days they spent on the Nile, living aboard a small boat, the Nile Express, and sinking deeply into the timeless rhythm of that great river.

Gladys would never forget the sight of the sunset, golden across the water, lighting the sails of the *falucas* with an unearthly glow, while she and Bob Adriance speculated that it must have looked exactly like this when Moses was pulled from the rushes.

They saw Abu Simbel before it was raised to make way for the Aswan Dam, lighted up in all its awesome glory one star-flung night, and watched what they were sure was a UFO circle, then swiftly fly away. They went to Egypt in search of the mystical, the spiritual, the

metaphysical, and they found it all in the very air they breathed and in the dreams that visited them at night.

They celebrated Hugh Lynn's birthday with a date cake that his wonderful wife, Sally, bought in a local bazaar. Everyone received a massage from one of the older women in the group, an amazing individual by the name of Ida Rolf. She had painfully strong hands and an infectious laugh and was as close to a force of nature as anyone Gladys had ever met. Except, perhaps, Aunt Belle.

She returned home feeling completely transformed, but hungry for the sight of her children and concerned about the state of the office after such a long absence.

She need not have worried. Before they'd left for the trip, they'd taken on a partner in the practice and she had very capably held the business together while they were gone.

Dr. Frances Serkowski was a dynamo, a tall, handsome woman with salt and pepper hair and a warm smile. She exuded confidence and skill. The patients were immediately comfortable with her, to Gladys' great relief. Frances and her partner, Eleanor Schaffer, (fondly known as Schaf), had been exploring the Cayce material for a few years and she was thrilled to be able to apply the concepts to her medical practice. A few months after Bill and Gladys returned from Egypt, it became apparent that the office was too small for their needs. They decided to move and possibly build to their specifications. Soon they purchased a large lot near the corner of Indian School and 40th Street and, after a minimum of fuss, finally built the clinic of their dreams. They incorporated with Frances and Schaf to form The Olive Tree Medical Group. In the patio by the entrance they planted an olive tree, a symbol of growth and of their purpose.

When they moved in, Gladys felt as if she'd fallen into the lap of luxury. It was huge! There were five treatment rooms, a lab, a front office with room for as many charts as they would ever need, a big L-

shaped office for the doctors (with their own bathroom!) and even a staff lounge with a small refrigerator and hot plate. At first it was a little sterile, but she cozied it up with beautiful wall hangings, pictures of the Southwest and, in niches here and there, kachina dolls and spider plants.

Besides being a highly skilled physician, Frances was an excellent business woman and under her guidance the practice flourished. They hired new office staff to meet their expanding needs, including a dear friend who was also in their study group, Peggy Grady. She had recently graduated from vocational nursing school and needed a job and, as Bill also needed a nurse, she became a part of the family.

More and more, they began to apply the Cayce principles to their work and were constantly amazed by the results. Bill and Gladys began speaking as a team more often than not, traveling all over the country to headline various ARE conferences. Bill held up the empirical end of the presentation while Gladys reached out and captured the audience's heart, bringing tears, laughter and an overwhelming response of love.

Bill and Gladys, Egypt 1962

June 1964, Pacific Grove, California

"If Mark Twain said, 'The coldest winter I ever spent was summer in San Francisco,'" Gladys muttered to herself, "that's because he'd never been to Pacific Grove in June. Brrr!" She shivered inside her lightweight jacket and hurried down the path to the main lodge. Asilomar Conference grounds are situated on the most spectacular stretch of beach of the Monterey Peninsula, a hundred miles south of the City by the Bay. The ARE sponsored a family camp here every summer; they took over the long houses and dining room, the main lodge and the chapel for a full week.

It was an event that the children looked forward to all year with the greatest anticipation. They had a completely separate program from the adults and saw their parents for only two hours every afternoon, and occasionally across the dining room long enough to wave. They were divided into age groups and each flock of kids was herded around the grounds by their counselors, long-suffering, sleep-deprived individuals who dearly loved their young charges, even when their beds were short-sheeted or their toilets Saran wrapped.

Each separate group was assigned to a dormitory called a long house and to a specific table in the huge dining room. The tables were round and large enough to seat a dozen people. The kids' tables were all on one side of the great room and were the scene of many a spitball and food fight.

The adults sat on the other side of the room and discussed dreams and philosophy with like-minded people who often became lifelong friends. They stayed in the more upscale, newer units, luxury accommodations by the names of Spindrift and Hilltop. They knew that their children were having the time of their lives, but they were responsible for them only two hours a day. The rest of the time they could pursue their own interests knowing that their offspring were well cared for and happy.

It was a situation which suited everyone. The adults had their own program of lectures and workshops. The kids' program was targeted to their age groups and included arts and crafts and lots of beach time, as well as short sessions on different principles taken from the Cayce readings. Parents got their time alone and the kids could be almost as crazy as they wanted.

Gladys and Bill, now well known presenters for the ARE, were the keynote speakers for this conference, sharing the podium with their good friend, Elsie Sechrist. She had been involved with the Cayce material for much longer than they had and was the author of one of the best known books on dreams, *Dreams, Your Magic Mirror.* Elsie's husband, Bill, was also in attendance and the four of them would often sneak into Pacific Grove late at night for ice cream.

Everyone has their own minor rebellions.

Gladys dearly loved the lectures, workshops and discussion groups with the adults. Her time with the kids was a much bigger challenge. Part of her job description was to teach an hour-long class to each of the age groups. Today she was on her way to talk to the six and seven-year-olds about meditation.

The path she was following broke out of the pine trees and crested a sand dune. Gladys was brought to a halt by the sight spread before her eyes. She took a deep breath, filling her lungs with the incredible freshness of the air, drinking it as if it were the finest wine.

"It may be cold," she thought, as she tasted the salt wind and the scent of misty sun on tall pine trees, "but it's worth it. This is almost too beautiful to be true."

The dunes stretched before her, covered with ice plant, rolling down to the sea. Soon even the sturdy ice plant gave out and the beach became pure white sand punctuated by great up-thrusting rocks, piled here by the hand of God on the very edge of the continent. The fog had

lifted an hour ago and now the sky was clear and the water blue – blue to the horizon. The waves rolled in from the immense Pacific and as they broke, they seemed to stop in midair, allowing the light to shine through the crest, emerald green and magical. Then, crash! They would plunge to their deaths against the jagged rocks, sea foam erupting into the air and blowing away in the offshore breeze. Miles of deserted beach curved in the great arc of the Monterey Bay. There were tide pools and piles of sea kelp that were an endless fascination for the children. And over it all arched the indescribable blue of a northern California summer sky.

She stood at the top of the dune, took it all in and said a prayer of thanks for her life, here, now. It was so wonderful to be with these people, create this community and to be able to do it in such an incredibly beautiful place. Not to mention how great it was to take a couple of weeks off from the hammering heat of the desert right in the middle of the endless Arizona summer.

This was the third time they'd attended this conference. Each year they would pack the kids in their VW van and drive across the Mojave Desert at night, then stay in Bakersfield with their friends, the Hottens. The next day would see them driving north toward Salinas, through summer hills that resembled great piles of crushed brown velvet. Finally, the air would cool and the magic of the Monterey Peninsula would embrace them.

She and Bill always looked forward to the holiday with pleasure, but the kids literally couldn't sleep for days beforehand from excitement.

"Oh, good gracious!" she exclaimed out loud, "the kids!" She glanced at her watch and hustled down the path. She'd become lost in her contemplation of the beauty around her and had forgotten that she was due at the lodge for the class on meditation.

She arrived with mere moments to spare and stopped inside the

big double doors to reconnoiter and catch her breath. The minute the counselors saw her they turned the reins over and fled. The kids were, predictably, running amok and it took all her parental authority to gather them in the small conference room, get them calmed down and seated around the table.

"OK, kids," she began, "I'm Dr. Gladys and today we're going to talk about meditation. Now, how many of you have meditated before?"

A few small hands poked up into the air.

"Good, good. Meditation is something we do to calm our minds and to try to hear God speak to us. In prayer we talk to God. In meditation we let God talk to us. Who can tell me what we use to quiet our minds so we can hear what God has to say?"

Complete silence. Blank stares.

Gladys waited a moment, then gave up and answered her own question.

"We use an affirmation. An affirmation is a phrase we repeat over and over to ourselves to keep our minds from wandering."

A few small heads nodded knowingly. That was encouraging.

"So who can give me an example of an affirmation?"

Silence and blank stares once again.

She took a deep breath.

OK, so it was going to be like this.

"Well, one of my favorites is this one: 'Not my will but thine, oh Lord, be done in me and through me.' Can you all repeat that for me?"

Reluctantly, they muttered along with her. She talked a little more about the benefits of meditation and they practiced the affirmation another few times. Finally, she figured it was time to try the acid test.

"OK, kids, now let's meditate for five minutes. Remember,

keep your eyes closed and try not to think of anything but the affirmation. Just repeat it to yourself – silently – over and over again.

After several false starts, during which she was forced to separate two of the little boys who were kicking each other under the table and three little girls who fell into fits of giggles the minute they closed their eyes, things quieted down. Four minutes of silence crawled by and Gladys began to relax, feeling as if she had achieved a major victory. Immediately following this reflection, the blessed quiet was shattered by stifled snickers and snorts. She lifted her eyelids ever so slightly to see what was going on. Shocked, her eyes popped wide open and her jaw dropped.

Apparently one of the older boys had taught each and every one of his cohorts to turn their eyelids inside out. A circle of bloodshot, lidless, ghoulish eyes and wide gap-toothed grins stared back at her.

After a horrified yelp, the humor of the situation struck her full in her always accessible funny bone and she gave a delighted shout of laughter. The counselors returned to find the entire group convulsed with hilarity. Never, to her dying day, would she forget that sight. And the memory of it never failed to make her smile.

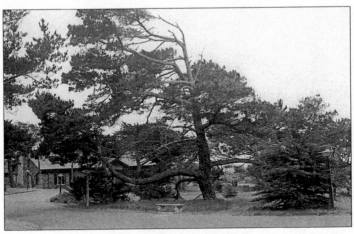

Asilomar Conference Center

Beach at Asilomar Conference Center

Chapter 29

ψ

July, 1964

\mathcal{S}uppertime at the McGarey's was always a raucous affair. Bill sat at the head, Gladys at the foot, and the six to eight chairs on either side of the long oak table were invariably filled with different combinations of kids, friends and the occasional bewildered newcomer.

On this particular night Gladys looked around with weary satisfaction as she dished up the fish sticks and vegetables and passed the plates down the table. Carl, Doug Riddle, Bill Crowley and Johnny were goofing around at the far end enjoying themselves immensely, while Bobby was indulging in a punning contest with his father. Annie and her best friend, Kathy, giggled and gossiped together and tried to ignore David who, along with his buddy Mike, was being as obnoxious as possible. Bethie, unusually quiet, drooped in the chair next to her mother and uttered a tormented sigh when the plate of fish and succotash was placed before her.

Gladys bent a stern look upon her youngest daughter. She knew this was Bethie's least favorite meal, but she was in no mood for histrionics. "Just eat it!" she said darkly and leaned back in her chair, closing her eyes, resting for a moment.

She was certainly tired, but it was a good tired, the result of being up most of the previous night with a delivery. She smiled to her-

self, reliving the moment. The miracle of birth was just that – a bright, pure miracle. Bringing babies into the world had always been her favorite part of medicine and her "O.B.s" as she fondly called them, were admittedly special patients to her. She empathized with all their fears and frustrations, for she had been there six times herself. And when the baby was finally born, she got to share the wonder and the joy, and to be the very first to touch the newborn babe, always with gentle, reverent hands. The fragility and power of that very first breath never ceased to amaze her. It was life recreating itself; it was a holy thing. Every time she scrubbed for a delivery and put on the gloves and gown, she secretly imagined that she was donning priestly robes. When she stepped into the delivery room it was as if she were stepping into a sanctuary where she would soon be witness to the holiest of sacraments. And then the miracle occurred. The tiny body slipped into her hands, squirming and red-faced, yelling with life. That was a moment unlike any other. "Bless you, little one," she would whisper, "and welcome to this wonderful thing we call life. May you be healthy, happy, loved and loving, and may you always remember who you truly are." She herself always felt reborn afterwards. It was worth a few hours of lost sleep.

Oops! She almost drifted off! Forcing her eyes open, she sat up and took a deep breath, picked up her fork and looked around the table. Everything was as normal as could be: wild, noisy and crazy. Everyone was wolfing down their dinner and enjoying themselves, as usual.

Everyone except Bethie. In her own quiet way, the child was throwing a fit. Annie may have made a big old *tamarsha* about blackstrap molasses in milk, Gladys thought to herself, but she was nowhere as picky as Bethie. She watched the child with a rueful eye; the seven-year-old was listing to the left and hunched forward over her plate, slowly pushing lima beans from side to side, as if hoping they would somehow disappear. Even her little blonde ponytail drooped.

"Bethie, is something wrong?" she demanded, fixing her with

what the kids called her doctor look.

The little girl looked up through her bangs, sad blue eyes as big a saucers, brimming with tears.

"I don't like lima beans, Mommy," she whined.

"I know you don't, but you know the rule. At least three bites of everything on your plate. Eat up now," Gladys replied with unusual ruthlessness.

"I took two bites," Bethie said piteously, then wilted even further and began to sob, thinly and somewhat hysterically.

This was over the top, even for lima beans, Gladys thought. Maybe the child really was sick. She put down her fork and tilted the little chin up, running a scrutinizing, diagnostic eye over her face.

"Bethie, what is it? You're so flushed." She pushed up the fringe of bangs and felt her forehead. Her palm came away hot. "What's wrong? Are you sick?"

The little girl shook her head and continued to cry. By this time Bill had become aware that something was going on at the other end of the table.

"Bethie," he commanded, in his no-nonsense, father's voice, "tell your mother why you're crying like that. And it had better not be just because you hate lima beans."

In a small tragic voice she finally told them, "No one picked me up from Vacation Bible School today."

Bill and Gladys froze.

"What!" they exclaimed simultaneously.

"I waited and waited and waited. Everybody else's mommies came and got them and I waited some more. But no one ever came. So I walked home."

Gladys looked at Bill, aghast.

Bill looked at Gladys, aghast.

"I thought <u>you</u> were going to pick her up!" they said, again

simultaneously.

"No one picked me up," she wailed, "and so I walked home."

"Walked home!" Gladys was overcome. "Bethie, it's at least seven miles from church. And it was 107 degrees today! Why didn't you ask one of the other mothers to drive you home? Or you could have gone to the church office and they would have called me."

"I was too scared!" the little girl whimpered, and promptly threw up all over her plate.

Deeply chagrined, Gladys swooped her baby up in her arms and with a baleful stare at her husband, stalked off. Annie and her friend followed and Bethie was given the rare treat of a cool bubble bath in her mother's bathroom, complete with bath pearls and a cooing, contrite audience.

Bill was left to clinically remove the plateful of regurgitated lima beans from the table to loud hoots of "yech!" and "gross!" while the whole bunch of grubby boys staggered around, putting their fingers down their throats, yelling "barf!" and "urgh!"

It was not one of their shining moments as parents.

Gladys, at a hospital delivery

June 1967 - Pacific Grove, California

"Spirit is the life, mind is the builder, and the physical is the result," Gladys said in ringing tones, and looked out over the fascinated audience. It was the final lecture of their week at Asilomar and everyone was so fired up she could almost feel the heat. The hall was crowded and the excitement in the air was electric.

"Those were compelling words that Cayce spoke. He repeated them over and over in his readings. And truer words have never been spoken. The way I like to explain it is this: the essential energy for creation and manifestation comes from the Spirit. Our minds focus the energy with every thought we think and every thought has an effect – every one. And that energy, focused through our thoughts and beliefs, creates what we see before us, manifested in the physical world.

"When I was a little girl in India, my parents used to go around to the villages and give magic lantern shows about Jesus for the villagers. It was just like a slide show, but they used kerosene lanterns instead of a slide projector because there was no electricity. But the concept is the same and I believe that this is a perfect metaphor for Cayce's idea here. The light from the projector – the magic lantern, so to speak – is Spirit, the illuminating source. The slides we put in the projector are our thoughts, the mind focusing that light in certain specific ways. And the picture we see projected on the screen is the result: the physical world, our bodies and everything around us. That's why, when we want to change something – like our health, for instance – we must think of the whole person. Not focus simply on the body, as western medicine does, for that's like trying to change the picture on the screen by changing the screen. That doesn't work! We must change the slide itself, change the way we think, and then that will change our attitudes, our actions and reactions, our habits. And the more brightly we allow Spirit to shine in our lives, the more beautiful and clear our picture will be.

do! Bill and I start with the body and work backwards. We look at our patient's physical manifestation and ask, 'What is this telling us?' We treat the body with remedies from the readings, or antibiotics, sometimes even surgery. Cayce said, 'All healing comes from one source. And whether there is the application of foods, exercise, medicine, or even the knife – it is to bring the consciousness of the forces within the body that aid in reproducing themselves – the awareness of creative or God forces.' But we also look at what the person thinks and believes. When we, in cooperation with our patient, create a treatment plan, we address not only the body, but the mind and spirit as well.

"The rest of the world believes that it's the doctor's responsibility to heal the patient. We know that this is not true. We, as physicians, work in cooperation with our patients. We tell them, 'We'll work with you and help you, as a partner. We'll be your facilitators, but we don't ever make anyone well. The healing comes from within you. You have to work with your body, and your mind, and your spirit to get results.'

"We tell our patients to listen to their dreams, to make conscious, responsible choices regarding diet and lifestyle. Western medicine is disease oriented; we are whole-person oriented. Cayce's suggestions varied from person to person, although the disease being treated might be the same. Each reading was tailored to the individual patient. That's how we try to work – always remembering that each person needs a different approach, for each one of us is a unique individual. And only you know yourself well enough to understand whether a dream about a dog, for instance, is, for you, a supportive, protective symbol or one of danger and fear. It all depends upon your past experience with dogs."

Gladys glanced at her watch, then took a sip of water, while her eyes traveled around the auditorium. Every eye was fixed on her; she felt as if she had her audience in the palm of her hand. She loved this feeling more than almost anything, but she had only fifteen minutes

300

left, so she'd better get down to a few specifics.

"Of course, one of the most important remedies to come out of Cayce's readings is the castor oil pack."

A few good natured groans arose from the old-timers in the audience. Bill and Gladys had been touting castor oil packs for years now, and had jokingly been accused of saying, when a patient called in the middle of the night with any complaint whatsoever, "Take a castor oil pack and call me in the morning."

Over their good-natured protestations, Gladys continued, "Yes, yes, I know that many of you have heard it before, but for the benefit of those who haven't, humor me for a moment.

"Cold pressed castor oil, also known in ancient times as the Palma Christi, or palm of Christ, is a truly miraculous thing. When used externally in a poultice or pack made of wool flannel and placed on the abdomen, it eliminates intestinal obstructions, stimulates the lymphatic system, and increases healing dramatically. It seems to work on more than just the physical level; I believe it has a metaphysical component that allows it to affect not only the body, but the mind and spirit as well. That's why it was called the Palma Christi; because, like the hand of Christ, it heals on every level.

"We've used castor oil packs applied to the abdomen to treat hyperactive children, epilepsy, menstrual cramps, constipation, and the common cold. They can also be applied topically to sprained muscles, injured spines, even boils to draw the poison out. They are amazing and even though you taunt," she pointed to the friendly jokesters in the audience, "you know that they work unbelievably well.

"Cayce also said that each cell in the body has an innate intelligence all its own and that it sends out messages to the other cells when it needs help. Science teaches that all intelligence is in the brain, but you know what? I don't believe that at all anymore. I have come to believe that every cell in every body is communicating – or trying to

communicate – with us every moment. We just don't understand the language we are speaking to ourselves. That's where dreams and meditation come in. They put the language into symbols and if we listen and pay attention, we are able to translate the message and oftentimes clearly understand what needs to be done.

"And then comes possibly the most important part of the healing process – a commitment to action.

"Time after time, Bill and I have seen patients with a strong will to live, a commitment to their healing on every level, overcome catastrophic illness. We've seen positive, receptive attitudes speed recovery, and negative, closed minds wreak destruction. We've personally witnessed miracles – or what the AMA would call spontaneous remissions – far too often to believe that they were just flukes."

Gladys took a deep breath, placed both hands flat on the podium and leaned forward, connecting with her audience, infusing them with her heartfelt conviction.

"You can create miracles! Listen to your body. Listen to your dreams, pray and know that your prayers will be answered in your meditations. Be aware of what your thoughts are telling your body because it listens and responds exactly.

"And remember, as much as our individual cells combine to make up our bodies, so each individual combines to create a body of community and a community of consciousness. The people in this conference have become your community, so support each other, love each other, stay in communication with each other. As we build health in our individual and community lives, we build health and peace on the planet and move into a global consciousness of love and tolerance and peace.

"So take what you've learned this week home with you, share it with your friends, support each other in your study groups, and most of all, love each other and have fun!

"And don't forget to use castor oil packs!"

As she added her final words, the audience erupted in applause, laughter and cheers and surged to its feet.

Bill came to the podium to share in the applause and she took his hand and looked at him with joy, eagerly sharing the triumph and adulation.

He looked back at her and she was shocked to see what appeared to be a flash of jealousy in his eyes. But no, she thought, it couldn't be. They were a team. The standing ovation was for him, too – he must know that. Before she could pursue the thought any further, she was enveloped in hugs and questions from the crowd and when she saw him again, all seemed normal and Asilomar was over for another year.

Several frantic hours later, they were headed out the gates in their VW van, all five kids hanging out the windows calling tearful farewells to their friends. Carl wasn't with them, as he was almost twenty this year and had much better things to do than hang around with his family.

They had planned to spend a few days with some friends in a small town north of San Francisco called Santa Rosa. It, too, was beautiful country; hotter than Monterey but still cool at night, graced with giant redwoods, magnificent oak trees, and more of those incredible crushed velvet hills. The town was inland, but close enough to the coast so the kids could spend a few more days getting sandy and salty and exhausted enough to fall into their beds without protest at night.

The Ballantines had a split level house and the children, as always, were fascinated by the stairs. They ran up them, slid down them, played monkey bars and Tarzan on the railings. The last night of their visit they were allowed to stay up late and David, while pretending to be Tarzan swinging through the jungle, grabbed for the railing and missed. He fell ten feet and landed, with a loud yelp, on his back on the bottom step. When the adults came running in, he was lying very

still, crying silently. It was nearly eleven o'clock. The nearest emergency room was forty-five minutes away, so, after having ascertained that he could move all his limbs, Bill and Gladys decided to treat him at home that night and to take him to the ER in the morning for X-rays.

He was in a great deal of pain, as the edge of the step had struck him across the middle of his spine. Even his breathing was shallow and seemed painful. Following their own advice, his parents applied a castor oil pack to his already bruised mid back and made up a pallet next to their bed so they could keep a close eye on him. The little boy had trouble sleeping; he tossed, turned and moaned softly until well after two a.m. He then became quiet and Gladys, hearing him settle down, breathed a sigh of relief and faded into a deep sleep herself.

She was awakened by a small, cold hand on her cheek.

"Mommy, Mommy," David whispered.

She opened her eyes to his sunny, smiling face.

"Mommy, can you please take this pack off me so I can go out and play?" he asked hopefully.

Bill popped his head up, and between them, they lifted the squirming child onto the bed. He seemed to be moving without any stiffness or pain and under the pack his back looked perfect. No bruising, tenderness or lack of sensation. They had him move all around, bend back and forth, and rotate his spine. No pain or limitation whatsoever.

Amazing!

"Well, honey, you look fine to me," Gladys pronounced and Bill nodded in agreement. "Did you sleep OK?"

"At first I hurt a lot," he told them seriously, "but I didn't want to cry 'cuz you guys were sleeping. So I closed my eyes and tried to go to sleep but it kept hurting and hurting for a long, long time. But I must have fallen to sleep 'cuz I had a dream that Jesus came into our room and he put his hand on my back and all of a sudden it felt all better. I feel really good now, Mommy, can I please go out and play? The other

kids are out back and I don't want to miss nuthin."

"Miss <u>anything,</u>" Gladys automatically corrected while she and Bill looked wide-eyed at each other and the theme from "Twilite Zone" played in their heads.

"Palma Christi indeed!" they thought and watched the child bolt out of the room, shouting for his playmates.

Bill and Gladys - a good team

Chapter 30

ψ

Agra, India 1969

*M*ost of the passengers shrieked in terror as the bus driver
barely missed killing them all for the tenth time since they'd climbed
aboard in Delhi that morning. The road from Delhi to Agra is known
world-wide as one of the most dangerous highways on the planet. Their
bus driver, however, seemed unaware of that fact as he passed other
vehicles on blind curves and, time after time, came within inches of
fiery death on the narrow, winding road.

Hugh Lynn, Sally and Bill were white-knuckled and green-
faced, as were the other members of the ARE group who had accom-
panied them on this round-the-world tour. But Gladys had traveled this
road many times in the past and knew that her fate was in the hands of
the gods. She also knew that it was folly to look out of the windows.
Witnessing every near-miss and staring with horror into the oncoming
traffic only made it worse. So she closed her eyes and, resting her head
on the back of her seat, occupied her mind with memories of the trip so
far.

They had visited Egypt and the pyramids and she'd climbed to
the top of the Great Pyramid. Only seven of them had made it to the top.
It had been an incredible feeling to experience the power focused in
that place and to see the whole of the great desert spread out around her.

But the most significant event for her had been the night they'd spent in the kibbutz on the Sea of Galilee in Israel. The idealism, the sense of community and cooperation there had been so strong that it had carried them away on a great wave of visions and dreams of the future. She and Bill had stayed up most of the night talking, as their purpose seemed to coalesce about them. They felt poised on the edge of momentous events. As dawn lit the sky over that ancient land, their choices became clear and their commitment was made. They would dedicate their lives and their work to the concept of medicine as Cayce had seen it, and they would be brazen, audacious, unashamed and unafraid to go up against the established medical hierarchy. They would stop tiptoeing around; they would stand up and shout that true healing goes beyond the physical body; that it is a holy thing – a holistic thing.

The first step in this process would be to transform the Olive Tree Medical Group into the ARE Clinic. There, in the eyes of the business community, the medical community and the world community, they would study, research and implement the suggestions made in the Cayce readings, as well as explore and document the overwhelming amount of paranormal information now available about healing.

As soon as the others awakened, Bill and Gladys cornered them. Over breakfast they described their ideas and plans. It was exactly what Hugh Lynn had been hoping for all these years and he and the other board members entered wholeheartedly into the concept of a medical research arm of the ARE. Of course they would have to put it to a formal vote upon their return to the States, but there was really no question as to the outcome.

So now they were (almost) officially the ARE Clinic and that opened so many doors, presented so many possibilities that they could hardly talk of anything else.

From Israel they'd flown to Delhi. Their plans were to see the Taj Mahal in Agra, then go on to Rourkee and visit the Children's

Home. Gladys' brother Gordon and his wife Beth were now the directors, and she was looking forward to the visit with great anticipation. The bus ground to a halt. Fervent prayer and the luck of the foolish had brought them to their destination unharmed. The group heaved a collective sigh of relief when the doors flapped open. There was a rush for the safety of terra firma, but Gladys was in no hurry. She was the last one to step off the bus.

She stood still for a minute, absorbing the sights and sounds, still familiar to her after all these years. The air was hot and heavy, laden with the smells so evocative of her childhood. She inhaled deeply and tasted garbage and diesel exhaust and dust, incense, and attar of roses.

"Ahh! India!" she said out loud and closed her eyes and tipped her head back to feel the fullness of the blazing sun on her face. She heard the high pitched babble of the vendors and the cries of the children begging. The language of Hindustan fell like music on her ears. The fierce love she felt for these people bloomed once again in her heart.

Shaking herself out of her reverie, she realized that the group had been rounded up by the tour guide and were headed off in the direction of the Taj. She caught up with them and looked around for Bill, spied him at the head of the group, walking between Hugh Lynn and Bob Jeffries. She fell into step next to Fonshon Lord and carried on a conversation with one of the vendors following them, who was shocked but pleased that the *mem sahib* knew his language.

They came through the great arches and stopped in their tracks, for there, shimmering in all its ancient beauty, was the Taj Mahal. It seemed to float in the air, ethereal and dreamlike, and its perfection was reflected by the pool of still water in front of it, created for just that purpose.

In his singsong, heavily accented English, the tour guide told

them the story of this monument to love.

"The Taj Mahal was built by a most great Shah in the seventeenth century as a memorial to his most beloved and very, very beautiful head wife whose name was Mum Taz Mahal, which was meaning 'Pride of the Palace.' This most devoted, most beautiful and brave wife followed her lord into war and camped in a lowly tent on the battlefield. In so doing, she risked her life, for she was pregnant with her fourteenth child, the Shah being a man of great fertility and vigor. Mum Taz's time came upon her in the midst of an oh, so great battle and she labored bravely. But in the end, and in spite of everything the esteemed midwife could do, she began to bleed and could not stop, and so, to great lamentation, Mum Taz Mahal died."

Suddenly Gladys was seized by a sense of dizziness and disorientation. The bright sun faded and the edges of her sight grew dim. She sank down on a nearby bench as her knees gave way. The rest of the group, mesmerized by the guide's story, kept walking towards the marble palace. But Gladys could go no further. Putting her hands to her face, she was startled to see them come away wet with tears. To her astonishment, she realized that she was sobbing as if her heart would break. Closing her eyes, she rested her elbows on her knees and her forehead on the heels of her hands.

She took a deep, shuddering breath.

The world tilted.

When she opened her eyes again, she was no longer a tourist sitting on a bench surrounded by tour buses and honking taxis, sweltering in the afternoon sun.

Instead, all was shadowed, dark; the smells were those of blood, carnage, and smoking oil lamps, overlaid with heavy jasmine perfume, rosewater, and sandalwood incense. And under it all, like a deadly water moccasin gliding beneath the surface, swam the greasy taint of fear, the promise of death.

She was wearing a midwife's *sari* and it was covered with blood. She knelt next to a magnificent bed, in a tent hung with heavy tapestry and rich embroidered cloth flashing with tiny round mirrors. The gloomy, flickering light came from dozens of smoking oil lamps and there was wailing – wailing all around.

Dwarfed by the great bed, the Mum Taz lay dying, bleeding from her womb in an endless flow. And although she was the best mid-wife in the land, she could not stop the bleeding.

The newborn babe was already in the wet nurse's arms, the Lady too weak to hold her newest child, her bane. As the head midwife, she'd seen the Mum Taz through thirteen birthings and they had never been easy, for the queen was tiny and fragile, beautiful as a lotus blossom. But she <u>would</u> follow her lord into battle and that had been her undoing, for it brought her time too soon upon her.

The baby's lusty cries quieted as the wet nurse began to suckle him. The sounds of battle outside the tent faded until all she could hear was the Lady's labored breath. Gently she cradled the beautiful head in her hands and wiped the sweat from the pallid brow with a cloth soaked in rosewater. Softly, she began to sing a lullaby. This great queen was, to her, as beloved as her own children. Her grief was so overwhelming that it mattered little to her that she would surely lose her own life for failing to save her Lady's. She may be most Senior Royal Midwife, favorite of the queen; she may have given the Shah fourteen healthy children from this one wife alone, but she knew without doubt, and accepted the fact, that if the Mum Taz died, her own head would roll. He would be mad with grief, unable to cope with the loss of this, the love of his life, his companion and mate.

She watched in sorrow as the beautiful, haunted eyes fluttered one last time. There was a final great gush of blood and life fled the tiny, pain-wracked body. With a great cry of anguish, she flung herself across the bed and the death wail was taken up by the junior midwives

and the ladies of the Zennanah. It burst from the tent and echoed over the battlefield, the call of carrion crows in her heart, the swoop of vultures in her soul.

"Gladys...Gladys! Are you all right, honey? I declare, you're pale as a ghost!" Sally Cayce was sitting on the bench next to her, shaking her gently by the shoulders. Gladys opened her eyes and stared in confusion at her friend's face. Sally was frowning in concern and the eyes that usually danced behind the big glasses peered anxiously into hers.

"We started to go into the Taj and I looked around and you'd just disappeared. So I came back and found you sittin' here, white as a sheet and dead to the world. Cryin' like your heart was to break. My, my." Sally's soft Virginia drawl was in sharp contrast to the cacophony of sounds that surrounded them. She opened her purse and began to paw through its contents.

"I know I've got a hanky somewhere in my reticule here; oh, there it is!" Gently, she wiped Gladys' cheeks. "Now you just take a big ol' breath and tell Sally all about it. Why are you cryin', darlin'? Whatever happened?"

Gladys leaned back against the coolness of the marble column behind them, took a deep breath and allowed her mind to re-orient itself.

"You'll never believe what just happened, Sally!" she said, thunderstruck.

"You just try me, honey-child," Sally replied and settled back to listen.

Gladys described her experience down to the last detail and when the rest of the group emerged from the Taj, they were still talking.

"Could it be that I was truly that midwife, Sally? And, for reasons established in that lifetime, that I would be born this time to parents who were both physicians, that I would be born in India, and that my

mother would go into labor the moment she saw the Taj Mahal? You know, after I was born, she hemorrhaged, too, and nearly died! Oh my gosh! And I became a doctor, too, and birthing babies is my favorite thing, but I get more than my share of complicated deliveries. Maybe I'm trying to make up for my failure." Grief overwhelmed her again, and the tears threatened to return.

But Sally Cayce, born to Southern gentility, yet married to the son of the world famous sleeping prophet and therefore quite used to hearing outlandish things every day, took it all in stride. She replied rather matter-of-factly, "Well, stranger things have happened, as I know better than anyone."

She rooted in Gladys's purse for her lipstick and compact. Handing them to her, she advised, "Here, honey-pie, fix yourself up afore the others get here. And now don't you be feelin' so sad. You helped her birth fourteen babies. And you did everything possible to save her life. You've just got to forgive yourself. Just think of all the beautiful children you've brought safely into the world this time. I'd say that, for sure, you've more than made up for it."

As the rest of the group approached, Sally stood up and reached her hand down to her friend.

"C'mon, sugar. Let's go get some lunch."

Gladys and Sally Cayce, 1969

Chapter 31

ψ

Phoenix, Arizona 1975

"You drive."

"No, you drive."

"Well, one of us has to drive this thing, Barbara!" Exasperated, Gladys tossed the keys to her nurse-midwife, Barbara Brown, who caught them and immediately threw them back.

"You've been driving that Volkswagen bus around for years now, so you're more used to a big, hulking thing like this. And besides," she said unarguably, "you're the boss. You drive."

She then climbed in the passenger side of the big white RV and slammed the door. When Gladys didn't move, Barbara rolled down the window, leaned out and said, "C'mon, Doctor G – if we don't hurry she'll have that baby without us!"

Reluctantly, Gladys acquiesced. "Okay, okay, I'll drive. But if that mobile telephone rings, you have to figure out how to work it."

She hauled herself up into the driver's seat, buckled her seat belt and flexed her fingers. She turned the key and placed her hands on the monstrous steering wheel, in what she hoped was a competent position. "Here we go!" she cried, and they both prayed very hard as she backed slowly out of the driveway.

It was the maiden voyage of the Baby Buggy, Gladys' brain child

and the result of three years of planning and dreaming.

She had had the inspiration during an ARE lecture at Lee's Summit, Missouri, in 1972. She'd been talking about the increasing number of home births happening all across the country.

"I've seen this trend developing over the past few years and have too often been called upon to take care of postpartum problems when a husband or friend has delivered the baby and unexpected complications have set in. There is obviously a growing need for a safe alternative to hospital births."

Suddenly she had the brainstorm.

"What we need," she said slowly, as the idea burst into her head, full-blown, "is a delivery wagon, or a Baby Buggy we could call it! One of those big motor homes that's fully equipped for emergencies. The midwife or doctor could drive it to the home when a woman goes into labor. They'd have all the equipment required if there was a problem and, if needed, the woman could be taken to the hospital in safety and comfort. If we had such a vehicle and a nurse-midwife to make it work, we would be filling a great need."

After the lecture, several women approached her and told her with great excitement that she should create a Baby Buggy at the ARE Clinic. One of them handed her a check on the spot. That got the ball rolling.

Three years later the dream came to fruition in the person of a big, white 1971 Winnebago motor home. It was fully fitted with the latest in medical equipment, including a fancy, new-fangled mobile telephone which scared the living daylights out of both of them. Barbara stenciled the words "The Baby Buggy" on the side in pink paint and Gladys added a big stork carrying a precious bundle. Then they painted a wide pink and blue ribbon, wrapped all around and tied in a bow. It was a most unusual vehicle and soon became a common sight driving here and there all over the metropolitan Phoenix area.

One Saturday morning in late fall, Gladys carefully pulled the Baby Buggy into her driveway, glad to be finally home. It had been a long delivery but, as always, she felt gratified and deeply rewarded to have been a part of the miracle of birth. There had been no problems, thank goodness, but she'd been called out at eleven o'clock the previous evening and had been up with the laboring mother all night long.

She climbed down from the cab and stretched the stiffness out of her neck and shoulders, looking around with a fond smile.

Their front yard looked like a used car parking lot. She'd pulled up behind her trusty Volkswagen van which was sitting next to Bill's Porsche.

"Good!" she thought, "that means he's home today." The clinic was forever in the red and he had been spending more and more Saturdays at the office working on financial strategies with his nurse, Peggy. He seemed to feel that she had a knack for business and it looked like he might promote her to administrator. Whatever! Just so long as she herself never had to fuss with that aspect of their practice. But it looked like Peggy's car was here, too, parked behind Bill's, so they must be doing some work at home.

The old English taxi that Bill had bought several years ago occupied the side driveway and sat in stark contrast next to Carl's old 1950 panel truck. The ancient Chevy was rusted and decrepit, but it certainly brought back memories.

He had bought it for a hundred dollars when he turned sixteen. Gladys was sure that it had saved her sanity, for he and his teenage cronies had disappeared into the engine compartment for an entire year. Rebuilding that old truck had kept them all completely engrossed and out of her hair for a good long time. She chuckled as she remembered how, at first, he'd had to drive it barefoot because none of them could figure out how to make the gas pedal come back up after it had been depressed. Whenever he'd needed to slow down or stop, Carl had had

to wrap his toes around the end of the gas pedal and lift it up while he applied the brakes with his other foot.

The first time they'd taken it out on the road, it had been a triumphal occasion with the whole family piled into the front yard. It was supposed to be just a short spin, but half an hour later, when they hadn't returned, Gladys began to worry. The boys finally pulled back into the driveway, laughing so hard they could barely stand. Ultimately they'd explained what had taken so long. In attaching the wheels to the axles, they'd put them on in such a way as to make it impossible to turn the truck to the right. It would only turn left or go straight. So once they got out on the road, they just kept turning left. They went all the way into Scottsdale and back before they could pull themselves together and figure out how to get home again.

She laughed out loud at that memory, saluted the old truck, and let herself in the side door. The sudden change from the bright, hot sunlight to the cool gloom of the hallway made her feel a little disoriented and she made her way into the kitchen by feeling her way along the wall.

Their big white Samoyed husky came bounding up and thrust a cold nose into her palm.

"Hey Khushi, good boy," she murmured, rubbing his ears and looking around in dismay. The kitchen was a disaster. And she had a pretty good idea who was responsible. The four older kids had been gone for years now; Beth and her friends were usually pretty good about cleaning up after themselves and Bill never came into the kitchen if he could help it.

How in the world could one fifteen-year-old boy and his friends make this kind of a mess. She was not, by any stretch of the imagination, an immaculate housekeeper; she knew that kids and clutter went hand in hand and she was usually quite relaxed about disorder in her home. But this! This was beyond anything.

Dirty dishes and empty cereal boxes were everywhere, all the cupboard doors were hanging open and what was that all over the floor? Cheerios! It looked like they'd thrown an entire box of Cheerios on the floor, then tried to slide in them.

Just as she was about to snap, the guilty party walked into the room, accompanied by his best friend. Both young men wore nothing but ratty cut-offs and flip-flops, and they came to a screeching halt, trying to gauge her mood before deciding which parent-handling tactic to adopt.

"Hello there, beautiful mother!" He'd chosen the charming, considerate, slightly apologetic approach. "Did you just get in? Long night, huh? Let me make you some coffee. Don't mind the mess; Mark and I were just about to clean it up, weren't we, ol' buddy?"

"Uh, yeah, we were. Hi, Mrs. McGarey."

"Mom...Mom, are you all right?"

Gladys stared at him fixedly, a bewildered look in her eye. And for the life of her, she couldn't remember his name.

"Carl?" (No it wasn't Carl, of that she was sure.) "John." (No, not John either.) "Annie, Bob, Beth." (No, no, not them – she almost had it.) "Khushi!" she exclaimed. Shaking her head, she gave up and looked at him in resignation.

"What is your name, anyway?"

"David," he said gently, patiently.

"Oh, right. David. Be sure you sweep up all the Cheerios and make sure Khushi has water. I'm going to bed."

David and Mark watched her stagger away.

"Hey, Dave. Doesn't she really know your name?"

"Oh sure, she does. She just gets confused sometimes," he replied with a tolerant smile, and poured another bowl of Cheerios.

Gladys and Barbara Brown in front of The Baby Buggy

*Teenagers
David and Helene
with 20-year-old Bob
Gladys and Bill*

320

Chapter 32

ψ

Hemet, California 1977

Gladys pushed open the sliding glass door and stepped out into a perfect day. She was the first one up. Cradling her coffee cup in both hands, she picked her way around the big swimming pool and sank into her favorite chair. The air was soft and cool, heavy with the scent of orange blossom and sweet with bird song. The solitude was wonderful; it gave her time to put her thoughts in order and to consider the ideas they'd all talked about last night.

Friendly Fellowship Retreat Center was nestled in the hills of Southern California, far away from the bustle and smog of LA, just outside of the tiny town of Hemet. Evarts Loomis, the director, had created the retreat center to fulfill his dream of offering residential fasting programs for people who wanted to experience the health benefits of fasting in a medically supervised environment. Usually the place was full of people in various stages of their personal fasting regime, but this weekend was different. Evarts had invited Bill and herself, Norm Shealy and Jerry Looney to spend a few days here. They planned to devise a working model to help legitimize the non-traditional types of medicine they were all practicing.

They had the place to themselves and, thankfully, fasting wasn't a part of the weekend. The five of them had sat up until the wee hours

321

last night throwing ideas around, arguing and discussing their intentions, sharing their dreams. It had been so exciting that Gladys had barely slept and dawn had seen her creeping quietly out of the casita so as to not awaken Bill. She'd let herself into the big dining hall and had brewed a pot of coffee. Now, enjoying the fruits of her labor, she sat looking over the valley awaiting the next early riser.

The door flew open and Norm Shealy burst onto the patio, already talking a mile a minute and waving his coffee cup around, in imminent danger of spilling it all over himself before he could drink it.

Not that Norm needs coffee, Gladys thought indulgently, as he kissed her on the cheek, plunked his cup down on the table and whirled around to face the rising sun.

"Ah, Gladys, this is the life," he exclaimed and began to perform a vigorous set of deep breathing exercises. She settled more comfortably into her chair and sipped her coffee as she watched him inhale, exhale, bend and stretch. As far as she was concerned, it was way too early in the morning for this kind of enthusiasm, but Norm was one of the most exuberant people she'd ever met and she loved him for it.

Fiery and opinionated, the gifted neurosurgeon was a veritable powerhouse of energy, blessed with a brilliant mind and a memory for facts that never failed to amaze her. His personality was forceful and compelling, his laugh loud and long; you always knew when Norm walked into the room. He was only a little taller than Gladys, but wiry and strong, with piercing eyes and a strong mouth that was always smiling when not arguing a point. And boy! Could he argue! The guy could out-argue anyone. He and Gladys went head to head often, for he, too, was a Sagittarius and not given to diplomacy or mincing words. But it was always with the best of intentions, and frequently he brought a clearer focus and a deeper understanding to whatever subject was in question.

He puffed out one last breath of fire and collapsed into the chair

opposite her.

"I had the most amazing dreams all night long," he told her. "Must be the fresh air and all the things we talked about last night. We're riding the crest of a wave here, Gladys. All the new information, the new energy coming into the planet is building up underneath us like the ocean building up to a tsunami. We just need to stay on top of it and ride it in and hope to direct it so it does the most good. There are so many people out there who don't know anything about this, but who would be so interested if we could just get the information out. Other doctors who are sick to death of the mechanized, soulless thing medicine has become, and so many patients who have been utterly failed by the medical community." He leaned over the table, his eyes drilling into hers. "We've just got to figure out a way to effectively disseminate this information."

Gladys started to reply, but was interrupted by the noisy arrival of the rest of the group. Bill and Jerry Looney were involved in an earnest discussion, waving their arms around and talking over the top of each other. They moved to the edge of the patio, so intent upon the issue at hand that they ignored everyone else.

Evarts loped over to the table and gracefully folded his six-foot-two frame into the chair next to Gladys. He said a gentle good morning and patted her hand, then leaned back with a satisfied smile. His plan for the weekend was shaping up nicely.

Evarts Loomis was a soft-spoken man; his twinkling blue eyes and kind face belied the fact that he was possessed of an iron will and a fierce determination. He was a tall man, angular and lean, and unlike most of his colleagues, still sported a full head of hair. He had been the one to bring them all together and it was his intention that kept their meetings focused.

They ate a hearty breakfast, talking of nothing more important than football games and gardens, family antics and political scandals. By the time they were finished, the sun was hot enough to drive them into

the shade. They pulled their chairs under the cool protection of the patio umbrellas to continue the discussion of the previous evening.

After several hours of animated debate and controversy, Evarts said, "What we need is an organization, a national one like the AMA, but based on the principles we've been discussing. It would give us a forum in which to communicate with doctors of like mind, safety in numbers and all that. It'd allow us to present a unified front."

"That's a great idea," Norm exclaimed. "We could have yearly meetings, share all the new things we've learned, get support from each other. Like Bill and Gladys' symposiums."

"But the symposiums have to do with the Cayce material," Bill put in. "These meetings would be more general and be open to all physicians, whether they had an interest in Cayce or not. And this would be an organization with on-going membership, not just a yearly meeting. Like the Academy of Parapsychology and Medicine."

Gladys looked around at the others and asked, "Do you guys know how the Academy got started?" When a couple of them shook their heads no, she leaned back in her chair and began the story.

"Well, in 1970, Bill and I took some time off and went to Apache Junction for a weekend. While we were there, Bill awakened one morning with a dream in which he saw himself coming down a set of stairs. Hugh Lynn Cayce was standing at the foot of the stairway and said to him, 'You need to start an academy of parapsychology and medicine.' When we woke up he told me the dream and we decided that it was something we needed to help put in motion. We had recently heard Bob Bradley speak about his book, *Husband Coached Childbirth,* and we both agreed that he would be a good person to be president of the academy and to get the ball rolling. So we wrote him a letter and told him our ideas. We received an answer six pages long." She looked at Bill and they both chuckled.

"The first three pages gave all the reasons why he couldn't pos-

sibly take on a responsibility of that kind, but in the middle of the third page he said, 'Well, why not?' and the last three pages were full of all the things he could do with it and how thrilled he was to be in on the creation of something of such great value to the world.

"We were too busy getting the clinic started to be of any significant help, so we put him in touch with Bill Burtis and Richard Miles, and the three of them put it together. Their first major conference was in Berkeley in '72. It was on acupuncture and there were 250 physicians who attended. I remember a gynecologist from San Diego, Paul Brenner. He told us later that he had been so disturbed by the things that were presented that he almost got up and left, but he was in the middle of a row and couldn't do so without being conspicuous. So he stayed and listened and it changed the course of his entire life. He said that it 'blew his mind' so completely that he closed his practice for a year and went on a search for the meaning of his life."

Jerry's square face lit up with his big smile. "Yeah, I've been to a couple of the academy's conferences. They're great. But as I see it, what we're talking about would be even bigger and more all-inclusive, not just parapsychology but every facet of natural healing. Physical, mental, emotional, spiritual. Maybe even the legal and business aspects. We'd be addressing the whole profession, the whole person. What is it you guys started calling it at your symposium, Bill? Whole medicine?"

"Not exactly," Bill replied. "At first we called it wholistic medicine because, as you pointed out, Jerry, it deals with the whole person. But then some folks started spelling it with an h and using 'holy' instead of 'whole' as the root word. We kinda prefer that because, when all is said and done, the basis of all healing is spirit. And the act of healing is a holy act."

There followed another spirited debate as to the spelling of the word; finally it was agreed upon to use holistic, spelled with an h.

Gladys glanced into the dining room and saw that the buffet table

had been magically laden with sandwich makings.

"Looks like it's time for lunch. Spelled with an 'L'," she joked. They were all starving. Piling inside, they built gargantuan Dagwood sandwiches for themselves. Then the men changed into swimsuits and horsed around in the pool for a while.

Gladys stretched out on a lounge chair in the shade, hopefully out of range of the volcanic splashes made by cannonballs and belly-flops.

She watched them through half-closed eyelids with a deep sense of appreciation and camaraderie. She was used to being the only woman in meetings like these and, she had to admit, most of the time she really liked it. The men were always considerate of her, but never patronizing. They listened attentively when she spoke and quite often she felt that they heeded her more than each other, for she usually gave a different slant to the story, a different spin to the idea. She brought attention to issues of the heart during discussions that tended to get bogged down in ideology and verbiage. And then when things lightened up, as they always did, and the boys started to play, she wound up feeling like a combination of cheerleader, best pal, sister and mother. She smiled to herself. It didn't matter if they were five or fifty, she thought. Boys will be boys.

"Hey Gladys, look at this!" Bill yelled and a great howl arose from the pool where he proceeded to win the cannonball contest by creating a titanic wall of water that rose up and soaked her, even in her relatively secure position.

She leaped up, dripping. "Okay, that's enough," she cried, "everyone out now! Time to get back to work."

Grumbling like eight-year-olds, they dried off and sat down, still in their swim trunks, to continue the discussion.

Evarts started them off. "So, now, let's see, we've decided to create an organization based on holistic health whose members are

physicians interested in exploring this field. We'll have membership fees and yearly meetings and a board of directors. But before we create a mission statement, I'd say that the next item on the agenda is to figure out a name. Let's see...." They thought deeply for a moment. "We could call it the Holistic Society."

"No, no," Jerry hooted, "that sounds like a cross between the Rosacrucians and a garden club."

All afternoon they tossed around different names and finally, just before dinner, they settled on one. Their new organization was to be called the American Holistic Medical Association. They elected Norm to be president and Gladys vice president.

This was the birth of the AHMA, a revolutionary force in medicine that remains strong and active today. Their first meeting was held in Denver, some ten months later, and there were 250 physicians who attended as founding members.

The revolt against mechanized, impersonal, didactic medicine had begun. These were the people who instigated the revolution. They were the pioneers, the way-showers. They were persecuted by the established hierarchy, as rebels always are, for they spoke heresy and taught their patients that wisdom and healing comes from within. They eschewed belief in the divinity and omniscience of doctors and placed the power firmly back in the hands of the patient.

Medical practice had become robotic; it was a body of knowledge with a brain but no heart; soulless and sterile. These men and women, visionaries all, performed CPR on the dead body of conventional medicine and brought it back to life. They created a new paradigm, a living medicine, one with heart and soul, as well as mind and science.

Bill, Gladys with Elisabeth Kübler Ross, AHMA meeting

Chapter 33

Phoenix, Arizona Spring, 1979

On the corner of 40th and Oak Streets there sits to this day a large house, overbuilt for the neighborhood, encircled by palm trees and oleanders. The only two-story house for miles around, it was built for a large family that fell upon hard times. When it appeared on the real estate market in 1977, it was the classic white elephant, for who wanted an eight bedroom, Tudor style monstrosity in a blue-collar neighborhood of cozy little two bedroom cinderblock houses?

Happily, Bill and Gladys did, and they bought it for a song. Not to live in, for the kids were all gone and they had their eyes on moving to a small house in Casa Grande as the next step on a personal level, in about a year or two.

But for their new dream, it was perfect. They had long been talking about a residential healing program, one in which the patient could be immersed for two weeks in the lifestyle changes that their healing required. The Temple Beautiful program, an intensive program in which all aspects of the healing arts could be explored and incorporated, was created for those patients whose needs went beyond simple office visits.

According to the Cayce readings, the Temple Beautiful had existed in ancient Egypt and had been a place of great healing. The priests

and priestesses used crystals and chanting, music, dance and massage, as well as other therapies of an ancient and arcane nature to create what seemed like miracles of healing.

So they bought the big house on Oak Street, dubbed it the "Oak House," and began to offer a two-week program. Bill became the principle facilitator, assisted by Peggy. After about a year, Gladys realized that many people who could have benefited greatly from the program were prohibited by time constraints or financial considerations. So she solved the problem by designing the Creative Living Program. The patients still stayed at the Oak House, but for only ten days and the cost was much less. She believed that she could condense and intensify the agenda, achieving the same benefits in a shorter period of time. She personally examined each patient and prescribed a diet and therapy program that closely addressed each person's individual needs.

Each day started with early meditation and yoga. After breakfast and dream work with Dr. Gladys, mornings were given over to the various therapies – massage, acupuncture, chiropractic, biofeedback. Participants were also introduced to the more esoteric sciences of crystal healing, aroma therapy, energy work, and music combined with movement or dance. After lunch, the schedule included group therapy or other activities of a group nature and a late afternoon of free time for napping, journaling, or reflection. In the evenings, Gladys or one of the staff would lead a discussion group pertaining to some aspect of holistic medicine or philosophy.

She joined them for every meal, analyzing dreams at breakfast and using the time after dinner, as they all sat around the big table drinking tea and nibbling fruit, to encourage people to share their life stories. This became a very special and powerful time for them. Many had never really thought about their life as a whole, or examined the patterns that had brought them to where they were today.

It was near the end of the second program that Evelyn told her

story. She had attended, not as a participant, but rather as an assistant to her grandfather, who was unable to walk and needed extra help. Therefore, she was completely surprised when, at breakfast one morning, Gladys turned to her,

"So, Evelyn, how about you? Did you have any dreams last night?"

The young woman shook her head. She had said very little during the past week and Gladys had observed that she seemed locked within herself, unwilling to relate to the others. Her thin blonde hair hung long over her face, hiding her eyes; she seemed sharp and brittle and desperately unhappy. She didn't look up as she replied, "No, I don't dream."

Gladys took a sip of her coffee. "Well, you may not remember your dreams, but you certainly have them. We all do. If you sleep, you dream. It's that simple."

"That's just it, Dr. Gladys. I don't sleep. Well, hardly at all." She finally looked up, her eyes filled with a depth of pain Gladys had rarely seen.

"How long have you been unable to sleep?"

"Ever since my little boys were kidnapped. Two years, four months and six days ago."

Shock held the group speechless.

"It's not that I can't fall asleep," she continued in a rush, the words tumbling out like water breaking through a dam, "but whenever I do, I have the exact same terrible nightmare and I wake up horrified. I don't dare go back to sleep." She stopped, as if appalled that she'd said so much. Mumbling an inarticulate excuse, she rushed from the table, leaving her grandfather with tears in his eyes and everyone else stunned.

Gladys, good shepherd that she was, went after the lost sheep and spent most of the morning closeted with her. And that night, with

loving encouragement and support from the others, Evelyn told her story.

"Six years ago I discovered that my husband was molesting my two little boys," she said woodenly, staring down at the table, fingers twisting in her lap. "I caught him red-handed; he tried to deny it, the sick bastard, but I know what I saw, and my boys had changed, had become quiet and fearful instead of happy like they'd been before." She looked up at Gladys, naked hate in her eyes. "I know it was true. I prosecuted him and divorced him. He was sentenced to just two years in jail; they were supposed to let me know if he was paroled. They did not." She stopped, took a deep breath, and tried vainly to compose herself. On a rising note of hysteria she continued, "He was released without my knowledge. And one day, two years ago, I went to pick them up at school and they were gone! He'd taken them! God knows what he's been doing to them all this time." She began to sob, terrible, racking sobs. The energy of the group closed around her, silently supporting her with their love and compassion. Suddenly she sat up and dashed the tears away with the back of her hands. "I hate him so much it's like a ball of fire in my gut, eating away at me," she cried. "He's got my babies and I can't protect them, can't touch them or rock them to sleep. I don't even know if they're dead or alive." Her voice quieted and took on a note of horror. "And every time I go to bed and fall asleep, I have the same nightmare, over and over." She stopped completely, lost in her own private hell.

"Evelyn, can you tell us what the nightmare is?" Gladys prodded gently, her own heart breaking for the pain so evident on the young woman's face.

Evelyn's whole body shuddered. Then, in a low, tortured voice she recounted the dream.

"I'm standing outside my house and looking into the kitchen window. I see my two babies sitting at the table. My ex-husband is

standing over them. I run inside the house and grab my butcher knife. I want to hurt him, stab him, kill him for what he's done to us. I raise the knife and bring it down as hard as I can." Her voice became high, hysterical, and she began to rub her hands together frantically. "But he picks up my littlest one, my Tommy, and uses him as a shield and I stab my own son. I scream and wake up, and I can still feel his blood on my hands." Once again, she broke into tormented sobs, while her grandfather stroked her hair gently and murmured words of comfort through his tears.

Around the big table every face was wet with sympathy and they held tight to each other's hands as Evelyn began, once more, to speak.

"I know I'm not exactly a part of the group, but I've been listening to what you've all been talking about this week. Love and forgiveness and understanding. But I tell you – I don't understand and I cannot, <u>will</u> not, forgive him. He's taken my children from me and I'll probably never see them again. I walk around like a dead person, with a burning hole where my heart should be. I can't feel anything but hatred." She stopped speaking and stared into space for a moment. Then she shook her head hopelessly and said in a small voice, "I just don't know what to do, Dr. Gladys – maybe you can tell me what to do."

Gladys was seldom at a loss for words, but this story had affected her so deeply, that it took her several moments to formulate a reply. She looked away from Evelyn's haunted eyes and gazed out of the big dining room window. The sky was turning from gold to purple with the last light of the sunset. Evening doves called softly from the tops of the palm trees. A car roared by, blasting the radio, provoking the neighborhood dogs into a frenzy. Silence fell again and still she made no reply. Amazing that life goes on in the face of such tragedy, she thought. What in the world could she say to this? Her life had been blessed beyond

belief; she had no experience whatsoever of an event of this nature.

The silence lengthened. Everyone was looking at her, expecting help and words of comfort. Mentally she shook herself out of her trance. She had to pull herself together. She knew it was up to her to bring healing to the situation. She, herself, had never had a broken leg, either, but she knew how to set one. As a physician it was her duty and her privilege to figure out a way to help this woman heal her broken soul. She said a silent prayer for guidance, took a deep breath and opened her mouth.

"I will not counsel you to try to forgive him or to attempt to understand. Being human, there are things that are simply beyond us, beyond our frail powers. Only God has the capacity to forgive something as hideous as this, and I think even He would find it difficult. To me, it seems unforgivable, unconscionable, beyond anything. And although I do believe that your ex has created lifetimes of terrible karma for himself and, I have to admit, that gives me a bit of comfort, it doesn't help you or your children in the here and now.

"So forget forgiveness. Just forget it. We're not even going to talk about it.

"Let's talk about your dream, instead. This is what I think it's saying to you: we have to do something with this hatred that is consuming you. I'm going to be totally honest with you – I believe your dream is telling you that your killing rage towards your ex-husband – however justified – is actually, on some level, hurting both your children and yourself. And we have to find a way to redirect that energy." When Evelyn realized the truth of this statement, she nodded mutely and wiped the tears from her cheeks with shaking fingers. "I know," she whispered, "but how? How?"

Gladys looked around the circle of concerned faces; the love and compassion were almost palpable and the answer came to her lips in a direct link with the Divine.

"You must simply love your boys with all your heart and all your thoughts and all your energy. Love is always stronger than hate, stronger than fear, stronger than anything. It doesn't matter where they are, you can reach your children through your love."

"But whenever I think of how much I love them," Evelyn replied in a piteous voice, "it makes me so terribly, terribly sad that they're gone and then I can't help it, it turns into rage that that animal took them..."

"And that's when you have to be strong." Gladys spoke with urgency, her intensity underlining each word. "We don't have control over what life gives us – the only thing we're in control of is how we respond to it. You have a choice – you always have a choice. You can choose to love your boys or you can choose to hate your ex. And your choice determines the quality and context of the only contact you have with your sons. I know you think of them every second of every moment of every day. But most of the time you're sending grief and hatred. Start sending them love instead. A mother's love is the strongest thing in the world. You have to choose to take hold of that love and use it as a talisman, an affirmation."

Evelyn simply shook her head in dismay, unable to comprehend what Gladys was saying.

"Evelyn, listen to me." She took the limp hands and looked deeply into the tortured eyes. "How did you show your boys that you loved them when they were still with you?"

"I held them, rocked them, sang to them," she replied brokenly. "I told them I loved them, I read them stories..."

Gladys nodded vigorously, "Yes, yes, exactly. And you can do that here, now, always, whether they're with you or not. Imagine it and it happens – maybe not on this level, but on the level of spirit, in the realm of the heart, it happens. Close your eyes, right now, and imagine that your arms are around both of them and you're holding them, pro-

tecting them, loving them." Again she looked around the circle and addressed herself to the group. "And the rest of you, do it too. Help her! Send light and love and energy to those two little boys; imagine that Evelyn is playing with them, holding them, tucking them in at night, singing a lullaby." She paused a moment, then added, "We're all going to concentrate on helping you to choose to love your boys rather than hate your ex. Your love can reach them, no matter where they are. It draws them to you and binds you together and no one can ever separate you again."

The session went on late into the night. When they finally went to bed, Evelyn fell into a deep sleep and dreamed. Once again she was standing outside her kitchen window. And her boys were sitting inside the brightly-lit room, laughing and talking to each other, happy and safe. Her ex-husband was nowhere to be found.

And she slept the whole night through.

She returned home at the end of the program a transformed woman. Gladys stayed in contact for a while, but lost touch with her after a few years. As of their last communication, Evelyn still had not found her children. But she had been empowered by her love, as she had formerly been made powerless by her hatred. She had found that she was able to reach her boys and to dwell with love on the deepest level with them. And although she may never see them again, she took control of an unendurable experience and learned to endure it. She was able to transmute a situation fraught with hatred and vengeance into one blessed with healing and love.

Gladys leaving The Oak House to go to the ARE Clinic

*Gladys
outside of
The Oak House*

Chapter 34

ψ

January, 1980

"To everything there is a season," Gladys said the words out loud, hoping to ease her heartache, "and a time for every purpose under heaven." She sat down on one of the larger moving boxes and looked around, trying to feel excited and reasonable, rather than desperately sad. Yes, a time for every purpose. Now it was time to move on, as before it had been time to linger in this precious house, to put down roots and raise her family.

They were leaving Lafayette, leaving the wonderful old adobe that she loved so much. The children had all flown the nest. She and Bill were getting on with their lives.

They were moving with their new dreams to the desert south of Phoenix. They had bought a small house near the tiny town of Casa Grande. The plan was to create a community of like-minded individuals, to build a new clinic and start a new life.

But that meant saying goodbye to this place. She didn't know if she could stand it.

They'd had a family reunion two weeks ago, at Christmas, to be together one last time in this house that had so tenderly nurtured them all. They'd sat up all night telling stories, laughing, crying and reminiscing.

And then the children were all gone and she was left with the ghosts of so many years, so many friends, so much life.

The movers were coming at noon and Bill was off on some errand. She had a few precious hours alone, to give herself over to her feelings, to wrap them warmly around her, like a patchwork quilt on a cold winter night.

She walked through the dear, familiar rooms, lost in the past. "This good old house," she thought, as she patted the thick adobe walls. "It sheltered us all for so many years." And they'd been good years, wonderful years, difficult, challenging, amazing years. Letting the memories wash over her like waves in a bittersweet sea, she bathed in them and drank her fill, stored them away like golden coins in the secret treasury of her heart. Every piece of furniture, every window, every door held a memory.

There was the old sofa, seven feet long and deliciously ratty by now, yet sturdy enough to have stood up to dozens of children bouncing on it over the years. She sat down on the faded green tweed cushions and stretched out full length. This had been the favorite place for the kids to spend the day when they were home sick from school, or for two or three teenagers at a time to take long afternoon naps in the summertime. On Christmas morning, the first ones to burst into the room always appropriated the sofa, for it was big enough to fit four of them with their presents piled all around.

She reached up with one hand to stroke the tiger skin mounted on the wall behind the sofa. It was a magnificent, ten-foot-long specimen that her father had given her many years ago. With fangs bared in a ferocious snarl and eyes of topaz colored glass, it was truly an imposing sight. It had become such an accepted part of the unusual decor of their home that she was always mildly surprised at the startled reaction of most newcomers.

She got up, threaded her way between the boxes and opened the

rickety French doors that served as the front entrance. Years ago, Bill had installed one of those little music boxes that plays a tune when the door is opened. It had already been taken down and packed away, but in her mind she still heard the tinkling strains of "Edelweiss" as she stood in the open doorway, gazing out at the palm trees that had grown so tall. They'd never had to lock the doors, she mused. They'd always felt so safe, so protected.

The air was full of eucalyptus, overlaid with a hint of sweetness from the few hardy honeysuckle blossoms that hadn't succumbed to the frosty winter dawns. She breathed deeply, thankfully, and looked out over the front yard, up over the pomegranate hedge, up, up to the mountain. Her mountain, her lodestone. How she loved that pile of rocks! Camelback dozed, dusky pink in the soft January sun, and she studied its outline hungrily, as she would the face of a lover about to be parted from her.

Lord, but she'd miss this view! Especially when she had something weighing on her mind. How many times had she sat on the bench under the nectarine tree and watched the sunset paint the mountain and the sky red, gold, purple. The changing play of colors and light had never failed to bring her peace. Being a witness to that glory renewed her faith and always made her feel close to the heart of her Maker. Nothing in the world was like an Arizona sunset, with the scent of orange blossoms on the breeze and the evening star blazing suddenly in the blue velvet sky.

The lump in her throat became too big to swallow and the thought of leaving all this became almost too great to bear. She started to break down, but instead, pulled herself up and mentally slapped herself around a bit.

"Pull yourself together, Gladys," she told herself severely. "It's not the end of the world! You'll still have sunsets and the couch and your tiger skin, and everything else is going along with us."

She closed the door gently, turned and walked back through the living room into the kitchen. The swinging door flapped shut behind her and she was besieged by the past. The tears began in earnest as she leaned against the wall and slid down to collapse in a crumpled heap. She indulged in a good old-fashioned crying jag. When she could breathe again, she reached out and stroked the cement floor tenderly. My, oh my, she'd had <u>such</u> a love/hate relationship with this floor! It was made of glazed cement and was cool in the summer, but so unattractive that she'd been forever devising new ways to cover it up. First she'd tried rugs, but that didn't work because the boys just ended up using them as indoor slip 'n slides.

So then she'd decided to do it in faux flagstone. She'd cut six different flagstone shapes out of cardboard pieces and one Saturday morning, armed with several different colors of spray paint, she'd painted the entire floor. Unfortunately, her color choice had been on the garish side and the elegant faux flagstones had ended up looking like a bunch of giant, multi-colored misshapen blood corpuscles. Or so Carl had described it.

She knew it had been spectacularly ugly, but she'd never admitted it to anyone. She'd ignored the pointed barbs and jokes about it for years, until the paint had almost worn off. Then she tried something else.

She'd covered the entire thing in battleship gray and had Bethie and David dip their baby feet in pink paint and walk around on it. That had been so much fun! She thought the floor looked adorable. But the older kids still made fun of it, so after that she just gave up and kind of ignored it.

And now she wouldn't have to worry about it anymore. Their new house had white linoleum in the kitchen, but look – there under the counter, there was still the shadow of a tiny pink footprint.

Before she could start crying again, she stood up and walked

over to the window, running her hand along the counters, thinking of the thousands of meals that had been prepared here, the laughter and hilarity, the love shared.

She remembered the Indian Dinners. For days beforehand, Peter and Alice, Annie and herself and anyone else they could impress into service had cooked pots and pots of curry, lentils and rice, enough to serve two hundred people. The Indian Dinners had been her brainstorm. They had been held once a year for six years as a fundraiser for the ARE. It was five dollars at the door for an all-you-could-eat Indian food buffet. She and her crew had spent hours in the kitchen, boiling huge pots of chicken and deboning it, chopping pounds of onions, making *dal* and *raita,* and chutney out of apricot jam. She and Bill donated the food and all the proceeds went to the ARE. It had been a rousing success every year.

They'd gotten the idea to call it a "come as you were" party, meaning come as you were in a past life. Bill and his best friend, Jim McCready, always came as a pair of Benedictine monks, in full regalia and hooded cassock. They were quite impressive, almost scary. She'd wrap saris around the girls and herself and the house and yard would be packed with people in every type of costume imaginable. With the driveway and the flat roof lined with luminarias, the house turned into a fairy tale castle decked out for a grand ball.

Standing now in the deserted kitchen, looking out at the tamarisk tree, her stomach clutched as she remembered the time that Johnny came screaming into the kitchen on the morning before the gala, "Mom, Mom, come quick! Uncle Peter just ran over Carl and he's dead!"

Dropping an entire colander of boned chicken onto the floor, Gladys had raced to the side yard, heart in her throat. There, Peter was kneeling over the prostrate form of her first-born, a gaggle of silent, wide-eyed children surrounding them. Peter looked up, eyes stricken in

343

a chalky white face.

"I didn't see him, I swear I didn't," he kept repeating and she fell to her knees beside them. Carl, to her eternal relief, writhed on the ground, very evidently <u>not</u> dead, but Peter <u>had</u> run over his arm and it was broken, a messy compound fracture. Gladys murmured words of comfort to both of them, whipped off her apron, and wrapped it around the injured arm. In so doing, she happened to glance upwards to where Doug was slowly inching away from the edge of the roof.

Forensic pathologist she was not, but even she could put two and two together. She looked at the swing still swaying back and forth from the tamarisk tree, then at the rope burns on Carl's hands.

"Douglas Allen Riddle," she bellowed, "you come down here right now!"

It turned out that the boys were having a contest to see who could leap from the roof, swing across the driveway in front of an oncoming car, and come closest to getting hit without, of course, actually <u>being</u> hit.

Obviously, Carl had lost, in more ways than one. Oh, she and Peter had been so mad! Those boys had almost driven her around the bend. Teenagers were such idiots. But she wouldn't mind a few of them running through the house right now, laughing too loud and eating too much.

There were so many memories! Leaving the kitchen behind, she crossed the patio and came through the screen door into the back yard. There, nestled under the huge eucalyptus, was the guesthouse they'd built for Mrs. Dunn and her husband to live in while she was still their housekeeper. After she retired and moved away, it was subsequently used for visitors, guests and family. They always called it the Little House.

Her mom and dad had stayed there often, especially after they retired from their work in India. As they had gotten older, the years of

hard work and myriad tropical diseases they'd endured began to catch up with them, and her mother had developed polycythemia, a terminal disease of the red blood cells. She'd spent her last few months here, valiant and good-natured till the end.

Just before she died, she fell and broke her left knee and four ribs. Gladys and her dad had rushed her to the hospital, and as they lifted the tiny, shrunken body onto the X-ray table, her brave, wonderful sense of humor flashed one last time. Shaking her head in dismay, she smiled and said, "The old gray mare, she ain't what she used to be." The next day she'd passed, and don't you just know that there was jubilation in Heaven when she finally came Home!

Gladys walked around the side of the Little House, under the arbor of night blooming jasmine she'd planted outside her bedroom window, and eventually came to the kids' pet cemetery. Here was planted every gerbil, rat, cat, bird, snake and dog that had ever graced their lives, with the largest plot and most elaborate headstone reserved for Khushi, their wonderful Samoyed husky who had died a few years before.

He had been essentially David's dog, for they had grown up together, and when the older kids left, all the dog duties had fallen to him.

When it was time for Khushi's monthly bath, Gladys would remove everything breakable from the bathroom and stand back. David, stripped down to his underwear, would wrestle the unhappy canine into the shower with him. Two or three times, at least, the soaking wet dog would come hurtling down the hall, half-naked boy in hot, dripping, pursuit. Back they would go, rolling and splashing into the shower, to repeat the process.

And she could never think of Khushi without remembering the time she came into the kitchen to find him schooching his bottom across the kitchen floor, whining softly.

"David! What's the matter with Khushi?" she asked.

David and several of his buddies were leaning against the counters, eating cereal. He put the mixing bowl filled with Wheat Chex and milk down, and turned to the troubled dog.

"Hey, boy, hey, Khushi, what's a matter, boy, huh?" he crooned, rubbing the soft ears, looking into the adoring eyes. He then reached over and lifted the dog's tail to reveal a large black wad of unthinkably filthy fur, crusty, matted and...

"Gross!" all the boys cried in unison.

"Here, Mike, help me with this." While Mike held up the tail, David, with blithe disregard for even elementary sanitation, tried to remove the offending mass. Grabbing it with his bare fingers, he began to pull.

"Oh geeze, it's bigger than I thought...oh my gosh...oh noooo...ohhh ohh groooosss..." Every kid in the room went into blissful cataleptic fits as David pulled an entire pair of panty hose out of Khushi's protesting, yet ultimately thankful, rear end.

She laughed out loud at that memory; oh, they'd had so much fun in this house. She said a final farewell as she heard the moving van pull into the driveway.

Yes, it was time to move on. She knew that. But she also knew, as surely as she was standing there, that she would carry this home with her in her heart until the end of her days. It had held her, shaped her, fulfilled her dreams and inspired new ones.

And the new ones were all set to go: expansion of the clinic, a community of friends, a family of choice, bonding together, growing with each other. Her new life beckoned and she was finally ready to go. But if only, just once more, if only she could hear that screen door slam, the thunder of a herd of children's feet, and a little voice yelling, "Mommy, Mommy, come quick!"

Christmas 1980 - the last gathering of the whole family in the Lafayette home

Gladys with Khushi

Come As You Were Party
Bill, Gladys, Hugh Lynn Cayce, Sally Cayce

Chapter 35

ψ

Casa Grande, Arizona Fall 1980

Bill and Gladys moved to Casa Grande in September of 1980, having spent nine months in a rented condo waiting for their new house to be ready. It was small and nondescript, made of cinderblock and painted an uninspired gray. There were three bedrooms, a garage that had been converted into a family room, a small living room and a miniscule kitchen. Their one indulgence was the hot tub they'd installed on the patio out back, into which they slid with grateful relief each night after making the forty-five minute commute from the office.

Admittedly, it was far from convenient to live in such a remote location. The two miles of dirt road that led to their driveway were dusty in the summer and oft times washed away by flash floods in the winter. She could not love this house as she'd loved Lafayette, but there were larger issues at stake and more important things to be considered than mere convenience or personal preferences.

They were here to start a community. Land had been donated for a clinic nearby and several of their friends and fellow seekers had also bought property in the same rural subdivision. Erica Bauer, who had been resident manager of the Oak House for years, had a parcel directly across from them, while Harvey and Peggy Grady were just down the road a piece. Doris Solbrig, their next door neighbor, was a

school teacher who had moved from Idaho to be part of the new clinic community. Gladys was especially happy to have her with them, for her energy, enthusiasm and devotion had, countless times, been a deep reservoir of strength.

They all shared the same great intention. They planned to create an ideal community, one of support and cooperation, based on the precepts set forth in the Cayce readings. It would be centered around the medical complex they would soon build. So far it was only a dream, but dreams have a way of becoming reality when like-minded people set their hearts to a task. They were already drawing plans for the building and getting funds together; next month they would begin to drill the well.

So Gladys settled into her new little home, settled down happily to a different life, one filled to overflowing with friends and patients, work and travel.

In the evenings, when she stole a moment of peace for herself, she would sit in the glider, softly singing her favorite hymn:

"Day is dying in the west,

Heaven is touching earth with rest..."

Her life was full, her heart at peace, but still she longed for her children and their antics, for Camelback glowing red in the dusk and the scent of orange blossoms on an April breeze.

*Gladys
at entry way
of Casa Grande
home, 1987*

*Bill and Gladys
outside
Casa Grande
home, 1984*

$\mathcal{e} \mathcal{e} \sim^{\psi} \mathcal{Q} \mathcal{Q}$

October, 1985

Between the glory of a blazing sunset and the ebony cloak of the star spangled night, for a fleeting moment twilight comes to the desert.

If ever there was a moment of repose in Gladys' life, it was at this time. Watching the flaming sun fall slowly out of the sky into the western mountains was the one thing she tried to give herself every day. Most of the time she succeeded. Tonight she'd dragged Bill, Peter and Alice outside with her. They sat for a while in contented silence, as old friends will, enjoying the spectacular show. Saguaros stood with up-flung arms, silhouetted black against the brilliant orange sky. Thunderheads limned in gold were piled purple on top of the mountains.

As darkness fell, Gladys lit the candle-lanterns, and they began to reminisce; oldest friends are the deepest friends, for so much of the journey has been along the same path. They spoke of the war years when Bill and Gladys had been newlyweds; they recalled when Alice and Peter had first met, remembering the magic of youth. The memories felt fragile and bittersweet, for they knew they wouldn't all be together much longer now.

Peter was dying of leukemia. He could do little before fatigue overwhelmed him. The long drive from their home in Scottsdale to Casa Grande had already taxed his strength. So they told funny stories to make themselves laugh, happy stories to help them smile.

From her kitchen window next door, Doris saw the lights on the patio and came wandering over. She pulled up a chair and was welcomed into the circle. Having never heard some of the stories before, she provided a fascinated audience, and Alice waxed eloquent with one of her favorites.

In her soft southern drawl she began:

352

"Well, you all know that more than anyone I've known, Gladys operates on blind faith. She always has. Over the years I've gotten used to it, although it used to give me palpitations. She'd just say, 'Oh, it will all work out,' and leap off the cliff! And the angels would always catch her, although usually they'd wait until the very last minute. It's happened enough times so that now, when she jumps out of a window, I just jump along with her and pray.

"But the first time I ever experienced one of her little miracles of faith was when she and Bill were first married. I was a nurse at the hospital and they'd invited me and a couple of my girlfriends over for Thanksgiving dinner. We went to the football game first, and during half time she pulled me aside and whispered the words I have since come to dread.

"'Oh, Alice, I'm really in a pickle this time!'

"'What d'you mean?' I asked her, with a sinking feeling in my stomach.

"'Well,' she replied, 'Bill and I ran out of money last week and so we couldn't buy any food for Thanksgiving dinner. I was sure something would turn up, but so far, nothing has.'

"I just stood there with my mouth hanging open. 'But, but, what are we going to do if we don't have any food?' I asked, not believing my ears. I was starting to get real nervous because, after all, I was the one who had invited my friends. This looked like it could turn into a real disappointment.

"Well, Gladys just waved her hand in the air the way she does and said, 'Oh, Alice, don't worry! It'll be all right. I only told you so you wouldn't be surprised if I ask you to help me make peanut butter sandwiches. But I bet that won't happen. Something will turn up – it always does.' And she went back to watching the game.

"Now, for the life of me I just couldn't imagine what we were going to do. It was just after the war, so there wasn't much food anyway,

but somehow I couldn't visualize feeding my friends peanut butter for Thanksgiving dinner. So I worried and fretted all during that football game, but Gladys, she just sat there having a wonderful time, as if she had nothing on her mind at all.

"'Aren't you going to tell them about our little problem?' I whispered to her as we were leaving the bleachers.

"'Oh, no,' she said, 'I'm sure everything will work out. Just have a little faith, Alice, and stop worrying.'

"All the way back to the apartment I was just eaten up with anxiety, but Gladys was laughing and talking as if she didn't have a care in the world. And when we got home and opened the front door, what do you think we saw?"

Alice paused for emphasis. Bill and Gladys chuckled at the memory and Peter smiled his sweet smile. Doris was the only one in suspense and she quickly urged Alice to continue.

"Well…the dining room table was set in beautiful china, with a centerpiece and everything and it was loaded with food, a turkey and all the trimmings, and it smelled like heaven. You could have knocked me over with a feather! Then I got mad as a wet hen because I thought Gladys had been pulling my leg. But she grabbed my hand and pulled me into the kitchen.

"'Very funny, Gladys, ha ha,' I said. 'You really had me going on that one! I nearly had a heart attack!'

"'But Alice,' she took me by both shoulders and looked me in the eyes. 'I was telling the truth. I didn't have any food. I don't know how that dinner got there. I'm just as surprised as you are!'

"We stared at each other for a moment, then I noticed an envelope on the counter. We tore it open and whatever do you think? The upstairs neighbors had been sitting down to their meal when they got a phone call. There was a family emergency and they had to rush to the airport. So instead of wasting it, they'd brought the whole feast down-

stairs and set it up for us.

"'See, Alice, I told you everything would work out,' she said, and I just shook my head and followed her back into the dining room where we all had the best Thanksgiving dinner ever."

They all enjoyed a good laugh; then Alice looked at Doris. "That's what Gladys is to me," she said with a catch in her voice, "pure faith. And when things look darkest, that's when her faith shines the brightest." She leaned toward Peter, put her head on his shoulder, and he wrapped his arms around her.

"Even when she was a girl," he added in his soft voice, "she believed with all her heart that everything works together for the best. And you know what? It's contagious. Being around her is like having a transfusion of trust in the rightness and balance of the universe. I don't think that anything could ever truly shake the foundation of her faith."

"Oh, come on, you guys." Gladys stopped the conversation, embarrassed by what she felt was unwarranted praise. "It's not that big of a deal. Peter, do you remember the time you had to change Carl's diaper for the first time and you couldn't figure out how to clean him off, so you sat him right down in the toilet bowl and flushed it?"

That story elicited a storm of laughter and protest, and after a few more tales of their early life together, the group of friends, answering the call of their grumbling stomachs, retired inside for dinner.

But the innocent comments about Gladys' faith served as a dark foreshadowing of the future, for the events of the next decade would threaten to tear apart her carefully constructed belief system. They would challenge her to the utmost to walk her talk and hold to the Light.

She had spent her whole life creating a home and a family, living a pattern of work and service to others. And now, just as she was moving into her golden years, hoping to enjoy the fruits of her labors, life would deal her a blow that would shatter everything. It would

topple the graceful towers of her hopes and leave her crawling through the ruins of her dreams, blinded and bloodied, the sole survivor of her own personal holocaust.

At times, bitterness and despair would overwhelm her. But always, when she descended, beaten, into the deepest stratum of her being, she would find her faith, shining and whole. It was the silver thread woven into the tapestry of her life, the golden cord that tied it all together.

And in her darkest hours she would remind herself that love is the key to all mysteries; that compassion opens all doors and heals every wound. And that strength comes from putting one foot in front of the other and just keeping on, through the darkness towards the light. For the light would surely come.

Of that, she was certain.

Peter Riddle
Cincinnati, Ohio
1948

Part 4

The Phoenix

Gladys with grandson, Andrew Wechsler, 1995

Chapter 36

eagle emblem

Scottsdale, Arizona January 1986

*T*he 17th annual ARE Medical Symposium was in full swing and was proving to be as exciting and successful as all the previous ones. The convention center of the Safari Hotel in Scottsdale was the perfect venue, and over the years the conference had grown and expanded at an astonishing rate.

The event had had its beginning in 1968 with only twenty participants. Now, in 1986, it boasted an attendance of more than 600 people. It was a five-day-long extravaganza of fascinating daytime workshops and elegant evening programs that explored the cutting edge of all that was new and extraordinary in medicine and holistic thought.

They'd had speakers who had since become world renowned, such as Elizabeth Kubler-Ross, Jerry Jampolsky, Lindsay Wagner and Deepak Chopra. Other lecturers had been known mostly for their work with the ARE: Hugh Lynn Cayce, Herb and Meredith Puryear, Elsie Sechrist, and many others who had given of their time and wisdom to make the symposium an exciting and inspirational event.

It was Sunday morning, the last day of the conference, and the excitement was palpable. Gladys stood in the center of a group of women, telling a funny story.

Her unmistakable laugh rang out and many heads in the sur-

rounding crowd turned admiringly.

She'd developed a distinctive style during her years spent in Arizona. Now, standing at her ease, her face lit up with delight, she presented a striking picture.

She had adopted the native garb of the Southwest, and it suited her to perfection. Her densely pleated white cotton skirt was sewn round and round with silver rickrack. The simple blouse offered a perfect foil for the elaborate Zuni jewelry she loved so much. Today she'd chosen her favorite squash blossom necklace, with earrings and bracelets to match. Belted around her still-slender waist was a fabulous conch belt, studded with great hunks of turquoise, the gift of a grateful (and wealthy) patient.

Hair that showed only a few touches of gray was pulled back from a face that had become classic with maturity. It was piled on top of her head in a coronet, with turquoise and silver combs securing the few stray hairs in the back.

She wore no makeup other than her favorite red lipstick and a dusting of powder, and needed nothing more, for her beauty was truly an inside job.

Gladys was in her prime. She'd gotten a standing ovation for her talk last night and today she felt like a celebrity. She was feeling her power and loving it.

Detaching herself from the group, she wandered off in search of Bill, her mind and heart filled with satisfaction. She was stopped often by friends and patients, and in between congratulations and good-byes, her mind charted its own course.

The years since they'd begun the Casa Grande community had been immensely fulfilling. After they'd drilled the well, they'd begun work on the clinic building. Now it was complete; small but perfect, the nucleus around which their world would be built.

In fact, on Friday night they'd bussed all the conferees down

there for a tour of the new facility and a picnic supper. Unfortunately, the skies had opened with a surprise desert thunderstorm. They'd all gotten soaked and had to eat dinner crowded inside the few buildings, perched on the exam tables. But in spite of that, a good time had been had by all.

She and Bill had continued to practice at the original ARE Clinic building in Phoenix and had expanded to a group of buildings across 40th Street. The business annex was full of offices now – personnel, financial and research. And, miracle of miracles, they'd just gotten a huge grant from the Fetzer Foundation to fund research into paranormal medicine.

Along with all of their professional success, her relationship with Bill had grown, and matured to a depth of love she'd never thought possible. They shared everything. Even when they arrived home at different times, they'd have dinner together, then sit close on the old green couch and talk deep into the night, dreaming up new possibilities, creating grand schemes. He was her mate, her mirror, that which supported and inspired her. What a great team they made! Hugh Lynn used to tell her that, "You two make an unstoppable team!" What a dear, wise man he'd been.

Thinking of Hugh Lynn made her nostalgic and sad, even in the midst of all the excitement. He'd passed from this life in 1982. Now Sally had become frail and didn't travel much. Gladys missed them all the time, most especially at times like this, for they had been with them since the beginning. They'd been two of the twenty people at the first symposium and had attended every year, without fail, until Hugh Lynn became too sick to travel.

And after the conference each year, the two couples would run off to the red rock country of northern Arizona, there to rent a cabin in the Oak Creek Canyon for a week. They would rehash the symposium, plan the next one, and play. Boy, those had been such great times!

They'd made a habit of having dessert each night at a certain restaurant in Sedona that served the most sinful and heavenly peanut butter pie. In a masterful piece of team justification, they'd rationalized that it couldn't hurt them (much) if they all four shared one piece. The amused waitress would place the delicious slice of materialized sin in the exact center of the table, hand each participant a fork and stand back. They'd attack with a vengeance, sometimes unable to eat, they were laughing so hard.

The four of them had formed a bond of such spiritual depth, such heartfelt love, that nothing else had ever come close. And she missed them with a physical ache.

She caught sight of Bill and brought herself back to the present. There he was up near the podium, in earnest conversation with Peggy. She studied them with a sinking heart and, without warning, all her old doubts and suspicions came flooding back.

Years ago, Alice had come to her in tears, had told her that she'd walked into Bill's office and had found him and Peggy locked in a fervent embrace.

"They tried to tell me that it was just a friendly hug, that they were celebrating some new funding or something," Alice had said, "but I saw her jump when I walked in like someone had stuck a hot poker up her you-know-where. Gladys, I know something is up. You've got to get to the bottom of this!" she'd continued indignantly.

Gladys had not wanted to believe it and had told Alice that she was crazy. But she'd heard rumors from other sources and, against her own will, was beginning to believe them. So she'd screwed up her courage and had confronted Bill with the information.

He'd denied it emphatically. He'd told her that he was surprised, disappointed and shocked that she would put any credence in vicious gossip. He'd pointed out (truthfully so) that one of her greatest faults was that she was suspicious and jealous. He'd told her that an

affair was unthinkable to him. It went against all he believed in. That if she didn't trust him by now, she had a lot of thinking to do.

Gladys had felt mortified and chastened, yet greatly relieved. She had taken his suggestion to meditate on the fruits of the spirit, to try to rid herself of the demon of jealousy that plagued her.

She'd chosen to believe in the wedding vows that he'd repeated to her not just once, but twice, for on their twenty-fifth wedding anniversary they'd had a recommitment ceremony. He couldn't possibly have looked into her eyes and vowed, once again, to love her forever if he was involved with someone else. It simply wasn't possible.

And besides, Peggy was her friend. They'd been in study group together, had worked together for twenty years. She'd delivered Peggy's two youngest children. She would never, ever, betray her in that way.

So she'd put it out of her mind those many years ago, and had chosen to trust. That had worked for a long time.

But recently the two of them had been spending more and more time together dealing with the business side of the practice. Or so Bill told her. The clinic depended heavily on charitable contributions and he seemed to think that he and Peggy made a great fund-raising team. So for the last few years, while she stayed home and kept the practice going, the two of them traveled all over raising the money that was so necessary to the survival of the clinic. Whenever she suggested that she go along instead of Peggy, Bill reminded her that someone had to be a full-time doc, and, of course, she knew that asking for money had never been one of her strong points. The idea of what she couldn't help but think of as begging was anathema to her, certainly not a role she relished. So, with secret relief, she'd left that aspect of the business to him, even though she couldn't understand where all the money went.

Well, she just didn't have a head for business; profit and loss sheets gave her a headache and she figured she just needed to follow

Bill's advice and concentrate on what she did best, what she loved. Which was working with her patients and speaking at conferences and groups like this one.

Up by the podium, someone approached Bill with a question. He turned away to answer it. Peggy walked off in the opposite direction, calling to her daughter Margy to help with some detail. Gladys felt petty harboring any suspicions whatsoever. After all, Peggy had worked like a dog to help coordinate the symposium and had done a great job of putting it together.

Forceably, Gladys thrust the doubts out of her mind and concentrated instead upon the energy and excitement in the room. This was what they were creating – brilliant minds and loving hearts meeting together, forging a new world, a new age of conscious awareness that had never before been seen.

How blessed was she to be even a small part of the revolution in consciousness that was exploding all around her.

Hugh Lynn and Sally Cayce at an ARE Clinic Symposium

Chapter 37

Casa Grande, Arizona August, 1989

*T*he dog barked in joyful greeting. Gladys heard Bill's car crunch over the gravel and pull into the carport. She felt as if she was on trial for her life, and the jury had just filed back into the courtroom. In many ways, it was true. The life that she'd known, labored for, and loved into being hung in the balance.

She feared she knew which way the scales would tip.

As the front door slammed, she checked her lipstick once more. She twitched her collar and smoothed her hair.

A wave of faintness swept over her, and she quickly sat down on a chair next to the bed. Her breath came shallow and fast, her heart stuttered.

"Please, please," she breathed, unable to articulate more, sending her supplication to a God who had never before deserted her.

As she tried to calm herself, she thought back to the board meeting a week ago. The Board of Directors of the clinic consisted of Bill, Peggy, Margy (Peggy's daughter), and herself. Bill had proposed to promote Peggy to president of the board, and name Margy as administrator of the clinic. The motion has passed with but one dissenting vote.

Hers.

So Margy had become Gladys' immediate supervisor, and Peggy was now in complete control of the business.

She'd awakened the next morning from a dream of her garden engulfed in flames.

"No, no, no!" she shrieked inside, sitting bolt upright in bed. "No, no, no! I will not continue to participate in this. I will not allow this to happen to me, to Helene, to the clinic."

She threw back the covers, stuffed her feet into her slippers and began to stride around the room.

Bill had already left for a breakfast meeting. She began to talk out loud:

"I won't let him elevate her to the most powerful position in the clinic. Peggy knows nothing about running a business. That's painfully apparent to all but a complete idiot. We've been in the red ever since she took over as administrator from Bob. And now my husband has chosen to promote her, has given her and Margy permission to boss the medical staff around, to tell us what we can and cannot do as doctors! I can't believe it!"

She stood at the window, breathing hard. There was no peace in the sunrise, no sweetness in the song of the birds. She stared blindly over her garden as her thoughts raced on.

Even as administrator, Peggy had been a petty dictator. Burned in her memory was the time she had refused to grant Gladys leave to attend Helene's (aka Beth) graduation from medical school. Of course, Gladys had gone anyway, but still! The nerve of the woman! In that act Peggy had declared herself an enemy; Gladys recognized on a primal level the language and intent.

And she had made the most difficult decision of her life. She could not, would not, work with that woman any longer. She had to take care of herself, and protect Helene, who was pregnant and newly employed in the clinic. Bill would finally, finally have to make a

choice. She would tell him that if he refused to fire Peggy, she herself would quit.

Her needs were few. She could get a position in the local women's collective, subsist on what they paid. It couldn't be much less than what she was making at the clinic, anyway. But she had been sure it wouldn't come to that.

So when he had returned home that night, she'd delivered her ultimatum. To her undying horror, Bill had looked gravely at her, and said he needed to think about it.

She couldn't believe it! Everything they'd dreamed, everything they'd built, and he needed to think about it.

He then packed a small bag and went away for the weekend, saying only that he needed to meditate and pray, seek guidance.
She was left to "stew in her own juices," as Aunt Belle always said, to think and worry and pray herself.

Gladys had ever been of an optimistic disposition, always expecting things to improve, to grow and blossom like the roses in her mother's garden. She took no pride in her faith, for she knew that, so far, it had come easily to her. It was a part of the very fiber of her upbringing. Not just words, but acts of faith, truly, entire lives of faith. Her mother and father, the *ayah* and Aunt Belle, all were convinced that love overcomes all obstacles, and believed in grace beyond understanding with every atom of their being.

They had taught her well, and the lessons were not lost on her. But in these last few days, she had found herself groping blindly for help, unable to save herself from the depths into which she had been thrown.

Now he was back from the weekend, and she had to go out there and hear his decision.

What if he accepted her resignation? She couldn't, wouldn't, believe it, that he would throw it all away.

Yet she knew, and the knowledge was like a shard of broken glass in her heart, how important Peggy had become to him. She knew to what lengths he would go to ensure her authority.

She grimaced as she remembered how they'd ruthlessly fired Bob as clinic administrator. The broken glass cut sideways, bloody and viscous, across her heart.

Every mother has countless regrets in regards to her children. Luckily, for her, the regrets had been, in most instances, gentle and easily resolved.

But with Bob it was different. She'd betrayed him and she knew it. She'd shied away from that knowledge ever since she'd chosen her husband's dictatorial ego over her own tenderhearted son.

For Bob was the most tenderhearted of them all. She could see him even now, a small chubby six-year-old in cutoffs, blue eyes shining as he ran into the kitchen and tugged on her hand. "Know what, Mommy?" He was serious and intent, wide-eyed at his own wisdom.

She stroked one hand over the soft fuzz of his first crew cut and smiled.

"What, honey?"

"Well, I just figured it out. If I make a friend, and then he makes a friend, and then he makes a friend, pretty soon it'll go all around the world and come back to me!" His face lit up in a grin at his own perspicacity. Why is a child with one tooth missing so incredibly endearing?

He was the smartest of them all, too. He effortlessly, consistently brought home straight A's, hardly ever needed to study. He was truly a child of eclectic thought processes, and absorbed metaphysical philosophy as well as didactic information like a great happy sea sponge.

In 1980, he had been hired as administrator of the Phoenix facility. He began to reorganize, and the clinic began to make a profit,

rather than being forever and always in debt. He was highly qualified; his determinations were educated and just. He took a hard line with Margy, firing her with due process. He'd expected to be supported in his decision, and appreciated for his efforts.

Instead, Bill and Peggy had slapped him down. They had rehired Margy, effectively stripping him of power. And she, his mother – she had chosen, to her everlasting regret, to support them, rather than her child.

Bob had been utterly destroyed. Stunned, he'd left Phoenix and ended up in Austin, Texas. Now he was finally getting his life back together, doing good work, starting a center of his own.

But oh! How she wished she'd chosen differently. Not that her voice would have counted, since Bill and Peggy always out-voted her, anyway. But at least Bob would have felt loved and supported rather than rejected and betrayed. By her, his own mother. What an unholy mess it had been.

She had tried to forgive herself. In the last few years she and Bob had talked extensively about it and had reached a loving under-standing. Still, she would that she could take it all back, and change the broken past.

She heard Bill rummaging around in the kitchen. He stepped into the hallway and called her name. She stood up and moved slowly into the living room. In her mind she heard the bailiff cry, "Will the defendant rise to face the jury."

Once again they sat side by side on the old green couch. This time there was a gulf between them as wide as the Ganges where it flows, brown and swollen, under the great bridge at Hardwar.

Solemnly, Bill handed her a sheaf of typewritten pages. She was to read them, then ask any questions she might have.

"Dear Gladys," the first page began.

These days have been spent in soul-searching for the answer that is right. How do we know what is right? Prayer and meditation helps, and if properly interpreted and if the questions are asked properly. I've used the Tarot cards, which are sometimes fantastic in how they tell a story. Reading has been important, and I've done lots of that. And the different astrological pieces of input I've had available have told me something about myself – most of which I knew, for they are tendencies. The book Jesus the Pattern has always been the greatest help, especially as I've tried to bring my soul purpose, my unconscious mind, my mission in the earth, God's will for me and my conscious mind all to bear on this choice.

As you will see in the material I've written up, my choice is to have us obtain a divorce,

Divorce! Her mouth dropped open and she stared at him in disbelief. Where did that come from? She'd said that if he didn't fire Peggy, she'd quit. But nothing had been said about divorce.

He motioned her to keep reading. Dumbly, she flipped through more pages labeled:

"Answers to Gladys' questions"

"Tarot reading for Gladys"

"Astrology"

"Thoughts that seem very important"

She couldn't process any of it, but a paragraph near of the end of that page caught her eye.

What would a divorce add to this picture, or how would it facilitate my goals? I need time to myself. The only books I've written have been when I've taken time off for myself – with the exception of the Home

and Marriage book we both collaborated on. I need my own space while I do these things. I need a physical environment that does not bring about discord to me or anyone else. I need to be making my own decisions, for I recognize that I have deferred much of that to Gladys over the years. Probably most important is the feeling I've had for several years now that a change of some sort is in the offing. I've made the statement to hundreds of people now that when I get to be 80, I'll decide what to do with the second half of my life. Time had sped on its way, and I think that urge is now manifesting when I'm 70, not 80. My recent book-writing has been away from home. If I'm in my own quarters, and not far from the clinic, I won't need to go somewhere else. I'll be quiet in my own place and can work on my books there.

And who gave him his own space to write his books? Who took over at the office, raised the children, managed the house? She wanted to throw the cold, heartless pieces of paper on the ground, jump up and down on them, and scream until the world collapsed.

"Bill, what are you talking about? I don't understand any of this! Please, talk to me, tell me how you feel. These are just words – they don't mean anything."

He assured her that if she just kept reading, she'd understand. With shaking hands, she turned the pages. Several were under the heading "My journal"; there were some obscure selections labeled "Dreams".

The final seven pages were entitled "Missions, Directions and Opportunities".

Apparently this was the explanation he was sending to the children, for it was cc'd to all six of them, as well as to the 25 members of

the ARE Board, the entire staff of the Clinic, and others who he thought might be interested in his justifications.

Because I know you care deeply about both Gladys and me, I'm writing this statement of mission, events and what can be seen as opportunities. You may have seen or understood at times that Gladys and I have been experiencing interpersonal difficulties. Emotions, disagreements, past-life difficulties surfacing, whatever – events have progressed to the point where we are in the process of obtaining a divorce. I know you will want to know why this had come about, or at least something about what is happening. These words that follow are a partial explanation from my point of view, and deal in a major way with my life mission here in the Earth this time around.

Most of my life has been as a physician, although I really started out to be a minister. And, concurrent with those years of healing, I have been part of a family that has been quite productive and creative. Gladys and I have parented six children and have since lived long enough to see six grandchildren born and another in the offing.

Together, we had the good fortune to be guided in creating the A.R.E. Clinic, which has become known world-wide as an organization that has put the practice of medicine together with the concepts of healing found in the Edgar Cayce readings. The Temple Beautiful programs currently being held at the Oak House, as well as the Energy Medicine department, the care of the brain injured and the research that we've accomplished,

are all outgrowths of that marriage of psychic concepts of healing to the centuries-old medical profession, as it is practiced today in the Clinic.

Much, then, has developed in my life experience as my talents in writing journeyed through the years with the passage of time-limited methods of healing the body. As those years mounted one on top of the other, it became clear to me that the body only needed to ripen as age came about in the experience of an individual – we don't really need to grow old. Thus it was that I kept telling my patients – and anyone who would listen – that when I got to be 80, I would decide what to do with the second half of my life. For years, now, I've related that little insight to my patients who are trying to regain health and regenerate their bodies, and have urged them to do the same.

Thus I am creating this document, developed after 70 years of fascinating, soul-shaping experiences, looking at where I am, what I really am capable of doing, what tools I have in hand, and what environment needs to be so that I can accomplish the tasks that I set out for myself. It has come about after much soul-searching, much prayer and meditation and really evolved over the years as a result of much discussion with others who have helped shape my journey through life.

I can look back at the 45-plus years Gladys and I have spent together and see the good that's come out of that union. I feel sure that Edgar Cayce would say of that lifetime (along with the earlier years), "In that experience, the entities gained." For I think those years

have produced much that has helped make the world a better place. Then why go separate ways? Couldn't this keep on and produce more of the same? More columns of type, more books, more helping individuals in the healing activities while still joined together, much as has happened in the past? Undoubtedly, it could, with certain reservations.

My unconscious, however, has been prompting me and apparently getting me ready for a change. When I am 70, I've said, I will decide what to do with the rest of my life – the next 70 years.

It is at that point, from my new perspective, that my mission in life has gradually come into view. And it requires a restructuring of my life. Much like when one dies and then is reborn, a whole new destiny comes into existence. I find I need to begin a new life that will fit my mission.

In my mission I need to be alone. I need to set new directions, and I feel the need of those influences that one would sense from a past incarnation as a monk. I need the freedom of my own environment.

So what is my mission? To write on many things dealing with the spirit and the healing of the body; to counsel with and talk to those who may not have felt the reality of the Christ within their con-sciousness; to help awaken other individuals to reality – the reality of God's plan for mankind as I can fathom it from my experiences. And to make sure that I am preparing myself to do these things with prayer and meditation. For these things, I need to make a fresh start, now that I'm only 70, and I need the beginning to

be in an environment that is like starting out all over again. I truly feel like I am beginning a new incarnation while having just finished another. And this time, I can carry the knowledge that I have gained forward into the conscious mind to be used in an aware and awakened manner.

July 28, 1989 Bill McGarey

She couldn't read any more. Speechless, she watched as he got up to pack his clothes, to leave her life forever. In that instant she understood why we speak of a broken heart. There was a physical agony in her chest, so severe she was unable to breathe. Her insides were on fire. Like the walls of a burning house, her well-ordered life collapsed into the emptiness of her soul, and disappeared, a shower of sparks on an icy wind.

She shivered as she heard him opening drawers, rattling hangers in the closet. Snapping his suitcase shut.

She stared, dry-eyed, as he stood at the door and said something trite about staying friends.

Then he turned and walked out of her shattered life.

The world disappeared. All that was left was pain, and fire, and bottomless, endless grief.

A week later

He was gone, gone. The years of working by his side, waking up in his arms were over. Her life stretched before her, desolate, and bereft of joy. Their tiny house echoed with silence. She wandered from room to room, picking up mementos, first this, then that. She relived the past, shrank from the present. But when she came to their closet, the truth struck her fully in the face, like the flat of his hand. No longer could she cower, hide her eyes in denial.

There was nothing there. Nothing where his clothes had been, nothing but an old pair of slippers sitting forlornly in the corner. He must have felt they were too old and tired to take along to his shiny new life.

Staring dully at the worn out moccasins, she did the only thing left for her to do.

She prayed.

"Lord, help me. Please help me climb out of this pit. Help me understand why he's doing this. What is he thinking? Where did I fail him? What did he need that I couldn't give him? If it's not another woman, what is it?"

Bill had continued to deny any involvement with Peggy, and that was absolutely crazy-making for her. She had trusted him, believed in him, given him children, loved him to distraction. She'd protected his ego, deferred to him, dimmed her own light so that his could shine more brightly.

So why, why? She tortured herself with the question. If only she could understand, she might be able to accept.

Vaguely, an idea took shape in her mind. What was that old saying of her mother's? Something like, "You can't understand another man's mind until you've walked a mile in his shoes." Yes, that was it. The idea took solid form.

As if in a trance, she slipped off her flip-flops. Thrusting her feet into Bill's old discarded slippers, she slap-slapped through the house and out the back door.

Their dog bounded up, tail wagging, barking with joy. Crystal had one blue eye and one brown eye, and both were fixed on Gladys' face with a hopeful expression. She wanted to play, but Gladys just didn't have the heart.

"Good girl, good Crystal," she murmured, stroking the soft head. "C'mon girl, just be my friend." The dog followed as she shuffled

blindly into the hot, moon-drenched night.

She began to walk in his shoes.

Around and around the house she trudged, far into the night, trying to understand. Trying to accept.

With every shambling step, the slippers, much too large for her, stirred up puffs of dust that hung white in the moonlight. And Crystal, faithful friend, kept pace with her, licking the tears from her fingers, holding fast to her side throughout the long, endless night.

As Gladys walked she cried out loud, a mad woman railing at the darkness in her soul. She prayed, cursed, and begged for enlightenment.

She received no answer.

All was silent, save for the shuffling of her feet and her voice, hoarse now with misery.

As the night wore on, she sank further and further into the depths of her grief. She threw back her head. The molten pain ripped through her and burst from her throat; a wild, primitive howl erupting from the depths of the fiery mountain she had once called her heart.

And Crystal, too, began to howl, with her nose to the moon, in empathy and acceptance of her pain.

In the surrounding desert, first one, then another, then a dozen coyotes answered. Their eerie, ululating cries echoed off the rocky hills, and filled the night with the sound of sorrow and pain, a spine-chilling eulogy to the death of a beautiful thing.

Chapter 38

December 1989

"*I* love the new office," Stella said, looking around in approval. The spacious treatment room was furnished in soft, earthy pastels and seemed inviting. Southwestern prints graced the walls. Afternoon sun was refracted into dancing rainbows by the crystals hanging in the high windows.

Stella Andres was a long-time patient and dear friend. Gladys had worked with her ceaselessly over the years. Together they'd faced Stella's cancer and the subsequent amputation of her leg. Dr. Gladys had always been a tower of strength, but in the months following Bill's desertion, it was she who had needed the support of her friends.

"You and Helene make a great team," Stella continued. "But, Gladys, tell me truly – how are you? You're looking well."

Now, Gladys knew that she <u>didn't</u> look well. The long sleepless nights filled with worry and heartache were beginning to tell on her. She saw it every time she looked in her mirror. She went to bed weary and woke up exhausted. For the first time in her life, she was reluctant to face another day.

Thank goodness for Helene! Bill had assumed that both of them would stay with the ARE Clinic after the divorce, but on an emotional level, that was just not an option for either of them. Although Helene

was pregnant with her second child, she'd been a rock, an anchor for her mother. They'd decided to go into practice together. They'd leased an office on Stetson Drive in downtown Scottsdale, and called their new business Scottsdale Holistic Medical Group.

Financing had initially been a problem, for banks were leery of loaning money to a 69 year old divorcee. She had received nothing as a settlement from the practice she'd spent 30 years building, for the clinic was nonprofit, and hence belonged to no one.

After having many doors slammed in her face, Stella's husband offered to co-sign for a loan. Soon they found themselves $100,000 in debt, but they were blessed with many loyal patients and a busy practice. They labored hard to get the business on its feet. Helene, especially, worked far into every night, since she had taken on the job of business manager as well as full time physician and partner.

It had been four months since Bill had walked out her door, and it felt as if time had healed nothing. Her sixty-ninth birthday last week had been one of the hardest days of all, in spite of everyone's efforts. She knew she was loved and supported, but still she felt dead inside most of the time.

And besides all that, she was catching a cold. She'd popped a couple of vitamin C capsules a few minutes ago. She'd not had time to grab a glass of water, so she'd swallowed them dry. They were stuck in the back of her throat. She gulped convulsively a few times before replying to Stella's inquiry.

"Ulp ulp – well, Stella, I'm doing okay, I guess. You know, you get through stuff like this by just putting one foot in front of the other. And yes, the office is wonderful. I love it. Helene has been such a God-send. I think we're starting to come around."

As Gladys took blood pressure and listened to heart sounds, they continued to chat. The vitamin C capsules were still uncomfortably lodged in her throat.

380

"You know, Gladys, I think the best way to get over Bill is for you to find someone else. You're a beautiful woman. You could get another husband just like that!" Stella snapped her fingers vehemently.

"Oh, pooh!" Gladys replied, struck by the sudden realization that she was beginning to enjoy, just a little bit, her life as an individual. "What do I want with another old man?"

"No, no, I don't necessarily mean someone older than you. You're attractive enough to catch a younger man, someone handsome and strong." Stella waggled her eyebrows and giggled like a schoolgirl. "Someone full of vim, vigor, and vitality."

"Oh, Stella, I don't want a young man, either. I've already raised four sons!" They both burst into laughter and Gladys' nose began to tickle with a sneeze.

"Ahhh – choo!" she exploded. Unbeknownst to her, the gelatin caps had melted in the moist warmth of her throat. So when she sneezed, she resembled nothing more than a fire breathing dragon with plumes of smoke streaming out of both nostrils.

Stella's eyes grew round with shock, and they both stared at the cloud of smoke for an appalled moment. Small tendrils continued to emerge with each exhalation.

"Oh, my!" they said in unison.

Then they looked at each other and collapsed in helpless laughter. As the hilarity continued, more powder puffed out of her nose, and set them off again.

As she staggered out of the room and ran for the bathroom, Gladys thought, "Thank the Lord there's still laughter in my life. With good friends like this, I know I can get through anything."

Gladys in the new office in Scottsdale

Chapter 39

Christmas, 1989

"But as long as you love me so
Let it snow, let it snow, let it snow"

\mathcal{G}ladys reached over and snapped off the radio. Christmas love songs were one thing she could do without. Everything else about this holiday reminded her of Bill. She didn't need Andy Williams warbling about romance on top of it all. She turned to the record player and selected several LPs of religious Christmas carols. Stacking them on the spindle, she put the arm down and switched the machine on. As the beautiful strains of "O Holy Night" filled the air, she went back to clearing the table.

It was the first Christmas since Bill had left, and most of her children had come home to help her get through it. Although they were fully grown, with children of their own, they were almost as devastated and bewildered as she.

Christmas dinner had felt forced and almost too jolly – everyone was trying so hard to be normal. Friends stopped by, too, and the house was lively with love, laughter, and the holiday spirit.

But to Gladys, the bright lights and cheerful conversation felt like a facade – the first delicate skin grown over a wound, which threat-

ened to break open again at the least pressure.

"Nanni, Nanni, come quick! Watch my slinky walk off the table!" Helene's eldest, Daniel, grabbed his grandmother's hand and tugged her outside to witness his prowess with his new toy.

In the kitchen, Helene, Annie and John were doing the dishes, assisted by John's wife, Bobbie.

It was generally believed by the entire family that Bobbie was John's angel, for since they'd been married, John's health had improved remarkably. They'd attended the same seminary in Tennessee. Now they were co-pastors of a church in Utah, and the parents of two wonderful kids.

Helene washed the turkey platter and handed it to Annie to dry.

"Maybe I shouldn't put this away," Bobbie said, as the platter was in turn passed to her. "Maybe I should just throw it away. You know how Mom gets when she sees it."

The serving dish in question was a huge oval platter decorated with branding irons. These encircled a raging bull jumping over a fire pit. It was obvious that the plate was originally intended for ribs, steaks, and haunches of barbecued meat. And, of course, it had a story.

Many years ago, just before serving up Thanksgiving dinner, a slippery-fingered child had dropped and broken the good china turkey platter. There was nothing else large enough for the twenty-four pound turkey, so Bill was sent on an emergency reconnaissance mission. He returned with the platter in question. Although it was arguably the ugliest thing anyone had ever seen, it soon became a holiday tradition. Gladys, especially, had disliked it, but hated even more the idea of buying a new one, when this one was still serviceable.

But when she'd pulled it from the cupboard earlier that day, memories of happier times had burst through her thin veneer of control. The children had all seen it and rushed to comfort her. Embarrassed by her lack of control, Gladys had insisted upon using it, anyway.

Annie, always the irreverent one, christened it the Bull platter; everyone began to refer to their father as Bull, rather than Bill. This brought humor into the emotionally tentative situation, and helped them get through the day.

The kitchen crew finished the last dish, and joined everyone else in front of the fire.

The conversation turned, inevitably, to metaphysics. They began to discuss the work of various shamans around the world.

"You know, Gladys, you are a shaman. You really are," said Joe Kalish, an old family friend. "You create magic wherever you go."

"Oh, no," she demurred. "I'm just me, just good old Dr. Gladys, Mom, or Nanni, just trying to get through each day as best I can."

With a shout of laughter, Joe pronounced, "Then we'll call you Shamananni! Oh, great Shamananni, help me to find the way," he joked, falling to his knees in front of her. The moniker delighted the assembled company and gave rise to a flood of gentle and affectionate ribbing. They all knew that the best way to divert Gladys' mind from her grief was to keep her laughing.

The evening eventually came to an end. David and his bride, Lee, left soon after Joe. Helene's husband, Fred, took their sleepy boys home. Only John and the three girls remained to keep their mother company. Gladys' eye fell upon the Bull platter, and all the emotions of the day came to a head. It was not sorrow and regret that flooded her heart – now she was in full-fledged rage.

She picked up the platter and shook it in the air. "Oh, I'm just so _mad_! So furious that he would do this to me, to you kids, to our work and all the people who believed in him. And I _hate_ this platter! I've _always_ hated it. It reminds me of him – so full of bull!"

The kids recognized the torrent of fury as part of the healing process, and encouraged her.

"That's right, Mom!"

"You be mad, you be really mad!"

"Let him have it, Mom!"

"That...that...that <u>stinker</u>!" she finally shouted, drawing from her pitiful stock of swear words. "That big, fat <u>stinker</u>! I just want to break this platter over his head."

Bobbie, Annie and Helene cast each other speaking looks. They came to a silent agreement.

"We need to have a ritual to get his energy out of your space, Mom," Bobbie said. "We can use this anger to cut you free. You be Shamananni. We'll be your handmaidens. And John can be the token male."

They ran into her bedroom. They rooted through her closet, pulling out silk scarves from Paris and Egypt, and shawls from India and Tibet. Tying them around their heads, they created elaborate head dresses that flowed down their backs. With great ceremony they carried the most beautiful ones of all into the living room, and laid them at her feet.

Softly chanting, "Shamananni, Shamananni," the handmaidens draped a vibrant silk scarf over her shoulders, tied another around her forehead, and placed the bull platter in her hands.

Then, each holding a lighted candle, they processed out the back door.

John was in the lead. He carried a pickax, and his long stride set the solemn pace. Next came Shamananni herself, head held high. The handmaidens followed in time with the chanting, Bobbie with a sledge-hammer slung over her shoulder.

They followed the path into the desert, and gathered in a circle in the sharp, cold night. Candles flickered on earnest faces and all was silent, listening.

By the light of the full moon, Bobbie read from her Bible. Psalm 50, verse 9: "I will take no bull out of your house." John swung the

pickax, and quickly dug the ceremonial hole.

He was Merlin, they were High Priestesses of Avalon, making holy magic, releasing the past, honoring the healing power of rage.

In the surrounding desert, the creatures watched in astonishment as the woman placed the platter in the center of the circle. She then hefted the sledgehammer, and with a mighty swing, brought it down to shatter the plate into pieces. Again and again she smashed it, breaking illusions, freeing herself. The circle cried out with each blow, then each of the women in turn took a swing. Then the man covered the fragments with the clean desert sand, and slowly, still chanting, they processed back inside.

Coyotes looked at each other, shook their heads at the antics of humans, got up off their haunches and trotted off. Lizards and snakes went back to sleep. And the saguaros stood, still and silent in the moonlight, marveling at the magic they'd just seen.

Chapter 40

🦅

January, 1990

𝒯he new Cadillac gleamed in the lights from the restaurant parking lot. Bob and Jane, Gladys and Annie stood around it in the frigid January dusk, admiring every detail.

On top of everything else, Gladys' old Chevy had finally died a week ago, leaving her stranded on the side of the freeway.

When Bill's brother Bob found out about it, he told his wife, Jane, that they had to do something. They had both been appalled by Bill's recent behavior. They wanted to help Gladys in any way possible, but up until now she hadn't seemed to need anything but their love and support. So they offered to loan her the money for a new car, and she had gratefully accepted.

Carl had flown in from Houston to help his mother pick out her "new ride" and in an unprecedented act of extravagance, Gladys had bought a Cadillac. A white one with electric windows and leather seats. It had been a secret dream for as long as she could remember, and she was as excited as a kid at Christmas.

Annie had been staying with her mother since the holidays, and they had met Bob and Jane at Macayo's restaurant for dinner. Now Gladys was showing Bob all the bells and whistles that made her new car so wonderful.

Jane and Annie stood to the side, leaning together in the cold. They watched the windows go up and down, lights go on and off, and chuckled with affection.

"Thank you so much, Aunt Jane," Annie said. "You can see how much this means to her."

Jane replied in a soft voice, "Well, I figure that's her winter coat."

Mystified, Annie asked, "Her winter coat? Whatever do you mean?"

Jane smiled. "Well, back when you kids were really little, Bob and I came to Wellsville to spend Christmas with you. Your dad had just gotten a new car – a Chevy or some such. You know how crazy he's always been about cars. Anyway, we were all outside looking at it. It was freezing cold, and the snow was piled up all around. Gladys was standing next to me shivering in this thin ratty old coat.

" 'Gladys, go put on a coat,' I told her.

" 'This is my coat,' she said.

"Well, I looked at it and told her flat out that she needed a new one.

" 'Oh, Jane,' she said, lowering her voice so the men wouldn't hear, 'Money's been tight lately. There was a strike at the steel mill and a lot of patients couldn't pay their bills. And what with Christmas and presents for the kids and all, we really can't afford it. So I just put a couple of sweaters under this and it works just fine.'

"Well, Annie, let me tell you what. I looked at her standing there shivering. Then I looked at that fancy, brand new car. And I thought, 'Boy, has he got you hoodwinked.' "

Jane looked at her niece and her smile widened into a satisfied grin.

"So, I figure, finally Gladys got her winter coat."

Irma McGarey, Gladys McGarey, Jane McGarey 1975

Chapter 41

Spring/Summer 1992

Gladys was recovering.

Of that, she had no doubt.

She moved through her process slowly, for at first she couldn't conceive of an existence without him.

She dreamed about him every night. In her dreams he was still her husband and her love.

Life went on without him. Yes, there was grief, and a deep sense of loss. But there was also joy and discovery, laughter and love.

Without someone to shape herself to, whose wishes and needs took preference over hers, she was forced to look within. At first she felt formless, without aim or direction. She was so used to putting her family and her husband first that now, bereft of both, her heart felt silent and alone.

It took time to learn to listen to herself.

Driving home from the office, she'd find herself wondering what Bill wanted for dinner, then remember that there was no one there. Devastated, she'd go slowly into the cold, dark house, fix herself a bowl of cereal, and cry herself to sleep.

But after a while, as healing took place, things changed. She began to discover who she was: Gladys herself, singular, individual,

strong.

When she finally began to ask herself what <u>she</u> wanted for dinner, the changes took root and began to grow. The day she stepped into the empty house and blessed the silence was a day of great blossoming. It came as a shock to realize that for one half of a century, Bill's life had, in every way, taken precedence over hers. She knew, intuitively, what her husband, her children and her patients required, every moment, every day.

But her own yearnings – ah! That was the mystery.

And so, with typical single mindedness, she embarked upon a journey of self-exploration. She reveled in her solitude. She sat for hours in the hot tub or on her roof top deck, and gazed at the stars, exploring the undiscovered country of her own individuality.

Without judgement, she began to act upon the promptings of her own desires, and it brought her a childlike delight.

Instead of fixing a nutritious dinner, she'd have a bowl of ice cream. Not every night, of course, but sometimes all she wanted was the crunch of butter pecan, or the sweet sharp taste of mint chocolate chip. Yum. Yum.

She'd turn on the TV and, rather than watching the news or an educational program, she'd cheer for Zena, Warrior Princess, and her sidekick Gabrielle.

And sometimes, instead of listening to Mozart while having serious discussions about the destiny of the soul, she'd put on a record of her favorite musical and read a novel by Louis L'Amour or Nora Roberts.

She soon realized that there was a richness to her being of which she'd formerly been completely unaware. The depth of her own thought processes astonished her. As she explored new paths, she found herself thinking, "Hey, I'm pretty smart. I have something important to say. There's wisdom here that comes from the depths of my own

experience. Unchanged by someone else's input, my ideas make sense. They make a whole lot of sense.

"Wow!"

She spent entire evenings on the telephone, talking to friends. They counseled her, gave her the benefit of their wisdom. Rachael Naomi Remen, Elizabeth Kübler-Ross, Lindsay Wagner, and many others were there for her during her time of need.

One winter night at the beginning of her journey, Gladys was talking to Lindsay on the phone. They had first met at the inaugural AHMA conference in 1979. There had been an immediate soul recognition, and their friendship had deepened over the years. The gentle heart and loving spirit of TV's Bionic Woman, together with her down-to-earth common sense, was oft times exactly what Gladys needed.

"Sometimes I just get so discouraged," Gladys said, despondently. "Everything we were to each other, everything we had, all gone. I feel just like an old coat that's been hung up on a peg. Lindsay replied, with an uncharacteristic sternness, "Gladys, that's just silly! You are not an old coat. If anything, your marriage is the old coat. You've taken it off and can let it be hung up on a peg, and now you're free."

It was <u>exactly</u> what she needed to hear.

Thank the good Lord for friends.

And her children! They were her rock, her sustenance, her grounding cord of bone to bone, blood to blood. Nothing is deeper, nothing more mysterious than the bond between mother and child. They crowded around her like cubs around a wounded she-wolf. Anything, everything she needed, they were there for her, usually even before she knew she needed it herself.

She talked on the phone endlessly to John and Bobbie. They counseled her with wisdom and tenderness.

Carl was a tower of strength, unfailingly generous and dear. His wife Dee Dee and Annie, the most outspoken of them all, ranted and

raved, to Gladys' secret satisfaction. David and Lee were a deep comfort and a consistent joy. Bob, bless him, called or wrote daily to reaffirm his loving support.

And Helene! Bless her coming and going, up one side and down the other. What would she have done without her? Besides being a great business partner, she and her husband Fred had encouraged Gladys to build a new home on the back of their property.

The forty-five minute commute had become too much for her, as had the memories of the shattered dreams of the Casa Grande community.

So, early in 1992, she hired an architect to design and build her a house. Six months, he told her, was all it would take to create a perfect jewel box of a home. It would be completely insulated and environmentally friendly, with a great big bathtub and a wonderful deck upstairs.

She put her old house on the market and it sold in less than two weeks. The new owners were to take possession in June, since her new house would be finished by then.

She dusted her hands of the past and prepared to move on.

But fate, it seemed, had a different idea.

There were problems with the design and the permits. June arrived and the foundation hadn't even been poured.

The Wednesday before she was to vacate the Casa Grande house ranked as one of the lowest moments of her life.

Driving home from the office, she raged out loud.

"And now I have no home. Not even a home! I sold my house and now I have no place to go! Those guys told me my house would be done but they're doing <u>nothing</u> – no permits, no foundation, no nothing. I know it's because I'm too darn nice – I never yell at them, I just smile like a wimp and say well, do your best. What a pushover I am! So now I have to go live in someone's garage, or be a burden on John and Irma

396

or Helene, for goodness only knows how long."

Then the true reason for her distress flooded her mind, as her eye fell on the wedding invitation sitting on the seat beside her. She stomped on the accelerator and began to scream.

"I can't believe it! They're getting married! And they had the nerve to send me an invitation. Even though he swore they weren't involved, it was all a lie. He told the kids he was going to start dating again and now, just three months later, he's marrying her. I can't stand it. I just can't stand it. Will I never be through with these feelings? It's been three years. People say I should be over it by now. But how will I ever get over it when he keeps breaking my heart over and over. Pretty soon I won't have any heart left."

The car sped down the freeway, faster and faster.

"God, how could you do this to me? Take it all away like this, give it all to Peggy? Now she has everything!" She pounded her fist on the steering wheel. "She has Bill. She has the Clinic. She has everything I spent my whole life creating. It's so unfair, so wrong, wrong, wrong! What will I do? Oh, dear God, whatever will I do?"

The tears broke like a storm, blinding her. Just past the Sacaton exit she brought the car to a screeching halt. With shaking hands she flung open the door and heaved her lunch up all over the hot asphalt and empty beer cans that littered the side of the freeway.

She remained motionless for a long, long time, as the world spun around her. Finally she sat up and closed the door. She wiped her trembling lips with a tissue and rested her head on the back of the seat. She felt drained of all feeling, weightless, incorporeal. Drifting into a dream, she was back on the verandah of the Rourkee compound, and she heard her father's beloved voice.

"Now, Gladdie, don't you despair. The ways of heaven are mysterious, and too great for our puny minds to comprehend. We may never understand why these things happen. Life doesn't always go the way

we want, or turn out the way we plan. But the important thing is to stay in the game! Never quit! Don't you _ever_ give up. You just do the very best you can, and take comfort in the knowledge that whatever the outcome, you gave it your best."

When she lifted her head, a new light shone in her eyes. She dried her tears and gave a great honk to her nose. As she started the car she looked at herself in the rear view mirror.

"Gladys, you are a fool," she ruefully told her reflection. "Peggy may have all those things, but she'll never be Gladys McGarey."

And she drove home to complete her packing, full of the knowledge that she had, indeed, given her marriage her very best, and willing to accept the outcome, incomprehensible though it may be.

Her new life stretched before her with great promise. She realized that she certainly wasn't ready to give up. Not even close! She would continue to do her utmost, and give life her best, and rely on her faith to carry her through the dark times.

*Gladys and
Lindsay Wagner*

Chapter 42

June 1993

\mathcal{G}ladys sat in a chair before the Arizona State Board of Medical Examiners. The group of grim-faced men were arrayed in a semicircle facing her. It was an arrangement designed to be as intimidating as possible, and it was working. She felt like a criminal. The blank look on her face belied her seething mind.

She thought about Job, in the Bible. This must have been the way he felt when God started raining trials and tribulations down upon him. Poor guy.

Poor me.

In the years since Bill had walked out of her life, it seemed as if nothing had gone right.

Well, she corrected herself, one thing had always gone well. Her practice with Helene was working out wonderfully. Their finances were tight, but she was used to that. She felt so blessed to have the support and companionship of her daughter, and Helene's husband, Fred, who had been so important as far as details and negotiations were concerned.

And, she added, to herself, the trip to Tibet with her brother Carl had been marvelous. In early 1990, he'd been asked by John Hopkins University to lead a six-week research expedition to study medical

care in the remote villages of Tibet. He'd invited her to join the team, and she'd jumped at the chance. Somehow, Carl always knew exactly what she needed. He must have been able to tell that, during those terrible months in her life, what she needed was distance. And perspective. And especially, the strong broad shoulders of her big brother.

Her relationship with him had always been very, very special. Throughout their lives, they stood by each other no matter what. His love and support was unfailing, and to be counted upon when all else failed.

She often thought how empty her life would have been if the jungle had had its way with him. For when Carl was but eight months old, he was almost carried off from their tent by a wolf, Mowgli-style.

He was saved only by the *ayah* who, awakening from a light doze, glimpsed the lantern light reflected from a pair of yellow eyes above the bunk in which baby Carl slept. The she-wolf's mouth was open wide, and the sharp teeth gleamed as they closed delicately over the bundle of sleeping child.

The *ayah* knew of many stories in which human children were stolen and raised by wolves. There was no doubt in her mind as to what this one was after.

With typical courage, she gave a loud cry and flung her *topi* at the creature. It hit the wolf full on the side of her head, startling her into dropping Carl and running from the tent.

All the camp dogs started barking, and the commotion aroused the entire encampment. When John returned from the village, he sat up all night, rifle at the ready, in case the kidnapper reappeared. Just before dawn, he heard a sound at the back of the tent. He cocked his gun, but before he could draw a bead on it, the wolf skulked off again into the jungle.

Beth told him that she'd caught the wolf in the tent two nights running, but didn't want to make a fuss, so she shooed it out with a pil-

low.

They broke camp the next day and moved on, and baby Carl was safe to grow up and become Gladys' buddy, protector and hero.

Traveling to Tibet with him had been fulfilling and exciting, in spite of the primitive conditions and back-breaking work. But a month away from the fledgling practice had put an immense burden on Helene and had created a cash flow problem that they were only now beginning to recover from.

And <u>then</u> she'd been named in a malpractice suit, and had spent six weeks sitting in a courtroom being harangued and insulted. The prosecutor had repeatedly called her a witch doctor, and had insisted upon calling castor oil packs "bits of rag soaked in oil." The only saving grace about the whole thing had been that moment on the elevator.

She'd stepped into the car and the prosecutor had followed her on. As the doors slid shut, a friendly blonde woman turned to her and said, "My, that's a beautiful jacket."

"Why, thank you," she replied. She was wearing a jacket that she'd embroidered with a splendid Phoenix bird. It had been an intricate project, but quite satisfying, completed during the last symposium. She always liked to do handwork during the other lectures, to keep her hands occupied. Since she'd heard most of the presentations many times before, she could listen with half an ear while creating something of beauty for herself or the kids.

The woman on the elevator looked at her closely and said, "Don't I know you?"

"I'm Dr. McGarey," she replied.

"I <u>do</u> know you," the woman cried. "You probably saved my life many years ago, so many you probably don't remember me." Then she turned to the other people on the elevator and told them, "This is a remarkable woman. She has six children and has had a full medical practice all these years. She's the best doctor I've ever had." As the

door opened and she stepped off the elevator, she called back, "The work you're doing is amazing. I'm so glad I ran into you again. Keep up the good work, Dr. Gladys, and thank you, again, from the bottom of my heart."

The prosecutor looked like he'd bitten into an unripe persimmon, and Gladys could hardly keep a smug smile from her face.

But that court case, along with the increasing amount of persecution aimed against holistic practitioners, had recently brought her up on charges before the Board.

And now the men were finished with their deliberations. The final judgement was that she was to receive a letter of concern. Thank the Lord they hadn't voted to revoke her license!

As she pushed herself to her feet, rummaging in her purse for her keys, one of the members of the Board stalked up to her.

He'd been the most vocal in his objections to her unorthodox methods, the most condescending and insulting in his condemnation. He obviously was not happy that the Board had dismissed this matter. He stopped a few inches away and glowered down at her.

"Now, let me tell you something, honey," he began.

As she looked up at his pinched, outraged face, fury such as she had never known overwhelmed her. The edges of her vision wavered; a red haze covered her sight. All the injustice, the despair, the anguish that she'd endured since long before Bill left coalesced into one dazzling moment of clarity, and she knew, in that moment, that she would never allow it to happen again. She may have felt cast aside like an old coat, her heart may have been trampled and her professional reputation impugned, but she knew, beyond a doubt, that it was going to stop here!

The strength and power of her woman's soul poured into her body. She felt herself grow and expand like a genie erupting from a bottle. She planted her feet, and felt the air around her crackling with righteous wrath. He faltered and stepped back.

In her right hand she held her large, turquoise studded key chain. Wielding it as if it were a weapon, she beat his chest with it, one thump for every word.

"Don't you call me honey!" she cried. "Don't you ever, ever call me honey again. I am your professional peer. I am older than you and wiser than you will ever be. I deserve your respect and your acknowledgement. I will not be belittled and degraded by your bigoted attitude and abominable manners. Who do you think you are, anyway?"

She glared at him, pounded his chest once more for good measure, and added, "You just think about that!"

Turning on her heel, she strode down the hallway, feeling better than she'd felt in a long, long time. She passed her lawyer who was convulsed in laughter against the wall, and slammed the door with a satisfying bang.

"So there!" she called, and she hopped in her car and peeled out of the garage. The sound of her triumphant laughter lingered long after she had gone.

Gladys, 1992

Carl and Gladys in Tibet, 1990

Chapter 43

1995

Gladys sat on the deck of her house, watching the sun set behind the mountains and palm trees. It was a beautiful, soul-soothing view, and she loved it.

She loved her whole house. She'd moved in on the Fourth of July, 1993, Independence Day. How symbolic! The deck was smaller than she'd wanted, as was the bathtub, but otherwise, it was perfect. It had two bedrooms – one up, one down – open-beam ceilings, and a stained glass window that threw rainbows all over her bedroom at the first rays of the sun.

It was the perfect size for her. She'd decorated it in her own off-beat, eclectic style. The tiger skin was once again stretched across the living room wall just above the old green couch. Angels, crystals, and kachina dolls, all gifts from grateful patients, filled every nook and cranny. She had a gallery of family pictures that covered the high wall of the stairwell, so, as she went up to bed, she could say goodnight to her dear ones.

The sun dipped below the horizon, and the evening star appeared. In the dying light, Gladys once again read the letter that lay in her lap. It was from Bill, and he'd ended it with, "I want you to know I still love you and send you my greetings, and it would be great to hear

from you that you have discovered forgiveness in regard to me."

"Hmmm," she thought.

What could she say to that? Of course she'd forgiven him. She'd forgiven him a long time ago. It didn't ease the ache in her heart when she thought of him, but after all, we each have our own paths to walk. He had to follow his. And she knew, as surely as she breathed, that their karma would bring them together again and again, as it had in past lifetimes, so, too, in the future ones.

They had all the time in the world.

She stood up and leaned on the iron railing of the deck, breathing in the sweet desert air.

She wanted to reply to his letter. She'd read that life is like a beautiful tapestry. We weave it with the colors of our lives, but if we fail to hem it, it can come unraveled. And the way to hem it is with gratitude.

She thought of all they'd shared, all he'd given her, the myriad things for which she was grateful.

And so, to hem the tapestry of their life together, she went inside, picked up her pen, and wrote the following:

> In regards to forgiveness:
>
> I continue to thank you for giving me 46 years of companionship and partnership;
>
> for giving me the opportunity to really love you;
>
> for giving me the blessing of being the mother of our really wonderful children and grandchildren;
>
> for giving me the joy and pain in creating the A.R.E. Clinic with you;
>
> for giving me the opportunity to express myself in the written word, *Born to Live* and *There Will Your Heart Be Also;*

for giving me the joy of sharing our home with some of the most wonderful people on this planet at our dinner table;

for giving me the excitement of the Sunday School class at Valley Presbyterian Church;

for giving me companionship as we traveled the world together;

for giving me the trips across the country with our children;

for giving me your love. It's sad to me that it didn't last;

for giving me special precious moments such as lying in your arms as we watched the sun come up in Rio Rico;

for giving me the opportunity of sharing a piece of peanut butter pie with Hugh Lynn and Sally;

for giving me a life which has been really blessed and I could go on and on;

but, finally, for giving me a chance to go on and do my work as God is directing me to do. It has been hard for me to see and understand and now I know that you have given me my freedom. It was not what I wanted but I believe it was what was needed.

I read somewhere recently that to create a beautiful tapestry and then not to hem it allows it to unravel, but it can be hemmed with gratitude. Our marriage and our life together created a beautiful tapestry, but it can unravel if I fail to hem it with thanks. I don't want that to happen. What we did together was beautiful and it will go on as we go our separate ways.

Grandchildren
L to R:
Daniel, Timothy, Hannah, Andrew, Gabriel, Jessica, Betsy, Taylor, Julia, Johnny

Chapter 44

The Big Island, Hawaii November 30, 1999

She awakened slowly, sweetly, to the sound of tropical birds and the scent of plumeria carried on a soft ocean breeze.

It was her seventy-ninth birthday.

"Happy birthday to me," she sang to herself, and stretched luxuriously. Her dream had left her feeling happy and at peace. This was unusual, since it had been about Bill.

For five years after he left, she'd dreamed of him every night. In the dreams he was still her husband, and they had left her shattered. But over time they had become less and less frequent, less and less heart-wrenching, until these days she was surprised when he appeared.

This morning she felt strong and powerful, as if something left unfinished had been completed.

In her dream they were eating dinner in the dining room on Lafayette, having a great time. Then her mother came to her, hugged her, and said, "Tell him he must go now."

So she said, "Bill, you have to leave."

He got up, kissed her, and walked out the front door. Then she felt herself being drawn to her feet and realized that he was holding ropes, like reins, that were tied all around her. They looked like thick, sticky spider webs. She was being pulled after him against her will. She

tried to get free, but was helpless against them.

Then the room was full of her children and family and friends. They all had silver scissors of different sizes, and together, they cut her free.

Bill walked out the front door and drove away in his Porsche. She sat back down at the table with everyone gathered around, and she shared a joyful Thanksgiving feast with all the people she loved. Then she woke up.

There was no doubt in her mind as to the meaning of the dream.

She'd finally, finally, let go.

Hallelujah!

At times since the divorce she'd despaired of ever getting beyond the bitterness and resentment, of coming to a place of true release.

She'd forgiven Bill a long time ago. But she found it much harder to forgive Peggy. She lay awake countless nights with hatred eating away at her gut. But after much struggle, she realized, in a flash of deep understanding, that she was truly only hurting herself. She remembered what her *ayah* had said once when she'd been enraged at a little friend and cried out that she hated her.

"No, no, Gladdie, you must never, ever hate anyone. For when you hate someone, you are taking their karma upon yourself. And then, if they are hating you in return, it goes round and round and round the world, to the sound of the angels weeping."

And if there was one thing she was sure of, it was that she didn't want even a part of Peggy's karma. So, almost reluctantly, she chose to stop nursing that grudge, and to let it die of neglect on the bright, dry cliffs of her detachment.

Now, she could honestly say, "Thank God for Peggy," because without her she would never have stretched beyond her comfort zone, never become the woman she was today.

Forgiving Bill was easy, but letting him go – that had been the hard part. She still loved him, and knew she always would. She had promised that long ago in the little chapel in Cincinnati, and she could not break that promise, not now, not ever. And it pained her so to see him cut himself off from his family. He was so obsessed with his new life that he spent no time with his children, and didn't even know his grandchildren.

God forgive her, she still couldn't stand to see him hurt, even though he'd chosen the pain.

And so, in recent months, her prayer had been, "Help me let go. Help me move on. Release me from the pain I feel when I see him growing old without me."

Her dream was a clear, joyous answer to her prayer. A smile spread across her face and she sat up on the side of the bed. She grabbed hold of the edges of the mattress and said her morning prayer, "OK, God – what are we going to do today?"

She couldn't wait to get started. She figured that maybe the reason things seemed so clear to her today was because of where she was, and who she was with.

It was the final month of 1999, and even the least superstitious believed that the changing of the millenium held deep portent. The most paranoid among the populace had visions of mass hysteria and terrorist attacks.

Gladys had come to this spiritual retreat with seventeen other women. At a conference in Council Grove, Kansas, the previous spring, they had been talking about the fear and panic being predicted by the media.

They decided to do something about it. The world needed feminine energy, focused and directed, to balance the apocalyptic visions of Y2K.

So they'd gathered here at Dragonfly Lodge on the Big Island

of Hawaii, for a time of powerful prayer and ceremony. They were envisioning world peace, creating harmony for the new millenium.

Luckily for Gladys, her birthday fell smack dab in the middle of their week together.

They were having the best time! At sunrise and sunset they gathered together, in a circle overlooking the impossibly blue sea. Under the canopy of rainbow colors, they called the Goddess and prayed for peace. They sang and danced, and laughed until they hurt. Her favorite song was one Chris Hibbard had taught them. It never failed to bring chills to her spine, and tears to her eyes:

Surely, the presence of God
 is in this place,
I can feel Her mighty Power
 and Her Grace,
I can feel the brush of Angels' wings
I see glory on each face,
Surely the presence of God
 is in this place.

She sang it softly to herself with her eyes closed, then reached for her robe, hoping someone had already made coffee.

She heard sounds of whispers and stifled giggles coming from the hallway. Her door burst open. All seventeen women surged into her room, singing Happy Birthday in lusty, vigorous harmony.

Gladys threw herself back on her bed, crowing with delight. They crowded onto the bed beside her, sat on the floor or on each other's laps, and gave her her birthday present. It was a book entitled *Girlfriends,* and each one had inscribed it in memory of their time together.

They then all began to sing the jingle that Gladys had taught them after an emergency midnight dessert run to the local café:

> Pie, pie, we all like pie,
> Apple pie and cherry,
> Peach and boysenberry.
> Pie, pie, we all like pie,
> Any kind of pie will do.

It was sung to the tune of "Hail, Hail the Gang's All Here." They sang it all the time, and for no reason at all.

They burst out of her room and feasted on an especially scrumptious breakfast. The morning circle was incredible, and Gladys felt transported by the energy and power that was generated. How could the darkness of fear stand against this brilliant flame of love? She had never before been a part of something so potent, so strong.

Later that day they decided to have their sunset circle on the beach. They piled into their two vans and bounced down the narrow island road.

They were on a narrow cliff when an oncoming car being driven much too fast sideswiped the first van. The accident brought all three vehicles to a stop.

The doors flew open. En masse, the women descended upon the young man at the wheel of the offending car. He was distressed beyond reason. It soon became apparent that he'd been on an unauthorized joyride in his father's new car. He was on the verge of tears, and when a cop showed up, he became truly panicked.

The sight of the boy's terror had a powerful effect upon the women. Damage to the paint job was forgotten as each responded to the child's fear by transforming from Avenging Goddess into the Nurturing Mother of all children.

The policeman watched in disbelief as the women wrapped soft wings of pity and absolution around the young man. Soon they were soothing him, assuring him that everything would be all right. They hustled him back into his car and sent him on his way.

Brushing the astounded cop aside, they climbed back into their vans, to continue their interrupted trek to the beach.

Gladys looked around at her friends' laughing faces and thought, "This is the way it should be, the way it must be. Not only in each of our lives, but in all the world. Forgiveness instead of revenge, caring in the place of condemnation. This is the way to peace."

She looked through the side window. A brilliant rainbow spread its perfect arch across the sky. She felt her heart swell with hope and a profound sense of new beginnings – always new beginnings, because nothing beautiful ever truly ends; not love, not spirit, not joy. They are eternal, and to experience them anew each moment – this is the essence of a life fully lived.

"Here we go again," she called. The women, shining with light, surrounded her with their bright spirits, as the vans rocked down the cliff-side road.

The cop took off his helmet and scratched his head in amazement. Then his face broke into an unwilling grin as the refrain floated back to him in the sweetly scented tropical twilight:

"Any kind of pie will do!"

One van load ready for the beach

Rainbow Meditation Loft, morning of the New Millenium

415

A circle of women's hands bringing healing for the New Millenium, 1999

Birthday Cake

Afterword

I could go on and on.

Every day of my mother's life tells a new tale. Or two. And even after she's gone, her story will not be over. The countless people she has touched and the revolutionary work she has done will live on, generating change, healing lives.

At present, she's 83, and still vigorously and actively alive. She continues to travel extensively and to teach what she has come to call "Living Medicine." When she is in town, she keeps regular office hours, hosts a Tuesday night study group in her home, and holds monthly dream interpretation classes and senior writers workshops. She also chairs regular meetings of the board of the Gladys Taylor McGarey Medical Foundation which she founded in 1989. The foundation offers educational seminars and workshops on holistic medicine, and continues to present the Phoenix program several times a year. She is an avid gardener and a wonderful grandmother. During the few evenings she spends at home, she reads, knits, and watches TV, all at the same time, just to keep herself busy.

Her children never know where she is at any given moment: Virginia Beach, San Diego, Tokyo...who knows? Doris is the only one who can keep track of her.

When she agrees to speak to a workshop or seminar and is asked to forward a biographical sketch for the brochure, this is how it reads:

417

Gladys T. McGarey, M.D., M.D.(H), is internationally known for her pioneering work in holistic medicine, natural birthing and the physician-patient partnership. Dr. McGarey is a founding member and past president of the American Holistic Medical Association. Her work, through the Gladys Taylor McGarey Medical Foundation has helped to expand the knowledge and application of holistic principles through scientific research and education. Dr. McGarey is past president of the Arizona Board of Homeopathic Medical Examiners and was a member of the Board of Directors of the American Board of Holistic Medicine, and a Founding Diplomat of the American Board of Holistic Medicine. She is on the Advisory Board of Arizona State University East.

A family physician for 55 years, she and her daughter have a joint practice, the Scottsdale Holistic Medical Group, in Scottsdale, AZ. Dr. McGarey lectures internationally at health conferences and is the author of numerous articles and books. She co-authored "The Physician Within You: Medicine for the Millennium, The States of Stress Leading to Disease," "There Will Your Heart Be Also," and wrote "Born to Live." In 1990 she received the Humanities Award for Outstanding Service to Mankind, presented by the National Committee for the Advancement of Parapsychology and Medicine. In 1993 she was named one of Arizona's "Ten Outstanding Women" by a state publication, "Today's Arizona Woman." In 1994 she received the David Stackhause Award for pioneering excellence in homeopathy. In 1996 Dr. McGarey received a Lifetime

Achievement Award, presented by Larry Dossey, M.D., from the Gladys Taylor McGarey Medical Foundation. In 1997, Dr. McGarey was a finalist for the Athena Award honoring women who have devoted time and energy to their community. Also that year, she was the recipient of the 1998 YWCA "Tribute to Women" award in the healer category. In 1999 she received the Elmer Green Life Long Achievement Award presented by International Society for the Study of Subtle Energy and Energy Medicine. In 2001 she received the Life-time Distinguished Service Award from Muskingum College in Ohio and the Native American Elder Award from the Phoenix area of Indian Health Services. In May of 2003 she was honored by the American Holistic Medical Association as a Pioneer of Holistic Medicine. In October of 2003, she received the Healer of the Year Award from Nurse Healers PAI.

She is honored, respected, and adored by her professional peers, her patients, her family and her friends. My mother is quite simply the kindest, most generous person I've ever known.

She is truly a hard act to follow. And if you don't believe me, just ask my therapist. I can give you her number.

Glossary

ayah - nurse
barfi - candy
Bara din Mubarikho - Merry Christmas
bhishti - water carrier
chai - hot sweet Indian tea, made of cardamom and lots of spice
chambili - jasmine
changa - unclean
chapatti - flat bread
chini - white sugar
dal - lentils
dandi - chair carried by four coolies
desdar - office
dhober - pet name for Gladys – clumsy bucket
dholuk - drum
dhoti - loincloth
fakir - holy man
ghee - butter made from buffalo milk
gulab jamen - deep fried whey balls cooked in syrup
gur - unrefined cane sugar
Harijan - untouchable
hathi - elephant
imli tree - Christmas tree
jalabi - squiggles of batter cooked in syrup
keri-sher - tiger
ladoo - candy
mahout - elephant boy
mali - gardener

mem sahib - married woman

michan - lookout in a tree

muggar - crocodile

nala - drain from bathtub

nini bébé nini - sleep baby sleep

nunga-punga - naked

Nyasal Mubarak ho - Happy New Year

pisa - coin

punkha - fan

puri - fried bread

raita - yogurt with spices

rat-ki-rani - "queen of the night" –
 sweetly scented night-blooming flower

roti makin chini - bread butter sugar

rupees - coin

sadhu - holy man

sarahi - clay pot with narrow neck full of boiled water

sher babar - lion

shirkaris - hunters

shirkars - hunt

sonar - goldsmith or silversmith; jewelry maker

sutte - funeral pyre for widow

tablas - drums

tamarsha - big show

tauba - "Oh my!"

thik ha - that's right

tonga - horse drawn carriage

topi - sun helmet, pith helmet

uzdaha - python

zamadar - landowner

zennanah - women's quarters in homes and palaces